PICTURING POVERTY

PICTURING POVERTY
Print Culture and FSA Photographs

Cara A. Finnegan

Smithsonian Books
Washington and London

Part of chapter 2 originally appeared in a different form as "Social Engineering, Visual Poli-tics, and the New Deal: FSA Photography in *Survey Graphic*," in *Rhetoric and Public Affairs* 3 (Fall 2000): 333–62. Part of chapter 3 originally appeared as "Documentary as Art in U.S. Camera," in *Rhetoric Society Quarterly* 31 (Spring 2001): 37–67.

Production editor: Robert A. Poarch

Copy editor: Jan McInroy

Designer: Brian Barth

Library of Congress Cataloging-in-Publication Data

Finnegan, Cara A.

 Picturing poverty : print culture and FSA photographs / Cara A. Finnegan.

 p. cm.

 Includes bibliographical references and index.

 ISBN 1-58834-118-6 (alk. paper)

 1. Photography—United States—History—20th century. 2. Documentary photogra-phy—United States—History—20th century. 3. American periodicals—History—20th century. 4. Mass media and art—United States. 5. United States Farm Security Administra-tion—Photograph collections. I. Title.

 TR23 .F55 2003

 070.4'9'097309043—dc21 2002075857

British Library Cataloguing-in-Publication Data is available

Manufactured in the United States of America

10 09 08 07 06 05 04 03 5 4 3 2 1

This book is dedicated with love to my parents,
Norma C. Tomte Finnegan and John R. Finnegan Sr.

CONTENTS

PREFACE

A Rhetorical History of Photographs

The beholder feels an irresistible urge to search such a picture for the tiny spark of contingency, of the Here and Now, with which reality has so to speak seared the subject, to find the inconspicuous spot where in the immediacy of that long-forgotten moment the future subsists so eloquently that we, looking back, may rediscover it.

—WALTER BENJAMIN, "A SMALL HISTORY OF PHOTOGRAPHY" (1931)

When there is no vision the people perish.

—FRANKLIN DELANO ROOSEVELT, FIRST INAUGURAL (1933)

Facing and Recognizing the "Grim Problem of Existence": FDR and the FSA

On a gray afternoon in March 1933, Franklin Delano Roosevelt took the presidential oath of office and inherited a country in profound economic, social, and spiritual trouble. Roosevelt's task that somber day was to convince a nation already three years into a great economic depression that there was reason to hope for better times. In his inaugural address Roosevelt did not sugarcoat the situation; indeed, he pledged to "speak the truth, the whole truth, frankly

and boldly."[1] While President Hoover had often resisted the use of federal re-
sources to alleviate suffering in the states, Roosevelt made it clear that he would
mobilize the resources of the federal government to address the economic and
social problems of the nation.

Throughout the speech Roosevelt relied heavily upon two terms with a dis-
tinctly visual inflection: "facing" and "recognizing." In exhorting Americans to
confront their anxieties about the Depression head-on, Roosevelt observed
that "we *face* common difficulties," reminded the audience that "a host of un-
employed citizens *face* the grim problem of existence," suggested that the prob-
lem of unemployment is solvable "if we *face* it wisely and courageously," and,
finally, warned that the nation must "*face* the arduous days that lie before
us."[2] During the first few years of the Depression, many in government and
business had buried their heads in the sand, but Roosevelt asked the American
public to turn and "face" the problems of the Depression squarely and coura-
geously. Only when Americans had faced the Depression, Roosevelt explained,
could they then go on to "recognize" what would be necessary for recovery.
Roosevelt argued that citizens needed to participate in the "*recognition* of the
falsity of material wealth," "*recognize* the overbalance of population in our
industrial centers," and understand that national recovery would involve a
"*recognition*" of the necessity of interdependence.[3]

Roosevelt's address is revered for its clear expression of strength and confi-
dence in the midst of great national crisis. But the speech is of interest for
another reason as well: the way in which its visual language echoes a larger cul-
tural shift in Depression-era modes of knowledge and representation. Note
that Roosevelt does not ask Americans to "confront" the problems of the De-
pression, but to "face" them, implying a literal as well as metaphorical visual
engagement. Similarly, he does not exhort Americans to "learn" or even "under-
stand" that the American economy must change, but to "recognize," to *see* and
know the ills of the current system. Roosevelt's choice of visual language in this
speech cannot have been accidental, for the twin notions of "facing" and "rec-
ognizing" so clearly embody his purposes. Furthermore, Roosevelt's visual
rhetoric curiously prefigures the decade's interest in the relationship between
seeing and *knowing*. Indeed, while FDR's use of visual language is primarily
allegorical (and thus reflective of a philosophical tradition in Western culture

that privileges the visual),[4] the speech also prefigures visual engagement more literally. The New Deal instituted a range of material practices in which visual remedies were often positioned as the cure for—or at least the mode for diagnosis of—what ailed the nation.

This study explores one of those visual remedies. In 1935 Roosevelt named Columbia University economist and Brain Truster Rexford Guy Tugwell to head the Resettlement Administration (RA), a New Deal agency formed to deal with the problem of rural poverty (its name—and mission—was changed in 1937 to the Farm Security Administration, or FSA). Tugwell believed that visual images could be helpful tools for the new organization, particularly in terms of legitimating its efforts to Congress. He hired his former graduate assistant, Roy Emerson Stryker, to head the Historical Section of the agency's Information Division. From 1935 to 1943, the Historical Section built a massive photographic file of images designed to document the impact of the Depression on American life and to chronicle and publicize New Deal efforts to combat rural poverty. The enigmatic Stryker employed a small but remarkably talented group of photographers that included Walker Evans, Dorothea Lange, Russell Lee, Arthur Rothstein, Ben Shahn, Marion Post, John Vachon, and John Collier Jr. The photographers not only made "working" images to be used as evidence of the FSA's influence in the area of rural relief but also dedicated themselves to the larger, potentially more historically significant project of making and preserving images of America itself. In the eight years of the Historical Section's existence, FSA photographers made more than 250,000 images. Of those, 107,000 prints and many more negatives were collected, organized, and preserved in the Library of Congress's Prints and Photographs Division, where they may be found today.[5]

Collectively, the FSA file constitutes a complex and fascinating, but often fragmented, visual narrative of American life. Although today we tend to think of the images as aesthetically appealing gallery artifacts or as visual remnants of our collective past, this project situates the Historical Section photographs in the contexts through which they circulated more than sixty years ago.[6] It aims to account for the ways in which the FSA photographs operated not as art or propaganda but as circulating images that made some poverty stories more rhetorically available than others. Specifically, I study the images as they ap-

peared in three magazines between 1935 and 1940: as evidence of rural poverty in the progressive periodical *Survey Graphic;* as examples of visual virtuosity in the photography annual *U.S. Camera;* and as elements of mass-produced "picture stories" in the popular magazine *Look.* In each of these contexts, I explore how the Historical Section images were used to frame particular kinds of stories about rural poverty, and I identify moments when the photographs themselves complicate, challenge, or perhaps even subvert those stories.

xii

In telling the story of these photographs, I offer a tale about the production, reproduction, and circulation of images, the relationship between photography and print culture in the United States during the late 1930s, and the history of Depression-era attitudes and beliefs about rural poverty. As a critical study engaging the materiality of history, *Picturing Poverty* is ultimately interested in how the eternally reproducible image negotiates its own status as evidence of history in the contexts of mass culture. Benjamin, among others, was well aware of the role that print culture plays in image politics: "Unmistakably, reproduction as offered by the picture magazines and newsreels differs from the image seen by the unarmed eye. Uniqueness and permanence are as closely linked in the latter as are transitoriness and reproducibility in the former."[7] I contend that the power of the FSA photographs' visual rhetoric may best be understood by situating the images in the contexts of print culture within which they appeared and by paying close attention to the uses to which they were put. Focusing upon the eventfulness of the FSA photographs reminds us to pay attention to their *specificity* as rhetorical documents, while accounting for circulation asks us to pay attention to their *fluidity* as material traces of history.

The "Documentary Decade"

That the Historical Section photography project appeared on the scene when it did is neither random nor accidental, but rather the result of two related developments: the appearance of rural poverty on the federal government's agenda and a more gradual cultural shift in acceptable modes of representation, which encouraged specifically *visual* documentation of social conditions. The heavy reliance on visual language found in Roosevelt's first inaugural address was timely in that it both responded to the need to publicize the profound rural

poverty of the Depression and echoed the decade's interest in realism and documentary as modes of knowledge. The Depression was just over three years old when Roosevelt took office, if one measures from the stock market crash of 1929. But for farmers, the market crash and subsequent plunge into depression only worsened conditions that had been steadily declining since the early twenties. The economic conditions that Roosevelt faced as he took office had not by themselves produced the profound rural poverty found in the United States in 1933. But few outside of rural America were aware of the dismal condition of American agriculture, since rural poverty had rarely been made a part of the mainstream political agenda. Roosevelt's inaugural declaration that Americans should face and recognize the nation's problems sent the message that rural poverty was now on that agenda; the Depression had provided the rhetorical occasion.

Furthermore, it is not surprising that Roosevelt's quest for a new vision of America involved the largely visual, experiential tasks of "facing" and "recognizing." The early twentieth century's move to realism in art, literature, and politics constituted a cultural shift in acceptable modes of representation. Miles Orvell notes that while nineteenth-century American culture valued "imitation and illusion," twentieth-century culture came to value "authenticity," a desire to "elevate the vernacular into the realm of high culture."[8] Such a transformation was embodied in changing aesthetic conventions and in technological developments in film and photography; these media increasingly came to be utilized by artists and communicators who were "inspired by the machine's capacities to record and analyze reality."[9] In terms of photography specifically, Orvell explains that the early decades of the twentieth century signaled a "distinct shift in the practice and theory of photography from an aesthetic to a social orientation."[10] While in the nineteenth century photography was admired as much for its capacity for artifice as for its realism, by the early decades of the twentieth century photography had been rearticulated into "a mode (in the 1930s) that was rooted in the 'objectivity' of social science."[11]

The 1930s have been called the "documentary decade," years when Americans actively sought out representations of the familiar, the real, the "actual."[12] William Stott contends that much of the impulse to documentary during the thirties was born of America's early experience with the Depression itself,

when in the absence of "truth" about the scope of the economic and social crisis, the public came to thirst for realism and "actual fact": "By the time the Great Depression entered its third (and worst) winter, most Americans had grown skeptical of abstract promises. More than ever they became worshippers in the cult of experience and believed just what they saw, touched, handled, and — the crucial word — felt."[13] Terry Cooney explains that documentary mattered during the Depression because "against the uncertainty of the times, the writer could array the apparent certainty of 'social facts.'"[14] If the writer could mobilize facts in the service of the real, then the photographer could do even more. According to the rhetoric of documentary, the photograph could serve as direct evidence of what the camera had seen, and thus the image could convey "truths" otherwise obscured by politics or fantasy. The camera thus became the tool of those who sought to visualize social facts, to show the truth of what was happening in the culture. At the same time, however, the camera also became, to note Benjamin's wry remark, "a way to adjust reality to the masses and the masses to reality."[15]

Studying Photographs Rhetorically: Five Principles

Susan Sontag observes that photography is not primarily an art, but "a social rite, a defense against anxiety, and a tool of power."[16] I would extend Sontag's point to suggest that photographs may embody these three functions simultaneously. The FSA photographs certainly operated in each of these ways. They served as a social rite in an era when "social work," to borrow Alan Trachtenberg's terms, often entailed "camera work."[17] They functioned as a defense against the anxiety born of poverty and the Depression, embodying FDR's claim that by facing that anxiety we might recognize it for what it was and overcome it. Framed in Sontag's terms, the FSA photographs functioned to "help people take possession of space in which they are insecure."[18] And the images served as a tool for power. Whether one understands power in terms of "publicity" or "propaganda" or something more Foucauldian in nature, the FSA photographs served the goals of a New Deal government interested in visualizing the management of poverty.

Given the complexities grounding the rhetoric of the FSA photographs, then, what critical principles must one bring to bear upon these images? Put

another way, what does it mean to study these photographs rhetorically? Several principles ground the assumptions I make about the FSA photographs in this study: (1) documentary photographs are not merely "evidence," but are by their very nature rhetorical; (2) photographic meaning is not fixed or univocal, but neither is it relativistic; (3) photographs cannot productively be separated from the texts they accompany, nor should they be viewed as mere supplements to those texts; (4) photographs created for public purposes are best studied in the contexts of the print culture through which they circulate; and (5) all images, including photographs, are the products of a particular visual culture that values and privileges certain forms of visual expression over others. I briefly outline each of these assumptions below.

xv

One of the assumptions of this study is that the FSA photographs do not serve as pure "evidence"—in the sense of being "objective" documents of an era—but are rather constructed by and constructive of the era. Given that our collective understanding of the FSA photographs is so strongly influenced by their generic identity as "documentary" images (as opposed to family snapshots or art photographs, for example), it is important to note the paradox of documentary: It purports to offer "real" and "natural" views of the world but is able to do so only through the framing and construction of those views.[19] Paul Rotha explains the documentary motive by echoing John Grierson's contention that documentary is about the "creative dramatisation of actuality."[20] Indeed, documentary is a paradoxical mode of inquiry, for it is as much about the creation of drama and emotion as it is about the "objective" recording of "facts." On the one hand, documentary is founded upon something "natural" that purports to explain real-life experiences. On the other hand, the documentarian interprets the actuality of that found material so as to create drama and, often, to allude to social responsibility. Rotha notes: "Frequently I hear it said that documentary aims at a true statement of theme and incident. This is a mistaken belief."[21] Documentary is not about an objective, verifiable, neutral fact, but about the interpretation and arrangement of what is "out there" in a way that best fits the documentarian's purposes and sense of social responsibility. The paradox of documentary reveals itself in many places throughout this study, but is particularly salient in the discussion of the relationship between documentary and art in chapter 3.

My second assumption about photographs is that their meaning is not fixed

or univocal, but rather multiple and ambiguous. There is no one identifiable meaning for a photograph, even when it is isolated as part of a specific rhetorical situation. At the same time, however, photographs are not simply free-floating signifiers awash in a sea of relativistic meaning. The raw materials of photography, according to John Berger, are "light and time."[22] The photograph's ability to freeze time and construct a bounded, static space enables the image to serve as a kind of witness to that moment, but at the same time gives us only a glimpse, ever incomplete, of the event itself. Given this problematic epistemology, one might ask where the "meaning" in a photograph is found. For Berger, meaning in photographs is found when one pursues the connection between the image and the "story": "Meaning is discovered in what connects." Meaning "cannot exist without development, without a story. . . . When we find a photograph meaningful, we are lending it a past and a future."[23] Only when understood in the context of that story, Berger would argue, can photographic meaning be intelligible. For Alan Trachtenberg, that intelligibility may be located if we think in terms of not only the "internal dialogue" of images and the texts of which they are a part, but also the identification of their "external dialogue with their times."[24] In this study I locate the "meaning" of the FSA photographs in the spaces where the images participate in stories about rural poverty, stories that circulate in the diverse contexts of social science, art, and mass culture.

A third assumption I make (following Trachtenberg and W. J. T. Mitchell, among others) is that photographs cannot productively be separated from their "internal dialogue" with texts. Mitchell notes that the desire to separate images from texts often originates in an "iconophobia" that treats images as things to be feared. Scholarly determination to enforce distinctions between images and texts is, for Mitchell, the indication of an ideology of purity, a "complex of desire and fear, power and interest" on the part of those who seek to engage in a "kind of utopian purification of language."[25] But such distinctions are largely superficial, for images and texts are always implicated with one another in ways that are difficult to separate. As Mitchell explains, "All arts are 'composite' arts (both text and image); all media are mixed media, combining different codes, discursive conventions, channels, sensory and cognitive modes."[26] Mitchell suggests that rather than treating images and texts as sepa-

rate and distinct entities, we instead adopt the construct of the "imagetext" as a way to avoid making artificial distinctions between the two. Mitchell does not want to argue that we should adopt a stance of "iconophilia," or uncritical acceptance of images; he rather would see us strike a balance. To emphasize the importance of text to the study of images is not to argue that photographs serve only as "handmaidens" or supplements to the texts with which they circulate. Rather, one must always recognize the interdependence of images and texts. Although image-text distinctions are never productive if we are to pursue photographic meaning as something tangible and intelligible, in this study it is particularly important to consider the hybrid nature of images and texts. In the following chapters the FSA photographs are studied not as isolated images, or even as groups of images, but rather as participants in rhetorical events that are inevitably both textual and visual. The photographs I study are always engaged with their captions, studied alongside the texts with which they appeared in each magazine, and positioned within a matrix of discursive conventions relevant to each context.

My fourth assumption (again following Trachtenberg) is that photographs created for public purposes should be studied in terms of their "external dialogue" with their times, specifically, in the contexts of print culture through which they circulate. We do not encounter photographs in an isolated fashion; each encounter is framed by the context in which the photograph is experienced, whether that context be a museum gallery, a family photo album, or the pages of a magazine. The primary way people encountered the FSA images was via the print culture of the 1930s, as the photographs circulated in specialized and popular magazines and newspapers. In our quest to understand how these images influenced public discourse about rural poverty during the Depression, we can learn much by situating them in the contexts where that discourse took shape.

The final assumption I make about photographs is that to study a photograph "in context" also means to understand it as a product of a particular visual culture, or what Martin Jay (following Christian Metz) has called a "scopic regime," that privileges certain ways of seeing.[27] Seeing and vision are not only biological processes, of course; they are also culturally constructed and historically specific. Jay notes:

Although perception is intimately tied up with language as a generic phenomenon, different peoples of course speak different languages. As a result, the universality of visual experience cannot be automatically assumed, if that experience is in part mediated linguistically. . . . In other words, [we must recognize] the inevitable entanglement of vision and what has been called "visuality"— the distinct historical manifestations of visual experience in all its possible modes.[28]

xviii

Because the practices of visual representation are historically specific, it is necessary to pay attention to how the ways of seeing are privileged or limited in a particular visual culture. As I have noted, American visual culture of the 1930s was dominated by the documentary motive, paradoxically interested in visual evidence and "the real" while at the same time mobilizing that experience into the construction of dramatic narratives available for circulation in the mass media. As a result, it is vital to recognize that the FSA photographs "look" the way they do because they were created to respond to a visual culture that privileged such expression.[29]

In sum, *Picturing Poverty* writes a critical history of photographs that is rhetorically situated and historically specific. It asserts that the meaning of the FSA images is to be found in the stories they help to tell, in the histories that they both illustrate and construct, and in the complex relationships among images, texts, and print cultures in which they participate.

The FSA Photographs and the Archive

The FSA photographs were rediscovered by a new generation in the 1960s, with interest fueled primarily by two museum retrospectives. The first, Edward Steichen's Museum of Modern Art exhibit of FSA photographs called "The Bitter Years," appeared in October 1962 with much fanfare. In 1966 a MoMA retrospective on the work of former FSA photographer Dorothea Lange rejuvenated global interest in her camera work. Both events, coupled with an increased historical interest in the "Old Left" at a time when the "New Left" was beginning to form, served to renew public and scholarly interest in the visual discourse of the 1930s. My project complements and extends previous studies

of the FSA project by considering for the first time in a systematic way the circulation of the photographs in the print culture of the era.

Since the early 1970s three scholarly approaches to the FSA project have dominated, none of which has shown particular interest in circulation. The narrative history approach of F. Jack Hurley, William Stott, and others features an emphasis on individual photographers and their FSA work.[30] While often illuminating, such an approach can overemphasize individualism, as Hurley himself later argued, by placing less emphasis on the project as a whole, "encouraging the reader to think of each person's work as separate and unique in a 'modern art' sense" rather than as part of a broader political project.[31]

One alternative to individualism may be found in other works of narrative history that focus on series of images organized according to a particular theme. Carl Fleischhauer and Beverly Brannan study the FSA photographs in series in order to reconstruct an understanding of the actual practices of the working photographer in the field. Pete Daniel, Merry A. Foresta, Maren Stange, and Sally Stein's *Official Images: New Deal Photography* reminds us that the FSA was not the only game in town; other New Deal agencies, such as the Civilian Conservation Corps (CCC) and the National Youth Administration (NYA), offer rich (and often anonymous) photographic histories as well. Andrea Fisher's study of the FSA's representations of gender in *Let Us Now Praise Famous Women* explores not only representations of women in the file but also the unique vision of the women photographers of the FSA. Melissa McEuen's *Seeing America: Women Photographers between the Wars* engages four women photographers, including the FSA's Dorothea Lange and Marion Post Wolcott, building an analysis of their work around a bio-critical study of each. And Nicholas Natanson's *The Black Image in the New Deal: The Politics of FSA Photography* demonstrates the depth and complexity of the FSA file in terms of its representations of African Americans.[32]

Another alternative to the scholarly focus on individualism tends to err at the other extreme by overemphasizing the ideological underpinnings of the project. The work of James Curtis, John Tagg, and Maren Stange engages in broad-based critique of the project's institutional and political motivations in light of New Deal ideology.[33] Recognition of the mechanisms of power at play in the project is important, to be sure. Within this scholarship, however, there

xix

lurks an argument that as a result of the powerful institutional bureaucracies of the New Deal, the Historical Section images constitute a monolithic narrative that merely serves a propagandistic New Deal ideology. This work, which Hurley terms "revisionist," both misreads the project overall by giving too much credence to "ideology" writ large and, at the same time, pays too little attention to the specific modes of production, reproduction, and circulation of the photographs themselves.[34]

Although the FSA project has been much studied, strikingly little attention has been paid to the ways in which the photographs circulated across a broad range of mediated contexts during the 1930s. Maren Stange briefly discusses the circulation of the images, but does not analyze particular images or sets of images as they circulated in different contexts. In his important essay on the history and structure of the FSA file in the Library of Congress, Alan Trachtenberg is interested in the notion of circulation, albeit in a limited way. He describes a Walker Evans photograph as it circulated in a number of different contexts, from the pages of Archibald MacLeish's prose poem, *Land of the Free*, to the pages of *U.S. Camera* (discussed here in chapter 3), to a retrospective museum exhibit of Walker Evans's work.[35] This discussion is compelling and fruitful, but isolated and incomplete. In the final chapter of his fine study, Nicholas Natanson describes the various modes of circulation of New Deal images of African Americans but does not make circulation a main focus of his argument. Although each of these authors gives us a glimpse into the contexts through which the FSA pictures circulated, overall the idea of circulation remains underdeveloped in FSA scholarship.

The lack of a detailed account of circulation is curious for a number of reasons. First, as Benjamin so astutely observed of this era, circulation was a primary feature of the mass society.[36] Photographs, in particular, were produced to be reproduced—and the historical record reveals that the FSA images were indeed widely reproduced. What began as a mere trickle of images from Stryker's office in late 1935 became a flood by 1940, when the Historical Section boasted an astounding average picture distribution of more than 1,400 photographs per month.[37] The FSA photographs circulated in both national and regional newspapers as well as in specialized and mass-publication magazines, picture books, government reports, pamphlets, and museum exhibits. In addition to *Survey Graphic, U.S. Camera,* and *Look,* FSA photographs appeared across the

range of print culture of the 1930s, from the pages of *Architectural Record, Birth Control Review,* and *Business Week* to *Collier's, McCall's, Travel,* and the *New York Times Magazine.*[38] Today scholars have extensive archival access to thousands of individual FSA photographs via the Library of Congress file and substantial electronic access, as more of the images are archived digitally. As a result, there is a tendency to forget that most Americans encountered the FSA photographs in the late 1930s primarily through the the images' circulation in print culture. In short, the Historical Section photographs were seen by Americans because they were *used.* An attempt to construct a rhetorical history of these photographs should have as its primary purpose an accounting of that use.

A brief discussion of the archival sources grounding this study is appropriate at this point. In addition to the secondary source material on the FSA and the three magazines that I consider in this study—*Survey Graphic, U.S. Camera,* and *Look*—I also make extensive use of primary sources and a wide array of archival data related to the project. I studied all relevant issues of each of the three magazines. In addition, the textual archival material of the Historical Section itself (Stryker's letters, photographers' letters, interoffice memos, and the like) stands as invaluable evidence of Stryker's (often maddeningly contradictory) impulses and motivations regarding the project. In addition, this material reveals much about photographers' practices in the field. Similarly, transcripts of oral history interviews with the participants in the project, including Stryker and most of the photographers, have helped me gain a sense of the temper of the times and access to the memories (however incomplete) of particular individuals from those years. Finally, archival sources related to the magazines themselves enabled me to chronicle closely the developing professional relationship between the magazines and Stryker and to trace out (in sometimes remarkable detail) the often complex editorial processes that brought many of the Historical Section's photographs to public attention in the pages of the magazines.

Arrangement of the Book

In the introduction I argue that the Historical Section project must be understood as both a *product* of its historical moment and a *process* through which

that historical moment was visualized for the public. The FSA photographs were products of several intersecting social and institutional forces, including the complex history of poverty discourse in the United States, the New Deal's interest in making rural poverty newly visible, and the need of sponsoring agencies to publicize their work in the face of political controversy and opposition. I outline these forces in chapter 1 by way of setting the scene for the story of the Historical Section. The interest of Historical Section chief Roy Stryker in constructing a vivid, appealing, and historically significant narrative of rural poverty makes up the narrative of that chapter.

Next, I study the Historical Section photographs as they circulated in American print culture of the late 1930s. In chapter 2, I explore the images in the context of the social welfare journal *Survey Graphic*. My analysis reveals that they upheld the necessity of expert governmental intervention into the lives of citizens by employing visual conventions to reveal the insurmountable odds facing the poorest of the rural poor and by visually affirming government experiments and controversial projects. At the same time, however, some of the photographs resist being easily mapped onto *Survey Graphic*'s narrative of bureaucratic social experimentation. These "subversive" photographs complicate the viewer's gaze, work with and against other images and texts in contradictory ways, and present a persistent particularity that the pragmatic instrumentalism of *Survey Graphic* sought to erase.

In chapter 3, I turn from the progressive social welfare context of *Survey Graphic* to the aesthetic context of the photography annual *U.S. Camera*. Even in their own time, the FSA images were widely circulated as both documentary and art. *U.S. Camera* removed the photographs from the specificity of their production as documents of the Depression and placed them in a context in which their aesthetic and technical qualities became the basis for judgment. *U.S. Camera*'s reproduction of the Historical Section photographs represents a compelling site of struggle over the social and political meaning of documentary images within the discourses of fine art.

Finally, in chapter 4 I explore the mass circulation of the FSA photographs in the picture magazines. Only one year separated the birth of the Historical Section and the founding of *Life*. But surprisingly, *Life*—the most popular of all of the picture magazines—very rarely published Historical Section photo-

graphs in the late thirties. Instead, it was *Life*'s upstart competitor, *Look,* that most often circulated the section's images to a mass audience. By exploring both the FSA photographs' relative *non*-circulation in *Life,* and their circulation in *Look,* I demonstrate how the section's images in the picture magazines constructed a narrative based upon a distanced voyeurism that discouraged a social response to rural poverty.

Overall, this study reveals that the Historical Section images were made to do complex and varied rhetorical work during the 1930s. By focusing upon the circulation of the photographs in American print culture, I seek to establish that the critical practice of rhetorical history gives us a unique purchase on what it meant to "picture poverty" in the 1930s.

ACKNOWLEDGMENTS

Research for a project like this necessarily involves exploring the holdings of several libraries and archival sites and tapping the generosity of institutions. I am grateful for those who helped me locate, copy, transcribe, photograph, and keep track of a variety of data. Staff at the Library of Congress Prints and Photographs Division warmly steered me through the often complicated maze that is the FSA-OWI Collection. The Photoduplication Service at the Library of Congress efficiently handled my many requests for photographs and slides. The Smithsonian's Archives of American Art offered welcome guidance as I explored the transcripts of the New Deal and the Arts Oral History Project. Sarah Hermanson of the Edward Steichen Archive at the Museum of Modern Art made sure my very brief visit to New York City was productive. Mark Stumme of the Cowles Library at Drake University forwarded me useful information about *Look*'s editorial practices. Allan Rieff of the University of Illinois Photographic Services helped with photo reproduction. With the assistance of many, I have made every attempt to track down copyright status and, when necessary, to request permission to reproduce images. Finally, fellow Minnesotan Dave Klaassen of the Social Welfare History Archives offered welcome guidance as I

searched the Survey Associates Collection. Not only did Dave offer considerable help during my days at the archive, but he has remained a valuable resource since. I hope my use of the Survey Associates material here sparks additional scholarly interest in this fascinating collection.

Funding for initial travel to research sites, and other financial support, was provided by a dissertation grant from Northwestern University in 1998–99. The Research Board of the University of Illinois funded additional travel and supplies for the project in 2000. No less important were the free beds offered by Kelly O'Keefe and Kim Connell in Brooklyn and Kathryn Tout in Washington, D.C.; these friends graciously took me in and listened patiently as I discussed each day's discoveries.

I am grateful to work on a campus with bright colleagues, an administration that supports junior faculty research, and dedicated students. Former department head David Swanson helped this project along by protecting my research time and giving welcome advice. Faculty friends and colleagues, including Scott Althaus, Dale Brashers, John Caughlin, Ruth Anne Clark, Tom Conley, Rachael Delue, Daena Goldsmith, Barbara Hall, Stephen Hartnett, James Hay, Michèle Koven, John Lammers, Trish Loughran, Jordana Mendelson, Peggy Miller, Dan O'Keefe, Andrea Press, Dave Tewksbury, Joe Wenzel, and Barbara Wilson, make the University of Illinois a wonderful and energizing scholarly home. And our talented graduate and undergraduate students make it a great place to teach.

At Smithsonian Books, Mark Hirsch took a chance on a young scholar's proposal. Emily Sollie offered help during the transition period to a new editor. Jan McInroy's wonderful attention to detail made the book a better read—and me a better writer. John Lucaites and Lester Olson reviewed the initial manuscript for the Smithsonian. Their feedback was insightful, their criticism on target and always welcome. Their generosity to me has been humbling, and I thank them.

This project began as a dissertation in the Department of Communication Studies at Northwestern University. It was guided to completion by Thomas Farrell, whose kind patience and scholarly wisdom have continued to influence my work. In addition, Michael Leff, G. Thomas Goodnight, and Dilip Gaonkar graciously contributed their expertise. I am grateful for the editorial guidance

of both Martin Medhurst, editor of *Rhetoric and Public Affairs,* who published an earlier version of part of chapter 2, and Gregory Clark, editor of *Rhetoric Society Quarterly,* who published an earlier version of part of chapter 3. Other portions of the manuscript were presented at meetings of the National Communication Association and the Rhetoric Society of America, and at colloquia at Northwestern University, the University of Wisconsin–Madison, and the University of Illinois. Thomas Thurston made my work on *Survey Graphic* available to the general public on the New Deal Network's Web site.

I am lucky to be able to count Rob Asen, Dan Brouwer, Grace Giorgio, Jean Goodwin, Stephen Hartnett, Stacy Kim, Michèle Koven, Michael W. Pfau, and Lisa Villadsen as friends, colleagues, and occasional partners in crime. Stephen Hartnett, Michèle Koven, and Rob Asen, in particular, are always willing to read a draft (or three), pose pressing questions, and challenge me to be a better thinker and writer. Each of them has read substantial portions of this manuscript; their insightful feedback and warm friendship have made it—and me—immeasurably better. Thanks also to research assistant Jennifer Jones, who nearly went blind reading microfilm on my behalf; I very much appreciate her valiant efforts.

My family has always been a source of great support, love, and wonderful good humor; a great big gang of five siblings and their beautiful families enriches my life beyond measure. It is especially nice to have a brother, John R. Finnegan Jr., "in the business"; I thank him for his sage advice about the ways of academe. And I thank my perfect partner in all things, Tony Nistler—for all the usual reasons and for the reasons known only to us.

I am deeply respectful of the experiences of the often anonymous individuals pictured in this book. For this, and many, many other reasons, *Picturing Poverty* is dedicated with love to my parents, Norma C. Tomte Finnegan and John R. Finnegan Sr. They grew up during the Depression and experienced some of its hardships firsthand. I hope that this effort will give them some measure of satisfaction and pride when they hold it in their hands.

INTRODUCTION

Making Rural Poverty Visible

THE DEPRESSION, THE NEW DEAL, AND THE HISTORICAL SECTION

"Exploiting This Thing": *The Grapes of Wrath* **and the FSA**

In the summer of 1939 FSA photographer Russell Lee spent several days with the family of Elmer Thomas near Muskogee, Oklahoma. Lee made more than one hundred photographs of Thomas and his family as they packed their rickety truck high with belongings, said good-bye to family and friends, and headed down the highway toward California.[1] Lee's trip to Oklahoma was a last-minute addition to his summer assignment, a direct response to the literary and cultural phenomenon of *The Grapes of Wrath*. In March 1939 Viking Press had published the 619-page novel by John Steinbeck. Within weeks the book topped all best-seller lists, with more than 428,000 hardcover copies sold in 1939 alone.[2] Widely praised and broadly criticized for dramatizing the problems of migrant workers in California, the novel won the 1940 Pulitzer Prize for Steinbeck, was translated into an acclaimed popular film by John Ford, and became an instant American classic even as it was banned in many of the California counties where its fictional action took place.

Historian Charles Shindo has argued that *The Grapes of Wrath* helped to

crystallize a narrative of westward migration that remains prominent in the American cultural imaginary even today.[3] In fact, Steinbeck's story of the Joads and their fateful trip from Oklahoma to California accomplished with fiction much of what Russell Lee and other Historical Section photographers had been attempting to do with their documentary photographs. By the time *The Grapes of Wrath* was published in 1939, Historical Section photographers had been documenting the effects of the Depression for four years.

Similarities between Steinbeck's novel and the FSA photographers' work were not lost on Russell Lee, nor were they lost on Historical Section chief Roy Stryker. Upon reading Steinbeck's book while on assignment in Texas, Lee proposed turning northward to Oklahoma to seek out and photograph a family of "real Joads." He wrote to Stryker: "Have just finished 'The Grapes of Wrath' and rate it as one of the best books I ever read. . . . I am going to . . . attempt to pick up as many of the shots that are so graphically told."[4] For his part, Stryker relished the opportunity to, as he put it bluntly, "exploit the public excitement over this whole thing." He responded to Lee: "I am just bubbling over with ideas. . . . We should make ALL possible of it and solidify our position as far as we can."[5] For a man who lived in a constant bureaucratically induced state of fear of losing his photography unit to the whims of congressional budget cuts and anti–New Deal sentiment, the Steinbeck book must have seemed like manna from heaven. Its success demonstrated the public relevance of the FSA's visual chronicle of farm tenancy and westward migration.

Sometime between late May and late June, Russell Lee met Elmer Thomas, a migrant who was planning to leave for California with his wife and several children. Lee's letters to Washington provide relatively little information about the family, though he made many photographs of the group. In a July 7 letter that accompanied some of those photographs to Washington, Lee told Stryker:

> The family was a tenant farm family ten years ago. Worked in California for several years as migrants, came back to Oklahoma this year for a visit. . . . As you may know the cycle of migrants from tenant farmers is roughly this—after leaving the tenant farm they become agricultural day laborers or work on WPA [Works Progress Administration] and gradually become disgusted and turn to

the road. In view of the fact that these people have no definite plans they may pack up overnight and leave for the west.[6]

Lee attempted to photograph the family a few times before he finally got the pictures he wanted. Rain and heavy mud on the roads trapped the family in Oklahoma and hampered Lee's own efforts as well. He wrote to Stryker: "I started taking pictures of the family moving this morning and got them as far as getting loaded in the car when it started to rain like hell. I'm going to carry them on to Henryetta tomorrow morning—getting pictures of them stopping in filling stations, eating lunch, camping for the night, breaking camp the next morning."[7]

The next day, Lee wrote to Stryker that he was still being hampered by the rain and other inconveniences:

Dear Roy—am writing this from Muskogee. I had expected to get the rest of my migrant family pictures today but there was a terrific thunderstorm that caught me on a road going through a cornfield to the migrant family's home. I was thoroughly stuck in the mud, had to get pulled out by mules after a nice walk through the downpour. I punctured my gas tank in the process and had to have that fixed. Hope to get the pix tomorrow.[8]

A few days after those failed, albeit heroic, first attempts, Lee completed photographing the Elmer Thomas family.

If we explore some of the photographs in the Elmer Thomas series, we can see that the FSA images were constructed by a range of social, economic, and institutional forces. Furthermore, the narratives circulating in and around Russell Lee's photographs of the family exemplify the range of forces that influenced the production and reproduction of all of the FSA photographs during the late thirties—forces that should be taken into account if we are to fully understand the rhetorics of poverty that these images helped to produce.

Perusal of the more than one hundred photographs that Lee made of the Thomas family reveals a *Grapes of Wrath*–like narrative of westward migration: a family of "dust bowl refugees" escaping the grinding, constraining pov-

3

4

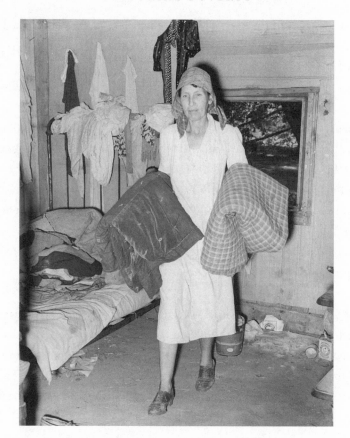

Figure I.1. The Elmer Thomas family of migrants. Mrs.
Thomas, carrying the blankets for packing into the trunk
en route to California. Photograph by Russell Lee (July 1939),
FSA-OWI, Library of Congress, LC-USF34-33774-D.

erty of the plains (Figure I.1). Lee meant for the Elmer Thomas series not only
to present us with the faces of a migrant family but also to depict the activities
of migration itself. In order to describe visually how migration takes place, he
chose to focus upon three moments common to the migrant experience. For
Lee, who would not be following the family all the way to California, these mo-
ments center on the beginning stages of the migration process. He photo-
graphed the Thomas family packing for the trip, getting gas (and surviving car
trouble), having a meal on the road, and saying good-bye to relatives. Studied

thematically, the photographs chronicle an archetypal migration story, with obvious parallels to Steinbeck's narrative of the Joad family.

But turn to another photograph, which Lee's caption tells us documents the family saying good-bye to relatives. Lee photographed the family in the truck as Elmer Thomas kisses a relative good-bye (Figure I.2). This image is remarkable for its candid expression of spontaneity, embarrassment, and awkwardness. The female relative leans into the car window to kiss Elmer. Elmer kisses her in return—or rather, he smirks, glancing at the stranger/photographer documenting this awkward moment. But what is for Elmer Thomas an embarrassing instant is for the rest of his family a bit of amusement. Both Mrs. Thomas, perched atop the family's belongings in the bed of the truck, and their son, sitting in the middle of the front seat, stare at the camera along with Elmer. Each smiles broadly. The family (apart from Elmer himself) clearly is enjoying the fact that the camera is chronicling this moment. Stuffed into an already overpacked vehicle, the Thomases share a moment of levity, produced in part by the photographer himself. The kissing picture does not by any means document a mournful good-bye. No one is expressing sadness or exhibiting tears. Rather, Lee's picture shows the viewer a family enjoying a lighthearted moment. One gets the sense that this good-bye is just one of many, that the family is not enacting a catastrophic separation.

When viewed in light of what we know about the Thomas family and its travels, which admittedly is not much, a good-bye picture like this challenges our received version of the myth of the migrant—and, indeed, even Lee's own narrative intentions. Lee indicated in letters that the family had been tenant farmers in Oklahoma ten years previously, had already been to California to work as migrants once before, and returned just this year "for a visit." While we have no idea of the length of the visit itself (a few months? a whole year?), this information, coupled with the lightheartedness evident in the kissing picture, makes a stereotypical migrant narrative problematic. While the *Grapes of Wrath* narrative would characterize the migrant experience as irreversible, for the Thomases migration is not irreversible. They have gone and come back once before, and now they are going again. Similarly, their good-byes are not good-bye forever but merely "good-bye for now." The tone of the kissing pic-

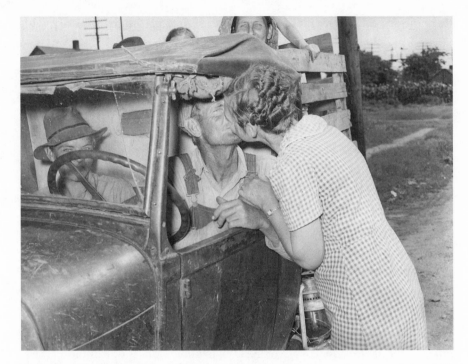

Figure I.2. The Elmer Thomas family of migrants. Kissing a relative good-bye. Migrant family bound for California. Photograph by Russell Lee (July 1939), FSA-OWI, Library of Congress, LC-USF34-33796-D.

6

ture, coupled with some knowledge of the Thomas family's circumstances, suggest not that migration is irreversible but that it is fluid. Families come and families go; the Thomases will be back, if only for another "visit." In fact, such back-and-forth movement was fairly common. James Gregory, historian of "Okie" migration to California, writes: "Nothing so readily reveals the accessibility of California as the pattern of annual migration that a few families adopted. In a gigantic, interstate loop, they would follow the cotton crop through Texas, Arizona and into California, returning home at the end of the year. . . . They went knowing that for the price of a few tanks of gasoline they could always return."[9] Although we do not know whether the Thomases adopted this particular pattern of migration, we do know that they were not the only families who left and came back, sometimes more than once.

The Elmer Thomas images visualize a historical moment of profound eco-

nomic and social transformation in which thousands of Americans made the choice to abandon their homes and migrate westward. The pictures, when studied alongside Lee's story of producing them, give us a brief glimpse into how profound changes in American agriculture, mixed with debilitating "acts of God" such as the dust bowl, challenged the deep-seated agrarian myth in the United States. The photographs illustrate the New Deal's interest in making rural poverty visible to the American public and palatable to congressional funding. They represent the Historical Section's desire to capitalize upon the phenomenal success of *The Grapes of Wrath* by mirroring the "myth of the migrant." They reveal the skills and unique experiences of photographer Russell Lee, the hardships of photographic work in the field, and his relationship, however fleeting, with the Elmer Thomas family. And, ultimately, they demonstrate that it is difficult to classify the images as univocal in meaning. For every Historical Section photograph that appears to model the mythical narrative of "the Joads," or of the sharecropper, or of the "dust bowl refugee," there is another that vexes, challenges, subverts such a reading, calling for renewed historical contextualization and nuanced rhetorical analysis.

As the Elmer Thomas photographs reveal, a range of forces influenced the production, reproduction, and circulation of the Historical Section's images. Because the project was created with the aim of visualizing efforts to combat rural poverty, I begin by exploring public attitudes about the poor. By the time of the Depression, competing views of poverty, each fraught with its own internal contradictions, circulated simultaneously in American discourse. While some appealed to an age-old rhetoric of pauperism, arguing that the poor were inherently "shiftless" and "lazy" and thus to blame for their own conditions, others—notably, progressive reformers and social scientists—argued that structural, environmental factors were responsible for poverty. Some argued both of these things simultaneously, sorting out the "deserving" poor from those who were deemed "undeserving." These complex views about poverty influenced not only how the Historical Section photographers framed their photographic subjects but also how Americans encountered and interpreted the photographs and, by extension, how they felt about the agencies of the New Deal. Next, I engage several themes relevant to the specific economic and social forces of the Depression era: the system of farm tenancy, environ-

mental challenges to that system during the Depression, and the phenomenon of westward migration. Finally, I trace the institutional origins of the Resettlement and Farm Security Administrations as attempts to communicate the New Deal's interest in making poverty visible. This material sets the stage for an examination of the Historical Section and the man primarily responsible for setting the agenda for the project, Roy Emerson Stryker, as well as for an analysis of the images. It elaborates the economic, social, and political conditions that lie at the heart of the decade's popularized representations of farm tenants, sharecroppers, "Okies," and "dust bowl refugees."

8

Poverty Discourse in America up to the Depression

They could do better in building homes, etc.
It's partly their own fault.

—Comments left at FSA Exhibit at the International
Photographic Exposition, 1938

The rural poor were relatively invisible, particularly in the years before the Depression. This invisibility resulted from the pervasiveness of the agrarian myth—the popular belief that rural America was a land of plenty where poverty did not exist. Acceptance of the agrarian myth made many Americans blind to the economic and social forces that conspired to fuel chronic rural poverty in the United States in the years before and during the Depression.

Not surprisingly, poverty discourse during the Depression reflected and recirculated prevailing attitudes about the poor that had held sway for many years. Three general themes dominate American poverty discourses from colonial times through the early twentieth century: a pervasive distinction between the "deserving" and "undeserving" poor, a marginalization of the "pauper" as a lazy, often dangerous member of the underclass, and the dominance of the work ethic as a moral and civic duty. Such discourses established the individual, rather than socioeconomic or environmental factors, as the source of poverty. Robert Asen explains that these themes reappear throughout American history, "subjected to alternative inflections, recombinations, and reversals as

advocates have deployed the discourses of poverty in a shifting and conflicted terrain."[10] And, as we shall see, these themes intersected with the agrarian myth to frame public perceptions of rural poverty throughout the Depression decade.

Early American Rhetorics of Poverty

Early rhetorics of poverty resounded with echoes of what William Ryan has called "blaming the victim"—if one were poor, one had somehow caused that poverty.[11] Most who came to the New World were, of course, poor. As Neil Betten notes, "Well-off Europeans seldom underwent the hardship necessary to start a new life" halfway around the world.[12] But early on, distinctions were made between those in poverty who were "deserving" and those who were not—distinctions dominated by fear of paupers and a strong belief in the ethic of work. The Puritans in New England colonies often physically punished the "idle poor" by publicly whipping and imprisoning those able-bodied persons who did not work. Unemployed newcomers to towns and cities were "warned out" by city officials, forced to leave town if they could not find work or a sponsor to provide them with financial support; in some colonies, there was no legal difference between vagrants and paupers.[13] In rural areas with small populations, the poor—especially orphaned children—could be auctioned off to farmers seeking cheap labor.[14] All in all, Betten argues, "the seventeenth and early eighteenth century elite, as a group, viewed the destitute as primarily lazy, immoral and anti-social, and (with some obvious exceptions such as the blind and widowed) as basically a criminal class."[15]

Although the ruling and elite classes always included some who were willing to help the poor by engaging in philanthropy, even reformers made distinctions between the deserving poor and the "pauper," and warned against misapplying charity to those who were not truly worthy. The poor were cared for primarily by family members through private charity or through "outdoor relief," a form of direct assistance in the home from members of the local community. Yet even those who believed it was morally responsible to care for the poor warned that charity bred "idleness." To many, "paupers were living proof that a modestly comfortable life could be had without hard labor. Their dissipation was a cancer demoralizing the poor and eroding the independence of

the working class."[16] As Robert Bremner notes, in early America the ability of citizens to take care of themselves was a "social asset, and the inability to do so a liability": "As one writer expressed it, the founding fathers may have intended the United States to be an asylum for the distressed peoples of One World; but it was a workhouse that they had prepared, not a refuge for idlers."[17]

By 1850 private charity and outdoor relief continued to be the primary form of public help for the poor in both urban and rural areas, but more formal ways of handling the issue had also been established. Institutions appeared to house the mentally ill, educate the disabled, and care for the poor. According to Michael Katz, the poorhouse, as one of these institutions, would "suppress intemperance" by sealing off "individuals from the corrupting, tempting, and distracting influences of the world long enough for a kind but firm regimen to transform their behavior and reorder their personalities."[18] The poorhouse was founded on the prevailing belief that pauperism was the result of individual faults that could, with proper care and attention, be erased. The poor were poor not because of socioeconomic forces out of their control but because they lacked the work ethic so highly prized in early republican culture. Asen notes one influential example of the cult of the work ethic in his discussion of the pervasiveness of the myth of Horatio Alger. In their assertion that the not-so-smart-but-hardworking man could always get ahead, the Alger stories "affirm the values of the middle class reader—thrift, frugality, piety," reinforcing cultural beliefs about the importance of humility and hard work.[19]

By the turn of the twentieth century, conflicting rhetorics of poverty persisted and became intertwined with one another in complex ways. What Betten calls "the hostile view" treated poverty as a moral flaw, "a sickness freely chosen through laziness, drinking, extravagance and sexual vices."[20] Such a view was often extended from individuals to entire groups; in the crush of late-nineteenth-century immigration, Betten observes, "the association of poverty and racism accelerated."[21] A second view, the "environmental" view, argued that poverty was not always the result of an individual's failings, but sometimes it resulted from structural inequities in the socioeconomic system. In the late nineteenth and early twentieth centuries, Walter Rauschenbusch's Social Gospel movement radicalized Protestant theology and "rejected the concept of the poor as evil or morally unfit."[22] Progressive Era settlement workers operating

in urban immigrant communities also subscribed to the environmental view of poverty and sought broader social reforms to eliminate it. What is important to note about the two views is that they are not necessarily dichotomous; rather, while in some poverty discourses one view predominates, both of them mutually and simultaneously influenced attitudes about poverty. The workings (and often the intermingling) of each view are illustrated briefly below, as I explore three quite different visual discourses about poverty: a series of images from Charles Loring Brace's 1880 edition of *The Dangerous Classes of New York and Twenty Years' Work among Them,* Lewis Hine's Progressive Era photography on behalf of the National Child Labor Committee, and Dorothea Lange's famous image of the 1930s' "forgotten man" in "White Angel Bread Line." Each image embodies the hostile and environmental views in varying proportions, reflecting each time period's ambivalent anxiety about the poor.

11

Three Images of the Poor: Brace, Hine, and Lange

Dangerous Classes is Charles Loring Brace's account of his work among juvenile "criminals" in the social reform movement of New York City; first published in 1872, by 1880 it was already in its third edition.[23] Brace dedicated his volume "to the many co-laborers, men and women, . . . [who] have striven, through many years, to teach the ignorant, to raise up the depressed, to cheer the despairing, to impart a higher life . . . , and thus save society from their excesses."[24] Brace's goal was to convince readers that "the cheapest and most efficacious way of dealing with the 'dangerous classes' of large cities is not to punish them, but to prevent their growth."[25] Without moral intervention, Brace warned, juvenile criminals would grow like a disease unchecked. In chapters with titles like "Overcrowding," "Sexual Vice," "Free Love," and "Intemperance," Brace conflated poverty with crime, reinforcing the hostile view that treated poverty primarily as the result of shiftlessness and vice.

Several lithographs accompany Brace's text, including a fascinating set of four images by F. Beard titled "The Fortunes of a Street Waif" (Figure I.3). In this sequence of images, scattered throughout Brace's text but collected here, the stages of the street waif's inevitable decline are vividly outlined. In the "First Stage," the young street waif sleeps on the street; in the "Second Stage,"

he learns to steal to survive. By the "Third Stage," he is older and wiser, engaging (seemingly all at once) in most of the vices one associates with nineteenth-century criminality: card playing, gambling, smoking, drinking, and gun toting. In the "Fourth Stage," presumably the last, the street waif has become a tattered old man rotting away in jail. Taken together, the images in the sequence suggestively illustrate key elements of a hostile view: the need to isolate the poor from "good" society, fear of the pauper as dangerous, and the pauper's rejection of the work ethic. The street waif is marginalized and isolated from the rest of society (save for his other street waif friends). He is dangerous in that he commits crimes and rejects the work ethic in favor of a life of gambling and shiftlessness. The inevitable result is permanent marginalization from society: imprisonment. Though Brace does emphasize throughout the text how one's environment can produce poverty (and, by extension, criminality), his solutions involve a primarily moral focus on individuals as opposed to a reorganization of social and economic systems.

Consider, by contrast, a photograph made about thirty years later by Lewis Hine, hired by the National Child Labor Committee (NCLC) to document working conditions for children in industrial sites across America. His "social photography" emphasized the dignity and industriousness of the poor and is often credited with raising public awareness of the need for child labor laws.[26] Hine's 1911 photograph of Mrs. Annie De Martius of New York City and her children is striking for the way in which it merges the demands of motherhood with the necessities of work (Figure I.4). Mrs. De Martius literally feeds her baby as she and her older daughters work to feed others by picking nuts. Although Hine's depiction of Mrs. De Martius nursing her baby may seem shocking, the image is not salacious. Rather, the nursing of the baby is just one other form of work that must be performed by the mother. The baby is peripheral to the composition of the image, as it is the work itself that matters here. Mrs. De Martius and her three daughters form an oval frame around the table, upon which rest orderly piles of nuts. The mother and children are clearly poor, and their living environment substandard, yet Hine's photograph represents them as dignified and hardworking. When compared to the firmly hostile view of the poor presented in *Dangerous Classes*, the view of poverty that Hine's poor family appears to embody is a more social, environmental

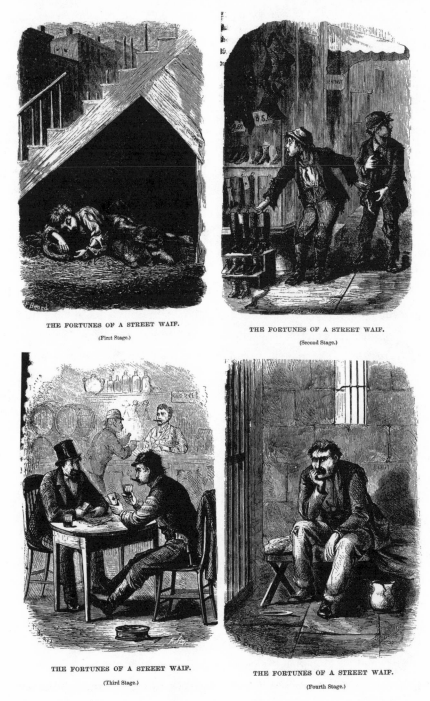

THE FORTUNES OF A STREET WAIF.
(First Stage.)

THE FORTUNES OF A STREET WAIF.
(Second Stage.)

THE FORTUNES OF A STREET WAIF.
(Third Stage.)

THE FORTUNES OF A STREET WAIF.
(Fourth Stage.)

Figure I.3. The Fortunes of a Street Waif. Composite of four images by F. Beard from Charles Loring Brace, *The Dangerous Classes of New York and Twenty Years' Work among Them*, 3d ed. (New York: Wynkoop and Hallenbeck, 1880).

one. Even so, it is also possible to imagine a use of this photographic image for purposes more suited to a hostile approach. Consider the caption accompanying the image in the NCLC collection: "Mrs. Annie De Martius, 46 Laight St., N.Y.C., nursing a dirty baby while she picks nuts with three other children—Rosie, Genevieve, and Tessie." The operative word here is "dirty." Is this word meant to pass judgment on the poor family, implying that Mrs. De Martius cannot properly wash and care for her children? Or is it meant to describe more blithely the environmental conditions of poverty under which the family, and other families like it, suffers blamelessly? It is difficult to know; thus, despite Hine's own progressive attitudes toward poverty and his beliefs in the power of his social photography, the image retains an ambivalent attitude toward its subjects.[27]

During the Depression the tension between the hostile and environmental views often played out with as much, if not more, ambivalence and contradiction. Consider, for example, Dorothea Lange's "White Angel Bread Line" (Figure I.5). In 1933 Lange, then a successful portrait photographer in San Francisco, photographed unemployed men waiting in a breadline (named for a wealthy woman known as the White Angel, who provided food for the unemployed men). The resulting image presents a compelling and vivid illustration of the "forgotten man." He is part of the group yet isolated, represented with dignity yet clearly vulnerable. The religious connotations of the image should not be lost here, for the man waits to be fed as if at a communion rail, hands folded around a tin cup. The image is, however, one of ambivalence. This "forgotten man" is old and unshaven, one of many disheveled men waiting to eat. Although Lange's photograph does not communicate the didactic, hostile view of Brace, neither does it suggest Hine's hardworking mother and blameless children. If the photograph implies a response to poverty, it is an ambiguous one at best. Indeed, the image is as much an experiment in aesthetic form as it is a "documentary" image of the poor. Lange experiments with shape (the hats) and line (the railing on which the man leans) to construct an image of intriguing depth, light, and shadow. As a result, our response to the image is ambivalent. Do we enjoy it for its aesthetic form? Do we pity the man at the railing? Do we blame him for his poverty?

Before the Depression, most social workers managed cases of *chronic* pov-

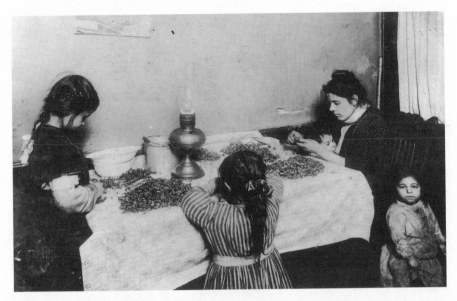

Figure I.4. Mrs. Annie De Martius, 46 Laight St., N.Y.C., nursing a dirty baby while she picks nuts with three other children—Rosie, Genevieve, and Tessie. Photograph by Lewis Hine (December 1911), National Child Labor Committee Collection, Library of Congress, LC-USZ62-90348.

erty—people who had always been poor, who "lived below the generally accepted standards of living . . . and for whom want had become a normal condition of life."[28] The chronic poor were the "'unemployables' (the aged, the sick, the disabled, children in female-headed families); disadvantaged minority groups; workers in unstable or low-paying jobs; and displaced employees in depressed areas or trades."[29] The Depression, in contrast, produced a new class, the "newly poor," those displaced by the profound economic upheaval that followed 1929. In the early Depression years, attitudes about these new poor were more positive in tone; newspapers "concentrated on personal tragedies and human interest stories concerning newly derived poverty," suggesting that the middle-class poor retained some measure of cultural respect.[30]

Franklin Roosevelt's version of the forgotten man embodied both the promise of American capitalism and its apparent failure for the middle and working classes. The image came from FDR adviser Raymond Moley, who borrowed it (largely out of context) from William Graham Sumner's 1883 *What the Social*

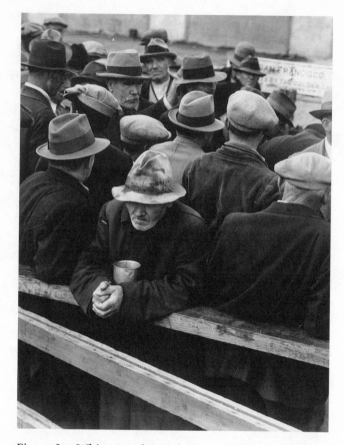

Figure I.5. White Angel Bread Line, 1933. Photograph by
Dorothea Lange. Copyright the Dorothea Lange Collection,
Oakland Museum of California, City of Oakland. Gift of
Paul S. Taylor.

Classes Owe to Each Other.[31] FDR's famous April 1932 campaign speech revived
the trope of the forgotten man in order to emphasize the necessity of recog-
nizing the plight of the working-class poor: "These unhappy times call for the
building of plans that rest upon the . . . forgotten man at the bottom of the eco-
nomic ladder."[32] The forgotten man came to stand for those "deserving" Amer-
icans who were "respectable, hard-working family men unable to find work."[33]
After Roosevelt's speech it also caught on as a shorthand way to express frus-
tration with economic conditions and to rally the working class. For instance,

in July 1932 Tin Pan Alley songwriter Bob Miller penned "The Poor Forgotten Man," a song that included the following lyrics: "Who's gonna vote on election day? Who's finally gonna have his say? Who's gonna cause a change—hey, hey! It's the poor forgotten man!"[34] In Miller's song, the forgotten man became a figure of political activism, serving as a rallying cry for those who sought to empower citizens to act collectively to change social conditions.

Yet Lange's photograph hardly suggests an uprising among the working class. Neither does another image of the forgotten man created by Dorothea Lange's first husband, the social realist painter Maynard Dixon. Like Lange, Dixon deployed a disempowered, isolated figure in his 1934 painting, *Forgotten Man,* which depicts a solitary, distressed man seated on the curb of a bustling urban street. Whereas Lange's photograph shows other "forgotten men" in the background, Dixon's forgotten man is alone; the well-heeled, bustling crowds that pass him on the street utterly ignore his presence. Thus the images of the forgotten man as depicted in Dixon's painting and in Lange's "White Angel Bread Line," could be a national workingman's hero or a more ambivalent figure— an icon of lonely misery—capable of containing both the environmental and the hostile views of poverty simultaneously.

Government and Public Attitudes about the Poor during the Depression

The ambiguous blending of the hostile and environmental views persisted in government, often influenced by the paternalism for which Roosevelt was legendary. Though Roosevelt championed the right to economic security for all citizens, he and his New Deal appointees agonized over the potentially disastrous results of "the dole." He consistently preferred work relief to direct "cash" relief because he feared creating a dependent population. His infamous description of cash relief in the 1935 State of the Union address makes clear the cultural power of the work ethic and its ever present obverse, the fear of "idleness":

> The lessons of history, confirmed by the evidence immediately before me, show conclusively that continued dependence upon relief induces a spiritual and moral disintegration fundamentally destructive to the national fibre. To dole out relief in this way is to administer a narcotic, a subtle destroyer of the human spirit. It

17

is inimical to the dictates of sound policy. It is in violation of the traditions of America. Work must be found for able-bodied but destitute workers. The Federal Government must and shall quit this business of relief. I am not willing that the vitality of our people be further sapped by the giving of cash, of market baskets, of a few hours of weekly work cutting grass, raking leaves or picking up papers in the public parks. We must preserve not only the bodies of the unemployed from destitution but also their self-respect, their self-reliance and courage and determination.[35]

The infamous language characterizing the dole as "a narcotic" is not the only striking aspect of this passage; perhaps more significant is the way that FDR subtly taps into a hostile view without directly placing blame on the poor. He not only uses the language of addiction here, but he marries it to a moral barometer so that those who partake of relief programs participate (apparently knowingly) in their own moral and spiritual destruction. Read this way, Roosevelt's speech offers an ambivalent view of poverty, but one more akin to *Dangerous Classes* than we might want to admit. In both cases, the poor are to blame for their addictions—whether to alcohol and gambling or to relief. Public opinion reports, incidentally, suggest that most Americans felt the same way—in 1938, 90 percent of those polled said that they preferred work relief to cash relief.[36] By the late thirties, popular discourse was rife with tales of welfare "chiselers" and relief "cheats" and jokes about the idleness of WPA workers. Even those who earlier in the decade had received sympathy for the seemingly sudden shifting of their fortunes, such as dislocated dust bowl farmers, became the subject of stereotypes—the "Okies" relocating to California were accused of "sloth and shiftlessness."[37]

Public reaction to an exhibit of FSA photographs in April 1938 at the International Photographic Exposition in New York City demonstrates the wide variety of views about poverty during the later years of the Depression—and the persistent mixing of the hostile and environmental views. Historical Section staff members placed comment cards near the exhibit exit and encouraged viewers to write down their responses to the images. The more than four hundred responses reveal a wide variation in attitudes about the poor and the New Deal's attempts to address rural poverty, with the pervasive tension between the environmental view and the hostile view being evident.

18

The majority of the comments implied an environmental view of poverty; these praised the Historical Section's project and stressed the need for the government to help the poor. One respondent wrote: "Wonderful. These pictures force your mind to ponder about a great social problem which must be solved before we can be really proud of our so-called 'American Standard of Living.'" Another: "The U.S. has a long way to go to release these people from the economic slavery which no doubt exists in those territories." Many visitors made note of how the images made rural poverty visible to city dwellers by invoking the familiar trope of the "other half": "Your pictures demonstrate clearly that one half the people did not know how the other half live." "The city people do not know how the other half lives." "We ought to see more of this type of picture. Let the public realize what the other half is doing."

Yet a more hostile view circulates through the comments as well. Several viewers seemed to be responding directly to the people represented in the pictures: "How about practicing Birth Control?" Another: "They could do better in building homes, etc. It's partly their own fault." Some viewers preferred to read the subjects of the photographs as individuals, rather than representatives of a general social condition, suggesting a preference for the hostile view. Explicitly, they challenged the Historical Section's representation of the poor in the exhibit: "They're human. But are they typical?" and "Aren't there any farmers who have enough clothes and food to eat?" Perhaps the best example of the complex ways in which the environmental view and the hostile view became impossibly intertwined may be found in the following observation: "Wonderful pictures! Pitiful sights! They need help sooner than many worthless W.P.A. workers."[38] In one sentence, this viewer manages both to praise and pity the individuals in the exhibit, who are apparently the "deserving" poor, and to caricature WPA workers who, apparently, are not so deserving—even though some of the individuals pictured could easily have been WPA workers themselves.[39]

Viewer responses to the FSA exhibit demonstrate broad cultural ambivalence about the poor. Those who commented on the photographs drew upon, and indeed recycled, a familiar—if sometimes ambivalent—discourse of poverty that accepted the environmental causes of poverty, yet at the same time insisted upon maintaining distinctions between the "deserving" and the "undeserving" poor.

As a result of these complex, and often competing, views, those who created

and managed the agencies of the New Deal had to walk a fine line. While Roosevelt and others made no attempt to hide their hatred of the dole and their desire to avoid creating a permanently dependent class of people, they also knew that it was important to show the poor in a good light if they wished to receive public and congressional support for their programs. Harry Hopkins, head of the Federal Emergency Relief Administration (FERA), agreed with Roosevelt about the dangers of the dole but continually emphasized that the poor were "not ne'er do wells, not paupers, not bums, but fine people, the workers, a cross-section of America's payrolls."[40] Roosevelt's forgotten man fit into this category as well; the forgotten man was framed by Roosevelt not as a pauper, not as a "chiseler" on the dole, but rather as a hardworking family man fallen on hard times. The problem with these more positive characterizations of the poor, however, was that they tended to define the experiences of the "new poor" rather than those of the "old poor," who had lived in chronic poverty for years. They implied that, as Patterson argues, "the unemployed were an undifferentiated group" and obscured "class and cultural divisions in American society" by ignoring the presence of the pre-Depression poor.[41]

Later I will highlight three relatively distinct rhetorics of poverty through which the FSA images circulated: a social science rhetoric exemplified by the social welfare periodical *Survey Graphic;* an aesthetic rhetoric exemplified by the photography annual *U.S. Camera;* and a popular, mass culture rhetoric exemplified by the picture magazine *Look.* In each case, we shall see how the Historical Section photographs both reflected and helped to construct prevailing discourses about rural poverty. But first, in order to understand something about the material conditions that produced the photographs, we will examine the experiences of the rural poor in early-twentieth-century America and explore the relative invisibility of the poor in light of the culturally dominant agrarian myth.

Invisible Americans: Rural Poverty and the Agrarian Myth

Many in the early years of the twentieth century did not believe that rural poverty existed. According to Sidney Baldwin, the agrarian myth (drawing on Jeffersonian ideals) "nourished a creed that embraced virtually all aspects of the

American farmer's life—his role in society, his farming practices, his political rights and obligations, the role of his government, and the nature of politics." Whereas urban life could be dirty, chaotic, and immoral, rural life was viewed as "healthier and more righteous."[42] In the rich, diverse agricultural fields of America, then, how could poverty exist? Furthermore, the Protestant work ethic reminded rural Americans that "virtue lay in individualism and self-reliance," whereas poverty "was the wages of sin and sloth."[43] As a result of such beliefs, poverty in the rural context was often kept hidden or explained away. On into the twenties, boosters hailed the plentiful farm as the "American ideal" and the landowning farmer-hero as its lofty embodiment, even though the agricultural system had been substantially redefined via the tenancy system, corporate farming, and increased mechanization.[44]

In a time when the agrarian myth, with its yeoman farmer-hero, still claimed the American imagination, neither social work professionals nor the public devoted much attention to the problems of the rural poor—this despite the fact that in the so-called Roaring Twenties, rural America was already suffering from its own intense agricultural depression. Indeed, the Jeffersonian myth of the farmer-hero dominated even in the far West, although farming in California, for example, had never been solely concentrated in the hands of the family farmer.[45] In what follows, I offer several "snapshots" designed to frame a picture of the economic and social conditions in the Depression and in the years leading up to it, conditions that the pervasive agrarian myth often obscured. Then I go on to explore two agencies of the New Deal, the Resettlement Administration (RA) and its successor, the Farm Security Administration (FSA), which were eventually charged with the responsibility of identifying and implementing solutions to chronic rural poverty. Neither agency would be much remembered today were it not for the impact of the photographs created to visualize its efforts.

Farm Tenancy and Chronic Rural Poverty

In rural America, a primary source of poverty was a system of farm tenancy that had grown more prevalent beginning at the turn of the century. A farm tenant was a farmer who did not own the land, "a farmer who rented and op-

erated a farm or portion thereof, the use of which he paid for either by a cash rent or by a cash share of his crop, or both."[46] Generally, distinctions among the types of tenancy may be collapsed into a basic distinction between "tenant" and "sharecropper." The tenant rented land but furnished much of his own equipment and material, and thus had more independence than the sharecropper. The sharecropper, by contrast, was "little more than a farm laborer, since he had no responsibility in raising or selling the crop and no claim upon its return until everything he had received from the landlord . . . had been paid out of his share of the crop."[47] The main difference between the two could be found in the degree of servitude: sharecroppers were the worst off, but tenants did not lag far behind.

The early twentieth century witnessed a growth in tenancy in the United States. From 1880 to 1935 the percentage of American farmers who rented all of their land nearly doubled, increasing from 25.6 percent to 42.1 percent.[48] Put another way, in 1900 nearly 60 percent of the total farm acreage in the United States was farmed by the owner of the land. However, by 1930 that number had decreased to just half.[49] Some of this change may be attributed to the decline of the family farm and the concomitant rise of the commercial farm. As farms grew in size, it became more cost-efficient for farmers to rent out portions of their land to others. Such changes were often the result of changes in the types of crops that farmers grew. In the Midwest, for example, shifts from growing grain to dairy farming and raising cattle "brought a decrease in the proportion of owners and an increase in that of tenants and laborers."[50]

During World War I, production of agricultural products boomed in response to the massive overseas market. Once the war was over, that boom abruptly ended, leaving farmers producing enormous amounts of food but fewer people to consume it. The surplus drove prices down; by 1920 farm prices had already dropped significantly. In 1922, for instance, "the farmer was at a 19 percent disadvantage compared to the price relationship that had prevailed in 1913."[51] Prices continued to drop throughout the twenties. In 1920 22 percent of the nation's families were farm families, but they received 15 percent of the nation's income. By 1929 farm families were receiving only 9 percent of the nation's income and earning an annual per capita of just $273.[52] Thus, by the time the Depression began in 1929, the nation's farmers had already experi-

enced nine years of steadily declining prices and worsening living conditions, a fact often forgotten in our national memory of the 1920s. Clearly, the Depression did not cause rural poverty, but, as we shall see, it did provide the rhetorical occasion for public recognition that such poverty existed.

The Depression-Era Tenancy Experience

At least three major environmental problems confronted farmers and farm tenants during the Depression: the repressive structure of the tenant system, increasingly low farm prices, and the poor condition of the land. The tenant system was, at best, painfully flawed and, at worst, evil and racist. Landlords ruled the lives of their tenants and sharecroppers. Historian H. C. Nixon argued that the tenancy system was inherently exploitative, not only but especially in the South, where landlord-tenant relations were inevitably grounded in racist oppression. The tenant farming system was not unlike the feudal system, Nixon observed, "the economy of the Middle Ages without the cathedrals."[53] Lorena Hickok, a reporter, federal employee, and friend of Eleanor Roosevelt, toured the nation in the early years of the Depression and wrote of the farm tenancy system in the South:

> The truth is that the rural South never has progressed beyond slave labor. Their whole system has been built up on labor that could be obtained for nothing or for next to nothing. When their slaves were taken away, they proceeded to establish a system of peonage that was as close to slavery as it possibly could be and included Whites as well as Blacks. That's all a tenant farmer is—or has been, up to the present time—a slave. You know how the system worked. The tenant lived on the landlord's farm, in a house owned by the landlord. During the slack season, when there was no work, the farmer took care of him—"furnished" him, as they call it down here—either by buying his food and giving it to him, or by giving him credit at a store he owned. . . . The property owner was his lord and master, could impose any terms he liked.[54]

Hickok refers here to so-called subsistence advances given to tenants and sharecroppers in order to see them through the year. Landlords would obtain

credit to purchase supplies and equipment and then turn around and charge tenants exorbitant interest rates, as much as two to three times higher than what the landlord had paid for the same items. In 1937 typical interest rates for tenants on Southern plantations hovered around 36 percent.[55] This meant that the tenant's already small cash income for the year would be substantially reduced, sometimes by as much as half, once the tenant paid off the debt to the landlord. Because tenants needed to pay off what they owed, they tended to concentrate their attention on the cultivation of lucrative cash crops (such as cotton) rather than on subsistence crops that could provide their families with an adequate diet.

Farmers were in distress in part because the land itself was in distress. Land problems grew to crisis proportions as a result of severe droughts that began in 1930 and hit the hardest in 1934 and 1936, producing the iconic image of the dust bowl. In 1934 the National Resources Board declared 35 million acres of land in the United States permanently destroyed. In addition, the board noted, topsoil had been removed on 125 million acres and "destruction had begun on another 100 million acres."[56] By 1937 the board had determined that about 450,000 farms in the United States, more than 75 million acres, were made up of submarginal land and should be retired.[57] Much of this land had been destroyed by a combination of inappropriate farming techniques, overfarming, and the farming of cash crops that neither replenished the land nor fed its farmers.

The droughts of the thirties, in many cases combined with horrible heat waves, constituted what one weather scientist called "the worst in the climatological history of the country."[58] In 1930 Arkansas received only 4.19 inches of rain in July and August, just 35 percent of the amount received during the same two months in the previous year. Rainfall in twenty-two other states in the Midwest and the Great Plains diminished by an average of nearly 40 percent in that same period.[59] By 1934 the drought had descended in full force upon the Great Plains and the central part of the country.

What made the drought even more severe was that it took advantage of the damage that humans had already done to the land by overfarming and overgrazing. Soil erosion and a severe lack of rainfall during the drought years proved to be a deadly combination. Poor land was even more vulnerable to

wind and water erosion. This devastating situation produced two immediate results, which in turn created their own set of problems for local, state, and federal officials. First, relief rolls grew heavy with farmers throughout the thirties. By 1935, 733,000 farm families had landed on relief across the United States.[60] In a 1937 WPA report, Berta Asch and A. R. Magnus observed that five states, including New Mexico and Oklahoma, were found to have more than 20 percent of their farmers on relief.[61] As late as 1939 researchers found that in the South, nearly a million and a half rural families were eligible for relief because their annual cash income stood below $312 per year.[62]

Westward Migration

Unemployment, combined with a desire to escape drought-stricken and farmed-out land, led some of the rural poor to migrate. Among the "transient" population of the early Depression years, unemployment was the "most frequent reason for the depression migration of needy persons and family groups."[63] In addition, WPA researchers C. E. Lively and Conrad Taeuber described three other causes of migration from rural areas: increased use of machinery on farms, concomitant increases in productivity per worker (leading to the need for fewer agricultural workers and tenants), and the increasingly poor quality of the land, "which has become unfit for agricultural purposes."[64]

It is estimated that during the decade 2.5 million people left their homes in the Plains states alone.[65] Although most of the individuals and families who migrated moved to nearby states, some took greater risks. The Pacific states made significant gains in population, many of the new residents coming from the drought-stricken Midwest and Plains states. In the first quarter of 1935, for example, the state of Oklahoma lost 1,721 relief families to migration, while California during that same period gained 5,176 migrant families needing relief.[66] Between July 1935 and March 1938, "more than 250,000 unemployed migratory farm workers arrived in California in search of work."[67] Historians and sociologists caution, however, that we must be careful in our assumptions about migration during this period. Not everyone was a "dust bowl refugee." James Gregory observes in his study of Okie culture in California: "Despite the popular perceptions, less than 16,000 people from the Dust Bowl proper ended

up in California."[68] Furthermore, census data show that only 36 percent of those who came to California from the Southwest between 1935 and 1940 had previously lived on farms, suggesting that the "dust bowl migration" of the thirties was more diverse than many had previously believed.[69] However, the *Grapes of Wrath* narrative—the "Okie" family that leaves the worn-out, dust-choked farm to find a better life in sunny California—nevertheless came to symbolize the Depression experience of rural Americans, and it continues to dominate our public memory of the Depression today.

Putting Rural Poverty on the Agenda—The Agricultural Adjustment Administration (AAA)

After more than a decade of public invisibility, the plight of the farmer was made visible via the new institutional apparatuses of Roosevelt's New Deal. During his "First Hundred Days," the new president pushed major farm relief legislation through Congress. FDR's primary concern, however, was not chronic poverty but the urgent needs of those who were about to lose their farms to foreclosure. If disastrously low farm prices could be raised, farmers might be kept afloat. The Emergency Farm Mortgage Act, a portion of the farm relief bill signed into law in May 1933, made it possible for farmers to gain emergency federal money to save their farms. The more controversial section of the farm relief bill was the provision that created the Agricultural Adjustment Administration (AAA). In order to raise farm prices, the AAA would encourage "government-subsidized scarcity."[70] In effect, the government would pay farmers to take land out of production, thus creating an artificial scarcity and raising prices. Farmers who participated would be paid a government subsidy, to be funded by a controversial tax on food processing. An estimated three million farmers took part.[71]

The AAA was mildly effective in that it, coupled with drought, helped to increase farm prices by 50 percent during Roosevelt's first term.[72] But in many ways the AAA made life harder for the poorest of farmers. Some farmers took only their worst land out of production, then went ahead and farmed their best land even more intensively. These farmers both increased their production *and* received a healthy government subsidy for their fallow land. Even worse, al-

though AAA rules stipulated that farmers must share government subsidies with tenants and sharecroppers, many kept the subsidies for themselves. Some threw their tenants off the land entirely when the portion that the tenants had been farming was taken out of production.

The example of the cotton-growing areas is illustrative. In April 1929 the price of cotton stood at eighteen cents per pound. By April 1933, immediately before the AAA was instituted, it sold at only six cents a pound.[73] Once the drought had passed through areas of the eastern South, plantations produced a bumper crop of cotton. To increase prices, AAA planters plowed up nearly 10 million acres of cotton. As a result of such measures, total cotton acreage in the South was reduced from 35 million acres in 1932 to 26.5 million in 1934–35. This reduction raised the price of cotton, but it also meant less work for tenants.[74] Those who had been able, even in the hardest of times, to maintain at least a marginal existence found that they could no longer do so; their labor was unnecessary in the face of lucrative government subsidies. Similar results occurred in other areas of the country. Lorena Hickok wrote that residents of Kansas had complained to her that certain farmers were "chiseling in on the AAA program. Some of them have had tenants on some of their land heretofore. Now they're getting rid of them, so they can grab off more wheat allotment money."[75] Some tenants and sharecroppers left plantations and farms as a result of the AAA abuses, many of them forced out by the landowners, and joined drought migrants moving west. Finally, in 1936, the Supreme Court repealed the law that created the AAA, declaring the tax on food processing that had funded the farmers' subsidies unconstitutional. But by that time New Dealers had already devised a way to help those farmers who needed more than the AAA could offer.

Recognizing and Facing Rural Poverty: The Resettlement Administration (RA) and the Farm Security Administration (FSA)

In 1935 FDR signed an executive order creating the Resettlement Administration (RA) and named its first director, Rexford Tugwell. A member of Roosevelt's fabled "Brains Trust," Tugwell used his progressive economic ideas to lay the philosophical foundation for the agency's work. Always controversial,

27

Tugwell resigned in 1936 and the Resettlement Administration underwent a name—and mission—change to become the Farm Security Administration (FSA), an agency that lived on well into World War II. Depending upon one's political perspective, FSA historian Sidney Baldwin argues, the two agencies were either a "dangerous, radical, and un-American experiment in governmental intervention" or "an heroic institution designed to secure social justice and political power for a neglected class of Americans; a pioneering effort to strike at the causes of chronic rural poverty."[76] Both the RA and the FSA would undertake massive reforms with only limited success. And perhaps, were it not for their sponsorship of the largest and most complete collection of documentary photographs of the era, the agencies might not be remembered at all.

The early seeds of New Deal reform may be found in the writings of Rexford Tugwell during his tenure at Columbia. In the twenties Tugwell coauthored an untraditional economics textbook, *American Economic Life and the Means of Its Improvement,* in which he argued for a more progressive, cooperative approach to capitalist economics. The book contained several chapters on rural poverty and argued against the agrarian myth espoused by most economic theory. In a chapter on reapportionment of wealth, for example, Tugwell and his coauthor, Thomas Munro, wrote that it was necessary at this point in American economic history to dispel certain myths, namely, the "belief in a certain divine or vaguely occult sanctity surrounding the individual's right to private property."[77] Tugwell and Munro also rejected the hostile view of poverty, noting, "The public conscience with regard to poverty finds an easy anodyne in saying that poverty is, in our free country, usually the result of laziness or stupidity."[78] At the same time, however, the authors noted in the 1930 edition that they were beginning to detect a different sentiment in American society, one that expressed interest in creating equal opportunity by increasing government involvement in the economic life of its citizens. Tugwell and Munro argued that government can "play a part in evening up the incomes of its citizens" by strengthening the economic position of the weakest members of society and "correcting the disadvantages under which workers and farmers characteristically suffer."[79] By creating a technically oriented, efficient bureaucratic machine, the authors argued, government could best help its citizens.

The authors appear to have been aware that their ideas about business and

economics would be viewed as radical; in fact, their text was rejected for adoption in Columbia's own introductory "Contemporary Civilization" course, the course for which Tugwell had intended the book.[80] Throughout the text they worked to make distinctions between their own progressive position and a more "radical" socialist one, noting that it was possible "for the government, without being thoroughly socialistic, to exert influence in several areas upon . . . production."[81] In fact, the authors argued, the government was already engaged in subsidizing and regulating certain industries, and it should continue to intervene at "crucial points and moments" in America's economic life.[82] These words would become prophetic, for when the Depression struck, Tugwell found that Roosevelt was interested in his ideas. Tugwell became a close adviser to FDR in New York State, helping to direct his presidential campaign in 1932, and in 1933 he joined FDR's Department of Agriculture as an undersecretary. In an era of "red fear," however, Tugwell's approach inevitably raised the specter of socialism.

"Everybody Else's Headaches": The RA, the FSA, and Rural Reform

When Roosevelt created the Resettlement Administration in 1935, placing Tugwell at the helm, he envisioned that the new agency would serve as an umbrella for all of the rural relief efforts of the government. "With some disappointment," Baldwin notes, Tugwell "described his responsibilities as 'everybody else's headaches.'"[83] Tugwell wanted the agency to concentrate on land reform, but it would need to do much more than that to be a viable entity in Washington. Indeed, from its inception the RA was positioned as the solution to a dizzying array of rural problems. According to a 1935 pamphlet announcing the creation of the RA, the fundamental problem facing the new agency was "the readjustment of people to the land resources of the Nation."[84] America was no longer a country with limitless resources, the pamphlet argued in a passage worth quoting at length:

America's frontiers are exhausted. It is no longer possible, as in earlier days, to abandon old, worked-out acres and move freely to fresh, fertile, economically productive lands. Too frequently the Nation has wasted its greatest source of

real wealth—the land. Erosion, floods, unwise farming methods, neglect, have exacted a costly national economic levy. American agriculture is undergoing fundamental changes. The transformation is primarily the consequence of man-made acts. . . . Rapidity of communication and transportation, mechanization, scientific advances, the decreased growth of population, spoilation of land resources have developed a new set of national economic concepts and problems. In the process, the agricultural labor market has been sharply curtailed. Thousands of farm families have been forced off the land, unable to sustain themselves by farming operations. Many more thousands have been reduced to a mere subsistence level. During the years of depression, more than a million farm families have been on direct relief.[85]

The AAA had been created to raise farm prices and was moderately successful, but it had not done enough to help the poorest of America's farmers. The RA would take up that slack. The new agency was charged with four primary duties: to buy up worn-out land and use it more appropriately, to relocate poor families to better land, to relocate families to government-owned and -operated suburban settlements, and to make loans to farmers and tenants. Soon after its inception, the agency also became involved in the building and maintenance of federally operated migrant worker camps in the Southeast and West.

According to the pamphlet, the aim of the RA was to convert land to its "best possible use."[86] Because of unscrupulous land management practices, the RA argued, America's farms and forests were being exploited to a ruinous degree. Submarginal land could not support families with adequate diet, nutrition, and overall quality of life. Cash crops, for example, were being grown on land more suitable for grazing, and the "mining" of forests left cut-over regions of the United States vulnerable, their residents "abandoned without support—stranded populations inhabiting 'ghost towns.'" In the West, overgrazing caused soil erosion that further damaged farmland. The RA's solution for such land problems involved buying up poor land from farmers and applying soil conservation techniques to restore the land to usability. Working with the Department of the Interior, the RA planned to "[purchase and withdraw] 1,000,000 marginal acres from present agricultural production."

To improve the lives of those farming the poorest land, the RA would es-

tablish a program of rural resettlement in which people could be moved from poor land to better land. Farmers working poor land would "be given a chance voluntarily to relocate on land capable of providing a decent standard of living." The program involved two phases: a temporary phase of "rehabilitation" and a permanent phase of "resettlement." In the rehabilitation phase farmers would receive loans to purchase or lease land, livestock, and necessary food and equipment in order to remain on their farms. Those who preferred to stay on or near their current land could participate in this phase of the program. Resettlement, the RA argued, would be an appropriate next step for certain groups of farmers, particularly younger farm couples or farmers living on land totally unfit for farming.

A long-term goal of rural resettlement was the creation of self-sustaining farming communities, overseen by the federal government but run in cooperative fashion by community members themselves. The RA had inherited the controversial Subsistence Homesteads Division of the Department of the Interior, whose plan was to build a series of rural settlements that would eventually become self-sustaining cooperative towns. "By developing such projects," the RA argued, "the Nation has created a positive economic asset. Thousands of persons, who today are destitute, become self-sufficient and self-reliant. Opportunities are opened up where none existed before." The idea of resettlement, however, would prove to be a controversial one.

The final component of the RA's plan for battling rural poverty was perhaps its most controversial: the suburban resettlement or "Greenbelt" projects. Although the RA was formed to focus on rural poverty, the agency was charged with finding ways to provide low-cost housing for slum dwellers. The increasingly crowded and unsanitary conditions of both urban and rural slums had revealed a strong need for low-cost housing. The RA argued that the "United States can rid itself of the blight of slums, both rural and urban, only with government assistance. Some form of financial aid is required to fill in the gap left where private initiative failed to function." The Greenbelt communities were never a major part of the RA's program but rather were designed as small experiments, aiming to house at most "a few thousand families." Nevertheless, they took much heat from anti-Roosevelt forces desiring to show that Roosevelt was playing dangerous "socialist" games with rugged American individualism.[87]

As early as 1931 the State of California began constructing migrant labor camps, which were taken over by the RA in 1936. Migrant workers, traversing the state to perform seasonal labor, lived "in the squalor of work camps either erected by themselves wherever they could with whatever they could or provided by the farmers."[88] Such camps were usually filthy, crowded, and riddled with disease. John Beecher, who helped to construct and manage federal camps, recalled that the government camps, in contrast, would typically provide "screened shelters and shower baths and flush toilets, and an infirmary, a community center, a school and playgrounds, laundry tubs and electric irons."[89] By the end of 1942, the agency had constructed ninety-five migrant worker camps throughout the country.[90]

Tugwell quickly built a massive bureaucracy to oversee the RA's projects. The Resettlement Administration was divided into fifteen divisions, each in charge of a separate segment of the organization's work. Twelve regional offices throughout the nation monitored the work in the field. Beginning in May 1935 with twelve employees, by the end of 1935 the RA boasted more than sixteen thousand employees in Washington and across the country.[91] In late 1936 Roosevelt appointed a commission to look more deeply into the farm tenancy issue, which had become a popular focus for writers, politicians, and social critics seeking rural reform. Although the commission looked favorably upon the work done by the RA thus far, it recommended abolishing the RA and replacing it with an agency whose aim would be more modest: to "finance the purchase of small family farms for those who had been forced off the land by natural disaster, economic necessity, or human iniquity."[92] That new agency, the Farm Security Administration, was created as a result of the Bankhead-Jones Farm Tenant Act of 1937, which "set up a three-year, $85 million loan program to help tenant farmers buy their own land, animals, seed, feed, and machinery."[93]

The shift from the ambitious plans of the Resettlement Administration to the more moderate aims of the Farm Security Administration resulted from the belief of many in government that Tugwell's grand long-term plans were simply not feasible in the face of the short-term urgency of rural poverty. Tugwell, frustrated at what he perceived to be the rejection of his goals, resigned from the RA in the fall of 1936. In creating the FSA, Congress also sought to

limit the reach of FDR's broad executive power, which had enabled the creation of the RA in the first place. While the RA had operated as an independent agency of the executive branch, the FSA would operate as a division of the Department of Agriculture, making the agency and its projects more accountable to Congress.

The Historical Section may be understood in part as an outgrowth of the RA/FSA's desire to make rural poverty visible. Yet the photographs must also be read as a product of the agency's need to publicize its work in the face of political controversy and anti–New Deal sentiment. The very institutional structures that Tugwell established within the RA demonstrate the importance of publicity to the venture. From its inception, the RA included an elaborate Information Division, consisting of five separate sections that together would oversee the agency's publicity needs: an editorial section to handle day-to-day, general publicity via news releases and bulletins; a publications section, which would be responsible for in-depth communications; a radio section; a documentary film section headed by famed director Pare Lorentz; and Stryker's Historical Section, which would document the agency's work using still photography.[94] As we shall see, that interest in publicity also contributed to criticism of both agencies, particularly the more "radical" purposes of the Resettlement Administration.

33

The RA/FSA: Controversy and Impact

Controversy hounded the Resettlement Administration from its inception. Barely six months into the agency's existence, the *New York Times* carried a front-page story charging that Tugwell had done nothing more than create a bloated bureaucracy. Specifically, the *Times* suggested that Tugwell had hired more than twelve thousand employees to provide relief for only five thousand people and was spending federal money on such extravagances as cars: "This staff, in addition to having 104 automotive units taken over from other government agencies, has bought eight passenger cars, all but one of the more expensive type, for use in Washington."[95] The charges ignited anti–New Deal sentiment and caused the Democratic National Committee to recommend

that the White House investigate the RA's practices. Tugwell replied that the RA's function was not only relief but also rehabilitation and resettlement:

> The Resettlement Administration is caring for 354,000 farm families, not 5,102 as reported. Our program is primarily one of rehabilitation rather than of direct work relief. We advance loans and grants to farm families to enable them to become economically self-sufficient. As an average farm family consists of more than four persons, you will see that nearly 1,500,000 persons are benefiting directly at this time.[96]

The *New York Times* printed Tugwell's response with its revised statistics—on page five. Few of the newspapers that had repeated the charges also published the reply.

In addition to questioning the agency's huge bureaucratic structure, critics also expressed worry about Tugwell's "red tendencies." The RA's interest in cooperative living—in the Greenbelt towns, homesteads, and migrant worker camps—signaled to conservatives that Tugwell aimed to make fundamental and frightening changes to the American free enterprise system. Plantation owners in the South and growers in the West feared that the RA's interest in cooperatives would make their areas "hotbeds of radical agitation and communism."[97] It is not surprising that charges of communism and socialism lurked beneath the discourse of those who attacked the RA and Tugwell. Robert McElvaine notes that for many Americans, particularly intellectuals and labor activists, Marxism and socialism were appealing alternatives to the apparent failure of American capitalism: "Marxism seemed to many in the American intelligentsia of the thirties to support their own moral condemnations of the marketplace economy and to uphold the values of community, justice, and cooperation that so many writers of the period favored."[98] At the same time, however, McElvaine cautions that the characterization of the thirties as the "Red Decade" is not entirely accurate. While intellectuals, some labor organizers, and social activists sought to introduce the ideals of socialism in order to change American society, most Americans had little desire to dispose entirely of capitalism.

Still, the "threat" of radicalism was a useful rhetorical tool with which to

attack the RA and other New Deal programs—even though the "radicals" themselves by no means embraced the New Dealers as their own. Norman Thomas, who ran for president in 1936 under the Socialist Party banner, attacked Tugwell on various fronts. "Mr. Tugwell's rural resettlement," he observed, "so far has been glorified and costly social settlement stuff."[99] Thomas argued that FDR's agricultural policies had failed to oppose increased Ku Klux Klan activity in the South and failed to support the Southern Tenant Farmers Union in its attempts to organize sharecroppers and farm tenants. Finally, Thomas complained that Roosevelt had not done enough to intervene when migrants were stopped at the borders of Colorado and California and not allowed to enter the state.[100] McElvaine argues that "radical" New Dealers such as Tugwell were really good old American progressives seeking to "Americanize" Marxism and marry it to liberal thought. While Marxist intellectuals wanted "liberal socialism," McElvaine notes, Roosevelt and his cohort sought "social liberalism."[101]

While some charged the agency with radicalism, other critics simply called the RA's projects extravagant and unnecessary. Senator Harry Byrd of Virginia "condemned what he believed were silly extravagances and costly absurdities, such as electricity, refrigerators, factory-made furniture and indoor privies for 'simple mountain people.'"[102] Others fought individual resettlement projects because they did not want a "low class of people" moving into their neighborhoods and communities.[103] Senator Kenneth McEllar hit upon the range of criticisms against the RA when he charged the agency and its successor, the Farm Security Administration, with "paying clients' poll taxes, promoting socialized medicine, excessive spending on travel and publicity and wasting funds on no-account people."[104]

In the face of such criticism, then, the two agencies' motives need to be understood not only in terms of the New Deal desire to recognize rural poverty but also in terms of the bureaucratic necessity for publicizing the agencies' activities to the public and to Congress. During his tenure at Columbia, Tugwell had become increasingly convinced of the power of visual images to frame issues and influence audiences. As a result, the Historical Section photography project would become an important, yet not uncontroversial, tool in the service of the RA/FSA publicity effort.

O N E

Imaging Poverty in the Historical Section

When Rexford Tugwell was appointed head of the RA in 1935, he brought colleagues to Washington to help him with the new agency. One of those colleagues was Roy Emerson Stryker, a former graduate assistant of Tugwell's from Columbia University's economics department. Stryker, a ranch kid from Montana, had worked for a time at a settlement house in New York City before beginning graduate study at Columbia.[1] Always interested in problems of chronic poverty, Stryker admired Tugwell's progressive approach to economics. Part of his admiration stemmed from his agreement with Tugwell's belief that it was important to show students economics in action. Stryker recalled to an interviewer, "So often he [Tugwell] said in his classes, 'How can you talk about an economic system if you don't know what a bank looks like?'"[2] As a teaching assistant at Columbia, Stryker himself was known for taking his students on field trips throughout the city so that they could view firsthand the conditions they were studying.[3]

Beginning in the mid-twenties Stryker worked with Tugwell and Munro on

their *American Economic Life* textbook, carefully choosing photographs and other graphics to illustrate the text. The 1930 edition contains a host of photographs, including the work of Lewis Hine. Stryker turned to Hine's extensive file of photographs of American workers and industry in order to illustrate some of the principles that Tugwell and Munro discussed. Each visual image was accompanied by a caption written by Stryker and designed to link the image to particular concepts in economics.[4]

Tugwell had seen from Stryker's work with the textbook that photographs could be useful tools for communication and persuasion. In May 1934 he offered Stryker a job at the Department of Agriculture as an "information specialist." Tugwell kept Stryker's job description sufficiently vague and encouraged the younger man to find his own way with the position. Tugwell recalled years later that there were practical reasons for being vague: "We didn't want to tell them what he was doing. We had no intention of telling them what he was doing. You know how these things were looked at in those days. Congressmen just loved to make fun of all kinds of projects of a cultural sort."[5] For $3,500 per year, Stryker was to "plan, execute, and advise with regard to informational material in the form of charts, graphs, and other pictorial and visual media relating to the programs and activities of the Agricultural Adjustment Administration."[6] When Tugwell became head of the RA, Stryker joined him as chief of the Historical Section, which was housed in the Information Division of the agency.

The institutional apparatus of the New Deal and a relatively unorganized but committed group of photographers produced a massive photographic project of a scale never before attempted by the federal government. Although clearly the thousands of images made by FSA photographers should not be reduced to an analysis of the impulses of one man, nevertheless Roy Emerson Stryker emerges as a pivotal, if enigmatic, figure in this story. He was both a consummate bureaucrat and a voracious collector of images; these characteristics framed his approach to the job of collecting and circulating the photographs.[7]

Given little guidance on how to proceed with the new entity, Stryker did indeed wield much power in determining the goals for the section. But that power must be contextualized within the ever-changing and often chaotic whims of the institutions overseeing the project. The impression one receives

from reading Stryker's letters, memos, and other correspondence is that of a dedicated, if distracted, administrator often forced to work within the system in order to achieve goals not necessarily valued by that system. Stryker consistently struggled to balance his own vision for the Historical Section with the bureaucratic demands of maintaining the unit as a viable entity in New Deal Washington. In the end, Stryker did not so much execute a grand master plan as do what so many of that era did—in the face of an ever-changing social, economic, and political context, he simply *made do*. And to his credit, that "making do" enabled photographers in the field to collect thousands of images that, in the end, went a long way toward fulfilling one of Stryker's many unrealized goals: the construction of a vast visual encyclopedia of the American people and landscape. While the Historical Section's origins are indebted to a progressive, bureaucratic New Deal ideology, neither the project, its chief, nor its photographers should be understood as mere servants of Roosevelt's New Deal agenda. Those who directed the project and made the photographs sought not only to publicize New Deal efforts to alleviate rural poverty but also to assemble a historical record of a time of sweeping change in the United States—one that would stretch the public's understanding of the possibilities for photographic communication.

Roy Stryker, Collector of Images

Though not a photographer himself, Roy Stryker knew that "documentary" photographers such as Lewis Hine had made significant contributions not only to social reform but to the preservation of historical events, and he wished for his Historical Section to do the same.[8] But Stryker also knew that he was venturing into new territory. Because Tugwell left Stryker's duties vague, the younger man was able to create something new—within, of course, a bureaucratic context. Despite the ambiguity of his initial assignment, two elements of Stryker's approach to the project grounded the more specific choices he made about the scope and direction of the section. First, his passionate motivation to *collect* images, developed during his days of working with Tugwell's textbook, dominated his approach and at least in part accounts for the massive size and scope of the file today. Yet this desire of his to collect was often cited by his

own photographers as evidence that there was a relative lack of *use* of the project's photographs in their own time. A second aspect of Stryker's approach was his belief (often belied by the powerful images in the file itself) that one photograph could not by itself tell a story; this perspective fueled his interest in the "photo-story" and his desire for better and more detailed captioning of images and pairing of images with texts.

When Tugwell moved Stryker to the Historical Section, the younger man had been working with his mentor at the Department of Agriculture to develop a book called *The Pictorial Sourcebook of American Agricultural History.* They intended it to be a kind of visual encyclopedia of American agriculture. Although that project eventually went by the wayside in light of the developing work with the Resettlement Administration, Stryker initially intended to use photographs made by the Historical Section photographers in the book. He recalled: "Now I certainly didn't go down [to Washington] on purely the idea that I was to be a collector of documents. . . . [Yet] before I saw the great feelings of humanity [in the photographs] I saw certain agricultural elements and I said this kind of stuff will do well, we can use this to get ourselves a lot of pictures for our encyclopedia."[9] The encyclopedic impulse grounded Stryker's orientation to the Historical Section's work, particularly in the early years.

Despite his interest in visual representation, Stryker always asserted that the photograph was never as important as the words that would frame or accompany it: "The printed word, . . . the *word* is the dominant thing, and the photograph is the little brother of the word."[10] Stryker's view that the photographic image should serve as a supplement to the word, while not necessarily revolutionary, does ring with irony given the visual thrust of the project's mission. But belief in the supplementarity of the visual grounded many of the choices Stryker made, from his interest in the construction of photo-essays and photographic stories to his belief that, in retrospect, his goals for the Historical Section's project had never truly been met. In a June 1964 interview, Stryker expressed his one regret about the file: "One thing we missed, that I to this day regret. I could not finance it . . . I knew in my own heart how vital it was: the captions. . . . I'm a believer, you see, a thorough believer that the picture is not the end."[11] For Stryker, the photographs themselves could not possibly tell the whole story of American rural poverty. Well-written, well-researched captions

would have to accompany the images—particularly if they were to have a life beyond their particular moment in history.

The duties of the Historical Section, though ill defined at first, eventually involved two types of work. First, photographers were to make what came to be known as "project photographs," pictures that documented the agency's efforts to combat rural poverty. Later, after the RA was absorbed into the Department of Agriculture and renamed the Farm Security Administration, the Historical Section took on "project work" for other government agencies as well, including the Departments of Public Health and Soil Conservation. In addition to the project work, and perhaps of more importance to Stryker, photographers were instructed to make photographs of anything that might constitute an "American" subject. Here, they would preserve on film all aspects of life in Depression-era America. An early photographer's job description reveals the breadth of the photographers' tasks, both in scope and in character: "To carry out special assignments in the field, collect, compile and create photographic material to illustrate factual and interpretive news releases, and other informational material upon all problems, progress and activities of the Resettlement Administration."[12]

The Photographers and the File

By late 1935 the Historical Section had set up its offices in Washington, D.C. The first group of Historical Section photographers included Arthur Rothstein, Walker Evans, Dorothea Lange, and Carl Mydans. In addition, the painter Ben Shahn, officially a WPA employee (and former roommate of Walker Evans), worked for Stryker on an informal basis in the early years; many of his pictures appear in the file. Rothstein was a former student of Stryker's and an amateur photographer. He was initially hired to set up the darkroom but soon was allowed to photograph in the field. Evans, who had studied for a time in France under the famed portraitist Nadar, was already a well-established photographer in New York at the time of his hiring. Lange had worked in the San Francisco area as a successful portrait photographer until the mid-thirties, when she began investigating the problem of migrant labor for the State Emergency Relief Administration (SERA) in California. Lange's photographs were

brought to Stryker's attention in late 1935, and he hired her to work out of her home in Berkeley and cover the West. Mydans left the section during its first year and went on to photograph for the newly formed *Life* magazine. In his place, Stryker hired Russell Lee, a former chemical engineer and self-taught photographer.

This core team of photographers—Lange, Rothstein, Lee, and (to a lesser degree) Evans and Shahn—would produce most of the early RA/FSA photographs. In 1937 Evans departed as a result of creative differences with Stryker and to pursue the publication of a collaborative work with author James Agee, *Let Us Now Praise Famous Men.*[13] Shahn, never officially an employee of Stryker's, used his photographic experiences in the field as the basis for his work in murals. Marion Post, an East Coast newspaper photographer, was brought to the Historical Section in 1938. Lange worked on and off for Stryker until 1940, when she was let go, ostensibly for budgetary reasons. Rothstein also left the section in 1940, to work for another budding picture magazine, *Look.* Russell Lee, Marion Post, and other photographers hired after them (including John Vachon, Jack Delano, John Collier Jr., Margery Collins, Esther Bubley, and Gordon Parks) carried on the Historical Section's work into World War II. From 1935 until after the Historical Section was transferred to the Office of War Information in 1943 and then disbanded in 1946, a total of thirteen staff (full-time) photographers and dozens of additional nonstaff photographers worked for the section.[14]

With Stryker at the helm in Washington and three or four photographers in the field at a time, the Historical Section was able to accumulate more than 250,000 photographs of America and its people. A glance at the Library of Congress's subject headings for the photographs hints at both the depth and the breadth of the file's coverage. The photographs are filed under twelve major subject headings (and, within those headings, 1,300 subheadings), among them "The Land"; "Towns and Cities"; "People, Homes, and Living Conditions"; "Transport"; "Work: Agriculture, Commerce, Manufacturing"; "War, Medicine, and Health"; "Religion"; "Intellectual and Creative Activity"; "Social and Personal Activity"; and "Miscellaneous." There is a tendency to divide the Historical Section's work into two broad themes. In the early years, the FSA concentrated on "problem pictures," seeking to highlight major problems in Amer-

41

ican life, particularly rural life, and to call attention to potential solutions. Later, beginning approximately in the early forties, Stryker became concerned that the file was too one-sided, and he turned the section's attention to the more "positive" aspects of American life. But the division of the file into images with "negative" or "positive" overtones does not do much to illuminate the specific content. Rather than sorting the pictures according to their tone, it is more productive to think of them as a series of relatively distinct but overlapping narratives that Stryker sought to communicate.

Stryker recognized that in order to be successful at visualizing the problems of the Depression and the solutions offered by the Resettlement Administration, he would need to pay careful attention to the development of visual narratives. Such narratives would involve not only the creation of "photo-stories" by individual photographers on individual assignments, but also the comprehensive collection of images (with accompanying captions) to illustrate a particular theme. Within the broad division between "negative" and "positive" representations, then, we may identify at least three narrative trajectories that Stryker attempted to build with the pictures: the American small-town story, the war story, and the tenancy story.

As early as 1936, Stryker became interested in the idea of making pictures that would tell the story of the "American Small Town." He was particularly drawn to the work of sociologist Robert Lynd, who was responsible for the famed Middletown studies of the twenties and thirties. In 1936 Stryker met with Lynd and told him of his interest in collecting photographs that would depict small-town life. Stryker compiled a list of suggestions from Lynd about what such pictures should include; among other things, the photographs would depict people at home in the evening, church attendance, group activities of people at various income levels, meeting places, work settings, baseball, and differences between the lives of men and the lives of women.[15] The section's early emphasis on problem pictures kept Stryker from doing an in-depth examination of small towns, but by the late thirties he had become convinced that such a study would benefit the file as a whole. Writing to Russell Lee in 1939, he mentioned how a visitor viewing photographs in the file had commented upon their depressing tone: "We particularly need a few more things on the cheery side. As one man said when he looked over it, 'Where are the

elm shaded streets'—meaning that, after all, the American Small Town does have some pleasant angles to it. All of you must keep this very much in mind all during the summer, and send in everything you can possibly find."[16]

Beginning in 1939 Stryker was able to approve extended studies of small towns by his photographers. Marion Post photographed New England villages in 1940, and Russell Lee did several in-depth studies of small towns, the most well known of which were made in San Augustine, Texas, in 1939 and Pie Town, New Mexico, in 1940.

As the war approached, Stryker sought to give the file as a whole a more "positive" complexion. He wrote to photographers: "Too many [pictures] in our file now paint the U.S. as an old person's home and that just about everyone is too old to work and too malnourished to care much what happens."[17] He encouraged photographers to focus upon how the buildup of the defense industry and the accompanying economic boom were positively influencing American life. Images made during the early forties began to highlight American efforts on the home front. A 1942 shooting script circulated by Stryker "called for pictures of rubber tires and scrap metal for recycling, automobiles in used-car lots, and signs that suggested the effects of the war." In addition, Stryker suggested that photographers make photographs of people who appeared "as if they really believed in the U.S."[18]

The "problem pictures" that Stryker eventually sought to get beyond compose the narrative with which I am primarily concerned in this study: the "tenancy story." Stryker, like many of his photographers, was intent upon articulating a narrative about rural poverty that took as its focus the tenancy system and related ills. The tenancy story, as it may be traced in the Historical Section archives, involves the two interrelated problems of farm tenancy and migrant labor. These issues, as we have seen, emerged during the thirties in a decidedly public way. Particularly in the early pictures, the Historical Section sought to emphasize the relationship between tenancy and migrant labor by relating both issues to the condition of the land. In his letters to photographers in the field, Stryker repeatedly asked them to make pictures that related people to the land and vice versa. To Dorothea Lange in 1936, he wrote that he would like to see "a few pictures showing the relationship between soil erosion and the human factors."[19] Similarly, to Rothstein he wrote, "Try hard to relate poor

houses and barns with poor land."[20] He encouraged Rothstein to "continue to pick up good drought pictures," for they served as effective illustrations of the land problems that plagued both farm tenants and migrants.[21]

In the West, Dorothea Lange contributed pictures to the tenancy story by photographing the abysmal conditions of migrant farmworkers throughout the state. Lange and her husband, Paul Taylor, photographed and interviewed migrants on the road, on the job, and in roadside camps. Though Stryker rarely gave Lange specific suggestions for making pictures, he did produce a list that outlined things she might emphasize in her photographs. He sought a detailed study of the lives of migrants: "How do the people live in those shelters? How do they distribute their few goods and their many bodies? How do they cook, sleep, dress and vice-versa, pray, visit, take care of their sick, their children, etc.?"[22]

That Stryker believed the tenancy story to be a central theme of the photographers' work is clear from a letter he sent to Lange in late 1936:

> On tenancy, we are already hard at work. Arthur Rothstein has gone South and our new photographer Russell Lee has been in Iowa for the past month documenting photographically, every way possible, the tenancy problem. With his material, yours, and material which Arthur will send in, we will be able to supply the rotos, magazines and special feature people with plenty of good illustrations on the tenant problem. Aside from that, we think we will be able to make some very telling exhibits.[23]

The section's emphasis on both farm tenancy and migrant labor fit with the RA's and Tugwell's interest in land rehabilitation and acquisition. Stryker's repeated entreaties to photographers to emphasize the relationship between the land and its people mapped onto the RA's official position that one could reduce or eliminate rural poverty by changing land practices. In addition, by late 1936 FDR had created a commission on farm tenancy, so the issue was entrenched in the political consciousness of those in Washington and in many other places around the nation; it had become a part of the public conversation. Finally, Stryker emphasized the farm tenancy narrative because that was what the magazines and newspapers or "rotos" (special sections of newspapers

that reproduced photographs via the rotogravure process) were interested in seeing. In late 1936 Stryker wrote to Russell Lee: "There is a great demand now for pictures of farm tenancy. We will be able to use everything we can get. . . . *The New York Times Des Moines Register* [*sic*] and various other papers, are hollering now for anything we can get hold of on farm tenancy."[24] Stryker knew, however, that not all photographs of farm tenancy would get equal play. He wrote to Dorothea Lange during her 1937 trip to the South: "Regarding the tenancy pictures, I would suggest that you take both black and white, but place the emphasis upon the white tenants, since we know that these will receive much wider use."[25] Here Stryker consciously frames the tenancy story in light of what types of images traditional (and, clearly, exclusionary) media outlets would, or would not, be likely to embrace.

With the passage of the Bankhead-Jones Farm Tenant Act in 1937, the Historical Section's emphasis on the tenancy story did not diminish. Photographers continued to document facets of that theme in their work. What did change slightly, however, was the emphasis of the images. By the late thirties, Stryker was asking photographers to focus more upon the "positive" aspects of the tenancy story. To Russell Lee, Stryker wrote that he wanted a series of pictures on "better farms": "We need these very much, and they will serve a most valuable purpose, to work in with the bad conditions which you have already covered very successfully."[26] To Marion Post he wrote: "My opinion is that we want to have two or three good tenant purchase families and rehabilitation families in each Region [*sic*], on whom we have spent two or three days or more, each in a photographic story."[27] The purpose of such stories, Stryker explained, would be to demonstrate how the families' lives had been improved as a result of their relationship with the FSA. Stryker communicated similar ideas regarding migrant workers to Lange in California, encouraging her to focus upon federally funded migrant camps, for "we are short on that portion of the positive side of our migrant camp work."[28]

Roy Stryker, Benevolent Bureaucrat

Many who write about the FSA photography project tend to paint Stryker as a benevolent dictator who attempted to rigidly control his photographers. In

many ways that analysis is borne out in the archival material of the Historical Section, though perhaps not to the extent that some might insist.[29] Stryker did require photographers to read background information about the areas they would photograph. He insisted that "photographers in the field know exactly what it was they were photographing and how it related to the overall regional socioeconomic picture."[30] Staff members (not only photographers but the secretarial staff in Washington, too) were expected to read books such as J. Russell Smith's *North America* as well as to gather other information to give them a good sense of each area and its population.[31]

In addition, Stryker often provided photographers with detailed "shooting scripts" to use as guides in the field. Such scripts typically contained suggestions for subjects that photographers should be certain to cover. Those who ascribe controlling tendencies to Stryker have made much of the shooting scripts; however, Stryker's correspondence with the photographers reveals little evidence that he expected them to follow such scripts verbatim, or that he tried to control *how* they shot particular subjects. A shooting script that Stryker sent to all photographers in 1939, for example, simply lists a series of desirable subjects, such as "Churches (on Sunday if possible), 'Court Day,' Children at play (dogs), Movies, Men loafing under trees . . . Barns (representative types), Fences (all types—rail, stone)."[32]

Apart from the shooting scripts, Stryker would often make suggestions to photographers in letters, occasionally alerting them to specific public relations needs of the agency, as in a letter to Marion Post in which he wrote: "Watch particularly for more pictures which cover the food diet problem of FSA. We want any type of photography which emphasizes the good results (if there are any) of the FSA Rehabilitation Supervision Program."[33] Or he might be more concerned with the general needs of the file, as when he wrote to Russell Lee: "Suggestions for tenant pictures—Tenant farmers on move from one farm to another. Try to get complete set—loading, on road, in new home."[34]

Stryker worried constantly that the Historical Section's budget would be reduced, if not erased entirely, by Congress. As early as 1935, he warned photographers that they needed to produce. To Walker Evans, who produced a high quality but a low quantity of photographs, he wrote: "Let me again warn you that you must push as hard as possible and get your pictures done because no

one knows how long we will be holding forth here, so you had better get everything you can in as short a time as is commensurate with good work. The bureaucrat speaking!"[35] In 1936 Stryker wrote to Dorothea Lange, whose location in California continually threatened her job security, seemingly on a day-to-day basis: "To date I can say you are still secure with us. Yesterday things looked pretty blue and discouraging for the photographic section, but not quite so bad today. However, we have to carry out economy to the limit. Do not send any telegrams that are not absolutely necessary."[36]

The move to the Department of Agriculture in early 1937 eased Stryker's budget woes slightly, for he realized there was potential for the Historical Section's work to receive wider recognition: "Our going to Agriculture has given us a new lease on life, we hope. There are so many things that we can do pictorially, not only for Resettlement, but for Agriculture."[37] Still, Stryker was painfully aware of the precariousness of his section's status. He remarked to Lange in 1939: "I suppose we ought to consider ourselves lucky that we have worked as long as we have. There are still times that I am surprised that we have been permitted to do as much photographing of the United States as we have. . . . I think it has wide appreciation even now. I feel certain that someday it will be a more important record than it now seems at the moment."[38]

Stryker and the Washington staff faced the financial constraints of belonging to a fickle bureaucratic machine that often did not recognize their work as relevant or important. Years later, he remarked to an interviewer, "What so often happens in a bureaucracy, you can't survive. A thing of this kind is extraneous, it is unusual, it's peripheral . . . it's not understood."[39]

"All Great Pictures Were Taken under a Handicap": Photographers in the Field

While Stryker and his darkroom staff managed things from the Washington end, the Historical Section photographers roamed the country with their cameras. Between 1935 and 1946, Historical Section photographers made pictures in forty-seven states plus Alaska, Washington, D.C., the Virgin Islands, and Puerto Rico.[40] In order to gain maximum coverage of the United States, Stryker would scatter his photographers simultaneously across different areas

of the country. A letter from Stryker to Dorothea Lange, written in late 1938, demonstrates the exhaustive range of the photographers' assignments:

> As things now stand (always subject to change, you know) the next few months' program will be somewhat as follows: You: California, wherever most needed, Oregon, Washington, part of Idaho and perhaps into Utah, back into California. Marion: Florida, back to Alabama, Georgia, the Carolinas in the early spring, in the mountain areas of Carolinas, Virginia, and West Virginia. Russell: Back to Arkansas . . . , south to Texas citrus and vegetable migrants, etc. Then a general trip up through the state, picking up rather general pictures Oklahoma later in the spring [sic] over into the Dust Bowl, or Region XII, and special assignments for them, plus general things probably into Arizona to do projects there. Arthur: Here, to clean up Public Health jobs, etc. until spring, then Montana by way of Nebraska and S. Dakota, some project stuff and general things. Then from Montana down through Wyoming to the edge of Idaho and Colorado.[41]

With the exceptions of Dorothea Lange and Russell Lee, who sometimes traveled with their spouses, the photographers usually worked alone, often relying upon regional FSA agents and local relief workers for help in the field. These individuals provided the photographers with information and in many cases introduced them to the area by serving as informal guides.

For the photographers, life in the field was hectic, occasionally lonely, and at times frustrating. They worked alone for months at a time, communicating with Stryker only by letter and telegram. They traveled mainly by car, in many cases to remote and nearly inaccessible areas. The success of their work in the field was dependent upon a number of factors: the interpersonal relationships they established with relief workers and potential photographic subjects, the ever-changing weather, the reliability of their transportation, the technical performance of their camera equipment, and their ability to communicate to "higher-ups" the urgent needs of the people and places they photographed.

Although all photographers reported back to Stryker about the hazards of life on the road, Marion Post most vividly expresses in her letters what life in the field was like for a government photographer (who also happened to be a woman). Post's letters to Stryker describe the often complex interpersonal ex-

changes in which a field photographer would have to participate in order to do her job. Of her attempts to persuade farm families to let her photograph them, Post wrote that they were often suspicious of the government photographer and would not let a "stranger" photograph their homes, either inside or out. In addition, "some said they didn't understand why I was riding around in that kind of country and roads all alone. A couple thought I was a gypsy (—maybe others did too) because my hair was 'so long and heavy' and I had a bandanna-scarf on my head and bright colored dressing coat. All of which I remedied immediately but it didn't seem to help."[42] Although all of the photographers had to deal with reluctant subjects, here Post describes her encounters with sexism and the implicit question "What's a woman like you doing in a place like this?" Like other photographers, she also found it difficult to rely on local relief officials to help her build relationships with potential subjects:

> When you are shown around by other people almost always a good deal of the time is lost as well as gained too. Unless you strike just the right guide, which is very rare, you *have* to see so many other things that you don't want to photograph and explain why not, and then return another time to try to get the people to be less self-conscious with you, alone.[43]

Then, of course, there were always prying local eyes, interested in what the outsider from Washington was up to: "Whether or not it's very obvious that one is working there are always a million blokes who want you to either teach them photography, explain the mechanics of yours and their cameras, or else they're sure that you have some valuable information concerning the country."[44]

Being literally "on the road" occasionally gave photographers cause for grief. As we have seen, while Russell Lee was en route to an appointment to photograph the Elmer Thomas family in Oklahoma, his car got mired in mud and had to be pulled out by a team of mules. Bad weather caused not only car trouble but camera trouble as well. Stuck in a Midwestern blizzard in 1940, Arthur Rothstein explained to Stryker how he had saved the trip through a unique act of photographic heroism: "Because of the below freezing temperatures it was necessary for me to use two Contaxes [a type of camera] interchangeably which I kept warm by carrying them in the seat of my pants."[45]

Stryker responded encouragingly a few days later: "Well, all great pictures were taken under a handicap, and a good photographer finds ways to keep a camera warm."[46] Marion Post reported her own troubles photographing during a harsh New England winter: "Tripods were out of the question very often because of . . . the snowdrifts. I finally have rigged up something which should help— have put a ski pole basket on each tripod leg so that they act like snowshoes and it doesn't sink in too easily."[47]

In some cases, photographers fought to convince Stryker and other superiors of the urgent nature of their efforts. Dorothea Lange's status with the section was always questionable because she worked out of her own facilities in Berkeley. Stryker rarely knew if he would have the money to pay her, so Lange often had to make formal requests to be allowed to photograph. In a letter to the head of the RA in California, Lange wrote of the need to make a trip to photograph a migrant camp:

> There is a job for Resettlement which should be done right away. . . . As you know RA has built and is conducting a camp for migratory agricultural workers in Kern County, California. The camp as it stands today represents a democratic experiment of unusual social interest and national significance. . . . At this time the camp is fully occupied (to capacity) and the harvesting of cotton is at its peak. The drought refugees continue to pour in there. If the photographs are not made now it will be another year before the time will again be right.[48]

Working in the field, photographers saw the potential of their photographs for calling attention to current conditions, and they often had to work to convince their superiors of the necessity for particular photographs.

With few exceptions, photographers in the field would make their pictures and send the negatives back to Washington to be developed and printed in the lab. As a result, they often did not see the fruits of their labor until they returned to Washington or until Stryker mailed them copies of their prints. This served as a constant source of frustration for some of the photographers. Arthur Rothstein wrote to Stryker: "If you only knew how important it is to a photographer in the field to receive frequent information about his work. He may take

pictures for days only to discover after he has spoiled or marred many shots that there was a slight defect he could have corrected."[49] Other photographers expressed similar frustrations.

Once negatives were developed in the Washington lab, they would be numbered. Test prints, also known as first prints or proofs, would then be made from each negative. In the early years, Stryker would sort through these prints and "kill" any images he deemed unsuitable for the file, sometimes by actually punching holes in the negatives. Although this technique was used mainly on images that were technically flawed in obvious ways, Fleischhauer and Brannan note that photographers complained. Thereafter, Stryker "established a procedure that gave photographers a well-defined role in image selection."[50] The revised procedure allowed photographers to see the first prints, which would be mailed to them in the field. Rather than destroying the negative, Stryker would tear off the corner of the print to indicate that he believed the print should be killed. Upon receipt of the pictures, the photographers were not only to write captions for the prints but could also express their disagreement with Stryker's decision to kill particular prints.[51] Once this editorial process was complete, the images (with captions) would be officially entered into the photographic file.

The Historical Section photographers traveled the country, worked with more or less cooperative subjects and consultants in a variety of local areas, digested information sent by Stryker and others reminding them of the FSA's goals and aims, and often battled Nature herself to obtain particular images. It is vital to recognize the material, often complex and occasionally idiosyncratic conditions under which photographers produced the Historical Section's body of images, for these conditions most certainly leave their traces upon the meanings we may locate in those images today.

The Historical Section and Controversy

Controversies about the section's own practices occasionally created institutional problems. In 1936 Arthur Rothstein photographed an old cow's skull in the Dakotas, and the images were widely circulated as examples of drought devastation in the Great Plains. Republican newspaper editors in Fargo argued

Figure 1.1. "It's a Fake: Daily Newspapers Throughout the United States Fell For This Gem Among Phony Pictures." *Fargo Forum,* 27 August 1936, LC-USF-004378-D. Used with permission of *Fargo Forum.* Image courtesy of ProQuest.

that the photographs were faked because Rothstein had moved the skull several feet and photographed it against two different backgrounds, and because the cow in question had obviously died long before there was a drought (Figure 1.1). The "skull controversy," as the incident came to be called, brought intense criticism to the already embattled RA, and Historical Section photographers were accused of manipulating the images for political purposes.[52]

In yet another famous incident, a 1937 photograph caused similar problems. A Russell Lee photograph of a tenant farmer's teenaged daughter and her younger sister was printed in the *Des Moines Register* and other Iowa newspapers accompanied by the caption "Tenant Madonna," implying that the two young girls were mother and daughter.[53] When the mistake was revealed, a public outcry ensued in which Lee was accused of "faking" the picture to make poor tenant farmers appear sexually promiscuous and immoral. In fact, the Information Division was at fault for miscaptioning the photograph, and its as-

sistant director apologized to Lee: "The notes you have sent in with pictures have always been scrupulously accurate and honest, and it is unfortunate that a mistake made in Washington should be charged against you."[54]

Throughout the life of the Historical Section project there were always critics who wondered why the government needed to fund a group of photographers in the first place. Such criticisms survived even the life of the agency, as *Life* magazine reported in 1948. While searching for a way to demonstrate the government's tendency to waste taxpayers' money, Senator Homer Capehart of Indiana "discovered" the FSA collection, which by then was housed in the Library of Congress. *Life* reported that when the senator learned the pictures were taken by the FSA, "at a cost of $750,000 . . . Capehart went storming on to the floor of the Senate to brandish the photographs and demand an explanation. He declared that the pictures were 'silly,' 'ridiculous,' and 'foolish.' He demanded an investigation of what in heaven's name the FSA had in mind, if anything, when it shot up all those rolls of perfectly good film."[55]

For its part, *Life* noted that "the FSA photographers produced some excellent documentary work, especially of the victims of the farm depression of the '30's," but Senator Capehart could not be dissuaded and demanded a full congressional investigation into the matter.[56]

Circulating Images: The Historical Section
Photographs in American Print Culture

By the time the Historical Section was absorbed into the Office of War Information in 1943, photographs from the file had appeared in nearly every major magazine and newspaper in the country as well as in museum exhibits, congressional reports, government pamphlets, specialized periodicals, and picture books. Yet interviews done in the mid-sixties as a part of the New Deal and the Arts Oral History Project reveal some disagreement among the principals about whether the photographs were circulated *enough* during the years when the section operated. Roy Stryker contended that the photographs were significant only if they were used: "You see, in the end, the 270,000 or 250,000 pictures are only going to be significant if somebody goes in and takes fifteen of them, one of them, fifty of them, and does something. He does an article,

makes an exhibit, he puts the frontispiece, he puts the cover. . . . I think *that's* the answer—what can somebody *do with it*?"[57]

Yet a number of photographers countered that Stryker's real goal was simply to construct a vast encyclopedic file to record the decade for posterity, rather than to use the images in influencing contemporary social change. As a result, they claimed, during the years when the photographs were needed most Stryker did not do as much to encourage their publication as he could have. Dorothea Lange observed that the photographic file "wasn't used in those days. The file was not used. Not much. Not much. It was one of the problems, that it wasn't used. . . . What actually came out was a trickle for what became a pretty big organization."[58] Similarly, Arthur Rothstein noted: "I think the pictures could have had wider circulation at the time . . . it could have been used more effectively. . . . The picture *was* the end—that was it. Once that picture got in the files, that was the end. The idea was to get the pictures in the files."[59] And John Vachon concurred, explaining that he believed Stryker to be more interested in expanding and increasing the size of the file than in using it: "I'm pretty sure that Stryker had a strong feeling that this was an important thing that he was putting together [the file], and that it was *the* important thing."[60] Such conflicting "memories" of the Historical Section point to a central tension about the project's mission that continues to resonate today: Was the true purpose of the file to record the era "for history" (Stryker's own encyclopedic vision) or to facilitate contemporary social change?

Regardless of where one falls on the issue of purpose and use, however, it is clear that the images *were* used, in some years extensively, and in a variety of ways. During the first few months of the Historical Section's existence, the photographers' work appeared only in government publications. From mid-1935 to the end of that year, 965 Historical Section pictures were distributed for publication, just 193 a month.[61] Editors soon realized, however, that not only were the images of high quality but their content was of great relevance to the contemporary scene. By 1940 the Historical Section could claim an average picture distribution of 1,406 images per month.[62]

Beginning in early 1936, Historical Section photographs started to achieve a wider circulation in American print culture. The progressive social science periodical *Survey Graphic* became the first nongovernment publication to re-

produce the agency's work, using several farm tenancy images in its January and March 1936 issues. Eventually newspaper and magazine editors recognized that the Historical Section's photographs offered both good image quality and broad coverage of the American scene, and soon the demand for the photographs increased. Maren Stange notes: "By the end of 1936, Stryker had placed photographs in *Time, Fortune, Today, Nation's Business,* and *Literary Digest,* and he had prepared twenty-three exhibits, including one at the Museum of Modern Art and another at the Democratic National Convention of 1936."[63]

Not only were the photographs circulated within the government and in the mainstream media, but they also participated in the more specialized discourses of social science and art. Social welfare and progressive periodicals, such as *Survey Graphic* and *Birth Control Review,* used FSA photographs to illustrate articles. Almost immediately, the Historical Section's photographs also roused the attention of those in the photography and art communities, who held up many of the images as examples of fine photographic art. The annual photography journal *U.S. Camera,* for instance, routinely chose Historical Section pictures as the best of the year in its issues. General-interest magazines such as *Collier's* and *Look* (one of many new picture magazines that appeared in the late thirties) published features on rural poverty and the New Deal using Historical Section photographs. And, as noted earlier, a well-received display of FSA photographs was included in the First International Photographic Exposition of 1938. Cosponsored by the Museum of Modern Art, the FSA exhibit used at the exposition was turned into a solo touring exhibit and traveled to cities around the country. That same year, former Historical Section photographer Walker Evans became the first photographer to mount a one-man show at the Museum of Modern Art.[64]

With the publication in 1937 of Margaret Bourke-White and Erskine Caldwell's popular picture book on Southern poverty, *You Have Seen Their Faces* (a text often mistakenly associated with the Historical Section's project), the demand for FSA photographs from picture book publishers and authors increased.[65] Poet and Librarian of Congress Archibald MacLeish used FSA photographs to illustrate his prose poem *Land of the Free.*[66] The Museum of Modern Art published *American Photographs,* based upon Walker Evans's 1938 exhibit and containing portions of his FSA work. Dorothea Lange and Paul Taylor

55

produced *An American Exodus,* a documentary study of the migrant labor problem.[67] Richard Wright used FSA photographs to illustrate his book on black poverty, *Twelve Million Black Voices.*[68] Evans and author James Agee published *Let Us Now Praise Famous Men* in 1941, a study of three Alabama tenant families made in 1937 while Evans was on loan to *Fortune* magazine. Although now praised as one of the most important works of the decade, the book was largely ignored at the time of its publication—as a result of its dense, self-conscious style and rapidly waning national interest in the tenancy story in the face of an escalating war in Europe.

The FSA Photographs in Print Culture

These initial discussions have aimed to set the scene for examination of the FSA photographs as they appeared in *Survey Graphic, U.S. Camera,* and *Look* during the late 1930s. A range of forces contributed to the appearance of the Historical Section photographs, including complex social attitudes about poverty in the United States, the New Deal's interest in making rural poverty visible, Stryker's belief in the urgency and efficacy of the tenancy story, and the photographers' own practices and experiences in the field. Taken together, these intersecting forces provide a historical and critical frame through which we may examine the photographs and study the uses to which they were put. Previous studies of the FSA photographs have tended to ignore or only briefly address the role that print culture played in the circulation of the Historical Section pictures during the Depression. Yet if we are to understand how images serve as inventional resources for argument in the public sphere, we must pay close attention to their use in these contexts. Indeed, the goal of the rest of this book will be to demonstrate what narratives of poverty are made available in the contexts of bureaucratic social reform discourse, aesthetic discourse, and the discourse of mass-mediated popular culture. It is only through consideration of the FSA photographs as they participated in specific textual events and circulated across multiple domains of expression that we may be able to offer a history of images that is truly *rhetorical*—that reflects the images' *specificity* as a response to particular public and institutional needs and that respects their *fluidity* as multivoiced expressions in an ongoing journey of circulation.

T W O

Social Engineering and
Photographic Resistance

SOCIAL SCIENCE RHETORICS OF
POVERTY IN *SURVEY GRAPHIC*

*The resource that has not yet been tried on any large
scale, in the broad field of human, social relationships
is the utilization of organized intelligence.*

—JOHN DEWEY, "AUTHORITY AND FREEDOM"

Expert Discourses of "Organized Intelligence"

It is not surprising that the first venue outside of
government to employ the Historical Section's pho-
tographs was the progressive social welfare periodical
Survey Graphic. By the mid-thirties *Survey Graphic*
had behind it more than twenty-five years of report-
ing upon and advocating progressive issues. During the Depression the journal
was particularly warm to the New Deal (though not entirely uncritical) and em-
braced its philosophies of social experimentation. From its beginnings in the late
nineteenth century as *Charities,* a small journal for charitable organizations, to
its later incarnations as *The Survey* and *Survey Graphic,* the journal consistently
maintained a progressive stance, arguing that efficiency, expertise, and reason
were the most appropriate tools to apply to social problems. The rhetoric of *Sur-
vey Graphic* and its predecessors embodied their editors' allegiance to the prin-
ciples of "scientific charity," "social invention," and other progressive conceptions
of social engineering. As a result, *Survey Graphic* became a periodical with a
decidedly modernist approach to problem solving: rational, cool, efficient.

The FSA photographs were mobilized in the service of this social-scientific rhetoric of poverty, as illustrated by a series of Historical Section pictures that appeared in *Survey Graphic* articles about cotton tenancy and migrant labor. *Survey Graphic* was an important early outlet for the Historical Section's photographs. Roy Stryker knew that the journal's audience was, in many ways, his ideal audience: liberal, progressive "social engineers" unafraid of government solutions to the nation's problems. Furthermore, *Survey Graphic*'s readers had shown their commitment to social welfare issues for decades. Thus understanding why and how the Historical Section photographs were used in the pages of *Survey Graphic* necessarily involves knowing something about *Survey Graphic*'s history: how it served as the rhetorical expression of early-twentieth-century progressivism and how that progressivism mutated during the twenties and thirties into a "pragmatic instrumentalism" that emphasized decidedly bureaucratic ways of dealing with social problems such as rural poverty.[1]

Progressivism and its accompanying philosophies of social invention, order, and expert authority served as the ground upon which *Survey Graphic* built its rhetorical foundations. Following an explanation of the journal's progressive ethos, my focus shifts to the Historical Section's relationship with *Survey Graphic* and finally to the photographs themselves as they appeared in its pages. A careful analysis of the FSA photographs reveals that the images uphold the necessity of expert, government intervention into the lives of citizens in two ways. First, they employed visual conventions to reveal the insurmountable odds facing the poorest of the rural poor, and second, they visually affirmed government experiments and controversial projects. At the same time, however, some of the photographs resist being easily mapped onto a social scientist's rhetoric of poverty. Such photographs complicate the viewer's gaze, work with and against other images and texts in contradictory ways, and present a persistent particularity that the social scientist's pragmatic instrumentalism seeks to erase.

The Survey and the Progressive Ethos

The journal that in the twenties came to be known as *Survey Graphic* was a child of the Progressive Era, with ties reaching far back into the social welfare practices of nineteenth-century charitable organizations. Its origins may be

traced to the early 1870s, specifically to the development of "scientific charity." For much of the nineteenth century, American charitable activity was closely tied to religious practices and beliefs, particularly among well-to-do Protestants. But by 1870 industrial changes in America had begun to produce strong divisions between labor and capital. The number of people requesting relief grew in both cities and rural areas, and capital responded by transforming the ways in which charity was conducted. Cities ceased giving direct moneys to the poor and advocated instead "scientific charity," a process that would involve not only helping the poor but studying them as well.[2] The foundation of scientific charity was the charity organization. The ideal charity organization, Michael Katz observes, "would coordinate, investigate, and counsel. It would not give material relief."[3] Rather, it would function as a bureaucratic entity, a kind of clearinghouse for public relief administration. Applicants for relief would go to the charity organization, which would decide what type of relief, if any, was appropriate and direct the family to the appropriate relief agency. The charity organization would also assign a "visitor," a precursor to the caseworker of social work, to work with the family.

During the heyday of the charity organization societies, a small cadre of journals and periodicals were founded to help charity organization workers with advice and information. The New York Charity Organization Society (COS) started the journal *Charities Review* in 1891. It offered advice and "dignified, scholarly, educational" analyses of issues faced by charity organizations throughout the country. The journal was highly specialized and not widely known outside of welfare circles. In 1897 Edward T. Devine, the most prominent American writer on welfare issues, launched another publication for the New York COS called *Charities,* a monthly and then later a weekly "review of local and general philanthropy." *Charities* absorbed *Charities Review* in 1901.

During the first decade of the twentieth century *Charities* reflected the basic assumptions of scientific charity: that what was necessary to reduce poverty was intervention into the lives of poor families by trained investigators who could, in a "neighborly" way, study the causes of the family's poverty and provide "'sympathy, counsel, and service'" but not "'groceries or coal or rent.'"[4] Although *Charities* proclaimed itself to be the "organ of the poor and the distressed," it also dedicated itself to the proposition that charity organizations

59

should promote "such programs as would 'enable the individual to eradicate, as far as may be, his personal defects before they have brought ruin and disaster.'"[5] As we have seen, the hostile view—the belief that the poor were poor because of their own defects—strongly influenced thinking about social welfare during the late nineteenth and early twentieth centuries.

Between 1902 and 1909, *Charities* embraced early developments in progressive thinking that conceptualized poverty not as the failing of an individual but as the result of complex interrelationships among corrupt systems. During those years *Charities* published articles on progressive issues such as child labor, housing reform, immigration, black Americans' migration to Northern cities, and the settlement movement, which was transforming the ways in which the upper and middle classes interacted with the poor. Then *Charities* again changed its name, merging with a popular journal of the settlement movement to become *Charities and the Commons.* The merger proved not only to be a sound business decision for two highly specialized journals with limited readership but also gave recognition to the increasing influence of settlement movement thinkers such as Jane Addams and Lillian D. Wald.

Social reformers such as Addams and Wald held a much more environmental view, believing that poverty was caused not by an individual's personal "flaws" but by a complex set of social forces (including economic ones) that produced in the poor feelings of hopelessness and despair. *Charities and the Commons* reflected such beliefs. Social welfare historian Clarke Chambers notes:

> It believed in the efficacy of facts; it believed in the ultimate benevolence of an informed public; it asserted that government could be a great agency for the elevation of the human race; it believed that when the people really knew what the conditions were that stood in the way of social justice, they would take appropriate steps to root out evil; it insisted on open, "scientific" inquiry; it had faith in an elite of well-trained social analysts and practitioners.[6]

Such beliefs not only reflected the editorial stance of *Charities and the Commons,* but more fundamentally they represented the foundations of a type of progressivism that Sean Dennis Cashman ascribes to "efficiency experts." While some reformers in the early part of this century located their desire to change

society in religious movements such as Walter Rauschenbusch's "Social Gospel," other progressives focused upon transforming social problems by managing them with greater efficiency.[7] These "efficiency progressives" were likely to be urban and of a professional class of college-educated Americans.[8] For this group, reform was not found in application of the Christian gospel to contemporary conditions; rather, it involved a desire for "reason, order, and efficiency."[9] The philosophy of social transformation to which *Charities and the Commons* and its successors subscribed was grounded in this latter approach. Those who produced and read *Charities and the Commons* were professionals: journalists and social welfare experts, people who read and understood the tenets of "social invention" and "social engineering" of philosophers and activists such as Louis Brandeis and John Dewey. The influence of these men and other progressive reformers resonated in the pages of *Charities and the Commons* and its successors.

In 1902 two brothers from Michigan, Paul and Arthur Kellogg, joined the staff of *Charities* just as the focus of the journal was beginning to shift with the times. The Kellogg brothers would within a few years become editor and business manager, respectively, Arthur staying until his death in 1934 and Paul lasting until the journal finally folded in 1952.[10] Throughout its existence in various forms, the journal would be strongly influenced by the Kellogg brothers, particularly the unabashedly progressive Paul Kellogg, whose editorial positions remained remarkably consistent throughout the years.

In 1907 Paul Kellogg, who was about to replace Edward T. Devine as editor of *Charities and the Commons,* was asked to conduct a broad survey of social conditions in the industrial city of Pittsburgh. Kellogg accepted the offer to direct the "Pittsburgh Survey" and assembled a group of progressive-minded investigators to assist him in the vast project. For more than a year and a half, Kellogg and his team studied nearly every aspect of life in Pittsburgh, including industrial accidents, industrial employment among women, labor issues in the steel industry, family life, schooling, health, and recreation. They amassed a huge amount of information and published reports in three special issues of *Charities and the Commons* in the spring of 1909. The completed Pittsburgh Survey was eventually published by the Russell Sage Foundation as six full volumes of research, and the undertaking became the model for a new kind

of social research based upon "modern" methods of information gathering, investigation, and analysis.

Upon the successful completion of the Pittsburgh Survey, Kellogg decided it was time to change the name of the journal to something that more closely reflected its current orientation. While the idea of "charity" no longer embodied the journal's interests, "survey" clearly did. Kellogg and his staff decided to change the name of the journal to *The Survey* in homage to the new kind of social analysis first undertaken in Pittsburgh. In 1912 the journal became fully independent of the charity organizations that had spawned it when the Kellogg brothers created a corporation called Survey Associates. Any subscriber who paid ten dollars or more could become a member of Survey Associates and would be entitled to vote for members of the board of directors. Some of the associates, such as Jane Addams (also a member of the board of directors) and Lillian Wald, would from time to time contribute articles to the journal. On the whole, the associates were conceived as a group of expert specialists "that society would have to accept and whose talents the nation would have to employ if rational control were to be asserted over the drift of life."[11]

During the teens and early twenties *The Survey* reflected the increasing professionalization of social work while at the same time it expanded its coverage to include broader discussions of social issues. In the mid-teens the journal devoted significant space to industrial topics such as wage-and-hour issues, accidents and occupational hazards, exploitation of child labor, and labor legislation.[12] In addition to its emphasis on industry, *The Survey* covered related subjects such as tenement living, discrimination against immigrants and black Americans, social insurance, woman suffrage, conditions in prisons, and even birth control.[13] During these years *The Survey* was still a professional social work journal, but one with a long lens. Its analysis of issues important to social workers in the field was always supplemented by a recognition that specialists needed to take into account a massive range of social factors that influenced their clients. Editor Paul Kellogg explained in 1915 that *The Survey*'s main job was to serve "as an investigator and interpreter of the objective conditions of life and labor and as a chronicler of undertakings to improve them."[14]

The Survey continued along this path until the early twenties, when interest

in progressive reform began to wane. During these years, the field of social work had continued to evolve as well, becoming increasingly professional in focus.[15] Partly to broaden the scope of his readership at a time when the field of social work was becoming more specialized, Paul Kellogg created *Survey Graphic*, a companion journal to *The Survey*. For years Kellogg had wanted to create a journal that would be aimed less at professional social workers and more generally at socially conscious members of the public. He wanted *Survey Graphic* to have some similarity to other journals of the time, such as the *New Republic* and *The Nation*, which incorporated analysis of art and literature into discussions of public issues. But he also believed that his new journal should be fundamentally different in orientation. While these other journals represented themselves as journals of "opinion," Kellogg wanted his new publication to represent itself as a journal of "social fact." He claimed he did not want to tell people what they should think; rather, he wanted to "provoke citizens everywhere into an awareness of new programs for social reform," to get citizens to see for themselves the necessity for particular social changes.[16]

63

Not only would the title *Survey Graphic* distinguish the new journal from *The Survey*, but it would also highlight the new magazine's interest in the graphic representation of social facts. *Survey Graphic* would over time treat many of the same issues covered by *The Survey*, but with a different, more popularized approach. Chief among the goals of *Survey Graphic* was to communicate information visually through the use of charts, graphs, illustrations, cartoons, and photographs. Paul Kellogg hoped to "engage the attention of a wide audience by use of graphic and literary arts in partnership with the social sciences, to catch the eye and heart as well as the intellect."[17]

Survey Graphic debuted in the fall of 1921 as a companion to the more professionally oriented *Survey*. The two periodicals were published on a staggered schedule, the *Graphic* coming out at the first of each month and *The Survey*, now known as *Survey Midmonthly*, in the middle of the month. People who already received the *Midmonthly* were expected to subscribe to both journals, while members of the general public could choose to subscribe only to the *Graphic*. Those who received the first edition of the new journal were greeted by a splashy blue cover featuring a giant sailing ship logo. Editor Paul

Kellogg abused the ship metaphor in his remarks welcoming readers to the new magazine:

> *Survey Graphic* bids you to a voyage of discovery. The magazine is founded in the belief that the drama of human living may be as thrilling as the tale of a battle; that the destiny of a million new citizens, the struggle for public health, the aspirations of workaday men and women are as colorful as a trip to the Fortunate Isles. . . . *Survey Graphic* will reach into the corners of the world— America and all the Seven Seas—to wherever the tides of a generous progress are astir. . . . Its cargo will be stuff of creative experience, observation and invention.[18]

Throughout the twenties and into the thirties *Survey Graphic* reproduced the progressive orientation of *The Survey,* but did so in a more publicly accessible fashion. Kellogg's commitment to the discussion of all types of public issues is evident when one considers the range of subjects the journal treated during the twenties. Viewed with the hindsight of history, *Survey Graphic* in the twenties produced analyses of social and political issues that were years ahead of their time. In a decade when few expressed interest in the problems of farmers, *Survey Graphic* began 1922 with a curiously prescient special issue titled "The Hole the Farmers Are In: How They Can Get Out."[19] *Survey Graphic* treated other subjects with foresight as well, producing special issues on heart disease (1924), the cultural contributions of the Harlem Renaissance (1925), "Woman's Place" (1926), "Family Life in America" (1927), the necessity for government intervention in the power industry (1927), fascism (1927), and, ominously, a 1928 warning about the potentially disastrous effects of growing mass unemployment.[20]

The journals' "pragmatic instrumentalism" was not formed in a vacuum. The principles guiding both *Survey Graphic* and the *Survey Midmonthly* during the twenties and thirties were those of progressive, modernist modes of thinking that believed in the authority of the expert, valued social invention, and possessed an interest in the communicative potential of visual explanation. *Survey Graphic* and the *Midmonthly* were indebted to their predecessors,

whose "efficiency progressivism" had mutated smoothly into a postwar modernist concern for social engineering and planning. Kellogg and the Survey Associates believed in the authority of the expert, whose task was to collect and explain social facts to the public. Armed with the expert's "scientific" knowledge, the public would ideally act accordingly to bring about necessary social changes. For Kellogg and the Survey Associates, empowerment of the public remained the ultimate goal. They wished to make certain that "study, research, and contemplation found their justification in purposeful social action."[21]

65

Survey Graphic embraced the ideals of social invention and experimentation put forth by the likes of Louis Brandeis and John Dewey. Brandeis, whose eightieth birthday was celebrated in the pages of the magazine in November 1936, was held up by *Survey Graphic* as the "People's Defender," a cool and rational social experimenter who believed that citizens should use their government to effect social change. The phrase "social invention" is attributed to Brandeis, who argued that in order for Americans to contend with "an ever-increasing contest between those who have and those who have not," we "need 'social inventions,' each of many able men adding his work until the invention is perfected."[22] Brandeis envisioned a form of social planning and collective experimentation that had as its ultimate goal the creation of a perfectly efficient, just society. Writing about the example Brandeis set in his own life, in which he worked for the creation of savings bank insurance, fought monopolists, and became an influential figure on the Supreme Court, A. A. Berle stated: "It is a Homeric saga: the saga of great deeds of championship done in this our time through the strictly modern methods of fact-finding, education, and political action."[23]

Survey Graphic celebrated Brandeis's lifetime of achievements in social invention because it, too, espoused the "strictly modern methods" in which Brandeis placed his faith. Throughout his tenure at the journals, Paul Kellogg believed that social invention, coupled with meticulous social planning, constituted the best way to create positive change in American society. The threat of "technocracy" did not bother Kellogg. Increased modernization, Chambers writes, only renewed Kellogg's faith in the possibilities of social planning: "No social possibility more engaged his enthusiasm in the 20's than his vision of a world renewed by the kind of social planning that modern technology made

feasible."[24] From the years of the Pittsburgh Survey through the twenties and on into the Depression years, both journals continuously embraced the ethic of social invention as the path to the kind of social justice Brandeis envisioned.

If social invention marked the path to social perfection, then social reformers would have to use methods that facilitated social invention. In the thirties the journals continued to embrace their time-tested method of social inquiry, the "scientific" collection of "social facts" by experts. Philosophical justification for their method could be found in the writings of John Dewey, himself an "expert" to which the journals occasionally turned for analysis, judgment, and inspiration. In an essay titled "Authority and Freedom," published in *Survey Graphic* in 1936, Dewey argues that the key problem of human relations is in fact the relationship between authority and freedom. Society needs authority to maintain rational social control, Dewey explains, but if authority is dominant then we lose freedom. In contrast, if freedom reigns supreme our ability to maintain a rational hold on society will suffer. For Dewey, the key is balance. If we can achieve the proper balance between authority and freedom, then we may have enough authority to control society and enough freedom to enjoy it. Like other social reformers of the time, Dewey finds the answer in science. He asks:

> Are there resources that have not as yet been tried out in the large field of human relations, resources that are available and that carry with them the potential promise of successful application? The resource that has not yet been tried on any large scale, in the broad field of human, social relationships is the utilization of organized intelligence, the manifold benefits and values of which we have substantial and reliable evidence in the narrower field of science.[25]

In *The Public and Its Problems,* Dewey had argued that while the public was becoming more comfortable with science, it was less likely to see how it might apply the principles of science in the social world: "Men have got used to an experimental method in physical and technical matters. They are still afraid of it in human concerns."[26] Dewey's position was that the public cannot adequately care for itself unless it can first know itself: "Genuinely public policy cannot be generated unless it be informed by knowledge, and this knowledge does

not exist except when there is systematic, thorough, and well-equipped search and record."[27] Although Dewey wrote these words before the Depression, his Depression-era arguments remain much the same. In *Liberalism and Social Action* he writes: "The crisis in democracy demands the substitution of the intelligence that is exemplified in scientific procedure for the kind of intelligence that is now accepted."[28] For America to engage in adequate reform, Dewey explains, reformers must apply an "intelligence" that models experimental science: the systematic collection and analysis of social facts.

Significantly, neither Brandeis, Kellogg, nor Dewey advocated rule by experts. The expert who embraces "organized intelligence" should not be an authoritarian figure who engages in judgment, they argued, but a knowledge-creator who simply provides the information upon which good public policy should be based. Dewey explains: "Inquiry, indeed, is a work which devolves upon experts. But their expertness is not shown in framing and executing policies, but in discovering and making known the facts upon which the former depend. They are technical experts in the sense that scientific investigators and artists manifest *expertise*."[29]

Dewey does not advocate a pure technocracy in which experts make all of the public's decisions, but he does demonstrate an optimistic faith in the authority of experts to generate and evaluate public knowledge. His implicit assumption that experts do not "frame" issues but merely provide information may seem naive, yet such a faith in the objectivity of experts grounds the discourse of *Survey Graphic* as well. Paul Kellogg contended that the experts provided the information, while his journals provided the framing and interpretation. He liked to invoke the words of welfare expert Karl de Schweinitz: "'The function of the interpreter is to take the discoveries of the specialist and make them part of the knowledge of the general public.'"[30] The job of the *Midmonthly* and the *Graphic*, then, was framed as an interpretive one: to make the neutral, "objective" information provided by experts relevant to the reading public, both the professional and the layperson.

Visual representation served as one way through which Kellogg sought to translate expert information for public consumption. When he founded *Survey Graphic*, he meant for the title to combine *The Survey*'s interest in social planning with a new commitment to the graphic depiction of social facts.

Writing to one of his reporters as the new journal debuted, Kellogg explained that a greater visual component would help the journal reach a broader segment of the public: "The keynote of the thing . . . is interpretation and we are going to employ photographs, etchings, drawings and text of a sort which we hope will get a new hearing for the big human concerns which lie underneath all this technical discussion of social problems."[31] In keeping with Kellogg's interest in making the new magazine more visually interesting, charts, graphs, and maps appeared in the pages of *Survey Graphic* much more frequently and with greater visual impact than in the *Midmonthly*. The famous "work portraits" of Lewis Hine debuted in the pages of *Survey Graphic,* and Hine's work would appear there on a regular basis throughout the twenties and early thirties.[32] In addition, *Survey Graphic* regularly turned to popular cartoonist Hendrik Willem van Loon to provide illustrations for its articles. Beginning in the mid-thirties, *Survey Graphic* intensified its commitment to the visual representation of social facts by espousing a new kind of "visual language" of symbols, the "Isotype," lauded for its potential to make communication across culture and language virtually seamless.[33] And, of course, *Survey Graphic* would continue to show its interest in the visual aspects of social welfare work by publishing many of the Historical Section's photographs.

In sum, by the 1930s, *The Survey* and *Survey Graphic* had matured into respected public welfare journals offering a decidedly progressive slant on social and political issues. Both publications relied heavily upon the discourses of social invention and the authority of expertise, and *Survey Graphic* placed visual representation at the core of its mission. As we shall see, the FSA photographs participated in the perpetuation of *Survey Graphic*'s progressive ethos.

Survey Graphic and the Depression: Efficiency and Expertise

Survey Graphic's interest in social planning and engineering intensified with the coming of the Depression and the New Deal. The magazine continued to cover a vast range of issues, both national and international in scope. During the first years of the Depression, *Survey Graphic* often anticipated the radical reforms of the early New Deal by advocating progressive solutions to social problems. But in doing so the journal remained consistent with its own his-

tory, in that its programs for social reform were always grounded in the firm ideals of the Progressive Era: "rationality, order, equity and justice, and social efficiency."[34]

In the pre-Roosevelt days of the Depression, *Survey Graphic* boasted a respectable circulation of about 25,000 paid subscriptions per year, which increased slightly as the Depression went on. Throughout the decade the magazine continued to treat a wide variety of social and political issues (Figure 2.1). In 1933 *Survey Graphic* published the results of the groundbreaking Payne Fund studies, the pioneering study of the influence of movies on children. Also during Roosevelt's first year in office, *Survey Graphic* analyzed the potential effects of the repeal of prohibition, studied how college graduates were faring in the Depression, explained how federal relief fit into the history of poor laws in the United States, noted the increasing importance of realism in art, and chronicled growing anti-Semitism in Germany. Continuing a trend begun with the heart disease issue in the twenties, *Survey Graphic* devoted many pages in the thirties to health issues, from the cost of medical care to the public health threat of syphilis.

69

Although today we have the impression that in the 1930s Americans' interests were focused exclusively on domestic problems, *Survey Graphic* did not ignore international issues, as Figure 2.1 shows. An examination of articles published in *Survey Graphic* from 1933 to 1940 reveals that roughly 20 percent focused upon international topics.[35] Issues related to urban and industrial areas of the country received the majority of coverage throughout the thirties, continuing a focus of the periodical from its pre-*Graphic* days. Roughly 20 to 25 percent of all articles published in *Survey Graphic* dealt in some way with urban and industrial issues, including manufacturing, labor, urban problems, and strikes. Beulah Amidon, a longtime reporter for Survey Associates, worked full time on the labor and industry beat. By contrast, neither the *Midmonthly* nor *Survey Graphic* assigned anyone to a beat for rural issues. In fact, the magazine's discussion of rural issues, including farm mechanization, migrant agricultural labor, farm tenancy, rural relief, and drought, never amounted to more than 10 percent of all coverage from 1933 to 1940. Coverage of rural issues made up only 2 percent of *Survey Graphic*'s output in 1933 and peaked briefly at 9 percent in 1936, an election year in which the drought in the Great Plains

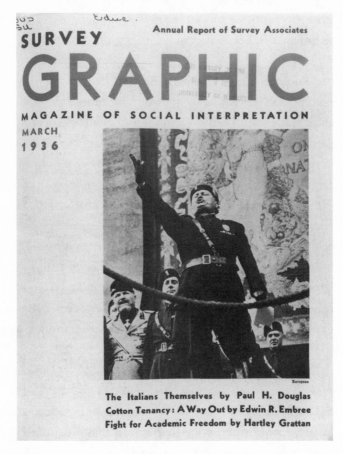

Figure 2.1. *Survey Graphic,* March 1936. Survey Associates Collection.

figured prominently in the news. If we factor in *Survey Graphic*'s coverage of general trends in social planning and its extensive analysis of FDR's New Deal proposals, the presence of rural issues in the pages of the journal does increase; however, compared to the number of articles on other topics, such as labor or international issues, a surprisingly small number focused solely upon issues related to rural America.

Why so little coverage of rural issues? Part of the answer may be found in the history of the journal itself. Those who founded and edited the *Mid-monthly* and the *Graphic* were mainly eastern urban progressives and professional social workers who had little knowledge of rural social welfare issues. Since social work was primarily an urban phenomenon, it was only natural

that the *Midmonthly* and the *Graphic* would concentrate their efforts there. By focusing upon urban and industrial issues, the editors of the journals focused their energy on what they knew best. When *Survey Graphic* did cover rural issues, it usually turned to outside experts for analysis.

Paul Kellogg devoted many pages to the explanation and evaluation of nearly all aspects of the New Deal. In 1934, for example, nearly a third of the articles published in *Survey Graphic* had to do with New Deal reform in some way. Key New Deal figures such as Agriculture Secretary Henry Wallace, Labor Secretary Frances Perkins, Interior Secretary Harold Ickes, and others regularly contributed stories to the journal. Arthur Morgan, head of the Tennessee Valley Authority, was a particular favorite of Paul Kellogg, who admired the TVA's fidelity to strict principles of social engineering. *Survey Graphic* published several of Morgan's long essays on the TVA throughout the thirties.

Much of *Survey Graphic*'s earliest New Deal coverage reads as optimistic and laudatory. Such infatuation with Roosevelt is not surprising, given that the journal and its predecessors had advocated similar policies for years. Yet *Survey Graphic* did not accept uncritically everything that the New Deal offered. The magazine's "honeymoon" with the New Deal slowly wore off after 1934, when the editors realized that FDR was not quite willing or able to take social experimentation as far as they would have liked.[36] Paul Kellogg's major complaint about the New Deal was that it "had established the principle that 'what's wrong anywhere is everybody's concern,' but it had not moved on to comprehensive social planning"—save for the much admired TVA.[37]

Having traced the development of the progressive ethos in *Survey Graphic* from the early part of the century through the Depression era, I now turn to the Historical Section photographs, considering not only the images themselves as they appeared in the pages of *Survey Graphic* but also the institutional process by which the pictures came to express, reflect, and occasionally challenge the assumptions of a bureaucratic progressive ethos.

Visual Collaboration: *Survey Graphic* and the Historical Section

In January 1936 *Survey Graphic* published an article titled "Relief and the Sharecropper," which surveyed the impact of federal relief efforts on the poorest farmers in the South. It used two Historical Section photographs by Arthur

Rothstein, making *Survey Graphic* the first publication outside of the U.S. government to employ the agency's pictures. From Roy Stryker's point of view, *Survey Graphic* was an obvious outlet for the Historical Section's photographs. As a former worker in the settlement houses of New York, Stryker was familiar with the social welfare journals of the time and had been reading *The Survey* and *Survey Graphic* for years. He understood that the audience for the journals was one that would likely be receptive to the RA's goals for rural reform. In addition, Stryker recalled that *Survey Graphic*'s orientation toward visual communication had influenced his own beliefs about the potential social uses for visual images. He noted that while he worked on photographic illustrations for Tugwell's textbook, *American Economic Life and the Means of Its Improvement*, he had consulted "the current issues of the bound volumes of *The Survey* and *Survey Graphic*. They had been heavy users of Lewis Hine pictures and others, other drawings and that magazine affected me."[38] Survey Associates' support of Hine's work during the twenties and early thirties gave Stryker reason to believe that the journals would support the Historical Section's photographic goals as well.

Indeed, editors at *Survey Graphic* were supportive of Stryker. As early as December 1935, Lewis Hine wrote to Roy Stryker that the Historical Section's work had caught the attention of editors at *Survey Graphic:* "Before I forget it, you may be interested to know that you have registered a 'high' with a little lady at the SURVEY, who is art editor (Mrs. Kellogg). I happened in yesterday to talk over some things and she was very appreciative of what you are doing down there."[39] The "little lady" of whom Hine wrote was actually a woman with a lot of power at the magazine: Florence Loeb Kellogg, art director for *Survey Graphic* (and the widow of Paul Kellogg's brother and partner, Arthur Kellogg).

Beginning in late 1935, Loeb Kellogg and Stryker corresponded frequently. Her first request for photographs came in December 1935, when she sent a telegram to Stryker asking for pictures to support an article about "white and black sharecroppers and how they live." "Please rush to us liberal assortment of those find [*sic*] photographs by Ben Shahn Walker Evans [*sic*]," she wrote. "Can handle them in issue which goes to press end of this week."[40] Stryker responded with an assortment of photographs, two of which ended up in the January 1936 sharecropper article by Lillian Perrine Davis. Loeb Kellogg expressed regret

that space considerations in that issue limited the number of photographs she could use, but she asserted to Stryker her continued interest in the Historical Section's project: "We shall be able to use more photographs on this subject in coming issues and will welcome with open arms any new ones you get. The Survey staff is enthusiastic about your kind of historical work!"[41]

That enthusiasm is illustrated by the number of Historical Section photographs that appeared in the journal in the mid- to late thirties. As we saw earlier, the tenancy story was not heavily covered by *Survey Graphic.* But when the journal did publish articles on the New Deal and the Depression, it more often than not turned to the Historical Section for visual collaboration. In 1936 fifteen pictures made by Historical Section photographers were published in *Survey Graphic.* Of those, thirteen appeared in essays that focused exclusively on issues related to rural depression, such as sharecropping, farm tenancy, and migrant labor.[42] The remaining two FSA pictures appeared in an article on New Deal unemployment relief efforts. In later years, *Survey Graphic*'s use of FSA photographs to illustrate articles expanded to include nonrural topics. In 1938, of eleven pictures used by *Survey Graphic,* only four related specifically to rural issues. Two focused on urban industrial issues, one appeared in an ad for the magazine, another in an article on the aging population of the United States, and four were featured in a short piece on Walker Evans's historic one-man show at the Museum of Modern Art. By 1939 Historical Section photographs were appearing with even greater frequency in the pages of *Survey Graphic;* thirty-six photographs were credited to the Historical Section. In 1940 the journal used forty-two Historical Section pictures. This number is somewhat inflated, however, since sixteen of those forty-two accompanied an essay by Hartley Howe on the FSA project.[43] The remaining images were evenly split between articles on rural issues and those on general social trends affecting both rural and urban Americans.

There appear to have been three typical avenues along which photographs moved from the Historical Section to *Survey Graphic:* requests from Loeb Kellogg for images to illustrate particular articles; unsolicited offers of specific photographs from Stryker; and photo-essays in which the selection of photographs was a collaborative effort among author, photographers, and the magazine.

The most frequent way the Historical Section photographs achieved circulation in *Survey Graphic* was through Loeb Kellogg's requests for particular kinds of images. She would often wire Stryker with urgent requests for images to supplement an already existing story. Most often her overtures mixed general and specific suggestions, as in this 1938 request for images to accompany an article on abuses of the fledgling Social Security Act:

74

> Now once again I'm turning to you in my usual hurry and desperation. Have any of your people taken photographs in Oklahoma? I have an article based on Security Board hearings which discusses the public need in that state and how too much of the money is being diverted to the aged to the neglect of others, especially the children. Human interest photographs of Oklahomans, of the poorer type (their whites, Negroes and Indians) and their setting, is what I need.[44]

Note that Loeb Kellogg's request is both general ("human interest photographs," "their setting") and at the same time relatively specific ("the poorer type," "whites, Negroes and Indians"); it is clear that she has an idea of what kinds of images would be compatible with the article's focus. While there is no record of what selection of images Stryker actually sent in response to this request, we do have the article as finally published.[45] "Sooners in Security" features four photographs, three from the Historical Section: an image of a tractored-out farm, one of a group of middle-aged white men (dressed in farmers' clothes) idling outside a bank; and a third of a lone man walking down the road carrying food that, according to the caption, was provided by relief workers. Each image is captioned to link it to the major themes in the article. It is interesting to note that the images themselves do not correspond very directly with the main argument of the story. In addition, the racial diversity that Loeb Kellogg asked for does not come across in what was published; all images are of whites—more specifically, middle-aged white men.

Sometimes Loeb Kellogg could be quite specific, as in this request sent to Stryker in December 1939:

> I still want first-aid from you and need it fast. (1) I want some pictures of resettlement projects that the FSA stands by—and of course pictures showing the

people resettled and rehoused. (2) Pictures showing better standards of living and equipment in rural homes (will you get them from REA or Extension Service if you haven't them?) (3) Anything that shows family groups in adequate, well planned environments. (4) Have you any pictures of the FSA work in Wisconsin where farmers are helped to leave isolated farms under the state rural zoning law? (5) Pictures showing craft industries at Cherry Lake, Florida and Dyers, Arkansas. . . . (6) Anything that shows a decentralized industry. Put someone on this job for me, won't you? I really have to have these *by the second of January at the latest.*[46]

75

Here Loeb Kellogg may be attempting to illustrate more than one *Survey Graphic* story, turning to the Historical Section's ever-growing file in order to demonstrate the effectiveness of programs in federal planning.

Less frequently, Stryker offered FSA photographs to *Survey Graphic* unsolicited; it is not clear, however, how many of these offerings actually made it into the magazine. In his letters to photographers Stryker occasionally mentioned *Survey Graphic* as a potential outlet for new pictures being sent in from the field. To Dorothea Lange, he wrote:

We were very much delighted and pleased with some of the subject matter— your Arizona sheriff, the ox cart and the Ford advertisement, the plantation owner at the plantation store, and will have Mr. Hill of the Associated Press come over to see if he can use any of them. I'm going to contact Survey Graphic soon and see if they would like to use some of these pictures to illustrate articles or just as illustrations.[47]

For Stryker, *Survey Graphic* was always a suitable outlet for the Historical Section's images, regardless of subject matter.

The final way in which Historical Section photographs appeared in *Survey Graphic* was in the context of photo-essays planned and edited jointly by authors, the photographer (or Stryker), and the magazine's editors. Two examples (one developed at length later in this chapter) illustrate this approach. Stryker participated actively in the editorial process for Hartley Howe's April 1940 essay on the Historical Section, "You Have Seen Their Pictures." The essay

described the origins of the FSA's photography project and pronounced its work vital to the very success of democracy in America:

> The story behind these photographs is not widely known, but it's a good story, and important to politicians, sociologists, economists, who can find in the camera a highly useful tool. Important to people who want to record the world of today before it slips away into the world of yesterday. And above all, important to everyone who believes that democracy can succeed in a gigantic country like ours only when people are informed about the troubles of their fellow Americans and thus are impelled to do something to help them out.[48]

Accompanied by a selection of sixteen Historical Section images, Howe's article argued that the Historical Section project "demonstrated the value of the camera as an instrument of government."[49]

The relationship between *Survey Graphic* and Stryker was warm enough that Stryker was able not only to proof Howe's article before it went to press but also to consult on the layout of the photographs. Stryker wrote to Victor Weybright, managing editor of *Survey Graphic,* that he approved of the piece as it had been written:

> With the exception of two or three small items which I suggested for correction, there will be no changes as far as I am concerned. I hope you will see fit to print the article, as I know it will do us a lot of good—and some of these days in the near future, we may be needing all the assistance we can get if we are to continue the work which we are doing. Any boost you can give us on making our position more solid will be greatly appreciated.[50]

Stryker perhaps even orchestrated the actual arrangement of the images in the essay. Loeb Kellogg noted to Stryker: "I followed your layout as exactly as I could; those pages couldn't bleed at the bottom otherwise I tried to go along with you. Some of the pictures seemed too good to me to be made so small but I got your idea and decided you knew what you wanted. It was all very smart—your scheme for pictures and text."[51]

Stryker was not the only representative of the Historical Section who col-

laborated with individual authors and the editors of *Survey Graphic.* Dorothea Lange worked with her husband, economist Paul Taylor, on a number of photographic projects in the early years of the FSA, and beginning in the early thirties, Taylor contributed several articles to *Survey Graphic* on agricultural and labor issues in the West. Articles that featured Taylor's writing and Lange's images constituted another important way in which the section's photographs circulated in the magazine.

Though Stryker's regular correspondence with Loeb Kellogg and others at *Survey Graphic* was often punctuated with urgent talk of deadlines, he also found his relationship with Loeb Kellogg to be very restorative. Until Stryker left the project in 1943, Loeb Kellogg remained one of his strongest advocates. He later recalled that she often motivated him to hold firm on the path he had set out for the section. In 1965 he commented to interviewer Richard K. Doud:

> Mrs. Florence Kellogg was—the Kelloggs were the major-domos on *The Survey* and the *Survey Graphic* and my contacts there were very good and it was one of my regular routine spots for more reasons than one: First, because I always had something to sell; second, and probably more important, as I said with many people you've got to get your battery charged up again, you went up for new inspiration . . . suggestions, criticism, ideas, corrections from her were always very interesting . . . —if she talked to you you didn't go back and report the words, you went back because you had changed yourself, you had dropped something, you had gained something. So that was her function, and it was a very important function.[52]

The appearance of Historical Section photographs in *Survey Graphic,* then, was not the result of a simple exchange of requests for images from Stryker's file, but rather the result of a carefully constructed and nurtured, mutually beneficial relationship between Stryker and Florence Loeb Kellogg. *Survey Graphic* depended upon Stryker to provide photographic images that would illustrate the major themes of the journal. In turn, Stryker depended upon *Survey Graphic* to circulate the section's work and thus demonstrate the section's practical worth to those in government who didn't understand why photographic documentation was necessary. More than simply a relationship of mu-

tual exchange, Stryker and *Survey Graphic* shared similar political commitments to the circulation of "public facts" that could point to social problems and, eventually, contribute to the public good.

The two essays to which I now turn represent the range of rural coverage in which *Survey Graphic* was typically engaged in the middle and later years of the Depression. Each piece is discussed here as the product of particular editorial choices and framing of images and texts: that is, as a textual event designed to influence public argument about rural poverty. The first article, "Southern Farm Tenancy: The Way Out of Its Evils," by Edwin Embree, appeared in the March 1936 issue of *Survey Graphic* and uses three Historical Section photographs.[53] The Embree essay serves as an example of an article for which Loeb Kellogg solicited photographs from Stryker. The second essay is by Paul Taylor, an economist who is remembered as the "father" of the federal migrant worker camps in California. Taylor's September 1936 article, "From the Ground Up," describes several experimental rehabilitation projects undertaken by the Resettlement Administration in the West[54] and features six photographs by Dorothea Lange. In contrast to the Embree essay, the Taylor and Lange article is an example of a collaborative photo-essay in which text and pictures were intended to work together from the start.

Edwin Embree's "Southern Farm Tenancy" and the Blameless System

One of the earliest articles featuring Historical Section photographs was based upon field research conducted in the Cotton Belt under the auspices of the Rosenwald Fund and the Committee on Interracial Cooperation. Embree had served as president of the fund, a charitable social science research organization, since 1928. A former researcher for the Rockefeller Foundation, he had done graduate work in psychology and education and had studied the "applications of medicine and biology to human welfare."[55] The *Survey Graphic* article was adapted from a forthcoming book summarizing the results of the Rosenwald Fund's research, *The Collapse of Cotton Tenancy*.[56]

As the title of the *Survey Graphic* essay suggests, Embree analyzes the state of tenancy in the southern states with an eye toward ridding the system of "evil." He describes how the system itself works but assumes that the reader is

familiar with its more dramatic aspects of poverty and exploitation. Embree carefully avoids an indictment of those who hold immediate power over tenants, and if he places blame at all, he blames only the system under which both tenant and landlord suffer. For Embree, the only solution to the evils of cotton tenancy would be a total dismantling of the system, a transformation possible through application of the resources and initiative of the federal government.

The article, consisting of Embree's essay and three Historical Section photographs, is highly racialized, even though Embree himself argues that cotton tenancy is not a "black" problem. By relying heavily on analogies to slavery, however, Embree's essay and photographs operate on a rhetorical continuum of *presence* and *absence* in their representation of the impact of tenancy on African Americans. Though Embree purports to be interested in tenancy as a system, my study of the essay reveals that he is ultimately blind to the ways in which the northern migration of African Americans is inextricably bound up with that system.

Of the three FSA photographs that accompany the article, two were made by Arthur Rothstein and the other by Ben Shahn.[57] The first, by Rothstein, occupies the top half of the first page of the Embree essay (Figure 2.2). It depicts a white, middle-aged man standing on the porch of what appears to be an old cabin or similar building. His body faces us at a three-quarter angle, but he stares forthrightly off to the right side of the image, perhaps at something beyond the frame. His mouth is slightly open, though he is not smiling. The man wears a white or light-colored shirt capped by overalls, the strap of one shoulder unfastened and dangling. The overalls are in bad shape—there are large holes in the knees that look to have been sewn over or patched many times. The wooden building in front of which he stands is inadequately built; the thin posts of the porch look as though they would be unable to support a roof. The building dominates the left two-thirds of the image, and much of that portion of the picture lies in heavy shadow, save for the man's white shirt and the sliver of daylight glimpsed through the window.

The photograph offers no caption to provide any information about the man or about the geographic location where the image was made. Certain features tell us that the man is poor—his worn-out and much-mended clothing, the ramshackle porch on which he stands, the heavy burlap bags behind him

Figure 2.2. Photograph by Arthur Rothstein (September 1935), FSA-OWI, LC-USF 34-000442-D. As reproduced in Edwin R. Embree, "Southern Farm Tenancy: The Way Out of Its Evils," *Survey Graphic,* March 1936. Survey Associates Collection.

suggesting a life of manual labor. His clothing and surroundings, surely, indicate poverty. But his manner suggests a certain kind of confidence, or at least fortitude. The hands on his hips give him an erect posture that, coupled with his confident gaze, suggests a willingness to meet things head-on.

In the original photograph and caption as they appear in the Library of Congress FSA-OWI file, there is some indication of potential reasons for the man's apparent hopefulness.[58] The photograph was made in Plaquemines Parish, Louisiana, in the fall of 1935. Rothstein's caption filed with the image reads: "The shack in which a rehabilitation client lives before obtaining a Resettlement Administration loan." The photograph itself is reprinted almost exactly as it appears in the Library of Congress file, demonstrating no substantial cropping or reframing on the part of the *Survey Graphic* editors; in this case, the editors modified the image contextually, rather than visually. By removing

from the image any identifying information or caption (other than the name of the photographer), they were able to remove the photograph from the context of particular Resettlement Administration solutions to rural problems and use it instead to represent in a more general way the cotton farmer who needs help. Here, the removal of the text enables *Survey Graphic* to supply meaning to the photograph through its placement in the textual event of the Embree essay itself. By refusing any recognition of the man's particular identity and situation, *Survey Graphic* makes the image of the man and his "shack" a visual synecdoche for all (white) tenants who need help.

The second photograph accompanying Embree's article appears at the top of the second page of the essay (Figure 2.3). It was made by Ben Shahn, the WPA painter (and former roommate of Walker Evans) who worked part-time as a photographer for the Historical Section in its early days. Shahn's image is more visually complex than the Rothstein picture. It features three people, two black women and one black man, standing outdoors near a wooden building. In contrast to Rothstein's picture of the solitary man, Shahn's image is populated and active. In addition to the three most prominent figures, in the background we can see additional people standing on a porch behind the group. All three figures have cotton sacks slung over one shoulder. The picture is printed in heavy contrast, the darkness of the faces and garments juxtaposed against the whiteness of the shirts and cotton bags.

The faces of the individuals in the photograph invite the viewer's gaze, but that gaze is jumpy and haphazard. In fact, one scarcely knows where to look when viewing this picture. Unlike the Rothstein image, Shahn's composition does not suggest an obvious direction for the viewer's gaze. The subjects of this picture themselves are looking in several different directions, forcing our own visual response to be just as divided. The smaller woman has almost completely turned her back to the camera. She gazes over her shoulder toward the camera lens, but does not look directly into it. The large woman in the foreground also stands with her body at an angle to the camera, gazing over her shoulder. She does not look at the camera either, but turns her gaze left— past the edge of the frame. Only the man stares directly into the camera's lens, and his body, too, confronts the camera head-on. He stands facing squarely forward, one hand on his hip (recalling the Rothstein pose) and one hand

82

Figure 2.3. In the past decade the number of Negro sharecroppers has decreased as a result of mass movements to the cities. Photograph by Ben Shahn (October 1935), FSA-OWI, LC-USF33-006028-M2. As reproduced in Embree, "Southern Farm Tenancy: The Way Out of Its Evils," *Survey Graphic,* March 1936. Survey Associates Collection.

propped on the wall of the building near which they are standing. Each of the subjects has the beginnings of what may be a smile on his or her face, but none completely smiles for the camera. There is a wariness, but not total antipathy, in their faces. The women, in particular, seem embarrassed about having their picture taken. The man's gaze is closer to one of suspicion, though not quite hostility.

If the previous photograph seemed like one of contrived unawareness, Shahn's picture reveals a recognition, and perhaps grudging acceptance, of surveillance. Although only one of the subjects looks directly into the camera, the placement of their bodies and gazes indicates that all three are very well aware of the camera and the photographer. Their responses to the surveillance, however, are quite different. The women appear uncomfortable being photo-

graphed; their body postures and their expressions suggest a distinct anxiety about being looked at. The man, however, does not share that anxiety. His body placement suggests acceptance of the camera's gaze. In addition, his return of that gaze indicates a willingness to challenge the camera's surveillance by engaging in his own.

Shahn's photograph is an image of discomfort. We may postulate a locus of the subjects' anxiety and resistance, be it suspicion of the white government photographer placing them under surveillance or embarrassment about their own obvious poverty. In addition, the gendered differences in response to the photographer's surveillance suggest (not surprisingly) an additional layer of anxiety on the part of the women.

The picture's caption, supplied by *Survey Graphic*, reads: "In the past decade the number of Negro sharecroppers has decreased as the result of mass movements to the cities."[59] *Survey Graphic* uses the caption to offer information—that blacks are moving to the cities in large numbers. But it withholds other information, such as where the picture was made and how the people depicted in the photograph might be connected to such a migration. In the caption filed with the photograph in the Library of Congress, the emphasis is not on flight but on work: "Cotton pickers, 6:30 a.m., Alexander plantation, Pulaski County, Arkansas." Shahn's caption says nothing about migration, but focuses upon the particulars of the scene: the time of day, the exact location (a particular plantation in a particular county in Arkansas), and the job of these individuals gathered near the building. It suggests nothing about flight or migration. Coupled with its original caption, Shahn's photograph is not so much about leaving as it is about waiting, about stasis.

The *Survey Graphic* caption, however, removes the photograph and its subjects from their particular time and location and casts them as potential migrants. They lose their identity as cotton pickers at the Alexander plantation and instead serve synecdochically to represent black movement north. Such "typecasting" is problematic, however, because Shahn's picture gives no indication that those it depicts have become or are going to become a part of the mass migration. One could imagine how another picture might make more sense with the caption, perhaps one showing a group of sharecroppers hopping a train north, carrying all of their belongings with them. But this picture

stubbornly shows people who have stayed, people who are most certainly *not* migrants. We are left, then, with a photograph and caption that seem to make no sense together. The image becomes as schizophrenic as does our gaze in the picture itself.

As the caption appears with Shahn's photograph in *Survey Graphic,* it accomplishes the curious result of erasing this group of people even as it presents them for viewing. Given the information that blacks are fleeing to the north in ever-increasing numbers, viewers are left to draw the conclusion that people who have stayed, like those pictured in the photograph, are no longer relevant. In short, the caption asks us to look at these individuals as if they are not there. Once we turn to the text of the article itself and compare Shahn's image to those of Rothstein, we will see that the negation of the black presence in cotton tenancy intensifies. Blacks are not presented as subjects in themselves, and their migration north is not presented as an inevitable outgrowth of the oppressive system of tenancy. Rather, African Americans serve in Embree's essay as conspicuously absent referents for talking about the white tenancy experience.

The final photograph, appearing at the bottom of the third page of Embree's essay, is another by Rothstein (Figure 2.4). It depicts two white men bent over in a field picking cotton. The men are photographed from near ground level so that their figures fill the entire frame from top to bottom. In fact, if the men stood up they would be visible only from the waist down. Such framing gives the image a hunched-over, claustrophobic feel. In contrast to the other two images, this one is dominated by light; technically, it is overexposed. The men and the field are bathed in harsh sunlight, the only real darkness in the image their shadows as they move up and down the rows. The vast expanse of the cotton field stretches far behind them. In the very background of the photograph one can see part of a farmhouse. But no other people appear in the image; the two men pick alone. They are wearing hats, their faces hidden. Each man occupies about half of the space of the picture; in fact, the two men are almost mirror images of each other as they work the evenly spaced rows of cotton.

It is an image of seemingly endless work, monotonous and uncomfortable, made even more so by its tone and framing. In comparing this image as it appeared in *Survey Graphic* to the uncropped version from the Library of Con-

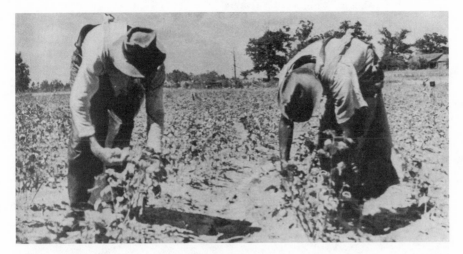

Figure 2.4. Mississippi cotton field. "White people have competed, since Emancipation, for the new kind of slavery involved in tenancy." Photograph by Arthur Rothstein (August 1935), FSA-OWI, LC-USF33-002030-M1. As reproduced in Embree, "Southern Farm Tenancy: The Way Out of Its Evils," *Survey Graphic,* March 1936. Survey Associates Collection.

gress, it is clear that *Survey Graphic*'s cropping influences interpretation of the picture (Figure 2.5). The Library of Congress version does not frame the cotton pickers so tightly, but shows much more of the background behind the two men. Here, if the men stood up they would not be cut off at the waist as in the *Survey Graphic* version. The context in which the men have been photographed is also easier to apprehend. The long row of trees behind them is more visible, traces of puffy white clouds in the sky above them. The effect of *Survey Graphic*'s editorial cropping, then, is quite significant. Rothstein gives us an image of two men performing backbreaking work, to be sure, but *Survey Graphic*'s cropping of the image gives that work an even more oppressive quality.

If the Shahn picture was an image of discomfort, in terms of both content and visual quality, this second Rothstein photograph is an image of oppressive labor. In the former case the discomfort was caused by the camera itself and its presence in recording the scene. In the latter case of the white cotton pickers the camera heightens, but does not create, the oppressive situation in which these cotton pickers find themselves. The tone and cropping of the image as

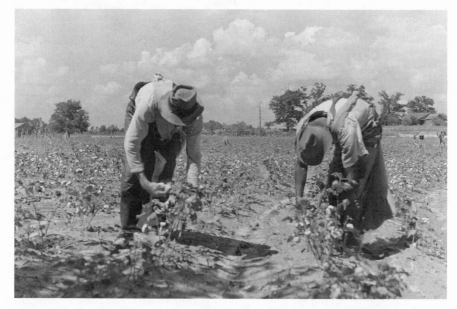

86

Figure 2.5. Cotton picking scene, Pike County, Mississippi. Photograph by Arthur Rothstein (August 1935), FSA-OWI, LC-USF33-002030-M1, Library of Congress.

it appears in *Survey Graphic* serves only to emphasize the nature of the labor itself.

This image, too, has a caption. It reads: "Mississippi cotton field. 'White people have competed, since Emancipation, for the new kind of slavery involved in tenancy.'"[60] Unlike the previous two photographs, this caption gives a general geographic location: Mississippi cotton field. Then the caption turns to a quotation from the Embree article. Whites, it explains, now "compete" with blacks for the "new kind of slavery," which is tenancy. The incongruity is readily apparent, for why would whites "compete" for slavery, something that should be completely undesirable? Yet the photograph reveals that they must, for it depicts two white men picking cotton. The caption argues quite explicitly that tenants, both black and white, are slaves, which implies that the viewer should think of the men depicted in this image as slaves as well. Furthermore, in coupling the photograph with the notion of "slavery" *Survey Graphic* blocks other possible interpretations, such as "This picture represents plain hard work" or "Here is an example of noble American farming." That whites are

willing or forced to compete for the kind of work that used to be performed by slaves suggests a flaw in the system, a problem that must be solved. The Embree article elaborates this "shock value" of the new kind of slavery that is tenancy.

Consider the caption for the photograph in the Library of Congress file: "Cotton picking scene, Pike County, Mississippi." The two captions are similar in that they both identify location, but this second caption offers even more specificity. While *Survey Graphic*'s caption makes a direct link to the text of the Embree essay by claiming that white folks are "enslaved" by tenancy, the original caption describes the men working as merely part of a "scene." The original caption is meant to suggest something typical but also neutral; it does not pass judgment upon the work or upon the men who perform it. In fact, these faceless men are not important for themselves; they are important only insofar as they are representative of a system. Furthermore, by calling the picture a "scene" the caption suggests that the photograph is meant to be part of a larger story or narrative. This cotton picking scene, when combined with other "scenes" (planting cotton or weighing cotton, perhaps), creates the larger story of the cotton system in the South. The "cotton picking scene" becomes but one interlude in a larger drama.

Our consideration of the three FSA images as they appear in the article has made it clear that the images, both as they are framed by their captions and as they are composed and cropped, aim to make the individuals they depict *visual synecdoches*. The cotton tenants are meant not to be distinct individuals but rather to stand for the oppressive system of cotton tenancy. The two Rothstein photographs depict white men who have been implicated in an oppressive system akin to slavery. In the second Rothstein photograph, the nameless cotton pickers in the field are also faceless. They are composed to be visually anonymous, to stand in for the labor of all who spend their days performing the monotonous acts of drudgery that perpetuate the system. As in the first Rothstein picture, these men are important to *Survey Graphic* not for their particularity but for their representativeness. And the caption for the Shahn photograph curiously articulates the black experience of tenancy by erasing this group of individuals from the scene; according to the caption they are not cotton pickers waiting to work; instead they are representative of black migration north.

This erasure does not appear to have been accidental, but rather planned

87

and in line with Embree's goals for the article. Editorial correspondence between Embree and Paul Kellogg reveals that Embree wanted the article to feature images of white tenants primarily. In a letter responding to Kellogg's request for photographs to accompany the article, Embree wrote: "I am sorry I haven't any good pictures. . . . In general I think that you should see to it that most of the pictures cover white subjects, for as my article will show nearly two thirds of the cotton tenants are white and it is very important that the nation as a whole should realize that cotton tenancy is not a Negro problem."[61] A few days later, Kellogg responded: "Of course we entirely agree that the emphasis on [the photographs] should be on white tenants."[62] Perhaps it is only coincidental that Embree's argument for greater visual representation of white tenants in the article (because whites were two-thirds of the tenant population) should have resulted in a set of photographs in which two of the three images depict white tenants.

Embree's interest in downplaying race fits with his insistence on arguing about tenancy at the level of the system. He begins his text with a general description of conditions for tenant farmers across the South, linking those conditions to an exploitative system that has left both groups in poverty and has caused increased black migration north. Describing the tenants' and sharecroppers' plight, he writes:

> The cultural landscape of the cotton belt is a miserable panorama of unpainted shacks, rain-gullied fields, straggling fences, dirt, poverty, disease, drudgery, monotony. Submerged beneath the system which he supports, the cotton tenant's standard of living approaches the level of animal existence. The traditional standards of the slave required only subsistence. The cotton slave—white or colored—has inherited a role in which comfort, education, and self-development have no place. For the type of labor he performs, all that is actually required is a stomach indifferently filled, a shack to sleep in, some old jeans to cover his nakedness.[63]

Solutions to such abject poverty, Embree argues, lie not in changing the behavior of tenants or their landlords but in transforming the system of cotton tenancy entirely.

Slavery is a key topos of Embree's essay. He uses slavery as a touchstone for

the absolute worst system of human oppression and exploitation, one easily recognizable to the reading and viewing public as "evil."[64] But Embree does not claim that the two systems are equal; in fact, he argues that tenancy is *worse than* slavery. He begins the article with a quotation from Booker T. Washington: "To keep a black man in the gutter a white man must stay in the gutter to hold him there." Embree continues: "The cotton tenants have gone Booker T. Washington one better. Two white men are in the sharecrop mire for every one Negro."[65] Embree explains that tenancy emerged after the Civil War, when both blacks and whites became absorbed into an increasingly exploitative agricultural system. The current system is so bad, Embree writes, that black tenants have been leaving the area and migrating north. From 1920 to 1930, he states, two thousand black families left the Cotton Belt, while the number of white tenants increased during that same period by 200,000 families.[66]

Tenants, Embree explains, are locked in a system that resembles "bondage," victims of the nature of the relationship between landlord and tenant.[67] In an argument that seems frighteningly blind to the peculiarly horrifying oppressions that defined slavery, Embree writes that because both whites and blacks suffer under tenancy, it is worse than slavery. In fact, as we saw in the caption to Figure 2.4, Embree holds that whites even "compete" with blacks to participate in this oppressive system. In addition, not only do tenants suffer under tenancy, but landlords suffer under this "evil" system as well. He writes: "A farm system might not be regarded as an unmitigated evil if only the laborers suffered. But in the case of cotton culture the owners are almost as much at the mercy of the system as the tenants."[68] The system, it seems, is inescapable for everyone and no good for anyone.

Tenancy is, for Embree, at heart an oppressive system. But he carefully (and, perhaps for today's reader, somewhat appallingly) avoids issues of social justice and blame almost entirely. Upon reading the vivid descriptions of the tenants' plight, the reader is tempted to assume that the problem lies in the hands of evil landlords. Yet Embree argues that the landlords are oppressed too. First, he explains, the South has always been at the economic mercy of the North, "a situation which kept the whole area in a secondary slavery to the capital of the North."[69] In addition, owners have a hard time finding credit and loans that enable them to operate in a one-crop economy. Even "King Cotton" itself is threatened by a range of factors, from a loss in the soil's fertility to the depres-

sion in world markets to the rise of competing fabrics such as rayon. In this sys-
tem the tenants suffer, the owners suffer, the South suffers, and cotton itself
suffers. Embree treats all problems of tenancy as problems of the system, not
as the fault of individuals or groups that may be morally or politically corrupt.

Given his emphasis on the system, it is not surprising that the solutions Em-
bree offers strike at the heart of the system. Only the government, he tells us,
can institute the kind of change that this evil and corrupt system requires. He
suggests that the government buy up unused land and give it to tenants, as well
as establish service agencies to facilitate the tenants' adjustment to land of their
own. Other, more radical changes might include the creation of cooperative
farms, where members share goods and services, or even the establishment of
government-run towns that provide all of the daily necessities of living for
their people. We can recognize in Embree's solutions the conspicuous outlines
of the Resettlement Administration's program: relocating farmers to better
land, buying up marginal land, and creating cooperative homesteads and sub-
sistence farms to help the rural poor escape the trap of tenancy. Government
intervention, Embree argues, must be sweeping in scope. It must disrupt the
system by replacing tenancy with independent farming, making it possible for
tenants to get out of the system. The only way to get at the system is to attack
it from outside, Embree argues. And only the government is capable of doing
this efficiently and completely.

Survey Graphic constructs in the Embree essay a story reflecting one of the
key tenets of bureaucratic social planning: The system takes precedence over
the individual. In his essay, Embree places no blame upon the landlords or
upon any individuals; instead, he asks us to consider the system as a whole.
Embree's tenancy story is based upon a construction of tenancy as a modern
system of slavery, rotten to the core but with no one in particular to blame.
Similarly, all changes to tenancy must be formulated as structural changes to
the system itself, conducted by experts.

Embree's argument about "the system" is, furthermore, highly racialized.
Blacks are both present and absent. As we have seen, the text and the captions
argue that blacks are important only insofar as they direct attention to the ways
in which whites participate in the oppressive system of tenancy. Embree ac-
knowledges that there are black and white tenants, but his text consciously

downplays black Americans' relevance to the issues that he describes. In fact, the black presence in the essay functions solely as a basis of comparison to whites. Tenancy is akin to slavery in its level of oppression, Embree explains, but is in fact worse than slavery because it affects "more than" black laborers. While slavery harmed only blacks, tenancy affects both whites and blacks. While slavery harmed only the slave, tenancy harms those on all rungs of the economic and social ladder. Tenancy as a system is an equal-opportunity oppressor, making it fundamentally different from and in fact worse than slavery.[70]

Furthermore, Embree's discussion of tenancy and slavery ignores the extent to which social forces, especially racial violence, not only marked the black experience as qualitatively different from that of whites but likely contributed to the "Great Migration" of African Americans to northern cities from the late teens to the early thirties. For example, Stewart E. Tolnay and E. M. Beck note how specific cases of black migration may be linked to particularly heavy numbers of lynchings in some southern counties.[71] In an era in which thirty to forty thousand of the Arkansas neighbors of Ben Shahn's cotton pickers left the state, more than one thousand blacks were lynched and another one thousand executed "legally" by the Jim Crow justice system.[72] Although racial violence was certainly not the only impetus for migration, Kimberley L. Phillips notes: "In many ways, blacks' departure from the South was a response to and a defiance of the varied and coerced effort to keep them bound to segregation and violence."[73] In Embree's desire to turn attention away from tenancy as a "Negro problem," he avoids discussion of precisely those conditions that contributed to black tenants' abandonment of tenancy.

The photographs themselves also participate in the perpetuation of attention to white tenancy. Rothstein's images of white male tenants map onto Embree's interest in white tenancy as emblematic of a flawed system. The Shahn photograph, with its incongruous caption, presents black tenancy to the viewer but not in any unified way. The photograph itself is haphazardly composed and, in the context of this textual event, difficult for the viewer to incorporate into a narrative that makes sense. Thus the viewer must turn to the caption for help, a caption that itself suggests one should not pay too much attention to the individuals in the photograph. The viewer is left in a quandary—what, if anything, do black Americans have to do with cotton tenancy?

Survey Graphic frames the FSA photographs synecdochically, its subjects anonymous representatives of the oppressive system of farm tenancy in the South. The essay presents tenancy as an evil and oppressive system that is worse than slavery because it affects not "only" black Americans but white Americans in increasing numbers. The FSA photographs are employed to represent tenancy in light of "the system" rather than in terms of individual experiences of tenancy.

92

Yet let us not be too hasty, for the photographs do not always fit comfortably into the tenancy story that Embree and *Survey Graphic* seek to tell. Although *Survey Graphic* wants to focus attention upon the system, the photographs show only one portion of that system. There are no images of landlords or "Northern capital" in the pages of *Survey Graphic*. Instead, there are pictures of those who occupy the lower rungs of the ladder: the anxious and hopeful tenant farmer on his porch, the faceless cotton pickers at work in the field, and the small group of black cotton pickers gathered for their day's labor. In Embree's essay *Survey Graphic* does not, or perhaps cannot (given the limitations of the Historical Section's choice of subject matter; after all, how does one photograph a "system"?), visually represent a complete picture of the tenancy system. *Survey Graphic* cannot show the effects of the system upon the landlord, upon the South, or upon the crop of cotton in general; these things may only be discussed in the text and the captions. Embree writes of a system, but shows only the worst victims of the system. Although he is careful to mention how the system as a whole is flawed, the article leaves a persistent visual impression that the tenants' suffering is the worst and thus the most important feature of that flawed system. Embree's textual explanation of a system for which there is no one to blame is contradicted by the images of poverty-stricken tenants; only their suffering is depicted, and thus it is only their suffering with which viewers may identify. The pictures' focus on the poorest of those implicated in the system thus questions Embree's insistence on the primacy of the system as a whole.

In addition, Embree's negation of the black experience of tenancy is contradicted by Shahn's photograph of the cotton pickers. Though the caption and the text try to dismiss them, the photograph asserts the presence of the black cotton pickers in a way that cannot be denied. Uncomfortable with the surveillance of the photographer, these subjects, halfway hiding from and

halfway confronting the camera, these subjects do not easily submit to negation by the text. The candid nature of their poses, as well as their gazes, produces an image whose meaning seems to spread beyond that imposed upon it by the caption and the text. Although the text argues that the black tenants do not matter in the way that the white tenants do, the viewer is confronted with black tenancy nonetheless.

The trope of presence and absence exemplified by the Shahn photograph suggests that, despite Embree's and *Survey Graphic*'s intentions, the essay is in fact very much about black migration north. Though its references to black migration are only oblique in the article, the photograph of the cotton pickers, along with its incongruous caption, points to such a reading. Shahn's black cotton pickers reference obliquely, but still powerfully, a tenancy story with just as great or perhaps even greater social and political consequences for the "system" that Embree wants to describe as so inherently evil.

Evidence for the viability of this particular reading may be found in one reader's response to the article. Shortly after the essay was published, Paul Kellogg forwarded a letter to Embree from a reader in South Bend, Indiana, that read in part:

> The article "Southern Farm Tenancy" in the Graphic explains graphically a situation we have had to contend with for more than a year and for which we failed to comprehend fully the basic cause until this article appeared—namely, that of the colored "transient" who has flocked to South Bend in great numbers during the past two years. After reading this article, we no longer have cause to wonder at the practical impossibility of driving these cotton pickers back to the cotton belt. We have had cases where by the use of a court order and in the custody of a constable families have been returned, only to have them show up in South Bend almost immediately. . . . Yours very truly, Ward H. Crothers, 807 Portage Avenue, South Bend, Indiana.[74]

For the exasperated Mr. Crothers, the Embree article resonated precisely because it explained something about his own local situation. In his letter Crothers sees precisely what Embree chooses to ignore but the Shahn photograph hints at: If it is truly the system of cotton tenancy that we should be concerned about, then

we must be concerned as well about black migration as a consequence of that system. Embree's denial of the presence of African Americans in his tenancy story curiously undercuts his own argument that tenancy is best understood as a system, rotten to the core and in need of complete reformation. Yet the essay's dialectic of absence and presence—enacted primarily through the Ben Shahn photograph—enables Crothers's reading and points to the many ways in which the black experience of migration is firmly and, in Crothers's telling, painfully implicated with conditions in the American cotton South.

94

The tenancy story as presented by Embree in *Survey Graphic* largely upholds the journal's interest in social engineering and large-scale bureaucratic intervention. We may locate the progressive philosophies of planning and social invention advocated by the likes of Brandeis, Dewey, Kellogg, and the FSA in the text and in the Historical Section photographs that appear alongside it. The Embree essay depicts a story of tenancy in which the system is of greater importance than the individual. The presence of difference within the system, such as the differences between the black and white tenancy experiences, is negated or glossed over in favor of a treatment of the system as a seamless whole. But the photographs do not completely map onto this particular narrative. It is possible to read the essay as one that is as much about black migration north as it is about white tenancy in the South. Although Embree's article largely ignores the ways in which black migration is implicated in the system that he seeks to dismantle, the reading is one that, through the FSA photographs, was rhetorically available to readers and viewers like Ward Crothers.

"From the Ground Up": Experiments in Rational Order

Beginning in the early Depression years, Paul Taylor, a University of California at Berkeley economist and consultant for California's SERA (State Emergency Relief Administration), contributed articles on labor issues to *Survey Graphic*. As a student and then later as a professor and researcher, Taylor was familiar with Kellogg's journals; he recalled that an economics professor at the University of Wisconsin had assigned his class to read Kellogg's Pittsburgh Survey. Several years later, Taylor met Paul Kellogg at Chicago's Hull House, where Taylor was doing fieldwork.[75] The two men found that they had much in com-

mon, and Taylor invited Kellogg to join him in the field near San Antonio, where Taylor was studying Mexican migrants. Taylor noted that while Kellogg "had been familiar with the European immigrants in the urban slums and ghettoes in New York . . . this was his first glimpse of rural Mexican labor."[76] In 1931 Kellogg published Taylor's piece on the migrants in *Survey Graphic*.[77]

In 1934 Taylor contributed two pieces on labor issues in the West to *Survey Graphic*. One, coauthored with Berkeley graduate student Clark Kerr, tracked the cooperative movement in rural California; the other chronicled with co-author Norman Leon Gold the July 1934 general strike that paralyzed San Francisco's waterfront for days.[78] While looking for images to illustrate the San Francisco strike piece, Taylor visited the San Francisco gallery of Willard Van Dyke, who happened to be hosting an exhibit of Dorothea Lange's photographs. Until the early thirties Lange had worked primarily indoors as a successful portrait photographer for San Francisco's upper classes. By late 1932, however, she had abandoned her lucrative business and ventured outside to document Depression conditions in San Francisco and in California's agricultural valleys. Explaining her shift to the documentary mode, Lange recalled: "I enjoyed every portrait that I made in an individual way, but it wasn't really what I wanted to do. I wanted to work on a broader basis. I realized I was photographing only people who paid me for it. That bothered me."[79] Although Taylor had never met or heard of Lange, he was taken with an image she had made of a striker speaking at a union meeting. He called Lange and asked for permission to use her photograph in *Survey Graphic*. She agreed, and the image was published as a full-page frontispiece for the September 1934 issue of *Survey Graphic*; Paul Kellogg paid Lange fifteen dollars for it.[80]

Taylor had been convinced for some time that social research required photographic documentation of the type in which Lange was engaged. During his earlier fieldwork with Mexican migrants, he had taught himself to use a camera to document the conditions he was studying. He knew that his field reports alone would not produce the kind of social change he desired as an outcome for his work:

Knowing the conditions and reporting them in a way to produce action were two different things. . . . I said that I would like for the people in the Relief Ad-

ministration, who would read my reports, evaluate them and make the deci-
sions, to be able to see what the real conditions were like. My *words* would not
be enough, I thought, to show the conditions vividly and accurately.[81]

But Taylor's employer was not fully convinced. In early 1935 SERA hired Lange
to come on staff—as a secretary. Lange biographer Milton Meltzer notes: "It
took a lot of talk before the agency got used to the idea of using a photographer
for social research. Still, there was no authority to hire one, no slot for a pho-
tographer in the table of organization, and no funds." So Lange was brought in
as a clerk-stenographer and her film purchases listed under "clerical supplies."[82]
Only later, after Lange and Taylor had proved the value of photographic work
for social research, was her true purpose at the agency revealed.

Working together for SERA, Taylor and Lange prepared a series of reports
in 1935 regarding conditions in rural parts of the state. In addition to circulat-
ing the reports to SERA and the Resettlement Administration (to which SERA's
activities were transferred after July 1935), Lange passed along copies to George
West, an editor with the *San Francisco News*. West used the reports as the basis
for editorials supporting Taylor's attempts to get the state to build additional
migrant worker camps.[83]

Lange and Taylor's work for *Survey Graphic* was the product of these col-
laborative efforts. Their approach featured a marriage of image and text de-
signed to highlight the problems of migrant labor in the West and advocate
progressive, bureaucratic solutions to rural problems. In an early joint effort,
the two contributed an article on dust bowl migration to the July 1935 *Survey
Graphic*.[84] Taylor's essay, titled "Again the Covered Wagon," argued that the in-
ternal migration taking place in the United States rivaled in importance the
westward migration of one hundred years earlier. Taylor had approached Paul
Kellogg about the possibility of such an article that previous April, and with it
he offered "photographs by Dorothea Lange, who is doing her usual stunning
work."[85] Lange's photographs included an assortment of images of migrants
she had photographed along the highways and in their makeshift camps in the
agricultural valleys of California. The couple hoped that their article would
draw attention to the problems and result in increased federal funding for
projects begun by SERA. In a June 1935 letter to Kellogg, Taylor confessed:

"Confidentially, we are very eager for publicity on the living conditions of California migrant agricultural laborers, for we have been unable to obtain the support from FERA [Federal Emergency Relief Administration] which we believe warranted to provide camps with sanitary facilities, water, etc. $20,000 has been granted, but no more."[86]

Survey Graphic published an additional Taylor and Lange collaboration, "From the Ground Up," in September 1936. The establishment of the Resettlement Administration marked the beginning of federal efforts to tackle rural rehabilitation. Taylor sought to demonstrate the value of the RA's approach to solving rural problems. "From the Ground Up" may thus be read as a kind of sequel to Lange and Taylor's 1935 piece, in that it focuses upon government attempts to solve the problems described in "Again the Covered Wagon." In the essay, Taylor describes several projects undertaken by the RA in New Mexico, Utah, and California, suggesting that it is not the quantity of people helped by the RA that matters but the quality of the social experimentation taking place in these carefully controlled environments. He seeks to show how the RA's experimental projects might be used as models for productive governmental intervention into the problems of rural Americans living in the West. Six photographs made by Dorothea Lange accompany the article.

In what follows, I consider how Lange's images and Taylor's text in "From the Ground Up" articulate a narrative that largely upholds the RA's ideology of bureaucratic experimentation despite *Survey Graphic*'s editorial attempts to challenge or complicate that ideology. Extensive editorial correspondence between *Survey Graphic* and Taylor, and among *Survey Graphic* staff, not only provides the opportunity to study how Taylor's text and Lange's images collaborate to construct this narrative but also offers unique access to the institutional forces circulating around the piece itself. The editorial narrative as it unfolds in the journal's archived correspondence reveals that *Survey Graphic* editors were suspicious, and most certainly wary, of glowing reports of New Deal success and sought instead more nuanced, balanced discussions that acknowledged common criticisms of New Deal agencies. At the same time, however, *Survey Graphic* editor Paul Kellogg shared Taylor's belief in the value of agencies like the RA and advocated the publication of articles that portrayed the agency's work in a positive light. Although it appears that *Survey Graphic* editors were

97

not successful in getting Taylor to offer a fuller picture of the RA and its projects, some of the Lange images leave open the possibility of an alternative narrative that challenges Taylor's own neat conclusions about New Deal experimentation and embodies the same kind of ambivalence about New Deal experimentation that was expressed by the editorial staff at the magazine.

The textual event of "From the Ground Up"—that is, what readers encountered as they paged through *Survey Graphic*—consists of three parts: two full-page photographic portraits by Lange (with captions), the text of Taylor's essay, and four Lange photographs (with captions) interspersed with Taylor's text. Their collaboration commences dramatically with the two large photographs, reproduced on facing pages. Devoting a full page to a single photograph was rare for *Survey Graphic,* despite the journal's interest in visual explanation. The first image is undoubtedly the single most famous product of the Historical Section project (and, easily, of the whole era): Lange's "Migrant Mother" (Figure 2.6). The second, lesser-known, image is a compelling portrait of a Mexican field hand (Figure 2.7).

Figure 2.6 features a woman and three children—two older children and a baby. The mother sits in the middle of the image, framed from the waist up in classic portrait fashion. The two older children stand on either side of her, turned away from the camera so that only the backs of their heads and bodies are visible. The baby lies in the mother's arms. She is difficult to see at first, because the image directs the viewer's gaze toward the mother's face. As a result of the portrait-style framing of the picture, there is little information about the family's surroundings. A post in the foreground of the image and fabric covering the background suggest they are seated underneath a tent or some sort of lean-to. The mother grabs onto the post with one hand, balancing the baby in her lap. The tattered clothing worn by mother and children and the smears of dirt on the baby's face signal poverty, but perhaps the strongest signal is the worried expression of the mother as she gazes off into the distance. The viewer's gaze is drawn to her face most of all. She props her free hand lightly on her chin, creating a line pointing up from the bottom of the picture to her face. This line tightly focuses the viewer's attention on her face, rather than on the older children or the baby; it is *her* suffering and anxiety that is presented for contemplation. As it is reproduced in *Survey Graphic,* the image is printed with a high-contrast tone, so that the right, top, and left edges of the photograph are

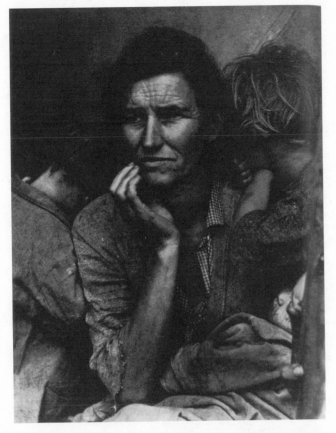

Figure 2.6. "Draggin'-Around people." A blighted pea crop in California in 1935 left the pickers without work. This family sold their tent to get food. Photograph by Dorothea Lange (February 1936), FSA-OWI, LC-USF34-9058-C. As reproduced in *Survey Graphic,* September 1936. Survey Associates Collection.

almost completely dark, showing only the barest outlines of the children on either side of the mother. Only the lighter tones of her hand on her chin, her furrowed brow, and the baby's face offer a respite from the darkness.

To write about "Migrant Mother" is not only an individual critical act, but an act that necessitates engagement with an ongoing interpretive controversy over the social, political, and ethical meanings of this image. Andrea Fisher has argued that the Historical Section frequently represented women as mothers,

100

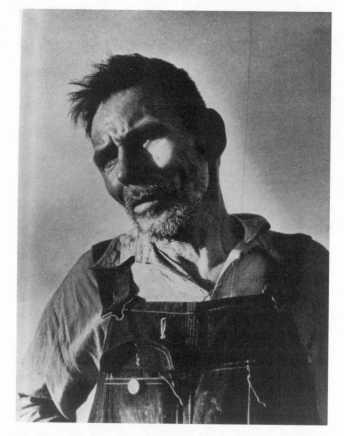

Figure 2.7. "I have worked hard all my life and all I have now is my old body," said this gaunt Mexican in Imperial Valley. Photograph by Dorothea Lange (June 1935), FSA-OWI, LC-USF34-1618-C. As reproduced in *Survey Graphic,* September 1936. Survey Associates Collection.

but in a way that ignored their material circumstances: "Women were repeatedly presented away from social context and in caring relation to their children. In this way motherhood was removed from historical contingency."[87] "Migrant Mother," she contends, exemplifies this problem. Indeed, nearly all who have written about this image note its universal qualities. Lange biographer Meltzer observes that the photograph "has achieved an independent existence, finding its place in the almost timeless tradition of art whose theme is Mother and

Child."[88] Lange's portrait of the woman and her family has, over time, become a condensation symbol for all Depression-era suffering and poverty. Interesting to note, of the six images Lange made of the "migrant mother" Florence Thompson, only this one fails to show much of the context of the family's physical surroundings (a crude lean-to in a muddy, makeshift migrant workers' camp); yet it is this picture that is the most frequently reproduced of that series and the one most familiar today.[89] Documentarian and critic Robert Coles echoes Meltzer's assessment that Lange's intimate, portrait-style framing universalizes the migrant mother, ironically removing her "from the very world [Lange] is meant, as a Farm Security Administration photographer, to document."[90] Yet for Coles, removal of the mother from her immediate context produces an added benefit: curiously, the elimination of "sociological cues" makes the migrant mother "psychologically more available to us."[91] Thus, while Lange's isolation of the mother from her surroundings may remove elements of historical contingency, at the same time the image resonates with a peculiar kind of universal intimacy that has remained continuously accessible across time.

Of "Migrant Mother" a frustrated Paula Rabinowitz has observed: "The photograph as much as its checkered history includes a woman and her children, a photographer, a government bureau, popular magazines, museums, scholars, and a changing public—an image and tale composed, revised, circulated, and reissued in various venues until whatever reality its subject first possessed has been drained away and the image become icon."[92] Indeed, as John L. Lucaites and Robert Hariman note, "Migrant Mother" is *the* visual icon of the Depression, and its incessant circulation across time makes it difficult to locate its "reality" in any material historical context.[93]

Yet if we wish to understand the photograph's contribution to the Taylor and Lange narrative in *Survey Graphic,* we must wrestle it back to some particularity. In fact, to call this photograph "Migrant Mother" is to misname it in the *Survey Graphic* context. In Taylor's essay the image is titled, in quotes, " 'Draggin'-Around People,'" a phrase that echoes a self-description by migrants quoted in Taylor's text. "Draggin'-Around" suggests aimlessness; it is a southern expression used to describe people who have no permanent place to live, but instead "drag around" from place to place.[94] In the worried, anxious face of the mother there is evidence of the toll that such "draggin' around" has taken.

Coupled with this title, the image becomes one of supreme weariness—and wariness. In addition to the title, the following caption accompanies the picture in *Survey Graphic:* "A blighted pea crop in California in 1935 left the pickers without work. This family sold their tent to get food."[95] The photograph's caption removes the image from the realm of iconic, universal suffering by providing concrete information. It locates the picture in space and time. It gives a justification for the poverty and anxiety represented in the photograph; the title and caption partially contextualize the suffering so clearly presented in the image.

The second Lange portrait featured in the set is titled "California Field Hand" (Figure 2.7). It shows a slight, thin older man in overalls and a light-colored shirt. His shirt is worn and sports safety pins instead of buttons. Like the previous subject, the field hand is photographed in a portrait style, from the chest up. The subject is alone, framed from a low angle against a backdrop of empty sky. His face is partially hidden in shadow, the other side openly exposed to bright sun. As a result, the environment in which he is posing seems harsh. He has a scruffy growth of white beard, making him look older than perhaps he is. The field hand's brow, like that of his counterpart on the opposite page, is furrowed, evoking anxiety. His eyes reveal a mix of resignation and perhaps the merest smoldering of anger.

The caption for this image offers what are purportedly the man's own words: "'I have worked hard all my life and all I have now is my old body,' said this gaunt Mexican in Imperial Valley."[96] The caption not only specifies geography and ethnicity but gives the man a voice by attributing to him an expression about his life and work. The caption creates for the viewer a sense of futility, for this man has worked hard, yet all he has to show for it is his "old body"—which, as the photograph reveals, is not much. It is an image of hopelessness, an image of a wasted life in the face of insurmountable odds. What saves the image from abject pathos, however, is Lange's framing. While we see the resignation in the man's face and read his despair in the caption, he is photographed from a low angle so that the viewer looks slightly up at him, not down, suggesting that the photographer is granting him respect.

The presence of the portrait photographs together, separate from and preceding the essay, necessarily prompts some questions about their function

within the essay as a whole. First, it is worth noting that the photographic portrait as a genre has a complex history.[97] Art historian Graham Clarke has suggested that "at virtually every level, and within every context the portrait photograph is fraught with ambiguity."[98] We know that Lange was a master of the portrait. She gained her first training in photography by working in a portrait photographer's studio, and she was a successful portrait photographer in her own right. More important, the choice of a portrait style for photographing these individuals suggests a particular relationship that Lange wishes the viewer to have with her subjects. The portrait traditionally has been associated with privilege, serving as a mark of social standing and respect. As John Tagg puts it, "To 'have one's portrait done' was one of the symbolic acts by which individuals from the rising social classes made their ascent visible to themselves and others and classed themselves among those who enjoyed social status."[99] In addition, the portrait is traditionally a presentation of the individual in a respectful way. The sitter often (though certainly not always) chooses his or her own attire, setting, and perhaps even the pose. As Susan Sontag suggests, "To photograph is to confer importance."[100] Such importance is intensified by what Sontag calls the "normal rhetoric of the photographic portrait": The camera gives dignity to the subject and conveys something about that subject's essence.[101] In the two *Survey Graphic* portraits, Lange subverts the traditional content of the photographic portrait in order to confer dignity and respect upon those who might not ordinarily receive it: the poorest of the rural poor. Lange uses the portrait to insist upon the "significance, and status" of her subjects, "if for no other reason than the *fact* of [their] existence, and the emotional resonance of [their] condition."[102] She presents the two subjects as individuals in their own right, possessing dignity and deserving of respect.

In addition to the photographs' generic identity as portraits, it is relevant to consider their size and placement in the magazine. First, there is the rare full-page layout. The sheer physical magnitude of the images suggests that they are important, different from others. In devoting a full page to each image, *Survey Graphic* commands the viewer to look. The location of the photographs before the actual text of the essay also signals that they are being set apart for special consideration. The viewer is, in effect, positioned to bear witness to certain aspects of the migrants' situation—poverty, hunger, homelessness, feel-

ings of worthlessness—*before* encountering Taylor's explanation of solutions to the problem.

By contrast, Lange's photographs within the essay proper are flat, prescriptive, dull—a surprise for even the casual fan of the respected Dorothea Lange. Yet, as we shall see, the prescriptive nature of the images is exactly their point, for they complement Taylor's written discourse of bureaucratic experimentation. The first of these photographs depicts a slight man in work clothes with his plow and team of horses (Figure 2.8). The image is framed to highlight the man, who faces the camera with a blank, unsmiling expression on his face. He holds something unidentifiable in his hand. His clothes are well worn and muddy, his boots covered in dust from the ground on which he stands. He poses at an angle to the camera, propping one foot on his plow. The photograph is a mixture of slightly contrasting light and dark spots, indicating that it was probably made in daylight but not in harsh sun. This photograph suggests that one's identity comes from one's work. By photographing the man in his surroundings and with his tools, Lange presents the activity of the farmer frozen in time, as if he has simply paused for a moment out of his day for a photograph and conversation. The importance of posing the farmer in this way becomes more clear in the caption: "A young farmer, resettled on the Bosque Farms in New Mexico." The caption suggests that he has abandoned a less productive existence for this work. Thus, the farmer in this picture has work to do; he is actively engaged.

The second photograph accompanying Taylor's essay depicts a new rural home and a large garden, fenced off from and surrounded by similar homes, yards, and fences (Figure 2.9). Long, perfectly linear rows tilled into the soil dominate the foreground of the image. Three figures work in the large garden. A man in the foreground operates a hand tiller to carve even furrows in the ground. Wearing no shirt, he is photographed from behind as he walks toward his companions in a straight line. Another person works at the opposite end of the row from him, near the house. A third individual works nearby, slightly hidden by the shadow of the house. Despite the man's presence in the foreground of the image, he is not the focal point of the picture. He stands in shadow, and the direction in which he walks leads the viewer's eye away from him and toward the house. None of the three individuals, in fact, is the subject

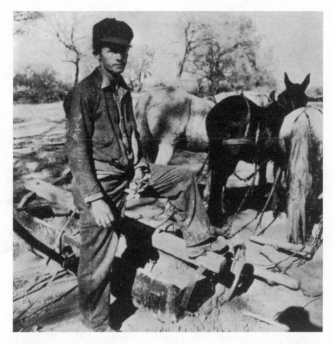

Figure 2.8. A young farmer, resettled on the Bosque Farms in New Mexico. Photograph by Dorothea Lange (December 1935), FSA-OWI, LC-USF34-1642-E. As reproduced in Paul Taylor, "From the Ground Up," *Survey Graphic,* September 1936. Survey Associates Collection.

of the picture. Rather, it is the house that dominates the photograph, lit by the sun and framed by trees and mountains. The man moves toward his companions at the end of the row in a linear fashion, giving the picture an aura of order and symmetry. The composition of the image—its sparse, orderly feel—coupled with its terse, fact-based caption ("The demonstration gardens of the El Monte Subsistence Homesteads project in California") suggests that the scene is a model of orderly governmental intervention. In addition, it is a picture about activity. Like the previous picture, which presents the farmer posing with the implements of his farming activity, this picture shows people in the process of using their tools to till the soil and, ostensibly, to contribute to their own betterment. The picture calls attention to these individuals not as individuals but as beneficiaries of government structures created for their use.

Figure 2.9. The demonstration gardens of the El Monte Subsistence Homesteads project in California. Photograph by Dorothea Lange (February 1936), FSA-OWI, LC-USF34-1708-C. As reproduced in Paul Taylor, "From the Ground Up," *Survey Graphic,* September 1936. Survey Associates Collection.

The third image is completely unpopulated (Figure 2.10). This project photograph shows a compound made up of a series of tentlike buildings, symmetrically lined up on the left and right sides of the frame. A small, dark-colored building stands in the middle of the scene. The ground around the buildings is dirt and dust; one can see remnants of tire tracks imprinted on the ground. A car sits parked near one of the tents on the left, and another one hides in the shadows on the right. Power lines are visible in the rear of the image, near a bank of trees that stretches across the back of the picture. Like the previous photograph, this image is composed to reflect symmetry and order. But here, the order is heightened because the picture is unpopulated. Unlike the previous images, this one includes no people to "clutter up" the scene or distract the viewer's attention from its sparse symmetry. This picture's caption, like the others, focuses upon "facts" by noting the geographical setting: "Camp for migrant agricultural workers at Marysville, Yuma County, California." The caption does not explain whether the camp is privately or federally run, but one may guess that it is a government camp. It appears

Figure 2.10. Camp for migrant agricultural workers at Marysville, Yuma County, California. Photograph by Dorothea Lange (October 1935), FSA-OWI, LC-USF34-9067-C. As reproduced in Paul Taylor, "From the Ground Up," *Survey Graphic*, September 1936. Survey Associates Collection.

clean, sparse, new, and as yet unpopulated. In addition, the presence of the power lines tells us that the camp has electricity; this camp possesses modern "luxuries" that other camps do not.

The final image is also unpopulated, but quite unlike any of the other images in the essay (Figure 2.11). It is essentially a landscape photograph, featuring a stack of rough-hewn wooden posts piled high in bonfire fashion. A huge expanse of sky hovers above, brightly filled with puffy white clouds. While other images in the essay suggest order, this one seems to represent a kind of organized chaos. The caption gives a clue: "New cedar fence posts for the old grazing grounds." Apparently, this pile of posts is waiting to be turned into a fence; order will be created out of the chaos.

If we consider these seemingly nondescript photographs together, a few themes emerge. First, unlike many of the Historical Section's most famous images, these project pictures focus upon solutions rather than problems. Lange offers the viewer a sense of how conditions may be improved by governmental intervention of the type described in Taylor's essay; the photographs literally visualize the positive aspects of reform. In Lange's photographs farmers work and have the proper tools with which to do so. Homes and farms are provided for the poor to rebuild their lives. And land is put to its proper use, not ex-

108

Figure 2.11. New cedar fence posts for the old grazing grounds. Photograph by Dorothea Lange (May 1936), FSA-OWI, LC-USF34-9083-E. As reproduced in Paul Taylor, "From the Ground Up," *Survey Graphic*, September 1936. Survey Associates Collection.

ploited. Each of the photographs represents the RA's social experiments by focusing upon action and solution. Visually, too, the images reveal a desire for order, in their careful composition and framing. Lange presents clean lines and parallel structures, evoking order and symmetry: the straight, freshly tilled rows of the garden, the perfectly composed scene with the farmer and his team, the image of the camp with its symmetrical presentation of the buildings, and the sparse, balanced character of a pile of fence posts framed against the vast Utah sky. The photographs reveal nothing of the controversial nature of the RA's experiments, nor do they hint at the time, money, and effort taken to complete them. The project photographs function as ordered representations of the potential for governmental transformation of rural life.

In addition to the photographs' suggestion of order, they also offer a gradual disengagement from the individual. The farmer on the Bosque Farms is the only subject in this group of photographs who is identifiable (yet even he is unnamed). The second picture moves to another level of disengagement from the individual. The people in this picture of the El Monte Homesteads are completely unidentifiable—either too far away to see clearly or, in the case of the shirtless man, turned away from the viewer. Finally, in the last two pictures the individual is lost entirely. The migrant worker camp looks like a ghost town; human dwellings appear, but with little evidence of occupation. Similarly, in the photograph of the fence posts we are presented with a still life, a landscape, with only the suggestion of future activity. Such disengagement suggests that those who appear in the images are not meant to be recognized as individuals, but rather are intended to be viewed merely as representative of the projects that Taylor chronicles in his essay.

In turning to Taylor's argument in the text, it is evident that Lange's photographs visually embody key themes of the essay: the importance of social experimentation, the creation of impersonal structure, and the value of expertise and authority over the contributions of the individual poor. Taylor begins the essay with a quote from an individual, a "dispossessed Texas farmer": "1927—made $7000 in cotton, 1928—broke even, 1929—went in the hole, 1930—still deeper, 1931—lost everything, 1932—hit the road." Yet he quickly points out that this one example is representative of rural conditions more generally. As a labor adviser for the Resettlement Administration in California, Taylor writes, he has met countless people with stories just like this one, "farmers cruelly dislocated from their farms joining the migrants of the west coast." The RA, Taylor asserts, "was organized to meet the problems of rural folk such as these, who are in the deepest distress, but whose rehabilitation is yet possible." Taylor's description of the RA's rehabilitation efforts demonstrates the intensity of the language of bureaucratic experimentation:

> Through its county and area rehabilitation supervisors it has been lending money to needy farmers who can be rehabilitated where they are, or elsewhere. It has been purchasing submarginal land, taking it out of cultivation and restoring it to beneficial public uses as grazing, or forest reserves, recreational areas, or wild

game refuges. It has been experimenting with removal of people from lands where their future is hopeless to others where a good life is possible. It has been aiding rural cooperatives where these offer better prospects for rehabilitation than do individual loans.[103]

Although the RA does organize broader efforts to help farmers keep and work their land, Taylor explains that his focus in the essay will be upon a very small group of experimental projects in the West, including those featured in Lange's photographs: the Bosque Farms, the El Monte Subsistence Homesteads and others like it, the Utah grazing lands project, California's cooperative movement (where farmers share duties, supplies, and profits), and federal migrant worker camps. These projects do not help a vast number of people, Taylor admits, but they are important for "their value as demonstrations of means of rehabilitating people and lands." Taylor presents such social experimentation as a rational, reasonable approach to a mounting set of social welfare problems in the West.

Another key term in Taylor's text is the creation of order. The essay's title obliquely refers to building by emphasizing that programs for the rural poor in the West must be built "from the ground up," that entirely new structures (both material and bureaucratic) must be constructed in order for such experiments to succeed. With material goods, the RA constructs new buildings, camps, and homes for those who need them. Farmers previously sweating over ill-suited land have been resettled onto better land, enabling them to achieve a more ordered life. Migrant workers crammed into crowded, disease-filled camps get a respite at the federal camps, which are carefully constructed to provide for the basic necessities of the workers. By "taking care" of the rural poor, both farmer and migrant, Taylor argues, it is possible to avoid the disorder and strife that come from depressed living and working conditions.

But, more figuratively, the RA is also interested in constructing a new mindset: confidence in the experiments of the federal government, coupled with a firm commitment to cooperation. Describing the El Monte Subsistence Homesteads program near Los Angeles, Taylor notes how individual families are able to have their own "small, carefully planned homes" and gardens. Residents, at least in Taylor's text, are enthusiastic about the government's help. Taylor

quotes an anonymous resident who states: "At first we wished we could have built our own house, but now that we've lived here we know it was planned better than we could have done it."[104] The new homesteaders now see why a government home is better; their mind-set has changed. The chaos of individuals fighting to improve their lives is alleviated by a benevolent (one might say paternal) bureaucratic order that guides the rural poor along an orderly path.

A third theme, closely linked to experimentation and order, is that of authority. Taylor expresses the idea of authority in two ways: faith in "the expert" and fear of "the people." Taylor's advocacy of the carefully planned RA projects suggests that he gives credence to the expert, who uses his knowledge of social systems to arrive at appropriate solutions to social problems. By focusing upon what is "right" about the RA's more controversial activities, Taylor casts his lot with those who use their authority and expertise to create model projects; the homesteaders "know" that the application of expert authority gives them a better chance than if they had tried to change their lives by themselves. But Taylor's faith in the expert is expressed in a more negative fashion as well. Taylor fears social unrest if the poor, particularly the migrant workers of California, are left to their own devices. The federal migrant worker camps that Taylor describes are sparse and simple, but, he argues, they provide what the migrants need: fresh water free of charge, sanitary toilets, showers, and a safe place to gather. Without the government to provide these basic necessities, migrants might turn to extreme measures such as strikes or rebellions. Taylor concludes that the migrant problem left as is will not only result in human waste but "can lead only to recurrent and bitter strife."[105] Not only will people fare better if they give the government some control, Taylor implies, but chaos may in fact result if they do not. Experiments such as the federal camps are necessary both for public health reasons and to head off potential violence and threats to the social order. Not that migrants are to blame if they resort to agitation, however; Taylor explains that it is reasonable to expect that people ensconced in the "shifting reservoir of human distress known as migratory labor" will pursue any avenue to self-preservation, including abandoning order and reason for chaos. But the expert is necessary to provide a detached, though empathetic, perspective that aims to improve the migrants' condition while at the same time maintaining order. Only the government has the vast resources,

both monetary and intellectual, to create and maintain such order. Although Taylor does not place his sympathy with the landowning class, his emphasis on authority does imply an underlying fear of chaos and agitation. He advocates governmental intervention to promote the migrants' well-being, but never at the expense of rationality and order. Though many in the thirties were revolutionaries, Paul Taylor was not. His plan was not to spark "the people" to revolution through grassroots political action but to ensure their well-being through the paternal benevolence of bureaucracy.

What Taylor does not acknowledge in the essay, however, is that solutions such as the building of migrant camps and subsistence homesteads were highly controversial, so much so that many projects were cut back or abandoned once the RA was absorbed into the Department of Agriculture in 1937 to become the Farm Security Administration. Throughout Taylor's tenure with the RA his ideas, like those of Rexford Tugwell, were labeled as radical, communistic, and subversive.[106] But in his essay Taylor never alludes to the controversial aspect of such social experimentation. He describes social experimentation not as radical, revolutionary, or visionary but as reasonable, rational, and efficient.

Although it might be assumed that Taylor was confident that readers of *Survey Graphic* would find his approach to social change consonant with their own values, his essay in fact produced much discussion among the editors at *Survey Graphic* before its publication. The substantial extant correspondence between the editors and Taylor provides unique access to the ways in which the institutional, editorial structures in place at *Survey Graphic* functioned (with mixed success, as we shall see) to temper Lange's and Taylor's aims.

Taylor submitted the initial manuscript for the article in May 1936. A May 27, 1936, memo from Florence Loeb Kellogg to managing editor Victor Weybright suggested the rocky road the essay would face in the coming months. Kellogg noted that Taylor had turned in an article on Resettlement Administration projects in the Southwest, but that it was "being rewritten to humanize it from the first-hand point of view of a regional labor administrator for Resettlement—to take away the purely pro-Resettlement flavor which it had."[107] In mid-June Taylor submitted the revised article to the editors.

From the editorial correspondence in the Survey Associates collection, it is clear that the revision did not do enough to eliminate the "purely pro-

Resettlement flavor" that initially concerned Loeb Kellogg. The first reviewer, associate editor Beulah Amidon, argued that Taylor's piece was "too superficial and too rosy": "It disregards the big problem (doesn't even try to define it in any specific terms) and even overlooks the difficulties which we all know have arisen in connection with the relatively small attacks on it. This certainly doesn't strike me as 'a dispassionate appraisal'—especially in a campaign summer." Amidon continued that Taylor's essay engaged no criticisms of the RA, overlooked some well-documented problems in planning and executing the projects, and paid no attention to the issue of cost.[108]

Managing editor Victor Weybright echoed Amidon's concerns in his assessment of Taylor's article: "A disappointing article, mainly useful as a vehicle for the fine . . . photographs. Its brief case histories of several resettlement areas seem gratuitous, lack general application, affect few people, and the reader is not informed whether they are demonstration activities or the beginning of a vast program."[109]

But in her review of the piece, Florence Loeb Kellogg reminded her colleagues of the article's purpose, and of Taylor's relationship with Paul Kellogg: "This looks to me much like the thing PK [Paul Kellogg] asked him to do. A man on the inside of the job cannot appraise and criticize Resettlement. If that was wanted he was not the person to ask. . . . PK said he wanted to show what Resettlement is doing, thought we owed them that."[110]

Taylor responded to the criticism of his essay by noting that he had addressed criticisms of the RA's projects in a past article and did not see the need to revisit them. He did offer additional information about the costs of various projects, and he clarified the scope of the RA's mission.[111] But some editors still were not satisfied that he had sufficiently addressed the criticisms. Weybright wrote in a memo to Loeb Kellogg: "Personally, I think this is still vulnerable, despite the insertions which answer some of BA's [Beulah Amidon's] questions. . . . Do you think that it scrapes safely past enough critical hazards?"[112] Apparently Loeb Kellogg thought it did "scrape past," so the essay was finally approved.

Taylor's narrative as it was published in *Survey Graphic* is a narrow story of apparently successful governmental experiments in the creation of social order out of chaos. As we have seen, Lange's project photographs visually embody

this story quite closely. The photographs depict symmetrical, orderly experiments. The images of the subsistence homestead gardens and the migrant worker camp are linear and symmetrical. The shirtless man tills the garden row by row in straight lines; his fine new house exudes suburban stability. The migrant camp sits vacant, awaiting those who seek a respite from the chaos of migrant living. While the homestead and migrant camp pictures depict order already achieved, the images of the farmer and the fence posts represent the coming of order, the imposition of order upon chaos. The farmer on the Bosque Farms creates order by using his plow and team, and by participating in the cooperative activities of the farm. The pile of fence posts awaiting deployment marks the end of the chaotic misuse of the land by signaling a return to its original function. The project photographs visualize and uphold the ideals of carefully planned social order espoused by Taylor in the essay. The essay presents a seamless union of the verbal and the visual, both oriented toward the same goals.

But the project photographs and Taylor's text must be considered alongside the other major component of the essay, Lange's portraits. It would be hasty to assert that the photo-essay serves only to support Taylor's interest in the rational establishment of government order to improve conditions for America's poor in the West. Although the project photographs supplement Taylor's narrative by portraying the orderly application of expert authority and disengagement from the individual, the intimacy and individuality of the portraits marks a poignant space of resistance, a point of tension in the essay that disrupts Lange's and Taylor's otherwise seamlessly woven paean to government authority.

One way to view the portraits is to understand them as the "before" for which the Taylor essay and the subsequent photographs are the "after." When the viewer encounters the photographs of the migrant family and the lone field hand, she encounters images of poverty and anxiety, of dignity, resignation, and passivity. The captions tell us that these migrants are suffering, living in a hopeless situation with no apparent way out. It appears as though they cannot make do for themselves. Taylor's essay may then be read as the corrective to the migrants' situation. The government experiments outlined in the essay, and

the orderly images that appear alongside the text, may in fact be the only hope for these migrants.

Yet such a reading rings hollow given the portraits' impact upon the viewer. The giant images possess a poignancy, or what Roland Barthes has called a "punctum," that muddies any easy categorization of the migrant subjects as mere recipients of government aid. The punctum of a photograph, according to Barthes, interferes with our ability to "read" a photograph in this conscious, rational way. The punctum represents the potential of the photograph to shock or surprise, to produce a response that may not map onto the norms of discourse but may in fact challenge or contradict them: "A photograph's *punctum* is that accident which pricks me (but also bruises me, is poignant to me)."[113] In the context of their presentation at the opening of the essay, the Lange portraits produce in the viewer a punctum in precisely the ways that Barthes describes: The portraits vibrate with a curious dialectic of universality and individual anxiety, a dialectic not explicitly engaged within the Lange and Taylor essay itself. The frontality and intimacy of these images contrasts sharply with the essay's subsequent impersonal representations of the recipients of government aid and, as a result, visually complicate our reading of the essay as a whole. Indeed, in the editorial correspondence regarding "From the Ground Up," Lange's photographs are consistently invoked and praised by those at *Survey Graphic* for accomplishing what Taylor's essay could not: broadening and universalizing the need for experimentation in the first place. Florence Loeb Kellogg notes that the photographs are "swell"; Victor Weybright calls them "epic," noting that Taylor's essay is "mainly useful as a vehicle for the fine . . . photographs."[114] Although the editors could have been talking about the collection of six images taken together, we may reasonably conclude that their reaction to the images is based upon the portraits in particular.

There is a discontinuity between what Taylor and Lange express in the essay and what the portraits offer. While the project pictures embody orderly governmental solutions to rural problems, the portraits invite repeated visits to the problem, another look at the faces of poverty that Taylor's essay addresses only obliquely. The actual progression of the essay, then, may not be from "problem" to "solution" but from problem to solution with a nagging return to

the problem. In fact, in their poignancy the portraits simultaneously punctuate the need for solutions and stand in opposition to the sanitized narrative of bureaucratic experimentation outlined by Taylor and visualized by Lange. The portraits themselves may do, by default, what *Survey Graphic* editors could not get Taylor to do in his revisions to the article. Whereas the essay focuses on solutions, the portraits suggest the persistence of the problem; whereas image and text in the essay are seamless, the portraits interrupt the narrative. Thus in the essay we find an irreconcilable disjuncture—not between image and text (as in the Embree piece) but between one kind of image and another: the portrait versus the "project picture," the criticism of social experimentation versus the praise of it.

Although never satisfied with using the term "documentary" to define her work, Lange could find no better word to describe what she and Taylor sought to accomplish. Lange unapologetically placed the documentary photograph "among the tools of social science," along with "graphs, statistics, maps, and text."[115] She argued that because documentary "records the social scene of our time . . . mirrors the present and documents for the future . . . it is preeminently suited to build a record of change."[116] In collaboration with Paul Taylor, Lange sought to create a kind of documentary expression that would serve as what Robert Coles has more recently called a model of "careful collaborative inquiry."[117] In later work, most importantly their 1939 book, *An American Exodus: A Record of Human Erosion,* Lange and Taylor believed that they had mastered a mode of documentary expression that achieved a seamless integration of image and text, both supporting and supplementing one another and both oriented toward the same goal: "pictures and words joined together in a kind of nurturing interdependence that illustrates the old aphorism that the whole is greater than the sum of its parts."[118] In early 1940, just after the publication of *An American Exodus,* Lange wrote to Roy Stryker that she believed the book represented their best attempt yet at achieving their desired documentary method: "I believe more and more that the method which we have developed is on the way to true documentary technique."[119]

The portraits' challenge to the essay suggests two conclusions, one related to Lange and Taylor's own practice of social science and the other related to the ways in which we may understand the contexts through which the FSA images

circulated. The dialectical tension between the project pictures and the portraits points to a fundamental blindness in the rhetorical practice of Lange and Taylor, a blindness that *Survey Graphic* editors sought to cure, or at least to temper. In their efforts to achieve a seamless integration of image and text, Lange and Taylor do not reflect explicitly on the nature of their social science or acknowledge the tensions inherent in their collaborative efforts. Consequently, they are blind to the rhetorical possibilities of the gap between the portraits and the essay. What might these rhetorical possibilities be? A turn to another important collaboration provides some clues. In stark contrast to Lange and Taylor's desire for integration, consider the agonized reflexivity of James Agee and Walker Evans in their 1941 book, *Let Us Now Praise Famous Men*.[120] That collaborative photo-essay makes explicit the tensions inherent in its own rhetorical presentation, enacting a radical separation between image and text, with Evans's FSA photographs of three sharecropper families (appearing with no captions or commentary) making up the first part of the book and Agee's fragmented narrative constituting the rest. Agee and Evans consciously keep image and text apart, and in doing so argue for the impossibility of the kind of seamless integration that Lange and Taylor pursued: "The photographs are not illustrative. They, and the text, are coequal, mutually independent, and fully collaborative."[121] For Agee and Evans, the strength of the two forms of expression lies in their separation rather than in their integration; the two forms "collaborate," but only obliquely. About more than the sharecroppers themselves, *Let Us Now Praise Famous Men* takes as its real subject the problem of representing "the other," as Agee notes at the outset: "The nominal subject is North American cotton tenantry as examined in the daily living of three representative white tenant families. Actually, the effort is to recognize the stature of a portion of unimagined existence, and to contrive techniques proper to its recording, communication, analysis, and defense."[122] Unlike Lange and Taylor, who believed that they had achieved the proper "techniques," Agee argued that a conscientious social reformer never could.

As many have observed, the rhetoric of *Let Us Now Praise Famous Men* is one of fragmentation, reflexivity, and a pronounced probing into the implications of surveillance and reportage among people who can never be equal.[123] As I have pointed out, Lange's portraits do constitute a space of resistance to

117

the seamless order of the essay itself. But although *Survey Graphic* editors encouraged them to do so, Lange and Taylor do not take advantage of that disjuncture to step outside of their carefully constructed rhetoric of liberal reform. As a result of the instrumental nature of their goals, and their zeal to integrate image and text into a unified rhetoric of bureaucratic experimentation, Lange and Taylor do not recognize or embrace the challenge of the portraits. They therefore miss the opportunity to articulate a more complex rhetoric that might attempt to account for the ways in which their own documentary practice is implicated in their visual politics—and that might, as a result, more successfully counter the charges that their bureaucratic approach to the problems of rural poverty constituted nothing but New Deal "propaganda."

Social Science Rhetorics of Poverty in *Survey Graphic*

During the thirties *Survey Graphic* espoused a progressive ethos valuing order, rationality, and the authority of the expert. Embree, Taylor, and *Survey Graphic* editors presented a rhetoric of poverty grounded in features of a progressive, bureaucratic approach to solving social problems: a focus at the level of the system rather than at that of the individual; a belief in controlled experimentation as a way to test social invention; a valorization of the authority of the expert; and an interest in forms of social control (reform) to eliminate social chaos (revolution). In the pages of *Survey Graphic,* the FSA photographs both contributed to the construction of the social scientist's rhetoric of poverty and also challenged and subverted it in important ways. The failure of the photographs to map perfectly onto a social scientist's rhetoric of poverty may be an inevitable result of photography's inherent problem of representation. As much as Embree and Taylor might seek to use photographs of individual poor people as visual synecdoches, each person standing for the larger problem, they cannot escape photography's impulse to particularize. As much as Embree would frame Shahn's Arkansas cotton pickers as merely representative of a class of persons who have chosen to leave the South, they stubbornly remain their individual selves, photographed where they were on that particular day in that particular location. "Migrant Mother" and the "Mexican Field Hand," too, retain their particularity even in the face of attempts to universalize them. Such

examples of photographic resistance suggest a fundamental flaw in the photograph's ability to effectively communicate a social scientist's rhetoric of poverty: There will remain a persistent tension between the particularity of the photographic image of an individual poor person and a social science rhetoric of poverty that prefers to emphasize the system over the individual.

The discussion now moves from the progressive social science context of *Survey Graphic* to the photography annual *U.S. Camera*. In the pages of that publication the FSA images confront a different rhetoric of poverty, one that is bound to another set of tensions: the relationships among art, realism, modernism, and socially conscious activism.

THREE

Intersections of Art and Documentary

AESTHETIC RHETORICS OF POVERTY IN *U.S. CAMERA*

What bothers me, I think, . . . is that these pictures were all related to each other as the parts of an organism are related, and were never intended for framing.

— EDWIN ROSSKAM, "NOT INTENDED FOR FRAMING"

Writing in 1981 of his years as a Farm Security Administration photo editor, Edwin Rosskam decried the increasing aesthetic commercialization of the work of the FSA photographers. Throughout the sixties and seventies the Historical Section had been rediscovered by academics, photography critics, and art museums, all of which expressed renewed interest in the aesthetic qualities of the images. Rosskam argued that the FSA photographs were "never intended for framing," and it made him uncomfortable to see them treated as such: "I don't adjust too easily to the reverence with which fragments of our portrait of America are hung on the walls of sophisticated New York galleries entirely given over to photography as Fine Art."[1]

Rosskam's anxiety about the aestheticization of the FSA file may be well placed, but it came about fifty years too late. Even in their own time, the photographs produced by the Historical Section were admired and applauded for their aesthetic qualities, and they were widely circulated as both documentary *and* art. They appeared not only in government publications, newspapers, and

social welfare journals such as *Survey Graphic,* but also in photographic salons, art museum exhibits, and photography periodicals. One journal that consistently celebrated the aesthetic merits of FSA photography was *U.S. Camera,* a yearly compendium of the best in American photography published by New York advertising executive and photography enthusiast Tom Maloney.[2] Maloney and his principal adviser, the respected and well-known photographer Edward Steichen, saw that in addition to serving as compelling visual evidence of rural poverty, the FSA photographs were often stunning aesthetic expressions as well. While *Survey Graphic*'s "pragmatic instrumentalism" offered a technical discourse designed to solve rural problems through the application of order and authority, *U.S. Camera* mobilized the FSA images in a very different context, asking its readers to view the Historical Section's photographs aesthetically, as models of visual virtuosity. The periodical removed the FSA photographs from the specificity of their production as documents of the Depression and placed them into a context in which their aesthetic and technical qualities became the basis for judgment.

121

The way in which the FSA photographs negotiate that complicated rhetorical space between "art" and "documentary" in *U.S. Camera* becomes clear through an analysis of two cases in which Historical Section photographs appeared in the periodical. Each embodies the problem of how to understand the role of documentary photographs in the context of a discourse that is itself a site of struggle over the meaning of photography. In *U.S. Camera 1936,* two FSA portraits of poor "madonnas with children" appear alongside other, more traditional art images of women. In *U.S. Camera 1939* a single juror, Edward Steichen, selected forty-one FSA photographs to appear in a special section. He matched the images with a series of provocative captions, all framed by an introductory essay about the FSA project. In giving the FSA photographs a special section, Steichen intended to be marking out space for viewers to consider the social and political aspects of the photographs rather than their aesthetic qualities. Despite *U.S. Camera*'s privileging of the aesthetic, the FSA pictures in both cases remain stubbornly wedded to the discourses of both documentary *and* art, leaving one to question the rhetorical availability of their political message in this context. They make available a narrative of poverty grounded in a false dichotomy that frames the discourses of "art" and "documentary" as

distinct even though they are inevitably intertwined. The deployment of such a dichotomy was in fact rhetorically productive for New Deal agencies seeking to articulate their own relevance in a climate of intense criticism and debate about the relevance of art in hard times. Edward Steichen's own creative trajectory can serve as a touchstone for an examination of the complex historical relationship between the medium of photography and the discourses of fine art. Steichen was instrumental in the creation of *U.S. Camera* and in the selection of photographs for each of its annuals.

Before addressing specific FSA images as they are presented in *U.S. Camera 1936* and *U.S. Camera 1939,* it is vital to understand how the *U.S. Camera* annuals came to influence American photography in the first place. As we shall see, *U.S. Camera* rejected the narrow interests of those who viewed photography only as a fine art. Instead, Tom Maloney and Edward Steichen favored a broader, more democratic concept of what constitutes an artful photograph. But, at the same time, *U.S. Camera* reproduced through its editorial practices many of the aesthetic norms and conventions advocated by "fine art" photographers. In the end, *U.S. Camera* does not embody a monolithic position about photographic aesthetics but rather constitutes one rhetorical (and relatively influential) response to a question that has always plagued the medium: "What is the art in photography?"

Steichen, Photographic Art, and the Documentary Motive

One issue with which historians and critics of photography have always wrestled is whether photography is art. Indeed, the question of the photograph's relationship to art is a persistent topos of the medium. Not only do aesthetic questions ground the choices made by photographers (including documentary photographers), but conventions of art haunt critical and historical interpretation of all photographic images, including the Historical Section pictures. In its earliest days, photography was seen as a way for painters, particularly portraitists and landscape artists, to free themselves from the "bondage" of human intervention and create a likeness identical to that of nature. There was a concomitant fear, however, that with the rise of photography painting would become obsolete. The painter Paul Delaroche proclaimed: "From this day on,

painting is dead."[3] And Baudelaire lamented that with the advent of photography, painters would cease to paint according to their imagination: "More and more, as each day goes by, art is losing in self-respect, is prostrating itself before external reality, and the painter is becoming more and more inclined to paint, not what he dreams, but what he sees."[4] Summarizing early anxieties about the medium, Lady Elizabeth Eastlake (one of the first academic critics of photography) argued that since the chemical process of photography was not capable of representing the subtleties of light and shadow, photography did not have an "artistic sense."[5]

Debates about the status of photography in the early twentieth century influenced and, to a great extent were shaped by, the career of Edward Steichen. Steichen's individual experiences mirror and parallel larger debates about photography and aesthetics; for this reason, it is useful to trace out his development as an artist and a photographer. We may divide Steichen's career into four phases, each of which represents a shift in how he viewed the role of photography: Steichen the pictorialist, Steichen the technician, Steichen the advertiser, and Steichen the communicator. Each of these distinct phases contributed to his decidedly democratic orientation to photography, one that later found its expression in the pages of Tom Maloney's *U.S. Camera*.

By the late nineteenth century, there had developed among many photographers a strong desire for photographs to be received as works of art. In 1893 several British photographers formed a group known as the Linked Ring. Members of the Linked Ring believed that photographic societies in Britain and Europe were not paying enough attention to photographs made with purely artistic intent—what they termed "pictorial" photography. In its mission statement, the Linked Ring declared the separation of pictorial photography from the photographic conventions of the day, which it claimed were hampered by "the retarding and nanizing bondage of that which was purely scientific or technical."[6] The influence of the Linked Ring was felt across the Atlantic, too, where photographic societies and salons began to focus more exclusively on photography as an art form in its own right.

As a young man at the turn of the century, Steichen was already a recognized painter and photographer in the United States and Europe. The teenaged Steichen's skill as a photographer was acknowledged by the photographic com-

munity when three of his prints were chosen for exhibition at the Philadelphia Photographic Salon of 1899.[7] His acceptance placed him in the heady company of other pictorial photographers whose work had been honored by the salon, including Alfred Stieglitz, Clarence White, and Gertrude Käsebier. These photographers, a group that came to include Steichen, made up the American contingent of pictorialists.

In 1902 Steichen submitted a large body of work to the Salon des Beaux-Arts, one of the most prestigious art competitions in Europe. In addition to some paintings and drawings, he included several photographs, even though no photograph had ever been chosen for presentation in the salon. Steichen (and, indeed, the art world as a whole) was astounded when ten of his photographs were selected for the exhibition: "Only painters and sculptors made up the jury, which debated the issue fiercely before coming to a contentious split decision. . . . In the end, however, the photographs were accepted, as one critic noted, as 'paragons of technique.'"[8] As a result of the controversy that erupted over the selection of "mere photographs" for such a prestigious exhibit, the photographs were never hung. Nevertheless, Steichen and his fellow photographers were thrilled that the art world was coming to see photography as a viable artistic medium.

Upon returning to America in 1902, Steichen joined fellow pictorialist Alfred Stieglitz in New York. The men took a cue from the Linked Ring and founded an American group called the Photo-Secession. According to Stieglitz, the term "secession" was chosen quite deliberately: "Photo-Secession actually means a seceding from the accepted idea of what constitutes a photograph."[9] Stieglitz amplified those aims in *Camera Work,* the journal he founded to promote the work of the Photo-Secession: "The 'Secessionists' . . . have admitted the claims of the pictorial photograph to be judged on its merits as a work of art independently, and without considering the fact that it has been produced through the medium of the camera."[10] Thus the focus of the Photo-Secession would be upon the creation of fine art and the promotion of the camera as a legitimate means for such creation.

The new modernism of the Photo-Secession would help to define photography's status in the art world for decades. Under the auspices of the Photo-Secession, Stieglitz, Steichen, and the other pictorialists set about legitimating

their photographic work in the eyes of the art world. The group organized exhibitions that received attention (and, sometimes, praise) from art critics. In 1903 *Camera Work* appeared. Stieglitz's journal meticulously reproduced the work of the group's photographers and included essays by well-known art critics, as well as other textual material designed to complement the photographs themselves. As a result, *Camera Work* and the exhibits arranged by Stieglitz tapped into standard conventions of museum and gallery culture of the time: an emphasis on the creative expressions of individual photographers, high-quality reproductions of photographers' work, and the courting of art critics whose appraisal would lend the images cultural legitimacy. When critics, museums, and galleries began to embrace the work of the Photo-Secession, photography historian Beaumont Newhall notes, "it was a vindication of their [the pictorialists'] belief that photography had the right to recognition as a fine art."[11]

Despite increasing acceptance of the pictorialists' work, Steichen was not destined to remain in the narrowly aesthetic world of the Photo-Secession. His trajectory as a pictorial photographer was interrupted by World War I, when the Steichen family was forced to flee France. Settled back in the United States, Steichen began to question the "art for art's sake" aims of the Photo-Secession, finding the work of pictorial photographers naively apolitical in a time of international strife. During this period, Steichen the technician replaced Steichen the pictorialist. When the United States entered the war in 1917, Steichen enlisted in the U.S. Army Signal Corps, where he joined the recently formed Photographic Division. In the world's first modern air war, photography had become an important tool for aerial surveillance. Steichen's wartime experiences marked his first taste of the technical uses of photography; it fully transformed his interest in the medium and led him to abandon pictorial photography altogether. Many years later, he wrote in his autobiography: "The wartime problem of making sharp, clear pictures from a vibrating, speeding airplane ten to twenty thousand feet in the air had brought me a new kind of technical interest in photography completely different from the pictorial interest I had had . . . in Photo-Secession days."[12] By the time he returned from military service, Steichen had given up on the idea that photography's greatest calling was to aspire to fine art.

Steichen the technician made way for Steichen the advertiser in the early 1920s when he accepted a job for which he would receive much criticism from his friends in the Photo-Secession: head photographer for *Vanity Fair* and *Vogue* magazines. For Steichen, the move to commercial photography represented more than simply a chance to make significant money. Of his new career, biographer Penelope Niven writes: "For years, he had deplored the inferior photography used in most advertisements, and now he saw his work . . . as an opportunity to enhance the quality of commercial photography."[13] During these post-Photo-Secession years, Steichen did not differentiate among genres of photography (war, commercial, or pictorial), only between "good" photographs and "bad" photographs. He always emphasized that a photograph could be "good" no matter what the subject matter or one's motivation for making it. In fact, he came to believe that his commercial work was just as aesthetically compelling, if not more so, than the pictorial photographs he had created during his years in the Photo-Secession. In a 1923 speech at the Pictorial Photographers of America meeting, Steichen shocked the assembled group by proclaiming: "I don't care about making photography an art. . . . I want to make good photographs. I'd like to know who first got it in his head that dreaminess and mist is art. Take things as they are; take good photographs and the art will take care of itself."[14] By the mid-thirties, when Steichen began working with Tom Maloney on *U.S. Camera*, he had moved far beyond his earliest interest in photography as art and was firmly of the belief that a good, artful photograph should make *communication* its primary purpose.[15]

Steichen was by no means the only photographer coming to the realization that the camera was perhaps most important as a public communication tool. The early decades of the twentieth century signaled a shift to a concept of photography as a social practice, a shift helped along by technological developments in film and photography. Although interest in photography as a "naturalistic" medium was not new—Jacob Riis made "documentary" images of immigrant ghettos in the 1880s, and Lewis Hine's Progressive Era "social photography" set the standard for documentary photographers who followed— the decade of the thirties marked the first time that what William Stott has called the "documentary mode" took on cultural significance.

Artists, writers, filmmakers, and photographers responded to the new ori-

entation. Theodore Dreiser, for example, published no fiction between the start of the Depression and the bombing of Pearl Harbor, asking, "How can one more novel mean anything in this catastrophic period through which the world is passing?"[16] And while escapist-fiction film certainly flourished in the thirties, the relatively new genre of documentary film gained currency through the work of Pare Lorentz and others.[17] Some photographers, too, questioned the purposes of their art in light of what was happening around them. By the early thirties Dorothea Lange was a respected and successful commercial photographer. Lange later asserted that it was the experience of making "White Angel Bread Line" that prompted her to take her camera into the streets and then later into the agricultural fields of California as a photographer for the FSA. She came to believe that practices such as elite photographic portraiture were inappropriate in depressed times.[18] For Dreiser, Lange, and others, nonfiction replaced fiction as the primary mode of artistic expression during the thirties.[19] Yet these seemingly individual artistic choices were social and political ones as well. The move to documentary was also guided by a growing class consciousness.

At the same time, however, it is not safe to make wholesale assumptions regarding prevailing cultural winds. The presence of the Historical Section photographs in the context of *U.S. Camera* illuminates a larger tension inherent in the visual culture of the 1930s: the role of photographic art in hard times. The impulse to documentary did not erase the prevailing norms of "art for art's sake" individualism embodied in elite, upper-class museum and gallery culture. Writing of the federal art projects of the 1930s (with which the FSA project was philosophically, but not institutionally, affiliated), Jonathan Harris argues that all federal art in the thirties was subject to scrutiny and comparison under elite "modernist premises," norms that included an emphasis on abstraction and a rejection of naturalist modes of art.[20] Such norms competed actively (and sometimes directly) with the documentary mode for cultural legitimacy.

Steichen understood these tensions, and this understanding in turn influenced the early volumes of *U.S. Camera*. Steichen's influence on *U.S. Camera* cannot be underestimated. His movement from "art for art's sake" to commercial photography, combined with a growing interest in the medium's documentary possibilities, gave the *U.S. Camera* annuals a distinctive voice and vision.

Unlike art photographers and critics of Steichen who preferred to produce and support fine art photography in museums and galleries, Maloney and Steichen sought for their journal to be inclusive and to reflect all types of photography. They believed in the potential *artfulness* of all photographs—that is, they argued that photography is a medium capable of multiple modes of artful expression. As a result, the pages of *U.S. Camera* display a dizzying variety of photographic styles and genres, from traditional fine art photography to commercial photography to documentary, news, and science images. *U.S. Camera,* then, should be read not as a mirror of the photography-as-fine-art movement but as a popular journal devoted to the artful photograph in all of its manifestations, including those produced as a response to the decade's growing documentary impulse.

Democratic Variety and Normative Aesthetics: The Orientation of *U.S. Camera*

In 1934 twenty-nine-year-old Tom Maloney was running a one-man advertising agency in New York City. Always interested in photography, Maloney admired the richly produced photographic "yearbooks" published in Europe (particularly in Germany and France). He wanted to create something similar that contained high-quality reproductions of the best of American photography. While there were already a few American annuals, Maloney thought they were stodgy and did not accurately reflect the depth and breadth of American photography in the modern era.

Maloney carefully prepared a dummy of a yearbook that he planned to call *U.S. Camera* and took it to Edward Steichen. At the time Steichen was in his fifties and in the midst of his hugely successful career as a commercial photographer for Condé Nast Publications. According to Harvey Fondiller, author of a brief history of *U.S. Camera,* Steichen liked what he saw and offered to help Maloney with the new journal. With Steichen on board, Maloney was able to gather enough photographic work and advertising to produce the first annual, *U.S. Camera 1935.* The first volume featured work by Steichen himself and other well-known photographers of the day, including Berenice Abbott, Margaret Bourke-White, Imogen Cunningham, Laura Gilpin, Edward Weston,

Ralph Steiner, and Dorothea Lange. Even though the spiral-bound volume sold out its 15,000 copies immediately, Maloney lost five thousand dollars on it.[21] But with each year, the popularity of *U.S. Camera* grew. By the late thirties and early forties it was selling about 25,000 copies a year, and it quickly "became known as a showcase for professionals."[22] In addition, each year Maloney would display some of the year's selected prints at a photographic salon in New York City and in other cities around the country and abroad to drum up interest in the annual and showcase the photographers' work.

In the earliest years of *U.S. Camera*, Maloney asked Steichen to handpick a group of "experts" to help him select pictures. For the first annual, in 1935, Steichen's jury included respected photographers Arnold Genthe and Lejaren Hiller, as well as M. F. Agha, the renowned art director for Condé Nast. Yet, as Maloney later recalled, the jury system was difficult to negotiate: "He [Steichen] served as chairman of the jury of selection, for the first two years. When I felt the book was suffering because a large jury of seven photographers had so many viewpoints that the result was too many compromise picture selections, he reluctantly agreed to do a singlehanded job the next year."[23]

Despite Maloney's belief that early editions suffered from too many compromises, the annuals from 1935 on offer a fairly coherent set of norms that illustrate Maloney and Steichen's approach to the "best" of modern photography: a wide variety in the types of photographs reproduced, a privileging of the individual photograph, a privileging of the individual photographer, a limited but pointed use of text, and finally, an interest in the technical aspects of photography.

The annuals published photographs representing a wide range of styles, techniques, and genres, offering an array of advertising, fashion, fine art, documentary, news, and scientific images in each issue. Although there are occasional attempts to sort the images into a few broad genres, the presentation of pictures in the annuals is surprisingly eclectic as one moves from page to page. Abstract, modernist work appears alongside fashion images, landscapes next to aerial survey photographs, poignant documentary images alongside sanitized medical photographs.

One indication of the democratic variety of the journal was its interest in the Historical Section's photographs. Beginning in 1936, *U.S. Camera* featured

the work of FSA photographers regularly. From 1936 until 1943, when the Historical Section was absorbed into the Office of War Information, *U.S. Camera* juries chose more than seventy Historical Section photographs for inclusion in the annual, showcasing the government work of Dorothea Lange, Arthur Rothstein, Russell Lee, Jack Delano, Ben Shahn, Walker Evans, Marion Post Wolcott, John Collier, and John Vachon.[24] Although Stryker professed a lack of knowledge of or interest in the technical aspects of photography, he welcomed the public exposure created by the reproduction of the section's photographs in *U.S. Camera* annuals.

Choices for the annuals often deviated from the traditional subjects of fine art photography, but the presentation of photographs typically upheld elite, modernist conventions of art. Like museums, art galleries, and salons, *U.S. Camera*'s selections focused upon individual images (rather than series or photo-stories). Such choices reflected the normative belief of modernism in the intrinsic importance of the individual work of art. Valorization of the individual work is also evident in the layout of the journal itself. The photographs in *U.S. Camera* are typically presented one to a page. Some of the photographs are enlarged to fit the entire page and bled out to the edges (including the FSA photographs), while others are printed in a smaller size, encased in a frame of white space that isolates the picture as an individual unit. It is clear from the physical presentation of the photographs that they are meant to be viewed as individual, privileged expressions.

Just as *U.S. Camera* privileged the individual photograph as an artful expression, it also privileged the individual photographer as the creator of that singular image. Most photographs reproduced in *U.S. Camera* are identifiable only by the photographer's name, placed unobtrusively in the corner of the picture. Photographs seldom appear with captions or other details, suggesting that *U.S. Camera* intended for readers to understand the images solely as the property of an individual creator. The annual's interest in the photographer suggests its belief that a photograph is, to paraphrase Ansel Adams's famous saying, "made" and not "taken."[25] Photographs, like other aesthetic expressions, must be credited to their rightful creators.

While *U.S. Camera* was not devoid of text, text served primarily to supplement the viewer's understanding of the photographs in three ways: occasional

captions, short essays, and an index at the end of each volume. At first Maloney used essays in the annuals to discourage viewers from browsing through the pictures without buying the book.[26] But there came to be other purposes for the essays as well. In each issue of the *U.S. Camera* annual, Maloney included short pieces on various aspects of photography to create a context in which readers might better understand the pictures themselves. The subjects of these essays varied. In *U.S. Camera 1936*, jurist M. F. Agha posed the crucial question "Is photography Art?" and answered (in line with Steichen and Maloney's own stance) that modern photography is based more upon "sound craftsmanship" than art.[27] In *U.S. Camera 1941*, Pare Lorentz contributed "Dorothea Lange: Camera with a Purpose," celebrating in writing the accomplishments of an individual photographer who was making an impact on modern documentary photography.[28] These texts served to expand the reader's context for understanding not only the photographs presented in each issue but the medium of photography in general.

Another textual component of *U.S. Camera* is the index of technical information that appeared in the back of each annual. Alphabetized by photographer (another way to privilege the individual), each entry described the photograph in terms of several pieces of information: the "home" location of the photographer (as opposed to the location where the picture was made, again suggesting a privileging of the photographer), the type of camera used, the kind of lens used, aperture, exposure time, and film type. Photographers were asked to submit this information with their photographs, but not all of them offered it. The highly respected Ralph Steiner, for instance, took an explicit stand against recording and submitting such information. In the entry for his *U.S. Camera 1936* photograph Steiner wrote: "I think all this very silly, would anyone ask what paints or make of canvas a painter used or on what kind of typewriter an author typed his manuscript."[29] Clearly, Steiner resisted the intrusion of technical discourse upon the "art" of the photograph. For him, the technical aspects of the photograph were irrelevant to the creation of a work of art, whereas for *U.S. Camera* (and, indeed, for other photographic periodicals, galleries, and museum exhibits) such technical information was the norm.

In summary, Steichen and Maloney aimed to make *U.S. Camera* a respected judge of the "artful" photograph in all of its manifestations. It is this diversity

that sets *U.S. Camera* apart from the narrower interests of those who practiced fine art photography. The *U.S. Camera* annuals also, however, upheld many of the norms and conventions of art photography by valorizing the individual photograph as the unit of judgment and focusing upon the individual photographer as the creator of that work. Thus *U.S. Camera* may be productively read as a "democratic" discourse, though one inevitably tied up with prevailing class-based, modernist assumptions about fine art photography.

Given *U.S. Camera*'s democratic approach, perhaps it is not surprising that the FSA photographs attracted the attention of Maloney and Steichen. *U.S. Camera*'s broad concept of what made a photograph artful did not disqualify the Historical Section photographers' work from being recognized as art. And Stryker's interest in publicizing the Historical Section's work did not disqualify *U.S. Camera* from being granted permission to reproduce the FSA's pictures for such seemingly apolitical purposes.

Art for Publicity's Sake: The Historical Section and *U.S. Camera*

Roy Stryker was intensely interested in obtaining wide exposure for his section's work. Early on, he embraced Florence Loeb Kellogg's use of FSA photographs in the pages of *Survey Graphic,* and he was also buoyed by *U.S. Camera*'s interest in the Historical Section's pictures. The archival materials of the Historical Section reveal a fair amount of communication among *U.S. Camera* editors, Stryker, and section photographers. An examination of these archival documents not only confirms the extent to which the Historical Section cooperated with *U.S. Camera* each year but also affords insight into how Maloney and the *U.S. Camera* juries selected and presented pictures for display in the annual and elsewhere.

U.S. Camera maintained an open door policy, by which photographers could submit their work, uninvited, to be considered for each year's annual. In addition, *U.S. Camera* made it a practice to solicit pictures from particular photographers whose work had been honored previously in the annual. Historical Section photographers were among those routinely contacted by *U.S. Camera* and asked to submit prints. In 1937, for example, Tom Maloney wrote to Arthur Rothstein requesting pictures for the next volume:

We are contacting the various photographers a bit earlier in the year so that we may have plenty of time for the printing itself. Therefore, we are asking that you get prints to us at the earliest possible date—March 1st being the deadline. The conditions are as follows: 1. Any number of prints may be submitted. 2. Pictures will cover all and any fields of photography. 3. All entries should be sent to U.S. Camera, T. J. Maloney, Inc., 381 Fourth Avenue, New York City. 4. Pictures will be chosen by an outstanding Selection Committee whose decisions are final (1936 Committee: Steichen, Hiller, Martin, Rockwell Kent, Agha, Genthe, Alvan McCauley, Lohse, Sarra).[30]

133

By noting that "pictures will cover all and any fields of photography," Maloney asserts *U.S. Camera*'s interest in representing the breadth of contemporary American photographic practice.

Stryker often helped photographers choose appropriate prints for submission to the annual. In 1939, for example, he wrote to Russell Lee in Texas: "We are trying to get out six glossy prints for U.S. Camera Annual. Can you give me some recommendations of the things you would like to have sent?"[31] Since photographers spent so much time in the field, and rarely saw the finished products of their work, they often had only vague ideas about which pictures would be suitable for submission. They would make suggestions to Stryker, who would then narrow them down and instruct the laboratory to produce the desired prints.

Years after working for Maloney at *U.S. Camera*, Noel H. Deeks described how the photographs for the early annuals were selected:

Mr. Tom Maloney would drive up to Umpawaug [where Steichen lived], his car loaded with prints submitted for the next Annual. Tom and the Colonel [Steichen] would sellect [*sic*] a nice cool, shady spot and spend hours mulling them over. My job was to spread the prints out on the grass before them and switch them around as directed until the new layout and sequence was completed. It was a chore which I thoroughly enjoyed.[32]

Once the photographs were submitted, selected, and arranged, they would appear not only in the annual but also in a *U.S. Camera*–sponsored salon. In a

1936 letter, *U.S. Camera*'s Evelyn Lamorey explained to Dorothea Lange what was to happen with her photograph:

> Now we are starting work on the assembling of the Salon. The first showing of the pictures will be here in New York City the Mezzanine Galleries Rockefeller Center [*sic*] from Sept. 28th to Oct. 12th. From New York it will go to all important centers in the states, and again will be shown abroad. All in all, we intend to have a more extensive showing than last year. . . . Last year's Salon proved so popular and was so well received in every instance that we want to follow it up with one just as fine or finer.[33]

Although *U.S. Camera* did not rely solely on fine art photographs for its content, it adopted a common practice of art photography—display in a photographic salon—for presentation of the images to the public. Thus photographs selected for *U.S. Camera* circulated not only in the pages of the annual but also on the walls of gallerylike spaces designed to focus attention on the aesthetic and technical merits of the pictures.

As he did with *Survey Graphic*, Stryker often referred his photographers and others to the Historical Section's photographs as they appeared in the pages of *U.S. Camera*. In one letter he even directed an interested high-level bureaucrat to the annual: "If you will look at the new U.S. Camera Annual you will find several pages of our photographs. This will give you an idea of a certain phase of the work in which we have become much interested—portraying people on the sub-marginal areas."[34] In early 1939 Stryker wrote to a friend, sociologist Robert Lynd of "Middletown" fame, about the special section of FSA photographs currently appearing in *U.S. Camera 1939*: "We are very much pleased with the way Mr. Steichen handled our pictures in the last issue of U.S. Camera. If you have an opportunity I wish you would look at it."[35] Note that Stryker does not focus upon the aesthetic qualities of individual FSA photographs in these letters, but mentions content and discusses them as a group. Even though the pictures were published in a photography journal, it is clear that Stryker still believed them to be good representations of the FSA's political and social goals. If Stryker shared any of Edwin Rosskam's qualms about Steichen's "fram-

ing" of the Historical Section's images in the aesthetic context of *U.S. Camera,* he never let on.

While Stryker clearly supported the presentation of the Historical Section's work in *U.S. Camera,* he apparently balked at more technically driven inquiries about the section's work. Responding to a request from *Popular Photography* to comment upon the equipment used by Historical Section photographers, Stryker wrote: "I will try to answer some of the questions which you attached to your letter. They are the type of questions which to us, seem awfully irrele- vant, but I can understand how a publisher would like to incorporate some such information in his article."[36] In the letter Stryker goes on to describe the various types of cameras, lenses, films, and enlargers used by the Historical Section staff, but it is clear that he does not believe technical questions to be the most important questions one should ask about the Historical Section's work. Years later, Stryker recalled of such questions:

And God knows, we did not follow *any* of the rules that the cover magazines talk about. You'd be surprised that we were bombarded with cover magazines— "What stop did you use on this picture?" "What film was used?" And I didn't know. And I didn't care. And sometimes I got so disgusted that I gave them fool answers and they published it. . . . That taught them *not* to ask questions like that.[37]

Questions about the aesthetic contributions of the FSA Historical Section project continued to dog Stryker long after the section had folded. Reflecting upon his FSA years later in life, Stryker discussed the issue of whether the His- torical Section's work was "art": "There's no question that photographers . . . produced some great pictures, pictures that will live the way great paintings live. But is it art? Is any photography art? I've always avoided this particular controversy. Nothing strikes me as more futile, and most of us in the unit felt the same way."[38] Here Stryker confirms that he never believed aesthetic ques- tions should be the main focus of the Historical Section's work. For him, the early Historical Section pictures functioned to supplement the work of the Re- settlement and Farm Security Administrations by calling attention to chronic

rural poverty. Yet at the same time, as his involvement with *U.S. Camera* reveals, Stryker embraced aesthetic use of the pictures because anything that called attention to the Historical Section and its mission was good exposure.

An examination of two sets of pictures that appeared in *U.S. Camera* in 1936 and 1939 will reveal how their presentation in these annuals makes available a narrative of rural poverty that reflects tensions inherent in discourses about documentary and art in the 1930s. *U.S. Camera 1936* lends itself to analysis because its presentation of the FSA pictures is typical of the *U.S. Camera* annuals as a whole, and *U.S. Camera 1939* works for this purpose for precisely the opposite reason: because its presentation of the Historical Section's pictures represents a conscious attempt to depart from the annuals' norms and conventions for displaying photographs.

U.S. Camera 1936: Two Mothers

One of the first FSA photographs selected for publication in *U.S. Camera* was made by Arthur Rothstein on an early trip for the Historical Section in the summer of 1935. The photograph, printed on a full page and bled out to the edges, features a young mother and child standing in what looks to be a doorway (Figure 3.1). The figure of the mother dominates the frame, filling the entire space of the picture from top to bottom. Her breasts sag and her threadbare checkered dress stretches and strains at the girth of her stomach. The picture leaves no doubt that the mother is pregnant; she fills the frame horizontally, focusing our attention on her expanding belly. Thus the viewer recognizes from the first that there are actually three figures in the picture: the mother, the older child, and the trace of another child not yet visible. Though the photograph focuses on the mother's body and its impending maternity, one's eyes are also drawn to her face. Like Lange's portrait of the migrant mother, this mother's countenance communicates anxiety. Her mouth is slightly open, her expression one of vulnerable perplexity; it is as if she has just been asked a question for which she does not have the answer. Leaning on the doorjamb, at eye level with the mother's pregnant stomach, stands a young girl with white-blond hair. Like the mother's clothing, the girl's dingy sack dress full of holes suggests poverty. The child scratches her hand absentmindedly, her facial

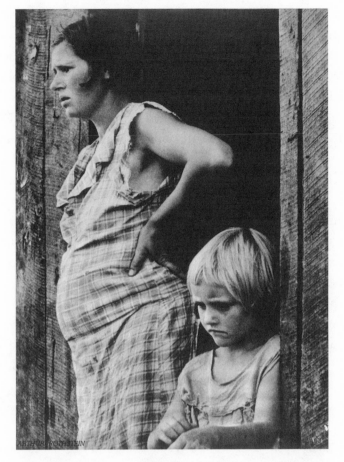

Figure 3.1. Untitled [Wife and Child of a Sharecropper, Washington Cty, Arkansas]. Photograph by Arthur Rothstein (August 1935), FSA-OWI, LC-USF33-002022-M4. As reproduced in *U.S. Camera 1936*.

expression revealing an anxiety beyond her years and mirroring the mother's worried countenance.

The Rothstein photograph as it is printed in *U.S. Camera* is framed to draw attention to the body of the mother. In addition to the mother's vertical and horizontal domination of the image, the photographer's point of view invites contemplation of the mother. Rothstein made the photograph from a vantage point slightly below that of his subjects, so that the viewer is placed in the po-

sition of looking up at the figures. Not only does such a point of view suggest respect for its subjects, but it also places the mother in a position of visual dominance over the child and thus over the whole scene.

The background of the photograph gives little information about the circumstances or location where the photograph was made. With the exception of the rough-hewn wooden doorway, there is no sense of place in this photograph. Mother and child emerge from the blackest of shadows inside the building, shadows that serve only to focus our attention even more solidly upon the two figures. The viewer is left to contemplate the mother, but without much information to go on. Emerging from the shadows of the doorway, one child in tow and another on the way, she presents an image of maternity and nameless anxiety.

U.S. Camera does not give any information about this woman and her surroundings. The contexts for interpretation that it does provide reflect the journal's primary interest in the aesthetic and technical aspects of photography. Unlike the usual *Survey Graphic* style, there is no caption to this photograph, save identification of Rothstein as the photographer. The annual establishes its own context for the picture by placing it within a broad set of generic categories and providing the viewer with technical information about the image. Given the probable urgency of the mother's poverty, one might expect to find the Rothstein photograph in the "news" section of the annual, but that is not the case. The picture appears in a very large section of photographs titled "Illustration/Portrait/Pictorial/Miniature." In *U.S. Camera 1936* this category runs the gamut from documentary images such as Rothstein's to abstract nudes and stylized fashion photographs. The rhetoric of the portrait involves a privileging of the subject and a concomitant sense of respect conferred upon that subject by the photographer and, by extension, the viewer. Portraits also tend to be static and timeless, quite unlike the urgency-laden, time-dependent news photograph. By classifying the Rothstein photograph as a portrait or illustration as opposed to a "news" image, *U.S. Camera* focuses not upon the circumstances of this particular woman's life but rather upon the more timeless aesthetic and technical qualities of the portrait photograph. Although the mother's circumstances might suggest urgent need, she is not "news." Furthermore, the index of *U.S. Camera 1936* frames the images in solely technical

terms. The index notes that Rothstein used the relatively new technology of the 35mm camera (a German-made Leica) and made the exposure at 1/60 of a second.[39] This information is meant to inform the viewer who is interested in understanding the technical aspects of the medium, but it also shifts attention from the subject of the photograph to the maker of the photograph.

The mother and her child, then, are presented in a context that appears to be contextless; that is, the photographs are abstracted from their role as examples of rural poverty and placed in a context where they are to be admired for their aesthetic qualities. If in *U.S. Camera* the mother and child stand at all for poverty, it is poverty only in its most abstract and, oddly enough, pleasurable sense.[40] *U.S. Camera* establishes the setting for that pleasure by contextualizing the image as an example of "good" photography, which is ostensibly enjoyable to view and consume even if the subject matter is decidedly unenjoyable. As Susan Sontag puts it, "Every subject [may be] . . . promoted into an item for aesthetic appreciation."[41]

Turning to the picture as it appears in the Library of Congress file, we find that the photograph looks quite different from the version used in *U.S. Camera 1936*. It is both more visually informative and less visually compelling than the *U.S. Camera* image. In the Library of Congress version, much more of the family's surroundings is visible—including, in fact, part of another child (Figure 3.2). Not only has the mother's family expanded, but her environment has expanded as well. The original composition of the picture is more open; it backs off from the woman and the child to include additional visual information. Now it is evident that the family resides in obviously substandard housing: a rough-hewn wooden sharecropper's cabin with a damaged roof and chipping paint. This version provides glimpses of tools near the house—a wooden handle near the mother's legs and, at the bottom right corner of the picture, what looks to be the top of a straw broom. Finally, because of a marked difference in tonality between the two pictures (the Library of Congress version is nearly underexposed), it is possible to see behind the mother and into the house, though the details of the interior wall and objects inside remain fuzzy. Overall, in the Library of Congress version the domestic scene is revealed in much greater detail. Although the picture is still "about" the mother and her anxiety, its greater amount of visual information disperses the viewer's attention and

140

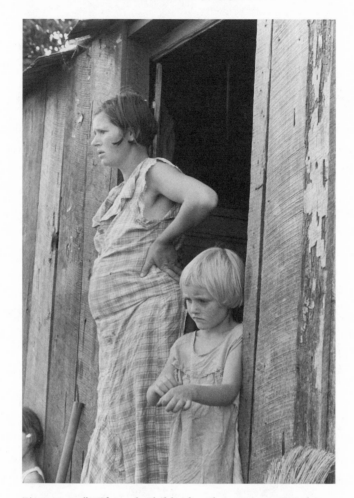

Figure 3.2. "Wife and Child of a Sharecropper, Washington Cty," Arkansas. Photograph by Arthur Rothstein (August 1935), FSA-OWI, LC-USF33-002022-M4, Library of Congress.

gives the scene greater balance. But that balance comes at the price of aesthetic interest. The *U.S. Camera* version is much more visually engaging, presenting the mother in stark profile, with strongly contrasting shades of light and dark that suggest the complexity of her circumstances. The photograph as it is cropped and presented in *U.S. Camera 1936* is framed to abstract the mother and child from the context of their poverty and focus attention instead on the fine quality of the image. A comparison of the two versions of Rothstein's pho-

tograph illustrates how choices in the darkroom and in the editing process can make an average, workaday picture more aesthetically compelling.

Next, consider the second FSA photograph published in *U.S. Camera* that year, Dorothea Lange's famous "Migrant Mother." The earlier discussion of this photograph showed how it both highlighted the problems of migrant labor and challenged potential government solutions. Though the photograph enacted the visual trope of Madonna and Child, in *Survey Graphic* the photograph resisted being abstracted into an icon of maternity because it was anchored to the material world with a caption describing the family's situation and it appeared within a text that focused on specific government solutions to poverty. At the same time, however, there is in the portrait an available narrative that rejects the rational order of Taylor's text and Lange's accompanying "project" pictures. Even within the specific context of *Survey Graphic*'s message, the migrant mother (and the portrait of the field hand) seem to stand apart from Lange and Taylor's bureaucratic aims.

A comparison of the *U.S. Camera* photograph to the version in *Survey Graphic* reveals differences worth noting (Figure 3.3). First, the picture is cropped more tightly around the mother and children. In *Survey Graphic* it was possible to identify a few aspects of the figures' surroundings, such as the canvas background and the tent pole in the foreground of the picture. In *U.S. Camera,* even those minimal pieces of information are missing. Here, the photograph is cropped right up to the top of the mother's head, removing all of the background and much of the foreground from the picture. *Survey Graphic* showed a good portion of the older children's bodies as they turned away from the camera, but in *U.S. Camera* much of that is cropped out of the frame. At the bottom, the photograph stops at the end of the mother's elbow, removing all of her lap and much of the body of the baby from view.

The immediate effect of the cropping, apart from simply excising the background from the photograph, is to focus attention upon details easier to miss in other versions of the picture. Whereas in *Survey Graphic* the mother was set back from the foreground, in *U.S. Camera* the absence of foreground means that all of the figures, but particularly the mother, confront the viewer in a more overt way. The mother's size enables the contemplation of details that might be overlooked in the *Survey Graphic* version, such as the textures and patterns on the cloth of the mother's dress and the children's clothing. The

142

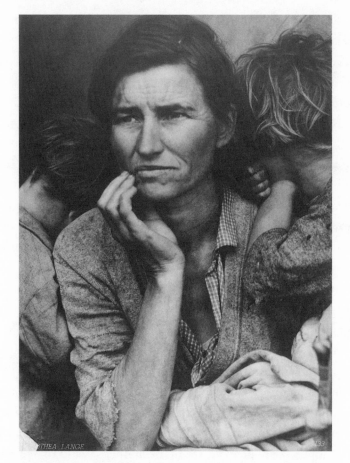

Figure 3.3. Untitled [Migrant Mother, Nipomo, California].
Photograph by Dorothea Lange (February 1936), FSA-OWI,
LC-USF34-9058-C. As reproduced in *U.S. Camera 1936*.

baby's face is easier to see, blissfully ignorant in the presence of maternal anx-
iety. Even the mother's disembodied thumb, so hated by Dorothea Lange that
she later removed it permanently from her negative, is more visible.[42] As a
result of *U.S. Camera*'s cropping of the scene the picture both loses visual
information and gains it, directing attention to different details.[43]

It is not only the cropping of the photograph that makes it different from
other versions of this picture, however. In *U.S. Camera* the Lange portrait is
printed with a distribution of light and dark tones not found in the *Survey*

Graphic version. Here, the main areas of light in the picture—the baby's face, the mother's face, and the mother's hand—have been exaggerated. It may be inferred from the *Survey Graphic* version that the natural source of light for the picture comes from the photographer's left, highlighting the mother's face, portions of the child on the left, and part of the baby's face.[44] But in *U.S. Camera,* that light is more intense and appears to come from below as well. The baby's body is almost completely bathed in light even though she is held close to the mother's body, which itself lies partially in shadow. In short, the *U.S. Camera* print has been not only cropped to emphasize the mother but dodged and burned to create light and shadows in quite specific places. As a result, the face of the mother and the body of the baby glow with an "unnatural" light.

143

The close cropping and strong areas of light in the picture function to divide the viewer's attention between the mother and the baby. The mother is still the primary focus of the image. In the stronger light her face takes on an almost sculpted, otherworldly air. She is, despite her obvious anguish, beautiful to look at. But the mother has competition for the gaze in the baby. In this picture the infant emerges from the shadows newly bathed in a halo of light, taking on a new significance.

The photograph takes up one full page of the annual. It appears with no border and, like the Rothstein picture, is bled completely out to the edges of the page (so much so that the magazine's spiral binding actually pierces the back and neck of the child on the left). While the *Survey Graphic* portrait provided a short caption describing the pea pickers' plight and explaining the family's poverty, here there is no such information. As with the Rothstein picture, the only caption appearing with this photograph is Lange's own name in the bottom left-hand corner. Also like the Rothstein image, the lack of information here forces the viewer to consider the photograph in ways apart from the specificity of its subject matter.

In the aesthetic context of the *U.S. Camera* annual, Lange's photograph takes on an even more iconic status. One comes to appreciate it both for its poignant, universal depiction of anxiety and suffering and for its textures, lines, and use of light—in short, for aesthetic reasons. One may admire the skillful use of light and shadow, which focuses attention on the resignation of the mother and the innocence of the baby. Viewing the details in this picture

elicits an almost tactile response; it is as though one could reach out and touch the baby's soft white face or finger the rough clothing of the children. Although viewers may read the photograph as an example of unfortunate poverty, no caption appears that would ground an interpretation of the picture in the urgency of the times. Rather, a primarily aesthetic appreciation of the image is reinforced by its presence in the "Illustration/Pictorial/Portrait/Miniature" section of the annual, which emphasizes the generic and aesthetic qualities of the photograph rather than the currency of its subject matter. By classifying these images as "portrait" or "illustration" rather than "news," *U.S. Camera* argues that what is important about them is not how they depict a current social problem or capture a fleeting moment but how they function as "good" examples of contemporary portraiture. Finally, the description of the Lange photograph in the index further focuses attention on the photograph (as opposed to its subject), thus satisfying the expectations of readers who sought in *U.S. Camera* both an aesthetic experience and a technical education.

In considering the two portraits together, it is possible to locate several similarities in their structure and meaning. A key similarity between the two images is their intimacy as representations of mothers and children. The Rothstein mother invites engagement by virtue of her pregnancy; viewers are drawn into the physical reality of her life. The Lange photograph draws the viewer in, too, perhaps more so than it did in *Survey Graphic*. Rather than being able to hold the family at a distance by saying, "This is an example of a poor migrant in California where the pea crop failed," here there is no caption to distance the mother. Paradoxically, it is precisely the lack of a caption that may enable *U.S. Camera*'s readers to engage this photograph more intimately. There is no buffer zone of information between subject and viewer; the mother's anxieties provide no text with which to rationalize them away.

In the end there are two choices for making sense of these pictures, neither of which negates the other: to universalize the mothers' plight through the images and to appreciate them aesthetically. The two pictures in *U.S. Camera* are framed to enable both experiences. There is in the women an intimate representation of universal motherhood made even more poignant by their obvious poverty, and at the same time the possibility exists to appreciate their strength and beauty. *U.S. Camera* appears to value the women as images most of all.

But *U.S. Camera*'s interest in the aesthetics of photography does not necessarily define the full scope of available narratives for the FSA pictures. There is also space for an alternative reading, one that challenges the pictures' role as aesthetically (and tragically) pleasing icons of motherhood. In comparing these two photographs to other representations of women in *U.S. Camera 1936*, one finds a marked resistance to aestheticization. In browsing through the pages of *U.S. Camera 1936* one is struck by the differences between the FSA photographs discussed above and other representations of women featured in the annual. Although a few other documentary photographs of women do appear in the issue (including one made by Ben Shahn on a non-FSA outing), the majority of the images of women are of a quite different order. In addition to representations of women in advertising, fashion, and celebrity, the annual includes six nude portraits of women.[45] A study of these nude representations of women reveals points of resistance to a totalizing aesthetic.

145

Consider two of the six nudes presented. The first is a black-and-white studio photograph by George W. Vassar; the other, an abstract nude made by noted Group f/64 photographer Imogen Cunningham (Figures 3.4–3.5).[46] The first thing one notices about the two photographs, apart from the obvious fact that they are representations of nude women, is their abstract, modernist quality. These are by no means documentary pictures; rather, they are carefully lit, posed, and printed studio images. They show women not as material bodies, as do the FSA photographs, but as abstract forms. Vassar's photograph features a nude woman reclining upon one hip, her body at a slight angle to the camera. Although she is entirely unclothed, she is strategically dressed in shadows. Her arm, upper legs, torso, and hair are bathed in bright light while her lower legs, genitals, and face remain hidden in dark shadows. She is exposed, but unknown and faceless. Cunningham's image, featuring the body of a nude woman kneeling in the fetal position, is more abstract than Vassar's. Cunningham photographs her from behind, revealing only the curve of her back, shoulders, and buttocks. The model is lit to focus attention upon the form of her back while masking the rest of her body in the blackest of shadows. While in Vassar's picture the model's face is hidden from view by tricks of lighting, in Cunningham's picture the model is photographed from behind so that she is not only faceless but headless as well. Clearly, we are not meant to identify these women

146

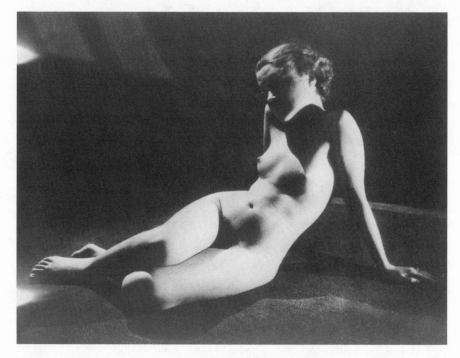

Figure 3.4. Untitled. Photograph by George W. Vassar. As reproduced in *U.S. Camera 1936*.

as individuals but to view them as modernist experiments in form.[47] While both pictures are imbued with a passive yet inviting sexuality, the women are not in control of that sexuality; they function instead purely as objects for spectatorship.

Both photographs uphold conventions of the nude long held sacred in the art world. In his discussion of the nude, John Berger observes, "To be naked is simply to be without clothes, whereas the nude is a form of art."[48] The nude constitutes one of the oldest and most traditional aesthetic expressions that one may find in Western art. In addition, Berger notes, "The nude is always conventionalized"—that is, presented in a historically accepted, standardized fashion.[49] The first of those conventions involves the necessary objectification of the subject: "A naked body has to be seen as an object in order to become a nude."[50] The second convention relates closely to the first: in order for the (female) subject of the photograph to become objectified, she must be made sub-

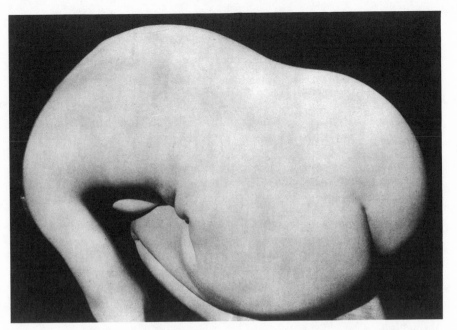

Figure 3.5. "Nude, 1932." Photograph by Imogen Cunningham. © The Imogen Cunningham Trust. Used with permission. As reproduced in *U.S. Camera 1936.*

missive and passive by the (usually male) gaze of the spectator. Thus, at the heart of the nude expression lies the implicit assumption that "*men act* and *women appear.*"[51] The man actively looks upon the woman and consumes her image. The woman, in turn, is aware of and accepts his spectatorship, but she does not possess her own image. Rather, she is owned by the all-encompassing gaze of the spectator.[52]

In comparing and contrasting the two pairs of photographs, differences emerge that provide keys to understanding the potential for resistance to *U.S. Camera*'s aesthetic discourse. The nudes presented in *U.S. Camera 1936* are framed as aesthetic expressions in ways that the Historical Section pictures are not. Rather than being bled out to the edges of the frame, as the Rothstein and Lange pictures are, both Vassar's and Cunningham's photographs are presented in the middle of the page, with a significant amount of white space surrounding them. The white space, echoing the empty space on a gallery wall, suggests that these images are meant to be contemplated as abstract aesthetic

forms. The Historical Section photographs, in contrast, are presented as "raw" documentary matter with no frame imposed upon them. The absence of a frame suggests that the Historical Section photographs are qualitatively different from the nudes and other images like them. Although the FSA portraits are a part of an eclectic collection of the "best" of American photographs, they remain necessarily apart from more purely aesthetic expressions.

148

Another key difference between the two pairs of photographs lies in Berger's useful distinction between the nude and nakedness. Berger observes, "Nudity is a form of dress," a way of objectifying the subject of art and representing the body in conventional ways.[53] To be naked, on the other hand, is to be exposed in a decidedly un-aesthetic fashion. The aesthetic conventions of the nude wrap the models in a set of assumptions about art, form, and spectatorship. Vassar and Cunningham present highly stylized, conventional portraits of women, nudes meant to be studied for their formal qualities. Viewers gain pleasure from the objectification of these women within the familiar aesthetic discourse of the nude.

If the Vassar and Cunningham images are nudes in Berger's sense of the term, then the Rothstein and Lange pictures, by contrast, suggest nakedness. The two mothers are obviously not without clothes, but when compared to the conventionalized "dress" of the nudes, the photographs of the mothers are more revealing. The intimacy with which the viewer is confronted with these women's anxiety is undeniable; the emotions expressed on the mothers' faces are raw. Although the mothers are presented in the context of *U.S. Camera* as art, each woman retains the vestiges of a material self, a self embodied in the way she holds her body as well as in the expression upon her face. Whether one notices the way the migrant mother grasps the tent pole to keep the baby's head propped up, or the unself-conscious way the sharecropper's wife stands with her hands upon her hips, it is possible to recognize subjectivity in these women. They were not *created* to be beautiful in the same way that the nudes were posed and lit and framed.

Furthermore, the two mothers do not readily accept the gaze of the camera/ viewer. In Rothstein's picture the mother does not even appear aware that she is being photographed; she is wholly unconcerned with the gaze of the spectator. Similarly, although it is clear that the migrant mother is posing for Lange's

camera, she too looks beyond the edge of the picture to consider something lying beyond the viewer's pleasure. Both women possess and direct their own gazes in ways that the women featured in the nude portraits cannot do. The images of the two mothers, though presented in *U.S. Camera* for aesthetic enjoyment, move beyond that aestheticization by refusing to be made nudes— that is, by remaining in possession of their own gazes they fail to conform completely to the conventions of art.

149

Finally, though all of the photographs possess a certain degree of sexuality, only the nudes represent sexuality in its most conventional and passive sense. The two mothers offer the viewer an active kind of sexuality, one intimately related to motherhood. With the closer cropping and detail of the migrant mother photograph, we see that her breast is slightly exposed, suggesting both sexual pleasure and the necessity of feeding her child. In the Rothstein picture the pregnancy serves as obvious evidence of the active sexuality of the mother; the image does not hide her condition. Though both women exude sexuality, neither mother is a passive sexual object.

The two mothers are both universalized and aestheticized as a result of their presentation in *U.S. Camera 1936*. Both Rothstein and Lange present aesthetically pleasing yet tragic images of the mother in poverty. The lack of information about the mothers' plights, combined with the framing of the mothers and their children, treats the mothers as art, as icons of suffering and motherhood. The images constitute aesthetic expressions (beautiful and pitiful at the same time) of a universal condition. Yet when compared with other representations of women in the annual, the two mothers resist complete aestheticization. The nudes conform to traditional conventions of art by presenting women as abstract forms rather than as self-possessed, material bodies. The Historical Section's pictures, on the other hand, resist such treatment; they oscillate endlessly between the poles of their "documentary nature" and their status as art.

The example of "Migrant Mother," as studied across two quite different contexts, is a useful one. In *Survey Graphic*, Lange and Taylor sought to tie the migrant mother to a particular context and to a concrete set of meanings about rural poverty. But the photograph resists being co-opted into such pragmatic instrumentalism. It retains a particular iconicity for which Taylor's text cannot

fully account. The same photograph functions in a somewhat opposite fashion in *U.S. Camera*. Here, the aesthetic and universal meanings of migrant mother are foregrounded by the context of the annual, but "Migrant Mother" resists that and retains meanings unaccounted for by the aesthetic discourse of the annuals, namely the intimacy of her subjectivity. Thus the available meanings for the photograph, perhaps predictably, shift with each change in context, while not being wholly determined by either.

150

If *U.S. Camera 1936* is largely blind to the ways in which the FSA photographs fail to map completely onto the discourses of art, something much different is going on in *U.S. Camera 1939*. In that annual's special section devoted to the FSA, Edward Steichen explicitly argues that the FSA pictures are qualitatively different from other kinds of pictures; thus he attempts to separate art from documentary. Steichen's rhetoric of separation functions to further complicate attempts to read the photographs aesthetically.

U.S. Camera 1939: The FSA Set Apart

In 1938 Steichen joined thousands of New Yorkers at the International Photographic Exposition at Grand Central Station, which featured a special exhibit of FSA photographs. Steichen was moved by the presentation and told Maloney that he wanted to devote a large section of *U.S. Camera 1939* to the FSA pictures.[54] The *U.S. Camera 1939* feature marked the first time that a group of the FSA photographs were published together in the context of a "serious photographic magazine."[55]

Maloney asked Steichen to serve as a one-man jury for the 1939 volume, single-handedly selecting all of the photographs to appear in the annual. The special section of FSA photographs consists of forty-one pictures presented across twenty-three pages. Steichen opens the section with his own three-page essay on the Farm Security Administration project. The majority of the photographs in the section are paired with captions. The captions, quotations from actual viewers' responses to the FSA images, were taken from more than four hundred comment cards filled out at the FSA's exhibit at the International Photographic Exposition in New York City. Although no detailed records are available that list specifically who attended the weeklong event, the comments offer evidence that the audience was primarily a middle- or upper-class mix,

Figure 3.6. Untitled [Hoe culture in the South. Near Eutaw, Alabama]. Photograph by Dorothea Lange (1936), FSA-OWI, LC-USF34-009539-C. As reproduced in *U.S. Camera 1939.*

including both amateur and professional photographers—all willing and able to pay the forty-cent admission.[56]

The section begins with Steichen's essay, titled "The FSA Photographers." Opening with a striking Dorothea Lange photograph of three sharecroppers hoeing a field (Figure 3.6), the article describes Steichen's interest in the Historical Section and serves as an introduction to the pictures themselves. Steichen's essay not only praises the FSA for the quality of its photographic work but also frames the section of pictures in ways that attempt to undermine and subvert the norms so carefully cultivated by Steichen and Maloney in earlier annuals.

Steichen begins by telling the story of the creation of the FSA project, and in the process he slips in a little misinformation. Someone, he explains, told "Uncle Sam" that "'times are hard and, among others, there are some cracking good photographers hanging around having quite a struggle to get along; you ought to give them jobs.'" So, according to Steichen, "Uncle Sam" hired Roy Stryker to run the Historical Section, which effectively put the government in "the photographic business."[57] In fact, things did not actually happen that way. Steichen confuses the orientation and purpose of the Historical Section with those of the WPA's Federal Art Project. Part of the WPA's mission was to create jobs to employ artists, writers, musicians, and actors at a time when those pro-

fessions were being hard hit by the Depression. But the Historical Section photographers were already practicing, and in most cases professional, photographers at the time of their hiring; the Historical Section was not created merely to employ photographers. In the pages of *U.S. Camera,* however, Steichen chooses to romanticize the Historical Section's mission—perhaps to counter charges of propaganda that were often leveled at the project, or to ascribe a more publicly acceptable purpose to the FSA photographers' work.

152

The FSA photographs, according to Steichen, are so powerful that they render any technical discussion of aesthetics insignificant: "These documents told stories and told them with such simple and blunt directness that they made many a citizen wince, and the question of what stop was used, what lens was used, what film was used, what exposure was made, became so completely overshadowed by the story, that even photographers forgot to ask."

Here Steichen appears to undermine a good part of *U.S. Camera*'s raison d'être by claiming that the subject matter of the FSA pictures trumped any and all questions of aesthetics. While some images might lend themselves to extended aesthetic discussion, Steichen implies, the FSA pictures do not. The images are powerful because they tell simple, direct, blunt stories: "We don't know if the photographers made these pictures with the purpose of telling a story. If they did not, then their cameras certainly put one over on them."[58] Regardless of the intentions of the photographers, Steichen contends, the FSA pictures do tell stories, and tell them in a compelling and straightforward fashion.

Contrary to *U.S. Camera*'s own norms of presentation, Steichen emphasizes that the FSA photographs must *not* be viewed as individual, isolated expressions; rather, the impact of the photographs upon the viewer is a cumulative one. The work of individual photographers or photographs is not, he argues, what makes the pictures important: "It is the job as a whole as it has been produced by the photographers as a group that makes it such a unique and outstanding achievement."[59] Here, Steichen clearly subverts the annuals' norm of individualism. While *U.S. Camera* consistently frames photographs as unique, isolated expressions attributable to individual photographers, Steichen eschews such framing for the FSA pictures. It is a mistake, he asserts, to read particular FSA pictures as individual creative expressions.

But Steichen's rejection of aesthetics is not complete. Although he advocates

that the FSA photographs be read apart from aesthetic considerations, he himself turns to the contexts of fine art to explain the impact of two photographs that he singles out for discussion. Lange's photograph of three sharecroppers hoeing a field (Figure 3.6) reminds Steichen of Jean-François Millet's painting *The Angelus* "precisely because the scenes are so different." And a Russell Lee photograph of an abandoned organ in a cornfield, Steichen remarks, "makes any cockeyed Dada picture seem like a blooming Christmas card in comparison to this grinning gargoyle."[60] For Steichen, both of these photographs possess a referent in the world of art to which they may be compared. Although he claims that aesthetic considerations are irrelevant to any reading of the FSA pictures, his own response is framed by his knowledge and understanding of various traditions of representation.

Steichen concludes the essay by reminding readers of the "old Chinese philosopher's" adage "A picture's worth a thousand words," adding, "If this thought was really spoken, and if he was really a philosopher, and if he could have seen these FSA photographs, he would surely have wanted to amend his statement to the point of adding a few ciphers to his original estimate."[61] Here, Steichen grants the FSA images power in part by devaluing the importance of text. This devaluation of text is in line with *U.S. Camera*'s primary interest in visual images. But curiously, in the special section Steichen uses text quite overtly—by pairing the pictures with specific captions. He argues that text is unnecessary when viewing the images, but then he provides it in a rhetorically provocative way. Why? At first glance, it appears that Steichen uses the captions to focus the viewer's attention away from aesthetic considerations and toward social and political concerns—a change that he deems appropriate for this set of pictures. If so, his recourse to text does not always succeed. In some cases the captions serve only to highlight the photographs' aesthetic qualities and thus subvert Steichen's own stated intentions in presenting the pictures. As we turn to the pictures and their captions, we shall see that they, too, capture the deep tension between the aesthetics of photographic representation and the social function of the photograph.

In *U.S. Camera 1939* the forty-one FSA photographs in the special section are generally presented one or two to a page, and all are bled out to the edges. The comments from the Photographic Exposition that were chosen as cap-

tions do not refer specifically to the images with which they are matched, but reproduce the reactions of viewers to the exhibit as a whole. If it is usually difficult to consider photographs apart from their captions, here such a task is utterly impossible. When the viewers' comments are paired with particular images, the captions produce a representation often dripping with irony.[62]

It is impossible here to describe in detail each of the forty-one photographs and captions as it appears in the special section. Instead, three of the photographs and their accompanying captions will provide a focus for discussion at some length. Each image embodies the problem of how to understand the role of the FSA photographs in the context of an aesthetic discourse that is already a site of struggle over the meaning of photography.

Figure 3.7, an image made by Walker Evans, depicts a group of African Americans standing in line. They are photographed in profile from the torso to just below the knees; their faces are not visible. One of the two figures in the center of the photograph holds a plate in his hand, the other holds a bowl. The chipped white bowl and the metal plate in the center of the picture dominate the image, their brightness contrasting sharply with the dark clothing and hands of those standing in line. For a documentary image, it is surprisingly abstract. It detaches the individuals not only from their larger context but from the rest of their bodies as well.

This photograph is one of the two that Steichen chooses to praise in his introduction, lauding its storytelling abilities. Indeed, his praise of this striking image is well placed for a number of reasons. Its simple composition and straightforward use of symbols give it a resonance not found in most FSA pictures. Evans's portrayal of the hands holding the eating utensils, waiting for food, tells its story clearly. This is an image of "the handout" at its most fundamental level: a visual representation of the human need for sustenance, combined with a poignant dependence upon others for the satisfaction of that need. Evans's photograph eloquently echoes images of the 1930s breadline embedded in the public consciousness of the time and present in our own cultural memory of the Depression: row after row of needy Americans asking reluctantly for what they could no longer supply for themselves. But the photograph is not only historically specific, it is profoundly moral in its universal, iconic message. By depicting the universal need for sustenance embodied in the hands

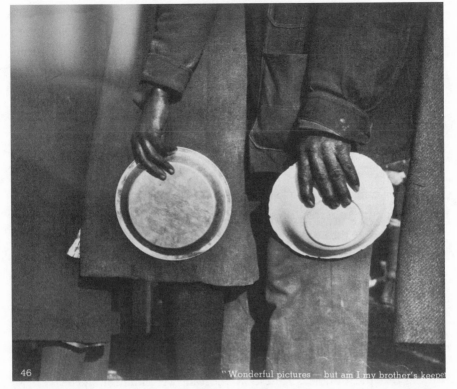

Figure 3.7. "Wonderful pictures—but am I my brother's keeper?" Photograph by Walker Evans (February 1937), FSA-OWI, LC-USF33-009217-M3. As reproduced in *U.S. Camera 1939*.

of black Americans, Evans offers the 1930s equivalent of the poorest of the poor, the rejected ones. He does not show their faces, but their need is clear: their bowls are empty, they are hungry. They stand at the threshold of the New Deal, bowls in hand, waiting to be fed.

The photograph is paired with a caption that reads, "Wonderful pictures— but am I my brother's keeper?" If this breadline of universal hunger has a moral tone all its own, that tone is only amplified by the caption's reference to the Cain and Abel story. The caption's question—"Am I my brother's keeper?"— raises the stakes for the image in a way that enhances the universal message projected by the photograph. Indeed, this question hovers over any interpretation of *all* of the pictures in the section, not just this one. Steichen's essay sug-

gests that he believes the answer to the question should be "yes." But the Evans photograph does not trump the meaning of the caption so easily. The caption praises the pictures as "wonderful" and then qualifies that assessment with the word "but": "*but* am I my brother's keeper?" The implication on the part of the caption writer is that he or she is not or should not be responsible for the situations of those depicted in the photographs. The writer wishes to view the pictures, and even to enjoy them, but does not wish to consider the larger implications of the FSA's project.

Such a response may seem callous in light of the suffering presented in the photographs as a group, but perhaps in this context it is not unusual. The viewers' comments were written at a photographic salon, an exhibition whose aim was to show the public the best in photography; *U.S. Camera*'s goals were similar. When social ills such as those depicted by the Historical Section photographers are presented in such a context, many viewers are likely to react by distancing themselves to some degree. The viewer of this photograph, like others whose comments Steichen reproduces, wishes to separate the photographs from the conditions they represent. Indeed, the initial response by the writer of the caption is a vaguely aesthetic one: "Wonderful pictures." While we may read the caption as a question whose answer should always be "yes," we must recognize that the question itself remains largely unanswerable here. To what extent do these photographs have the ability, when presented in a context that typically calls for an aesthetic response, to elicit a social or political response? In such a context, a gap is bound to exist between the act of viewing photographs and feeling a sense of social responsibility for their subjects. Susan Sontag writes: "To suffer is one thing; another thing is living with the photographed images of suffering, which does not necessarily strengthen conscience and the ability to be compassionate. . . . Aesthetic distance seems built into the very experience of looking at a photograph."[63] Such aesthetic distance is amplified when the photographs appear in a context that is interested primarily in the artfulness of photographs. Thus, in terms of the Evans picture at least, Steichen's wish for a predictable, socially responsible reaction to the Historical Section's pictures is complicated by their presence in an aesthetic context that may not readily accommodate such a response.

The issue of an aesthetic response is raised more overtly by another photo-

Some lousy prints and enlargements. Too much grain.

Figure 3.8. "Some lousy prints and enlargements. Too much grain." Photograph by Russell Lee (May 1937), FSA-OWI, LC-USF341-10865-B. As reproduced in *U.S. Camera 1939*.

graph in the section (Figure 3.8). In a kind of still life with farm implements, the Russell Lee photograph depicts several old farm tools and other items propped against the side of a wooden building: a wagon wheel, a rake, two beat-up cast-iron bed frames, two hooks, and some planks of wood. The picture is printed with high contrast, so that the shadows of the implements fall harshly on the sun-bleached building. The photograph depicts the stark interplay not only of light and shadow but of shapes as well. The round wheel and curved rake contrast sharply with the straight lines of the siding on the building and the perfectly rectangular panes of glass in the half-darkened window. The shadows from the tools cut across the face of the building in angular lines, further enhancing the composition of the image.

The caption that Steichen matched with this picture makes no reference to its subject matter at all: "Some lousy prints and enlargements. Too much grain." That Steichen believes this caption to be mistaken is clear for two reasons.

First, the caption is paired with a picture that is by no means "lousy" from an aesthetic or technical point of view. The image is printed sharply and clearly and cropped to emphasize the fascinating interplay of light, shape, and shadow upon the garage. In addition, the photograph was made from a five-by-seven-inch negative; the large format provides a vast amount of visual detail and sharpness that could not have been achieved using a smaller format.[64] Lee's photograph is, by any account, a "good" picture from an aesthetic and technical point of view. Second, all of the photographs are presented under the ethos of Steichen's vast reputation. If the "great Steichen" chose and arranged all of the pictures in the annual, who is this anonymous respondent to question his choices? By imposing such a caption upon Lee's photograph, Steichen makes it clear that the picture "wins"; he establishes the fine aesthetic quality of the FSA pictures by demonstrating visually how this caption's negative assessment is wrong.

The Lee photograph of the farm implements does not carry the moral weight of the Evans photograph previously discussed, nor does it purport to. Whereas the Evans photograph might be described as an artful image that speaks strongly to Judeo-Christian values, the Lee photograph is an artful photograph that is primarily interested in being an artful photograph. The photograph functions for Steichen as a kind of aesthetic touchstone. By using a photograph that so obviously contradicts its caption's judgment of aesthetic and technical merit, Steichen is able, by extension, to establish the aesthetic quality of *all* of the images. At the same time, however, his interest in promoting the FSA pictures aesthetically contradicts his own statements about the locus of the photographs' power. Steichen argues in his essay that those who viewed the pictures, even photographers, "forgot" art altogether because they were so enthralled by the photographs' larger social and political import. But just as he turns to Millet and the Dada movement to explain the images of the sharecroppers and the organ, so too he uses the Lee picture to solidify an aesthetic reputation for the FSA as a whole. Steichen may wish to get beyond questions of art, but that desire is complicated by his apparent need to justify the images' aesthetic worth.

The final photograph to be considered from *U.S. Camera 1939* appears at the very end of the section. Unlike the others, featured two or three to a page, this

Figure 3.9. Untitled [Bethlehem graveyard and steel mill, Pennsylvania]. Photograph by Walker Evans (November 1935), FSA-OWI Collection, LC-USF342-00167-A. As reproduced in *U.S. Camera 1939.*

photograph of Bethlehem, Pennsylvania, by Walker Evans is printed over two pages (Figure 3.9). In addition to its large size and prominent position at the end of the special section, this photograph differs from nearly all of the others in that it is not paired with a caption. The image features a portion of a cemetery on a hill, with a cluster of small brick row houses behind and below the cemetery. Beyond and above the houses the thin, tall, black smokestacks of the local steel mill reach toward the sky. The photograph is a high-contrast image, with a stark mix of dark and light tones. Its primary visual feature is a huge white stone cross in the cemetery that dominates the foreground. The photograph has a nearly infinite depth of field, the result of which is that the entire image, even the most distant elements of the background, remains sharply in

focus. The image is a mix of vertical and horizontal planes, the horizontals of the porches and rooftops of the houses at play with the verticality of the cross and the smokestacks.

The overall impression one receives upon encountering this photograph is one of density. The cemetery butts up nearly to the houses, which because of the depth of field appear to butt up against the steel mills. It is a crowded, claustrophobic picture. The cemetery and the mill surround the small houses, sandwiching them uncomfortably in between. The depth of field is such that the three places—the cemetery, the houses, and the mill—appear to be nearly on top of one another, intruding upon one another's space. The key to understanding this image, it seems, is to consider these three distinct social spaces and their relationships to one another, for Evans's photograph implicates them in the same overlapping space.

The first thing to notice about the houses is their simplicity. These are not the homes of the wealthy, by any means. They are small brick row houses, crowded not only between the mill and the cemetery but also against one another—each uniformly designed porch separated from its neighbor by only a waist-high railing. If the home is supposed to be a private place to which one can retire for a break from the hectic world, these working-class homes do not seem to offer much respite or solace. They are dark, sparse, and too close for comfort—places in which outside forces may easily encroach upon one's private life.

One of those outside forces, and certainly the most powerful, is the steel mill. The crop of smokestacks signifies the dominant presence of industry. Evans's composition collapses space, giving the illusion that the mill is jammed right up against the row houses in which the mill's workers live. In a mill town, economic existence is entirely dependent upon and utterly implicated in industry. Evans captures this fundamental reality of industrial life in the photograph via the omnipresence of the tall smokestacks of the steel industry.

In turning to the cemetery, it is possible to fill in the third part of the equation. What does it mean that the house is encroached upon not only by the steel industry but by the cemetery as well? The cemetery, in fact, is what dominates this image. As Evans has composed the frame, a giant white stone cross fills the foreground, the most prominent element of the picture and by far the

most perplexing. The tension between the home and the mill is clear; the image asks us to recognize the ways in which the two worlds are implicated in one another. But what to make of the relationship between the home and the cemetery? There appear to be two possibilities, neither of which seems sufficient by itself. The first reading might go something like this: Three stages of life are represented in this photograph—birth, labor, and death. All are inevitable and they are intertwined with one another. We are born into a more or less private world, the world of the home, where we grow, more or less protected, until we are old enough to become self-sufficient. In order to become—and more important, to remain—self-sufficient, we must spend all of our lives laboring, day in and day out, just to keep our heads above water and stay alive. When we are too old to work, or when the stress and anxiety of our jobs have worn us down and ruined us, we die. The story that Steichen praises in the Evans image is, at its core, the story of our lives in the modern age: the eternal march from home to work to graveyard. The size of the cross and its rough-hewn stone are a permanent reminder of the inescapability of our future. Each day the laborers leave the houses and head to the mill, but one day they will turn in the other direction and head for the cemetery. There are no other choices. Thus read, the photograph is an image of drudgery, pain, futility, and hopelessness.

But this is not just any burial ground. It is a Christian cemetery, and the giant cross is a recognizable icon of redemption, resurrection, and new life. The encroachment of the cemetery on the world of the home may not be death knocking at the back door; it could be redemption from suffering offering itself to believers. The cross, while a symbol of death, also offers a symbolic resurrection to those who have suffered, whose lives have been deadened to the world of the spirit. Viewed in this way, the prominence of the cross becomes a beacon of hope, a reminder of a sacred space that cannot be infiltrated by the material world of industry. So the cross marks out a space of tension in the picture, an ambiguous and undecidable point of futility and hope. The photograph focuses attention on the encroachment of the world of labor upon the home, the interrelatedness of the private sphere and the sphere of industry, and on the relationship of both of these to death and to the world of the spirit.

Steichen clearly meant for the Bethlehem photograph to serve as a final statement for the section; its size, placement, and mention in his essay suggest

161

as much. But as a final statement, within the pages of a journal devoted primarily to the aesthetic aspects of photography, what does the Bethlehem image suggest? Unlike the Lee photograph of the farm implements, the Bethlehem image is not a picture about being an artful picture. The photograph *is* aesthetically remarkable in the way that it simultaneously visualizes the three interdependent worlds of the mill town. But like the image of the hands and plates, this photograph tells a story of moral weight. If the first Evans picture asks, "Am I my brother's keeper?" the Bethlehem photograph (the name of the town should not be lost on us here) answers, "How can you not be, given our interrelatedness?"[65]

The FSA special section ends, then, on this apparently documentary note. Has Steichen finally, with this last photograph, reached his goal of moving the FSA images beyond aesthetics and into a realm that for him is more meaningful: storytelling of a compelling social and political nature? The Bethlehem photograph, presented as it is without caption or much commentary, does visually embody a depth of meaning about the ways in which institutions affect our daily lives. But at the same time its very presentation—large, singled-out, without text to accompany it—also upholds its continuity with the same aesthetic conventions that guided *U.S. Camera* all along. Even if Evans's picture could stand alone as a documentary "story" without text to accompany it (and, given the reading above, it is clear that it can), Steichen still frames it as a unique, notable, individual aesthetic expression.

The False Dichotomy: Documentary "versus" Art

U.S. Camera's presentation of photographs was grounded in a series of assumptions about photography that, while progressive in terms of their democratic subject matter, presented photographs in ways that tended not to violate traditional norms and conventions of modern art. *U.S. Camera* treats photographs as individual, artful expressions made by uniquely talented photographers. Text, when present, often frames the photographs in aesthetic terms. The Historical Section photographs featured in *U.S. Camera 1936* are, however, able to resist total aestheticization. The intimate images of the two mothers contrast sharply with the formalistic nudes, suggesting that, even in an art context,

the documentary photographs retain a particularity and materiality not found in the more abstract images. In *U.S. Camera 1939,* by contrast, the FSA pictures are given their own special section; they are set apart. Having thus separated the pictures from the rest of the annual, Steichen is free to make arguments that subvert *U.S. Camera*'s own conventions for displaying photographs. Though his presentation of the FSA photographs sets the pictures apart from questions of aesthetics in order to highlight their social function, it ultimately fails to sep-arate these documentary images from questions of art. Instead of providing an answer about the relationship between documentary images and questions of art, the FSA special section merely restates the question in a particularly vivid way. It resists Steichen's stated purposes and serves instead as a compelling site of struggle over the meaning of documentary images within an aesthetic con-text—and, conversely, of the role of photographic art in documentary times. In the end, then, in *U.S. Camera* the Historical Section photographs do at times resist aestheticization, but in such a context they can never be wholly apart from art, regardless of what Steichen himself proclaims.

163

What the presentation of FSA photographs in *U.S. Camera* annuals reveals, then, is a false dichotomy at the heart of distinctions between the discourses of documentary and those of fine art. To be sure, the documentary genre has never maintained a complete dissociation from questions of aesthetics. But in his zeal to elevate the status of the FSA photographs beyond that of "mere art," Edward Steichen denies one aspect of what makes these documentary im-ages so compelling—their *artfulness.* The images in the context of *U.S. Cam-era 1939* assert their own aesthetic worth in spite of Steichen's conflicted at-tempts to deny it. And conversely, the FSA images presented as "art" in *U.S. Camera 1936* are still able to assert their documentary qualities. In the context of *U.S. Camera* the Historical Section photographs are not *either* (documen-tary)/*or* (art), but *both/and.*

Yet let us not conclude here by merely charging Steichen and Maloney with blindness on this point. To do so would undermine an understanding of the images as participants in rhetorically situated events. As best we can, we must consider the specific context in which Steichen, Stryker, and others worked, particularly the unique norms and institutional constraints that governed their rhetorical choices with regard to the FSA photographs. Thus, in the context of

this particular set of highly contested rhetorical and photographic practices, we would do well to ask whether Steichen's disavowal of the FSA photographs' aesthetic qualities is in any way a *rhetorically productive* move. If we consider the presentation of the FSA photographs in *U.S. Camera* in light of prevailing political debates about art and, more specifically, in light of institutional threats to the Historical Section itself, we shall see that both Steichen and Roy Stryker had a legitimate motivation for upholding the false dichotomy between the discourses of documentary and those of photographic aesthetics.

The ambiguous, often contentious, nature of the relationship between documentary and "art" during the New Deal era is vividly illustrated by a letter written to Stryker by Professor James McCamy of Bennington College in Vermont. In early 1938 McCamy invited Stryker to speak to his students about the FSA project. But he made it clear to Stryker that he desired little discussion of the artfulness of the FSA's work:

> My only suggestion is that you stay off "ART" and talk about photography as documentation and as a medium of information, education, publicity, propaganda, or whatever word you prefer to use for "publicity." Of course incidental reference to the aesthetic quality of a picture would be appropriate, but I wouldn't make esthetics [*sic*] a central or very noticeable part of the talk. You know as well as I how little can be accomplished in talking to artists on such debatable subject. . . . Of course your exhibit will be damned good art and will be recognized as such, but I know from experience that a social studies speaker is always more impressive if he stays off of esthetics.

If Stryker wanted to maintain a focus on the subject matter of the FSA photographs (and the proposed title of his talk, "Photographing a Third of a Nation," suggests that he did), then any insertion of "ART" talk would be only a frustrating distraction. McCamy explained further: "Well, there are a lot of artists around here, most of them having views on photography. . . . The artists would disagree, however, on what was art and what not art in the particular photograph."[66] For McCamy, any discussion of "ART" would serve only to divert the audience from the social and political goals of the project.

The efficacy of keeping discussions of art and documentary separate may be illustrated more generally by turning briefly to the example of the federal art projects of the WPA. The Federal Art, Writing, Music, and Theater Projects, collectively known as Federal One, suffered under the scrutiny of those who believed that government-sponsored art was aesthetically inferior. In the late thirties *Art Digest,* one of the most influential art periodicals of the day, called for "a more orthodox modernist lexicon of values for the production of art in America," which produced increased hostility toward artists employed by the government's art programs.[67] At the same time, the hostility went both ways. Federal Art Project discourse often defined its own goals by explicitly rejecting the "elitist" norms of museum and gallery culture. The project "was antagonistic toward modernist notions of art that seemed to place art and artists outside the society."[68] While the federal artists were cast by the project as patriotic, American "citizen artists" devoted to the visualization of the lofty goals of the New Deal, modernist artists were often framed as too out of touch, too avant-garde, or too "European."[69]

In addition to an ideological impulse to keep the discourses of art out of federal projects like those of the WPA and the FSA, a more practical institutional constraint most certainly came into play as well. As we have seen, New Deal projects were continually forced to justify their worth, particularly those projects that could be deemed "cultural" in nature. The anti–New Deal coalition in Congress consistently argued against federal funding for projects like those of the FSA and the WPA, claiming that they wasted taxpayers' money and encouraged communism and radicalism. Senator Everett Dirksen, for example, thundered against funding the Federal Theater Project on the floor of the Senate: "If you want this kind of salacious tripe, very well vote for it, but if anybody has an interest in real cultural values you will not find it in this kind of junk."[70] At the FSA, of course, Stryker recognized the precariousness of the Historical Section's position and lived with an ever-present fear that the photographic project might be eliminated at any time. There were those in Congress and elsewhere who continually questioned the need to spend public dollars on "mere photographs" in a time of national crisis. In the final years of the project, in a statement that Stryker submitted to accompany the section's budget

request, he does mention the photographs' "style," but his primary focus is squarely upon the section's documentary contributions:

> In the six years of its existence the FSA photographic section has made and assembled more than 50,000 photographs which record American civilization as no other civilization has ever been recorded. Everyone recognizes the FSA style, which at its best combines technical virtuosity with a mature, intelligent, and candid approach to the subject: the state of the nation in terms of the land and the people.[71]

Stryker was well aware that those with the power to eliminate the section would not be interested in the aesthetic quality of the FSA images. This emphasis on the documentary nature of the FSA's portrait of America was the key way to justify its continued existence; it was this narrative that had to be rhetorically available, even in the context of an "art" journal such as *U.S. Camera*.

That Edward Steichen understood this dilemma is clear from the thrust of his essay in *U.S. Camera 1939*. His insistence upon sorting out the documentary purposes of the FSA project from issues of aesthetics relies upon the construction of a false dichotomy. Yet we must understand further that the dichotomy is itself rhetorically productive, for it recognizes the realities of the time—that a government photography project created to publicize efforts to manage poverty could not align itself with the discourses of art and expect to survive. Terry Cooney has suggested that the decade of the 1930s may be best understood as a series of "balancing acts" in which competing forces and values jockeyed for influence: the desire to preserve tradition versus the desire to escape it, radicalism versus reform, "fact" versus "fiction."[72] To this list we might add the rhetorically productive dichotomy of "documentary" versus "art." While the photographs of the FSA were by no means the only cultural expression that negotiated the balancing act between documentary and art, they do serve as vivid and memorable examples of its pervasive influence.

Up to this point the FSA photographs have been examined as they appeared in two different contexts of 1930s print culture: the bureaucratic social welfare context of *Survey Graphic* and the aesthetic context of *U.S. Camera*. In both periodicals, the narratives of poverty made rhetorically available in each con-

text are not stable or fixed, but rather messy and permeable. On one level, the contexts of *Survey Graphic* and *U.S. Camera* do appear to make certain readings of the images more or less rhetorically available. Yet as often as the Historical Section images reflect the assumptions of their insertion into a particular context, they also question their insertion into those very contexts, challenging the available rhetorics of poverty in each case. In *Survey Graphic,* photographs such as "Migrant Mother" and Ben Shahn's picture of the Arkansas sharecroppers defy the texts' attempts to define a social science rhetoric of poverty. In *U.S. Camera,* the FSA photographs challenge an aesthetic rhetoric of poverty that would seek to separate art from documentary.

167

Although the Historical Section photographs circulated widely in *Survey Graphic* and *U.S. Camera,* the potential audience reached was quite small. Each periodical had a modest circulation (around 25,000 per issue), narrowly limited to those readers with particular interests in social welfare issues or photography. The periodical in which the FSA images achieved perhaps the widest circulation was also the one that presented the most tightly controlled poverty narratives: *Look* magazine. Through the new genre of the "picture magazine," in the pages of *Look,* the Historical Section images were made to communicate a spectacle-driven, "popular" rhetoric of poverty.

FOUR

Spectacle of the Downtrodden Other

POPULAR RHETORICS OF POVERTY
IN *LOOK* MAGAZINE

*The people have become very photographic minded
(since the advent of "Life" and "Look" magazines).*

—RUSSELL LEE, MEMO TO ROY STRYKER,
SEPTEMBER 1940

In March 1937 a writer for the *New Republic* observed of the new picture magazines: "Hardly any mental effort is required to look at a picture and to spell out a few lines of accompanying caption, written in primer English. The attractiveness of such periodicals is enhanced if the pictures are themselves sensational, faintly salacious, or gruesome." The brand-new magazine *Look* was singled out for special criticism, the author noting that it was "a combination morgue and dime museum, on paper."[1] Commentator J. L. Brown, writing in the *American Mercury,* concurred, noting that *Look* was "a fitting title for a magazine aimed at a public afflicted with adult infantilism."[2] Indeed, given that some picture magazines, including *Look,* tended to publish garish photographic stories such as "Auto Kills Woman Before Your Eyes!" and "Will Former Dope Fiend Rule Germany?" both critics might be forgiven for their alarmist tone.[3]

Sensationalism in journalism was hardly new, but critics (particularly those in literary circles) responded to the new periodicals with suspicion. Indeed, in

the middle years of the Depression a revolution was taking place in American media. Beginning in the early thirties, Henry Luce, the father of *Time* and *Fortune*, had determined that America needed an illustrated photographic magazine along the lines of the highly successful European picture magazines. Yet it was not until 1936 that Luce was able to produce one that lived up to his editorial and technical standards: *Life*. Halfway across the country the Cowles brothers, newspaper moguls from Des Moines, decided that their success with a special Sunday picture section in the *Des Moines Register* warranted exploring the possibility of producing their own picture magazine. Just a few months after *Life*'s debut, they launched their venture and called it *Look*.

169

Only one year separated the birth of the Historical Section and the founding of *Life* and *Look*. Surprisingly, *Life*—the most popular of all the picture magazines—only rarely published Historical Section photographs in the late thirties; instead, it was *Life*'s upstart competitor *Look* that most often circulated the images to a mass audience. Curiously, however, *Life* is often assumed to be one of the venues where the FSA photographs frequently circulated; even some FSA scholarship implies a closer relationship between the magazine and the section than appears to have existed.[4] Attention to the archive, on the other hand, shows something a bit different. Such historical amnesia prompts several questions: If the picture magazines developed at roughly the same time, why was *Look* the primary outlet for the section's images, rather than the more popular and respected *Life*? What precipitated the assumption that *Life* was a heavy user of the FSA photographs? And, perhaps most important, what are the rhetorical implications not only of the circulation of the FSA's images of poverty in *Look* but also of their relative *non*-circulation in *Life*?[5] Exploration of these questions provides the occasion to consider more directly the complexities of rhetorical circulation of the FSA images in 1930s visual culture.

A confluence of social, economic, and technological developments in the production, reproduction, and consumption of photographs made the picture magazines possible, and Roy Stryker sought to establish the Historical Section's reputation in relation to the new genre. Here the question of circulation takes center stage. As we shall see, a series of letters exchanged between Dorothea Lange and Stryker on the subject of *Life*'s (non)use of Lange's photographs not only questions the common assumption that the FSA photographs circulated

unproblematically in *Life* but also suggests that the circulation of these images in the picture magazines was complex and not guaranteed. In contrast to the non-circulation of the FSA images in *Life*, however, is their circulation in *Look*. Mobilizing a vision that deemphasized current events in favor of what was merely "current," *Look* deployed the Historical Section pictures to produce an image of the downtrodden other that differed little in tone from the less serious subjects covered in the magazine. By allowing its readers to venture voyeuristically into the realm of rural poverty—just as they might peer into the homes of Hollywood celebrities—*Look* made rural poverty a fictionalized spectacle, something to "LOOK" at, but not to engage as a social or political reality.

Origins of the Picture Magazine: Reproduction, Production, and the Technology of Consumerism

The technological innovations that made the new genre of the picture magazine feasible—and marketable—occurred on two fronts. First, improvements in techniques of *photographic reproduction* enhanced the ability of publishers to produce high-quality photographs in the pages of newspapers and magazines. *Life* and *Look* could not have appeared when they did without the availability of good photographic reproduction in the periodical form; other illustrated magazines and newspapers had failed because they could not achieve sufficiently high-quality reproduction.[6] The picture magazines' success also depended upon the sheer availability of "good" photographs. As a result, advancements in *photographic production* were also crucial. Without the cameras that allowed photographers to get the candid, spontaneous "shots" that became increasingly prized during the late twenties and early thirties, magazines like *Look* and *Life* would not have been able to establish their unique styles.

Before the late nineteenth century, photographs could not be reproduced directly in newspapers and magazines. Instead, they had to be converted to wood or metal engravings by a trained engraver. By the early 1880s Frederick Ives and others who had begun experimenting with the "halftone" process began to get reproducible results. By the turn of the twentieth century, the publishing industry had moved solidly into using halftone technology. Magazines such as *Harper's, Illustrated London News,* and *Leslie's Weekly* routinely

reproduced photographs in their pages, and these reproductions sometimes outnumbered the drawings in a given issue. Because the quality of newsprint was not as conducive to halftone reproduction, newspapers lagged somewhat behind the magazines, but eventually they, too, employed halftones regularly.[7]

Halftone provided significant benefits to magazine and newspaper publishers when compared to earlier modes of image reproduction. First, halftone allowed for automated production of visual material at a substantially reduced cost, enabling publishers to charge less for their products and expand readership into the working classes. In addition, halftone produced a more complete marriage of print culture and the increasingly visual world of advertising, enabling advertisers to use photographic images in their ads for the first time, thus enhancing the realism of their products.

As the technical barriers to high-quality photographic reproduction in print were eliminated, and as newspaper editors came to see the benefits of using photographs, they began to collect them in what became known as "Sunday supplements." The first Sunday editions of newspapers appeared in the 1880s, and over time they came to feature "supplements" containing illustrations and literary content similar to that found in magazines of the day.[8] The *New York Times* began reproducing halftone photographs in its Sunday supplement in 1896. In 1914 the *Times* launched an expanded tabloid supplement called the *Mid-Week Pictorial*. Originally conceived as a visual record of the war in Europe, the *Mid-Week Pictorial* eventually carried content of about 95 percent pictures, mostly of recent news events.[9] During the twenties the publication languished in circulation but, in the spirit of the popular European illustrated magazines, experimented with using fewer news photographs and more photo-stories and sequences of related photographs.[10]

Sunday tabloid supplements, known as rotos since they were produced by the rotogravure process, became increasingly popular in the twenties. The Cowles brothers, publishers of the *Des Moines Register,* found out just how popular tabloids had become in 1925 when they commissioned a young public opinion researcher named George Gallup to survey the newspaper's readers. Gallup discovered that the best-read stories in the *Register* were those that contained both pictures and text. This information convinced the Cowles brothers to revitalize their Sunday supplement and turn it into a Sunday "picture

magazine." While most rotos published a hodgepodge of unrelated photo-graphs, Mike Cowles elected to focus on photo-stories, series of related pictures and text. The new approach brought success, as Sunday circulation rose from 200,000 to 300,000 readers.[11] In 1933, four years before publishing the first issue of *Look,* the Cowles brothers started their own photographic service and "sup-plied themselves with the type of pictures they wanted. Their narratives-in-pictures became so successful that they syndicated roto pictures to twenty-six large newspapers."[12] In essence, the Cowles brothers used their Sunday supple-ment as a testing ground for their ideas about what might work in a national picture magazine.[13]

Henry Luce was also experimenting with photographs in his successful magazines, *Time* and *Fortune.* Luce and his Yale schoolmate Briton Hadden had founded *Time* in 1923 as a summary of the week's news, conveniently di-gested for the businessman who was too busy to keep up with a daily news-paper. By the early thirties, *Time* boasted a circulation of 500,000 readers per week.[14] In 1930 Luce founded *Fortune,* intending it to be a substantial, intellec-tual business periodical designed for "the coming tycoon," the "well-educated chief executive officer" who was a "cultivated citizen of the world."[15] Despite the unfortunate timing of its launch (just months after the 1929 market crash), within four years *Fortune* was turning a profit.[16] Luce was interested in the possibilities created by the new miniature cameras (what we know today as standard 35mm cameras), which could produce more-candid photographs because of their faster shutter speeds and more portable size. The public's de-sire for candid photographs, particularly of celebrities and public figures, made possible the market for *Life* and *Look* and popularized the technology of the "mini."[17]

Miniature cameras, such as the popular German-made Leica, had a number of desirable features that distinguished them from the larger-format cameras already in use. First, rather than using sheets of film that required frequent switching, the miniature camera used long strips of 35mm movie film. For the first time, photographers could make multiple exposures of one scene, often in quick succession. In addition, the miniature camera featured a small view-finder on the back. The photographer could hold the camera directly up to the eye rather than having to focus the image on a glass plate. And the cameras

were simply smaller than other cameras. A Leica could fit in the palm of the hand and weighed only a few pounds. An early article on miniature photography in *Fortune* magazine pointed out the shock value of the new object, a strangeness that is hard to fully appreciate today: "The Leica didn't even *look* like a camera. No bellows, no bulk, no focusing hood; you shot from the hip, so to speak, and got your man."[18] The technology fundamentally changed the relationship of the photographer to what he or she photographed. Wilson Hicks, longtime *Life* magazine photo editor, observed: "With the introduction of the Leica, a vitally different relationship was set up between the photographer and the world about him. . . . Combining large lens and small negative size, the Leica could preserve, in picturing a scene or situation in existing light, the quality of naturalism."[19]

Not surprisingly, the camera manufacturers heavily publicized the new cameras' possible uses—particularly the way they might be used for "candid" photographs. Beginning in the mid-1920s, an amateur photographer named Erich Salomon sought to photograph people in candid poses, when they were clearly unaware of the presence of the camera. In 1928 he took up the Leica and began photographing celebrities and international political figures caught unawares; in 1930 the German picture magazine *Berliner Illustrierte Zeitung* published several of his so-called candid-camera photographs.[20] In these years, *Time* and *Fortune* publisher Henry Luce became aware of Salomon's work and hired him to photograph some assignments for *Fortune*.[21] As a result of his well-publicized images, Salomon became a role model for a generation of younger photographers interested in the possibilities of the "candid camera." News photographer Peter Stackpole solidified the American reputation of the miniature camera in that respect when *Time* published his photograph of former president Herbert Hoover sleeping during a speech by Labor Secretary Frances Perkins.[22] The power of the mini as a "candid camera" combined with the opportunities that it presented to criticize and mock those in power made the new technology incredibly attractive.[23]

Fueled by the success of his photographic experiments with *Time* and *Fortune*, in the early thirties Luce became interested in the possibility of a picture magazine. In Europe, such magazines as *Vu, Berliner Illustrierte Zeitung,* and *Illustrated London News* were extremely popular with readers. The circulation

of Germany's *Berliner Illustrierte Zeitung,* for example, reached more than two million in the years following World War I.[24] The prospect of high-quality mass production, coupled with heavy readership, was enticing to publishers such as Cowles and Luce, for heavy readership meant lots of consumers and lots of potential advertisers for a new picture magazine. Between 1909 and 1927, the percentage of periodicals' income that came from advertising rose significantly, from 51.6 percent to 63.4 percent.[25] The number of national advertisers turning to magazines grew during these years as well, illustrating the importance and vitality of a national public culture increasingly bound together by the mass communication trio of radio, film, and print—with advertising linking all three.[26]

174

Americans were becoming more comfortable with the presence of visual images in all aspects of their lives. Most Americans had photographs in their homes in the form of family portraits and snapshot albums, and they had long accepted images as a feature of print culture as well. The rise of the picture magazines not only influenced the reach that the Historical Section was to have, but it also signaled the growing receptivity of the American public to the telling of visual narratives. In 1940 Russell Lee prepared a report designed to demonstrate the continued need for projects like those of the Historical Section, arguing that the American public was ready for education by visual means:

> The people while evidencing a great interest in government are not but only vaguely aware of their rights, their privileges, their duties and their obligations towards their government. As the people have become very photographic minded (since the advent of "Life" and "Look" magazines) it is felt that the photographic presentation of the above would be the quickest and most effective way.[27]

Lee implies here that the picture magazines had paved the way for visual education of the type in which the Historical Section engages. Lee's argument that *Life* and *Look* had made the public "photographic minded" demonstrates the affinity that Stryker, Lee, and others found between the picture magazines and the Historical Section's own goals. Interestingly, Lee's report anticipates arguments that Warren Susman was to make about the culture of the thirties

decades later. Americans' acceptance of an increasingly visual culture, Susman argued, had implications beyond the mass media:

> The photograph, the radio, the moving picture—these were not new, but the sophisticated uses to which they were put created a special community of all Americans . . . unthinkable previously. The shift to a culture of sight and sound was of profound importance; it increased our self-awareness as a culture; it helped create a unity of response and action not previously possible; it made us more susceptible than ever to those who would mold culture and thought.[28]

"Those who would mold culture and thought" constituted the mass culture industry, which grew in power by increasingly treating the scene of culture as a *market,* the production of culture as *product. Life, Look,* and their competitors certainly participated in this transformation.

Rush to the Newsstand: *Life* and *Look*

Life and *Look* were not the first, and certainly not the only, picture magazines to appear in the 1930s, but they were the most successful and by far the most widely read. By most accounts, Henry Luce became interested in the idea of a picture magazine sometime in 1931; by early 1934 he was fully committing the resources of Time, Inc. to the task of investigating whether a picture magazine would be viable.[29] From December 1933 to June 1934, Luce assigned several Time, Inc. employees to work in its first "Experimental Department." But it was not until 1935–36 that technology advanced to the point that Luce could get what he wanted. Using a new kind of coated paper produced in rolls rather than sheets, printers could publish the magazine on a high-speed rotary press while at the same time preserving a high degree of image quality.

After many rejected dummies, *Life* debuted on November 23, 1936. Its cover featured a dramatic photograph of the Fort Peck Dam by Margaret Bourke-White, a visual testament to the culture's twin triumphs of modernism and technology. The magazine's immediate popularity surprised Luce, who was unprepared for such instant success. Partly to keep costs down and partly to fuel interest in the magazine, he kept *Life*'s early print runs to a minimum. On

the first day, the 250,000 copies of *Life* sold out, and people scrambled to find copies on the newsstands. By the end of its first year of publication, *Life*'s circulation was reaching 1.5 million per week.[30]

Despite *Life*'s instantaneous success, *Scribner's* deadpanned, it "has broken practically all money-losing records."[31] To entice early advertisers, *Life* had offered extremely low rates: "Before anyone knew what its circulation would be, the magazine's advertising department went after all contracts it could get, with rates set for a circulation of 250,000. When *Life* rode to well above a million, advertisers holding contracts jumped in with full schedules to get the circulation premium."[32] For all of 1937, then, *Life* had to carry advertising at the rate of $1,500 per page; only in 1938 did the new rate of $5,700 per page go into effect.[33]

The Cowles family of Des Moines watched *Life*'s struggles and successes with great interest, for they too had plans for a picture magazine. A midwestern newspaper publishing company, Cowles was guided by two brothers, John and Gardner (known universally as "Mike") Cowles. Their father, Gardner Cowles Sr., had bought the *Des Moines Register and Leader* in 1903 and turned it into the dominant newspaper in Iowa.[34] By the mid-twenties, sons John and Mike had taken over the editorial operations of the newspapers and acquired other midwestern newspapers, giving them the beginnings of a media empire.[35]

Mike Cowles was not a photographer, but early on in his newspaper career he became interested in experimenting with visual images. He had revitalized the *Register*'s languishing Sunday supplement in response to the polling of George Gallup, and successful syndication of the picture section to other newspapers further demonstrated reader interest. Mike Cowles recalled in his memoirs that his desire to produce a picture magazine originated in 1933, when he constructed a feature for the Sunday rotogravure section using images from an illustrated book on World War I; the venture was highly successful and was eventually syndicated to other newspapers.[36] "The enthusiastic reaction from readers," Cowles later recalled, "did more than confirm again my belief in the popularity of photojournalism."[37] First Cowles explored the possibility of producing a national Sunday supplement (similar to today's *Parade* magazine), but he rejected that idea because Sunday supplements were notoriously un-

profitable ventures. He noted: "The way around this problem was obvious: a separate picture magazine—costing ten cents, I reckoned—to be sold on newsstands."[38] Though no one in the Cowles family had experience with magazines, the brothers forged ahead and in 1936 began assembling what would eventually become *Look.*

After hearing a rumor that Henry Luce was preparing his own picture magazine, Mike Cowles took a dummy of *Look* to Luce in 1936. The men thought that the two magazines would in fact be quite different. *Life* would be a weekly, *Look* a monthly; *Life* would focus on news while *Look* would be feature-oriented; *Life* would be aimed at the middle and upper classes, while *Look* would cultivate a more middle-to-working-class readership. Convinced that the Cowles venture would not be a direct competitor, Luce decided to invest $250,000 in *Look.*[39] Later that year, *Look* even took out an ad in the first issue of *Life,* advertising its own upcoming debut.[40]

John Cowles persuaded his brother to postpone bringing *Look* to the newsstands until they could gauge the success of *Life*'s debut. The miscalculation of *Life*'s circulation and advertising rates, and the resulting financial losses, confirmed Mike Cowles's position that *Look* should wait to accept advertising. In his autobiography he commented on the state of the business during the first few months of *Look*'s publication:

> We knew *Look* was a big risk, and the idea was to keep that risk as low as possible. We had a staff of only 18 which was working out of cramped offices on the 11th floor of the Register and Tribune Building in Des Moines. We were borrowing most of our pictures from the newspaper's morgue. By the same token, we thought it was unwise to go to all the expense of organizing a high-powered advertising department when we might not have a magazine to put ads in a few months down the line.[41]

In addition to serving as an early cost-cutting measure, waiting on advertising also allowed the Cowles brothers to better predict the magazine's circulation and set advertising rates accordingly. Thus *Look* would be able to avoid the money problems that were plaguing Luce and *Life.*

Unlike *Life,* which had waited to publish until Luce could be assured that a

high-quality, state-of-the-art product was feasible, *Look* was published cheaply, by the same rotogravure process used for most Sunday supplements and roto sections. The Cowles brothers even touted the amateur status of their venture. They took out an ad in the trade journal *Editor and Publisher,* proclaiming: "Two newspapermen who have had no magazine experience announce a new publishing venture."[42] Of their magazine's technical quality, they offered a barb clearly aimed at Luce and *Life:* "Don't look for coated paper or fancy printing. Do look for reader interest!"[43]

Look's first issue, dated February 1937, went on sale on January 5, 1937, just six weeks after the highly successful debut of *Life*. The cover declared: "Keep Informed . . . 200 Pictures . . . 1001 Facts!" On page two, underneath a dramatic photograph of a bull attacking a bullfighter (captioned "Bull Bites Man"), Mike Cowles offered *Look*'s statement of purpose: "*Look* is an educational magazine for *EVERYONE*. It is the belief of the editors of *Look* that the news of the world can best be told today in well edited pictures — not in long columns of type."[44] The claim that the dramatic photograph now trumped the word would be oft repeated in the pages of *Look,* fueling critics' beliefs that the magazine was, at best, lowbrow.

The first issue featured a cover story on Germany's Hermann Goering, asking, "Will Former Dope Fiend Rule Germany?" Other stories included "Roosevelt — Why So Popular?" and "Can Life Be Restored to the Dead?" That month's celebrity feature offered a multipage narrative of Joan Crawford's life and career, heavily illustrated with photographs. When the first issue's print run of 400,000 looked to be a sellout, Mike Cowles ordered another printing of 300,000.[45] Then he discovered a rather idiosyncratic reason for the issue's huge success. The back cover of the magazine, advertising the next month's celebrity feature, showed a large head-and-shoulders photograph of Greta Garbo. Cowles recalled: "Within a few days we discovered one of the main reasons for reader interest: the Garbo picture. It turned out that when the page was folded in half, the result looked very much like a female crotch. Word of this curiosity spread with amazing speed." Cowles learned that a particularly alert telegraph operator had first noticed the "foldover effect" and had taken the opportunity to spread the information around the country to his fellow telegraphers.[46] After police in Montreal seized hundreds of copies, the Cowles brothers were forced

to recall more than $100,000 worth of unsold copies of the first issue.[47] Despite the embarrassment that the event produced for the fledgling magazine, the Garbo controversy also gave the Cowles brothers considerable free publicity and helped to fuel newsstand sales for months to come.

The "Garbo problem" persisted, as *Look* was branded a "sensational" publication. The incident produced a reputation that *Look* had trouble shaking but that was not undeserved. Though Cowles often complained that the "Garbo problem" had given the publication the unfair stigma of being tawdry, in fact *Look* embraced sex as a taboo subject. The controversy tellingly foreshadowed the magazine's participation in the construction of a modern image industry based upon sex, participation that proved profitable for Cowles.

The Famous, the Salacious, and the Curious: *Look*'s Vision of the Picture Magazine

In 1945 Daniel Mich, *Look*'s executive editor, and Edwin Eberman, the magazine's art director, published *The Technique of the Picture Story: A Practical Guide to the Production of Visual Articles*. The book was an outgrowth of a writing course the two men had offered at New York University. Proclaiming "picture-writing" to be "the most radical and recent advance in modern journalism," the authors explained that their book would help students learn how to write for picture magazines.[48] The book offered insight into the assumptions about photographs, text, and audience that grounded *Look*'s approach in its early years as it sought to define the new genre for itself.

The authors began by observing that "picture-writers" do not need to know much about the technical aspects of photography in order to successfully construct a picture story. However, they "must have an understanding of picture values and picture effects"—in other words, the writer must know how to identify a good visual story.[49] Mich and Eberman argued that a good picture story should contain a sharply focused narrative, employ photographs with "impact," focus on people as opposed to things, and recognize that universal interest transcends spot news.[50] Because picture stories take planning, they become dated and hence less newsworthy; therefore, they must have some angle that makes them interesting in a non-news way.[51] Indeed, *Look* held faithfully

to the tenet that spot news must be avoided. With rare exceptions, the magazine seems both of its time and curiously uninformative about its time. Although *Look* absolutely reflected the trends, impulses, and practices of mass culture in the late thirties, it seldom made explicit reference to specific events, whether social, cultural, or political.

"Picture-story writing," the authors explained, is like other forms of writing in that its main goal should be effective communication with the reader. Yet picture-story writing is different in that it is more "popular" than other forms of writing. "Do not let the adjective frighten you," they advised, "even though it may be spoken with derision by your more intellectual friends." Writing for a mass audience is not a debased activity, they asserted: " 'Mass' means all kinds of people, high and low, rich and poor, Phi Beta Kappas and fifth-graders. Communicating facts and ideas to such a cross section of humanity in a single medium is possible but many writers with 'literary' reputations have never learned how to do it."[52] One goal for a *Look* picture story, then, was that its text should be clear and simple in order to communicate to the broadest audience possible. Of course, such an approach opened up the magazine to criticism from its "more intellectual friends," as Mich and Eberman were aware.

What is important about Mich and Eberman's discussion for this study is that it demonstrates the existence of a relatively well-conceived set of editorial standards by which *Look* operated. Although *Look*'s own editorial vision was far from coherently realized in its early years, the ideal was already in place, and that ideal differed in certain ways from the norms that defined *Life*. Mike Cowles described the content of *Look* in relation to the content of *Life* with an analogy to newspapers: the kind of people who read *Life* would be people who read the *New York Times*, while people who read *Look* would be more likely to read the *Daily News* (Figure 4.1).[53] Indeed, *Look* spent many years fighting the reputation that it was a "working-class," more sensationalized, version of *Life*. Part of that reputation stemmed from the furor over the first issue's "Garbo problem." In addition, the graphic design of early issues of *Look* was crudely amateur. Because *Look* was printed on inferior paper and used the less expensive rotogravure process (while *Life* used expensive coated paper), the visual quality of its pages suffered. By the early forties, when *Look* sought to improve

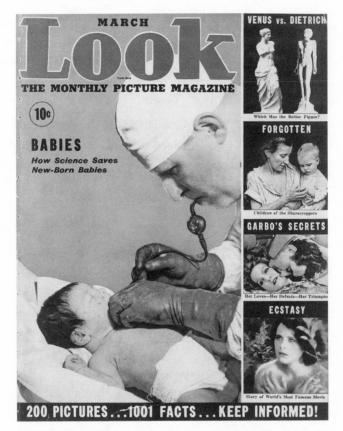

Figure 4.1. *Look*'s second issue, March 1937. Courtesy Library of Congress.

the physical production of the magazine, it had already acquired a reputation as *Life*'s lower-class cousin.

The quality issue and scandals like the Garbo fiasco were not the only reasons for the perception that *Look* was sensationalized. Because *Look* was not a weekly, it could not cover the news as *Life* attempted to do. Instead, Mike Cowles framed *Look* in much the same way as he had framed the *Register*'s Sunday supplement—as a human-interest feature magazine. In *Scribner's,* Jackson Edwards described *Look*'s editorial content as "old stuff, tried and proven."[54] *Look* editors, Edwards said, had classified the content of the magazine according to thirteen areas of human interest: personalities, romance, beauty and

fashion, self-improvement, child and animal interest, movies and stage, religion, health and popular science, adventure and travel, social problems, sports, curiosities and oddities, and fiction.[55] While each of these elements may be found in *Look,* its early issues tended to focus on only three: personalities, self-improvement, and curiosities and oddities. Though serious social problems and political issues occasionally took center stage in the pages of the magazine, such coverage was typically not connected explicitly to particular news events.

The Cowles brothers did not pretend to be magazine experts, and *Look's* early appearance, especially when compared to early issues of *Life,* evidenced its founders' amateur status. A typical issue of *Look* from 1937 used a layout that can best be described as affected and cartoonish. Early on, its photographs were cropped into odd-looking shapes, including circles and squares, giving some of the images a "cookie-cutter" look (see, for example, Figure 4.2). By contrast, Luce, in directives to his staff at *Life,* spoke out against garish cropping techniques.[56] The crude photographic manipulation contributed to an overall look that was not graphically sophisticated. The amateurish layouts also added to the perception that *Look* was *Life's* pale imitator.

In later years, *Look* overcame its initial problems with layout and developed a style more similar to *Life's* "group journalism" approach. From the start, *Life* differed from *Look* in its use of photographs. While Cowles relied in the early years on his newspaper's photo morgue and wire services, Luce saw that *Life* must do more to acquire compelling photographs. Staff photographers at *Life* appeared on the masthead with writers and were treated with equal respect at a time when, as James Baughman notes, "few journalism schools taught photography" and "unflattering stereotypes burdened the photographer."[57]

Editorially, Cowles's magazine lived up to its command to readers to "LOOK." Celebrities, particularly Hollywood movie stars, constituted much of the content of each issue. Early issues featured a celebrity on the cover and a multipage "photo-biography" of that person inside, outlining important events in his or her life and career. The text accompanying the photos was often fluffy and worshipful ("*Look* Calls on Ann Sheridan and Finds Her in Slacks, Drinking Iced Coffee"), but not all celebrity information published in the magazine was flattering.[58] For example, the June 8, 1937, issue discussed recent Hollywood divorces and showed photographs of Fred Astaire without his toupé.[59]

The new mass culture industry, fueled in part by the technology of the "mini," was transforming the business of Hollywood.

As the Garbo problem somewhat accidentally foreshadowed, a favorite subject of picture magazines was sex. The female body was frequently and overtly displayed in the pages of *Look*. The earliest issues of the magazine always featured a celebrity centerfold photograph, typically a starlet in a bathing suit or evening gown. In March 1937 *Look* published five pages of "exclusive" stills from the Czech film *Ecstasy*, featuring a topless German actress named Hedy Kiesler (later known to American audiences as Hedy Lamar); the film had been banned in the United States for its graphic nudity and sexual content, and *Look* touted that fact on its cover (Figure 4.1).[60] In later years, Mike Cowles complained of *Look*'s attempts to include "sex" in its issues:

> In reflecting on it, I have to admit that *Life* was much more adept than we were in injecting sex into its issues. When they published a nude, it always seemed to be part of an anthropological study, or an illustration of "great art," or in pursuit of some other high-minded purpose. *Life*'s nudes were seen as educational. Our [*sic*] always seemed to be regarded as sensational.[61]

Note that Cowles does not suggest that such images might be inappropriate or represent prurient appeals to the image market. He merely bemoans the fact that *Look* was unable to get away with a more upscale contextualizing of the images.

Self-help articles, most of them aimed directly at women, also dominated *Look*'s early issues, and "curiosities and oddities" also figured prominently. The first issue alone offered fuzzy images of a car wreck with the headline "Auto Kills Woman Right Before Your Eyes!", a photo feature on hermaphroditic athletes, and a photo-story of "Interesting Facts about Japan" that included a detailed description of the ritual of hara-kiri.[62] The exotic, or cultural other, often figured as a "curiosity" in the pages of the magazine, embodying the commodified orientalism that Edward Said and others have so eloquently exposed.[63] "Odd" global customs and practices were vividly described, in ways that emphasized their strangeness to mainstream American culture and marked them as other. In March 1937 *Look* offered two visions of the cultural other in two

separate features, one a "how-to" story titled "Hindu Rope Trick" and the other, "A Savage Buys a Wife," a picture story about arranged marriage in African tribal nations.[64] *Look*'s exploitation of the cultural other was echoed in its use of the Historical Section photographs; the magazine characterized the poverty of the photographic subjects as odd, curious, and decidedly different from the experiences of *Look* readers.

184

As the magazine matured, its layouts lost their cookie-cutter style. Although the content itself did not change much, it did become more structured. By 1939 and 1940 the content of *Look* had been organized into a relatively stable collection of "departments," similar to those in *Life:* American spotlight (nationally oriented features), brainteasers, including *Look*'s trademarked "Photocrime" game (in which a crime was visualized in a series of photographs, the viewer urged to solve it by scouring the images for visual evidence), fashions, humor, letters, movies, people, sports, and world spotlight. Through its comprehensive and diverse content, the magazine aimed to offer what one *Look* staffer described as "a balanced diet of reading and looking for our customers."[65]

Despite this mix of the famous, the salacious, and the curious, editors did not completely ignore contemporary social problems in the pages of the magazine. While *Look* was never intended to be a newsmagazine, Mike Cowles believed that the magazine should comment on pressing social issues, particularly those that could be easily portrayed in pictures. In later years, when asked about the magazine's "sensationalism," Cowles often turned to these examples to argue that *Look* was in fact not sensational but merely interested in the human condition. Even in its earliest years, *Look* featured discussion of social problems. Famed American political writer Drew Pearson contributed occasional commentary to the magazine. *Look* offered some coverage of (admittedly extreme) aspects of American race relations by featuring (and expressing outrage at) images of a public hanging of a black man in Kentucky and publishing an "exposé" of the Ku Klux Klan.[66] It received accolades (in some circles, grudging accolades) for its two-part series on civil liberties published late in 1937.[67] And rural issues such as farm tenancy and migrant agricultural labor appeared in the magazine, often accompanied by Historical Section photographs.

What made the picture magazines popular, the *New Republic* argued, was

not a "new" interest in pictures, but rather the mindless presentation of "sensational" photographs. The *American Mercury*'s J. L. Brown went even further and predicted the imminent downfall of American civilization. In a move similar to Theodor Adorno's later critique of mass culture, he traced the beginning of the end to the birth of motion pictures and tabloid newspapers, naming picture magazines as only the most recent manifestation of the problem: "Their genius consisted in discerning what the mob wanted, then feeding it in great gulps. . . . Hordes of people who never ruffle the pages of a book devour with fierce interest the pictures of sex and death which the tabloids print as news. The average man is the average tabloid reader, which is, of course, the chief reason why both remain average."[68] Noting Mike Cowles's belief that *Look* employed a "picture language" that would appeal to readers, commentator Brown noted wryly: "It might be observed that cave men had the same idea, but that was a long, long time ago."[69]

Despite the initial widespread criticism of the picture magazines, both *Life* and *Look* quickly became popular outlets for photographs and picture stories aimed squarely at a mass audience. Circulation was high even though many of the picture magazines debuted during 1937's deep economic downturn. *Business Week* reported in December 1937 that *Life*, just over a year old, had a circulation of 1.6 million readers, almost evenly split between subscribers and newsstand sales. *Life*'s readers were also generally well-off people. A survey reported that 57 percent had incomes of more than $3,000 per year and fewer than 5 percent had incomes less than $1,200. By the end of 1937, *Look* boasted a more widely fluctuating circulation, topping out at two million (higher than *Life*'s but with fewer subscriptions) and then falling to roughly 1.5 million on average.[70]

For Roy Stryker, while publication of the Historical Section photographs in the pages of such magazines might not result in praise from literary or aesthetic quarters, it would bring the images to a vast number of people. And that, in turn, would enable him to continue to justify to Congress and others in Washington the need to renew and extend the project's always threadbare budget. Given the ubiquity of both *Life* and *Look*, and Stryker's desire to keep the section running, one might wonder why *Look* was the dominant picture

magazine outlet for the FSA photographs in those years. An answer to that question involves exploring the historically specific complexities of circulation and the often contradictory motives of Roy Stryker.

"More *Life*-Like": Picture Magazines and the Question of Circulation

186 *Life* debuted with an issue dated November 23, 1936; coincidentally, that same day Mike Cowles wrote a letter to Roy Stryker asking for a sample of the Resettlement Administration's photographic work. Cowles noted that his brother-in-law, who was working in Washington for the secretary of agriculture, "mentioned that you have a very fine collection of intimate pictures of typical families of the type to be reached by the Resettlement Administration."[71] Cowles was interested in the Historical Section's pictures, he noted, because "confidentially, we are now in the process of establishing a new national picture magazine." He went on to make a specific request: "I should much appreciate it if you would mail me a fairly large number of pictures which show the worst conditions in the south, pictures which might run under the caption 'Can such conditions possibly exist in the United States?'"[72]

When compared to other periodicals, such as *Survey Graphic*, *Look* may not appear to be an obvious choice for the section's pictures. Its early reputation as a sensational publication and its focus on celebrity and curiosity would not have made it an obvious candidate for the publication of government-sponsored photographs of poverty. But Stryker's goal, both as a bureaucrat and as a proud collector of images, was to get the images *seen*. In late 1936, when Stryker was first contacted by Mike Cowles, the FSA photographs had had little circulation outside of government publications and a few specialized periodicals such as *Survey Graphic* and *U.S. Camera*. Magazines like *Look* offered the possibility of mass circulation, the chance for the Historical Section photographs to reach a wide national audience of hundreds of thousands—perhaps even more than a million—"average Americans." In letters to photographers throughout 1937, Stryker wrote often of both *Look* and *Life* as prospective outlets for the section's images.

Life would also come courting, in a more limited fashion, but it was Cowles who first piqued Stryker's interest. He replied on December 2. In keeping with

Cowles's emphasis on marking the *Look* project "confidential," Stryker was opaque in his response: "Dear Mr. Cowles: Your letter of Nov. 23 is at hand, and I am in the process of assembling a collection of pictures which I am sure you will find satisfactory for the purpose you have in mind."[73] He went on to note that he was also providing "some things which are slightly different from those suggested in your letter because I thought you might find them useful in the new project."[74] While it is not clear which pictures Stryker sent, or which he believed to be "slightly different from those suggested in your letter," several of the Historical Section's photographs appeared a few months later in the second issue of *Look.* For its March 1937 issue *Look* used six Historical Section photographs in a two-page spread on sharecroppers titled "Children of the *Forgotten Man! LOOK* Visits the Sharecropper" (Figure 4.2). Just a few months later, the magazine did a similar two-page spread on the migrant problem, "Caravans of Hunger: Thousands of Landless Farmers Wander California's Highways" (Figure 4.3). This layout featured an additional six Historical Section photographs.

In addition to honoring Cowles's request for material for *Look,* Stryker also used his December 2 reply to drum up additional business:

> At the present time we have a photographer working in Iowa and Illinois on material concerning farm tenancy. As soon as his pictures begin to come in, I will see that you receive some of this material as I am sure that it would be useful either for your roto or for the new project. As new material comes in, we will keep you informed and send on things in which we think you would be interested. If you could keep us informed of topics that might be covered in your roto, we might be able to make more definite contributions from our files.[75]

Here Stryker not only responded to Cowles's specific request for material to be used in *Look* but also showed an interest in the Sunday supplement, or "roto." As we have seen, Cowles used the *Des Moines Register*'s Sunday supplement to communicate in the form of visual stories. Stryker likely found a commonality with Cowles's approach, since Stryker was coming to value the importance of communicating narratives via collections of pictures united with text. Furthermore, it is important to note Stryker's interest in circulating the RA's photo-

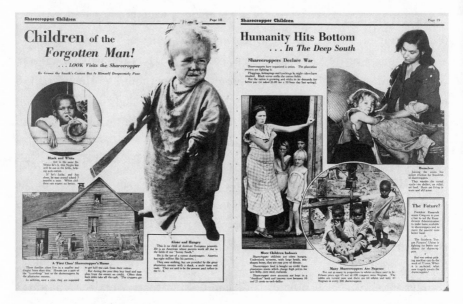

Figure 4.2. "Children of the *Forgotten Man!* LOOK Visits the Sharecropper." *Look*, March 1937. Courtesy Library of Congress.

graphs regionally. Just as Dorothea Lange and Paul Taylor's work in California could have an impact on the RA's activities in that state, so too could the appropriate placement and circulation of the Midwest photographs have an impact on RA policies in that region. Not long after, Stryker's offer of photographs for the roto section was accepted, and the *Register*'s Sunday supplement ran two feature stories using Historical Section images.[76] After their initial exchange of letters, Cowles and Stryker developed a relationship that worked to the benefit of both *Look* and the Historical Section. Stryker succeeded in getting photographs placed in *Look* and in Cowles's popular syndicated Sunday supplement, read by hundreds of thousands of Midwesterners each week. And Cowles and his editors were able to rely on the Historical Section for photographs—and on Stryker for advice.

In January 1937 Mike Cowles provided Stryker with an advance copy of *Look* featuring the sharecropper photographs. He wrote: "I hope our treatment of the pictures meets with your approval," then went on to request, "Incidentally, I should be glad to have your criticism on this second issue of *Look*. What do you think is wrong with the magazine? If you were editing it, what would you

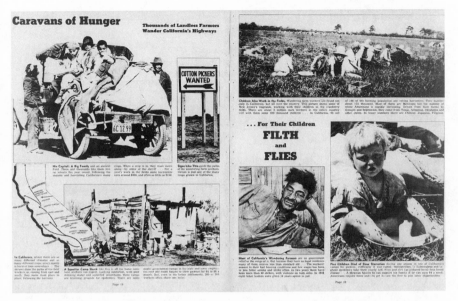

Figure 4.3. "Caravans of Hunger: Thousands of Landless Farmers Wander California's Highways." *Look,* 25 May 1937. Courtesy Library of Congress.

do differently?"[77] Stryker replied a few weeks later with a three-page, single-spaced letter. Stating his approval of the way that his own agency's photographs had been handled, he wrote: "I have nothing but a satisfactory report to make, either from myself or my associates, on that lay-out."[78] He went on to offer a detailed analysis of the March issue, referencing specific page numbers, questioning captioning choices and commenting upon photograph selections. In pointing to several layouts in the issue with "cookie-cutter" features, Stryker noted that they were, from a reader's point of view, confusing: "I believe the same elements hold for most adults as hold for kindergarten children—that lay-out is most effective which is least confusing."[79] Near the close of the letter, Stryker raised the perennial issue of credit lines:

> I have one quarrel with you people, and with *Life,* that is regarding credit lines under the pictures. Is it such a difficult job to place the credit lines under pictures? We realize that in a set of pictures like ours (pages 18 and 19) that the story is the important thing. . . . But we need every bit of help we can get if we are to be permitted to go ahead and keep up the quality of photography which we are

now doing and, of course, the credit line is of tremendous value to us for this purpose.[80]

Here Stryker's goals are clear. Although he acknowledges the importance of the story (presumably over the identity of the photographer), from an institutional point of view the credit lines are vital. Note the difference between the plea for credit lines here and their automatic inclusion in the context of *U.S. Camera* (see chapter 3). In that context, the credit lines were an obvious element of the piece, given the magazine's interest in upholding the individualistic norms of art photography. For *Look* and *Life,* on the other hand, it was typically not necessary to identify an individual picture as the work of an individual or an organization; what mattered was the photograph in the context of the larger narrative.

Mike Cowles responded to Stryker a week later, thanking him for his critique of the magazine and noting that *Look* would include credit lines on each page from then on.[81] Yet despite these assurances, when the next set of Historical Section photographs appeared in the May 25, 1937, issue, credit lines were still absent. Despite what Stryker's complaint suggested, *Life* actually did print credits for photographs in its issues, but most often they appeared in an index apart from the photographic stories themselves. Called "*Life*'s Pictures," the index was clearly not a priority for Luce if one judges from its placement. In the early years, it floated throughout the magazine, sometimes appearing in the front near the table of contents, sometimes appearing near the back of the issue.

During the months of early 1937 when the picture magazines were bursting upon the scene, Stryker began preparing sets of photographs to offer as "exclusives" to particular magazines. In a January 13, 1937, letter to Cowles, he explained, "What we are now trying to do is offer the various papers and picture magazines exclusive sets of material for their use. We would hold these exclusive for a period of two or three weeks before releasing them for general use."[82] It was a savvy move on Stryker's part, as he was attempting to capitalize on the increasing competition for picture stories among the various magazines. Sometimes, however, as in the case of a set of Lange's photographs of migrants, prom-

ises of exclusivity may have actually impeded wider circulation of the photographs.

Unlike the editors at *Life, Look* editors were in regular contact with Stryker and visited the offices in Washington to browse the files in person. By late summer 1937 Mike Cowles had placed a full-time employee, Bill Nelson, in Washington to work on stories for *Look* and for the *Des Moines Register.*[83] Nelson not only had occasional exclusive access to sets of captioned images in the file, but Stryker also allowed him to see some images before they had even been captioned or filed. In a letter to Marion Post in Atlanta, Stryker noted: "Bill Nelson, of *Look,* is here working on a big Southern story in the magazine. He promised he will give it the works and let our pictures dominate. I am breaking a rule by letting Bill look at them before the pictures are even captioned or in the file. I hope it's worth it."[84] As with *Survey Graphic,* Stryker was willing to give *Look* editors access to the newest information in the files if he believed that it would be "worth it" to the section—that is, if editors would agree to highlight the Historical Section's work over other pictures. Similar references to *Look*'s interest in specific photographic stories appear throughout the Stryker papers, particularly in 1940–41 when demand for the section's photographs was particularly high.[85] Such requests enabled Stryker and his Washington staff to manage, to a good extent, the images used by *Look* and other magazines. In selecting the picture sets to be offered to editors, Stryker could at least minimally influence the eventual narrative.

Life offered a similar, if slightly more upscale, mass audience for photographs. But although *Life* published stories on migrant labor and other rural issues, the section's photographs barely circulated in the magazine. Between the first issue of *Life* in late 1936 and the end of its third year of publication in late 1939, only three Historical Section photographs had appeared in its pages.[86] Yet during these same years *Look* used dozens of the section's images.

Initially, *Life* was interested in the section's photographs. During the week of *Life*'s debut, Dorothea Lange reported to Stryker that *Life* had contacted her: "Please know that I am flooded with requests for photographs. . . . Life, the new magazine, have been [sic] writing me for photographs. On my return from the field found a letter saying that they were interested or probably would be

interested in running a feature story on migratory labor of California, and could I do the job for them?"[87]

Lange went on to ask Stryker how he would feel about her working for *Life*. She was about to begin a layoff period, ostensibly for budgetary reasons, and she proposed doing the work for *Life* during that time, when it would not conflict with the needs of the Resettlement Administration. Stryker responded that as far as he was concerned, she could do the work for *Life* on RA time and with RA equipment—with only one caveat: "I see no reason why you shouldn't do it on Resettlement time, or certainly from Resettlement negatives. . . . As far as I am concerned, you can use material from the Resettlement pictures which you have already taken, giving us the proper credit under the picture."[88] Again, Stryker's interest in getting credit for the agency was paramount; if *Life* was going to use Lange's images, it should use the images owned by the RA *and* give the RA photo credit.

The "feature story on migratory labor" that Lange mentioned in her letter serves as a fascinating case study of the complexities of the FSA photographs' rhetorical circulation in the picture magazines. The tale of this "story-that-wasn't" demonstrates how the demands of institutional bureaucracy, the needs of competitive media markets, and the creative desire of the photographers impeded attempts to circulate the section's images. Throughout a good portion of 1937, Lange and Stryker corresponded about the feature story on migrants for *Life*. While Stryker told Lange that she was welcome to use RA photographs in the piece, he cautioned her to retain control over the layout and captioning of the feature: "I don't trust that crowd too far in the handling of pictures. They can't change the picture, but they can certainly raise hell by the type of caption they use."[89] Stryker's initial distrust of the *Life* editorial process appears to have been grounded in the magazine's apparent lack of credit lines. If it wouldn't be obvious within a feature that the images came from his agency, then their appearance in *Life* was of little use to Stryker. Thus, despite his complaints about *Life* being able to "raise hell" through its use of captions, Stryker was not really quibbling with the contextualization of photographs per se. The larger context was his love-hate relationship with *Life*. He knew the section's photographs would get wide exposure if they appeared in this culturally important and popular magazine, but his frustrations with *Life*'s presentation of

credits, combined with rejections of some Historical Section images by *Life* editors, eventually made him bitter about the possibilities for a productive relationship with the magazine.

During these same months, two other projects competed with the *Life* feature for Lange's attention. She was busy completing work on an illustrated Department of Labor report on migratory labor in California, and *Mid-Week Pictorial* had recently published some of her migrant photographs. In early February Lange wrote to Stryker that *Life* might resent the publication of her photographs in the pages of the competition: "I fear that the migratory worker photographs in *Mid-Week Pictorial* have spoiled the story for *Life*. I have heard so not directly, but indirectly."[90]

At the same time, Lange was interested in making new photographs in the field in order to make the *Life* feature as up-to-date as possible. She wrote Stryker: "Could we hold it [publication of the photographs in *Life*] until I have my new negatives?"[91] Stryker reluctantly agreed: "*Life* is terribly interested in a migrant lay-out, but we are holding everything up now, awaiting the new migrant stuff which you can send us. Would you please send in your new prints as soon as you can."[92] Two weeks later, Lange reported that she was hard at work arranging her old and new photographs: "This *Life* job I am totally interested in. . . . I have been receiving letters from them and I am in hopes that we can make this set of pictures really count."[93]

Given the delay on Lange's end, Stryker sought to sell *Life* on the idea of publishing the piece to coincide with the public release of the report. The Department of Labor had requested that *Life* not publish Lange's migrant images until the report containing those images was released. Not only would this further delay give Lange time to complete her layout and captions, but it would enable her to produce something of a public relations coup for the Department of Labor and for the FSA.[94] *Life*, however, did not appreciate the delay. In early May, Stryker reported back to Lange about his visit to the New York offices of *Life:* "I am in a bad spot over it [the report] with *Life*. I had quite an argument up there last week over using your pictures. . . . I am very much disappointed over the way it has been handled." Stryker went on to note that the Department of Labor had held up the report, and thus the release of photographs to *Life*. As a result, *Life* was no longer interested in a feature timed with

the release of the government's report. But Stryker noted that he would approach Wilson Hicks, *Life*'s photo editor, to see if the magazine would be interested in a more general feature on migratory labor.[95]

The apparent answer was yes, for Lange prepared a set of other migrant images made in California and sent them to *Life*. The magazine published one Lange portrait of a migrant in late June, properly credited underneath the photograph to the Resettlement Administration—the likely result of Stryker's stressful face-to-face meeting with *Life* editors in May. *Life* also featured a Lange photograph of corn on its July 5 cover, credited to Lange but not to the RA. The magazine never published the promised migrant feature, however. In fact, editors claimed to have lost the material. Stryker reported to Grace Falke, former assistant to Rexford Tugwell: "Last Spring Lange prepared a set of pictures for *Life*. They have not used them but have contrived to lose them someplace in their files."[96] Ironically, a few months later Stryker was contacted by editors at *Life*'s sister publication *Fortune,* who were also interested in photographs of migrants. Stryker reported to Lange:

> *Fortune* wrote us for a set of migrant pictures, so I played a joke on *Life* and suggested to *Fortune* that *Life* had such a set in their possession and perhaps they would turn them over—which they did. The last report I had of them in *Fortune*'s hands was that they wanted to wait until they had both sides of the story. I judge that they felt that you had taken only one phase of the subject.[97]

This excerpt makes it clear that the struggle to publish Lange's migrant images in *Life* was particularly vexing for Stryker, who appears to have spent a good deal of time thinking about the new demands the picture magazines were placing on photographic agencies such as his. From very early on, the Historical Section staff seemed to be aware that there existed a "*Life*-type" of photograph, and they strove to construct it even while they openly doubted that *Life*'s approach would provide suitable publicity for the agency. While in negotiation with Lange and *Life* about the migrant feature, Stryker discussed with other photographers how they might construct narratives that would best conform to those being published in *Life*. Russell Lee wrote to Stryker in June 1937, asking that a set of captioned prints he was sending to Washington be studied

"with the idea of making them more '*Life*'-like."[98] While Lee did not go on to explain what he meant by "*Life*-like," Stryker seemed to know. He responded that he and photo editor Ed Locke had gone over the images in detail, and observed, "I am quite sure that, as a set, *Life* would react somewhat against them." Stryker advised Lee to look through copies of *Fortune* and *Life,* and to think about creating not only photographs that showed a process or operation (in this case, the workings of a forest products plant) but also "atmosphere" pictures. After offering detailed criticism of nineteen separate images, Stryker concluded: "I know you will appreciate that these criticisms are made on the basis of getting the type of picture which *Life* will want. I have seen so many of their rejects that I am sure that I can forecast what their comments will be."[99]

What exactly was a "*Life*-like picture"? In general, *Life* took a dual approach to imaging. Luce, as we have seen, saw the value of the spontaneous, candid "shot" in the work of Leica photographers such as Salomon and Stackpole. *Life* editors liked to reproduce these "stolen" images, which the magazine narrativized into brief stories of human drama or humor. Yet what was most important for Stryker was that *Life*'s bread and butter was the longer photographic essay, a multipage narrative in which images did not so much stand out on their own merits as individual photographs but rather worked together to illustrate a process and create a coherent narrative. Luce described these two uses of photographs as "two rhythms": one "the rhythm of 'the nervous alert news-magazine,' the other the rhythm of the essay, presumably more reflective."[100] Thus while *Look* was content in the early years (perhaps out of necessity) to take others' photographs and mold them into photo-essays, *Life* photo stories were from the outset specifically constructed to *be Life* photo stories. This of course did not make them any more "constructed" than the *Look* features, but it did give them a narrative coherence not initially required by Cowles at *Look.*

There were, then, likely a range of reasons why the Historical Section photographs failed to appear in significant numbers in the pages of *Life* magazine at a time when the images were getting wide circulation in other publications. First, *Life* was clearly sensitive to competition. Editors were aware that photographs by Lange and others were already appearing in the pages of *Look* and *Mid-Week Pictorial.* It is likely that *Life,* widely viewed as the first and best pic-

ture magazine, did not cotton to playing second fiddle to so-called inferior publications. Second, *Life* editors may have grown impatient with the delays—both the creative delays from Lange herself and the bureaucratic delays from Stryker and from the Department of Labor. It is certainly possible that Luce's editors simply grew weary of what they regarded as needless government delays. Third, despite its recognition of Lange's abilities as a photographer, *Life* did have its own staff of talented photographers hired by Luce to construct the magazine's brand. These included, among others, Alfred Eisenstaedt, Peter Stackpole, and Margaret Bourke-White.[101] With plenty of talent at home, *Life* probably saw little need to seek out government images, no matter what their quality. Finally, Stryker and his staff appear to have failed more than once in their attempts to construct "*Life*-like" narratives. Whatever the mix of reasons, by the spring of 1938 a bitter Stryker had all but given up the pursuit of publication in *Life.* He wrote to Ed Locke: "I have come to the conclusion that we had best give up the idea of getting pictures into *Life;* that is, pictures that have any guts to them."[102]

Since both the FSA photographs and *Life* are so closely associated with the visual culture of the era, one would assume that these famous photographs must have circulated in the most famous picture magazine. Indeed, the fact of the relative *non-*circulation of the FSA images in *Life* serves as a reminder that the process of rhetorical circulation was not seamless; in fact, in some ways it was decidedly idiosyncratic. Recall that Cowles, in his initial letter to Stryker, mentioned that he learned of the project through his brother-in-law, who at the time was working for the secretary of agriculture—fellow Iowan Henry A. Wallace. Cowles's willingness to consider using mere "government photographs" may have originated through this family link. Such a personal connection suggests that *Look* may not have been as odd an outlet for the section's photographs as one might initially think. The photographs' circulation in *U.S. Camera* and especially in *Survey Graphic* was fueled not only by the images' utility for the editors of the respective periodicals but also by the quality of the relationship Stryker forged with those at each magazine. The magazines got what the section offered, and Stryker was able (at least eventually) to get what he wanted: credit lines, primarily, as well as the publicity for the agencies afforded by features (like Hartley Howe's in *Survey Graphic*) and special sections

196

(like Steichen's in *U.S. Camera*). *Life*, by contrast, did not offer that kind of easy, personal connection, which made Stryker's dealings with that periodical much more tenuous.

Though the FSA photographs weren't doing much rhetorical business in *Life*, they were doing a particular kind of rhetorical work in the pages of *Look*, which used the Historical Section photographs to construct a popularized rhetoric of poverty that encouraged an ahistorical, "spectacular" view of rural poverty.

"Children of the *Forgotten Man!*" and "Caravans of Hunger": The Poor as Spectacle

"Keep Informed!" the March 1937 cover of *Look* trumpeted (Figure 4.1). Inside, six Historical Section photographs appeared in a feature titled "Children of the *Forgotten Man! LOOK* Visits the Sharecropper" (Figure 4.2). A few months later, *Look* published another two-page spread of Historical Section photographs, this time focused on the problem of migrant agricultural labor in California: "Caravans of Hunger: Thousands of Landless Farmers Wander California's Highways" (Figure 4.3). As their headlines suggest, the essays tapped into typical tropes of the time. References to the "forgotten man" and the "caravan" conjured up for viewers an image of modern-day pioneers struggling to make a living from the land, then abandoning it for a new frontier, which turned out to be equally bleak. The features reflect *Look*'s early editorial and graphical fits and starts as well, pitting the magazine's purported interest in "facts" against its desire to increase readership through the use of dramatic photographs and vivid captions. Although *Look*'s picture stories were ostensibly meant to educate readers and generate sympathy for the poor, the content and layout of the features undermined such goals. By designing each feature as a closed, relatively ahistorical narrative, *Look* circa 1937 constructed a rhetoric of poverty that kept the reader on the outside "LOOKing" in.

Readers encountering the sharecropper feature in the March issue would find the discussion of tenancy sandwiched between a two-page photo feature on marriage in Zululand (titled "A Savage Buys a Wife") and a two-page center-fold of actress Myrna Loy posed provocatively in a bathtub filled with flower

petals (the caption announcing that Miss Loy "wears only tailored under-wear").[103] Similarly, the May 25 feature on migrant workers was wedged between a chatty "exposé" titled "Is Spiritualism a Fake?" and a feature on the sign-language alphabet, "How to Talk with Your Hands."[104] Within *Look*'s editorial vision, however, there is no cognitive dissonance here. The "savage," the sharecropper, and the sexy starlet all merit equal representation and treatment in the picture magazine. Such equal treatment, though, has implications for how we understand the Historical Section photographs' rhetoric of poverty in the context of *Look*. The layouts of both features encourage a stance of surveillance on the part of the reader/viewer.[105] In addition, the use of candid images, many made with the new 35mm technology, gives the images a "stolen," surreptitious tone. Third, images of children predominate in both features, encouraging an infantilization of the poor. Finally, while the features purport to offer "information" about the problems of sharecroppers and tenants, they construct an ahistorical present that provides the viewer very little context within which to understand the sharecroppers' and migrants' circumstances.

The sharecropper feature offers what Henry Luce derisively had called a "cookie-cutter layout"—photographs cropped into odd shapes, circles, and cutouts. The primary visual element of Figure 4.2 is a large cutout of a small child crying.[106] He is dressed in ragged clothing and shoes, and his face is dirty and distorted. In one hand he holds a small wooden plank or utensil. He looks to be in distress. The image dominates the spread, taking up nearly half of the left-hand page. The caption below the child's image reads in part: "Alone and Hungry: This is no child of destitute European peasants. He is an American whose parents work all day in the fields of our 'Sunny South.' He is the son of a cotton sharecropper. America has eight million like his parents."[107] The sheer size and distressing appearance of the image, coupled with the caption, serve both to remove the child from any geographic or social context and at the same time to associate him synecdochically with the larger social problem of rural poverty.

This photograph carries a strong shock value, thanks not only to its content but also to *Look*'s distortion of photographic scale in the layout. Yet Roy Stryker, in his response to Mike Cowles's request for criticism of the March issue, wrote approvingly of the layout of photographs in the sharecropper fea-

198

ture and mentioned this image specifically: "I think the placing of that little boy in the burlap clothes in a prominent position as you did was extremely effective."[108] Stryker's reply is disconcerting, but not surprising, for it suggests again that he was largely unreflective regarding the qualitative representation of the images in the magazine.

The layouts encourage the gaze because they feature cropping of the images so that they "zoom in" on the children, position them prominently, and frame them in odd ways. In the top left corner of the feature, an African American girl is isolated in a circular cutout frame. She leans out of a window, but there is no visual context in the photograph beyond that. The uncropped version of this Ben Shahn photograph in the FSA-OWI file reveals the wider context in which the girl was photographed.[109] That uncropped image shows that she is looking out of a broken window of a building. An older person stands next to her, his or her face partially veiled behind a torn screen. This second person has been cropped out of the image as it appears in *Look*. The cropping of the photograph, coupled with the circular shape of the layout, isolates the girl and makes her appear to be under surveillance—seen as if through a camera's lens.

In addition to the layouts' encouragement of the monolithic gaze, the quality of the images themselves reinforces the idea of surveillance. The images displayed in *Look* tend to be ones that reject the formal pose of the photographic portrait in favor of more "candid" subject matter. Most of the images in the feature, save a few of Dorothea Lange's made with the 4-by-5 Speed Graphic, were made with 35mm "miniature" cameras; the images appear spontaneous, made on the fly, "taken" of a subject caught momentarily unawares. As a result the reader/viewer is positioned to look in on the giant image of the crying child dressed in the burlap sack (Figure 4.2), to spy on the young girl peeking out of the squatters' camp shack (Figure 4.3), to peer through the circular, camera-like frames around the photographs of the African American children, and to survey the pregnant mother and her children in the doorway (Figure 4.2). While *Survey Graphic* and *U.S. Camera* reproduced FSA portraits that granted their subjects some measure of dignity, *Look*'s reliance on candid images presents the FSA subjects as downtrodden others whose conditions readers might pity, but with whom they would not likely identify.

Another theme found in both features is an almost exclusive focus on chil-

dren. The dominant figure in each is a child. The child in the burlap sack in Figure 4.2 is nearly interchangeable with another blond child sitting in a pan of water, covered in dirt and flies, in Figure 4.3.[110] Similarly, in this second image, photographer Dorothea Lange has cropped out the legs of an adult, perhaps a parent, lying near the child on the ground. When adults are present in the features, they are typically shown in passive positions. The irony of the title "Children of the *Forgotten Man!*" is clear, because the sharecropper himself, the "forgotten man," is utterly absent in the photographs. Furthermore, across both features only one adult looks at the camera directly.[111] All others are focused on their work or on their children. As a result, the reader's *direct* visual encounters with the poor happen with the children, not the adults.

The mothers, while present, appear passive and anxious. The Arkansas sharecropper's wife featured in *U.S. Camera 1936* and discussed in chapter 3 reappears here in another view (Figure 4.2).[112] *Look*'s version shows the pregnant mother in the doorway, with three children of various ages gathered next to and behind her. A portion of the caption underneath the image reads, "More Children Indoors: Sharecropper children are often hungry. Undersized, scrawny, with large heads, misshapen bones, they are easy prey of disease."[113] The word choice here is vivid and crude, implying that although a mother is present, she is unable to care for such a brood. The hint "more children indoors" tells us that this place is overrun with children, suggesting excessive fertility on the part of the mother coupled with an inability to care for her "scrawny" and "misshapen" offspring. In fact, there are several images made by Rothstein of this family, and they show only one additional child not featured among the group of three here, not the unspecified large brood implied by the caption.[114]

The strategy on the part of *Look* editors is obvious: Use children to create pity in the viewer, and sympathy for the plight of the poor, by showing those most innocent and helpless in the face of poverty. Yet at the same time, the emphasis on children in both features has the effect of infantilizing (and thus disempowering) the poor, particularly the nonwhite poor. The images of children of African American sharecroppers in Figure 4.2 demonstrate this point most vividly.

The caption accompanying the cutout image of the African American girl at the window reads:

Black and White
. . . Are in the same fix. When he's 6, this Negro boy will be out in the fields, helping pick cotton. If he's lucky, and has shoes, he may attend school 3 months a year. White children can expect no better.[115]

Strangely, the child who is clearly a girl in other photographs made by Shahn that day has had her gender transformed via the caption, which describes her as a boy.[116] Gender, it seems, is irrelevant, as this isolated child is meant to be representative of sharecropper children in general. As did the *Survey Graphic* article on sharecroppers, *Look*'s treatment too emphasizes that tenancy affects both black and white laborers, and the "news" is that whites are suffering. This parallel is evident most strongly in the photograph of the three boys gathered near a water pump.[117] Each child stares at the camera. They are all barefoot and wear worn clothing. Like the image just described, this photograph shows no adults. The caption beneath the image further develops the notion that tenancy now extends to whites:

Many Sharecroppers Are Negroes
But not as many in proportion to whites as there used to be. Fifteen years ago 65 out of 100 croppers were Negroes. The tables are turned now and there are 60 whites and only 40 Negroes in every 100 sharecroppers.[118]

As with the Embree article in *Survey Graphic* (chapter 2), here the images of black children are employed primarily to reference the increase in white tenancy. Thus the children's experience is erased by the text even as it is represented visually. But where we have at least a glimpse of the adult white sharecropper (via the images of the passive mother), here no African American adults appear. They are truly the "forgotten men" and women that *Look* so dramatically announces. *Look*'s reliance on images of black children not only accomplishes the same result that Embree's essay did (to erase the black experience of tenancy from consideration), but also does something more insidious—it erases the

African American adult experience of tenancy altogether. The African American sharecropper, then, is represented solely via the image of the African American child. Thus *Look* infantilizes not only the poor in general, but particularly the African American poor, reinforcing plantation-era stereotypes about dependence and the "child-like" nature of the black laborer.

The text accompanying the images participates in the infantilization of the poor and reinforces the interest in white tenancy as opposed to black tenancy. The captions accompanying the photographs purport to be "factual," and they do offer information about tenancy and migrant labor. They note that the migrants earn anywhere from $150 to $400 per year for their labor in California. They explain the "furnishing" system, in which tenants buy food on high-interest credit from plantation owners.[119] The migrant feature notes that "in two years there have been more than 40 strikes, with violence on both sides."[120] At the same time, however, the "factual" information offered in the captions is not credited to any kind of expert who might testify as to the accuracy of the facts.

Stryker praised Cowles for the sharecropper feature's use of captions, noting: "May I compliment you on the frank captions which you attached to these pictures. You certainly 'shot the works' on your captions here."[121] Presumably, "the works" refers to the way in which *Look* used vivid language to describe the conditions facing the sharecroppers. Indeed, the "factual" nature of many of the captions, already undermined by the lack of attribution, is further undercut by the tendency to dramatize the conditions being described. So, for example, the sharecropper feature declares in bold type, "Humanity Hits Bottom . . . In The Deep South."[122] And the migrant feature observes: "Thousands of Landless Farmers Wander California's Highways . . . For their Children FILTH and FLIES."[123] In describing the dangers of unionizing, *Look* observes: "Black terror stalks the cotton fields."[124] Headings such as "Black and White," "Alone and Hungry," "Homeless," and "Sharecroppers Declare War" function to capture reader attention, but at the same time they discourage a more critical examination of the issues.

Furthermore, the often vividly phrased captions contribute to the visual narrative by connecting those individuals represented in the photographs to the broader social category of "them." Thus, rather than noting that those in the photographs are "Americans, just like us," or that "we" should help them,

the captions reference the subjects of the photographs as "they" almost exclusively: "*They* own nothing. . . . *They* are said to be the poorest paid toilers in the U. S."; "*They* number about 175 thousand."[125] From the perspective of *Look,* "they" are decidedly not like "us," *Look* readers and viewers.

Look's combination of the photographs and captions produces a narrative that is curiously ahistorical. The essays say little, if anything at all, about the causes of the poverty depicted in the images, nor do they suggest much in the way of solutions. Neither essay develops a context for the rural poverty it depicts. The essay on sharecroppers does not allude to "the system" emphasized so intently by *Survey Graphic* (chapter 2) save for its reference to the high-interest credit to which sharecroppers are subject. The migrant feature offers little explanation of the history of migrant labor in California, particularly the shifting reasons for migration over time. Both essays briefly suggest possibilities for change in the future, but here, too, little context is present. Under the heading "Sharecroppers Declare War," a caption observes: "Sharecroppers have organized a union. The plantation owners are fighting it. Floggings, kidnapings and lynchings by night riders have resulted. Black terror stalks the cotton fields. But the union is growing and sticks to its demands for better pay (it asked $1.00 for a 10 hour day last spring)."[126]

The caption here refers opaquely to the Southern Tenant Farmers Union, actively organizing in the South (particularly in Arkansas) at the time.[127] Another caption goes on to suggest that the STFU has also "meant eviction for hundreds of sharecroppers. They wander the rutted roads—no shelter, no relief, no food. Some are living in tents and old autos."[128] Unionization, one potential solution readers might infer for themselves, is dismissed by *Look* as a hopeless and downright dangerous option.

Similarly, a text box appears at the bottom right of the sharecropper feature, blocked off with double black lines with the heading "The Future?" It notes that the Resettlement Administration plans to relocate tenants from poor land to better land and that "the Southern Tenant Farmers' Union is fighting for better conditions for sharecroppers." But it concludes: "But one cotton picking machine can do the work of 75 men. When it is perfected, what new tragedy awaits the sharecroppers?"[129] With this brief reference to agricultural mechanization, *Look* employs language akin to a radio soap opera ("Tune in tomor-

row to see what new tragedy awaits . . . !") to argue that the sharecroppers are defenseless.

In "Caravans of Hunger," the hope for the future is even more bleak. References to unionization of migrant workers emphasize the violence associated with strikes: "The workers' answer to their bad housing conditions and low wages has been to join labor unions and strike often . . . with violence on both sides."[130] Apart from this reference to unionization, and a suggestion that "there are some model government camps" in which migrant workers may find better conditions, there is little in the way of contextualization of the issue. No mention is made of the news of the day, including federal efforts to engage rural poverty such as those outlined by Taylor in *Survey Graphic* (chapter 2).

Look, as we have seen, was never meant to be a newsmagazine. Bookended as they are by picture stories that reflect *Look*'s investment in human-interest material—celebrity entertainment and "curiosities and oddities"—the 1937 Historical Section features stand in isolation from the current events of the day. Each picture story in *Look,* including the sharecropper and migrant stories, is presented as a hermetically sealed narrative; the reader is not encouraged to go beyond the narrative for further investigation of the issues. *Look*'s primary interest is in showing—in encouraging (indeed, commanding) the viewer to "LOOK." Although the photographs published in *Look* had great potential to expose viewers to the FSA's plans, the picture story itself suggests that, really, there is nothing to do but look. The magazine positions the reader to be a passive spectator, to see and consume images and text in a vacuum, devoid of context or history. The cumulative impact of the 1937 features, then, is that there is no difference between the American sharecroppers or migrants and the "savage" taking a wife in Zululand. Sharecroppers and migrant laborers are just as much a "curiosity" to be looked at, a "them" to be surveyed, as are the "savages" of Zululand, the spiritualists, or the celebrity centerfold in the bathtub.

"America's Own Refugees": *Look*'s Rhetoric of Poverty and *The Grapes of Wrath*

In March 1939 John Steinbeck published *The Grapes of Wrath. Life, Look,* and other magazines took instant notice of Steinbeck's work and sought to develop picture stories related to the novel, and editors contacted the Historical Section

for images. Roy Stryker wrote to Arthur Rothstein: "Life is illustrating 'Grapes of Wrath.' We are trying to take out pictures to help with the story. I have a suspicion that Look is also doing something similar."[131] Although *Life* eventually published a feature that used photographs made by staff photographer Horace Bristol rather than Historical Section photographers (likely vexing Stryker yet again), *Look* used FSA images in a feature intended to show readers the "truth" behind the fiction in Steinbeck's novel.[132]

In its August 29, 1939, issue, *Look* published an eight-page feature on the migrant labor problem in California, "America's Own Refugees: The Story Behind 'The Grapes of Wrath'" (Figure 4.4).[133] By this time *Look* had matured both editorially and graphically. Thus the *Grapes of Wrath* feature serves as a good example of how the Historical Section's images were mobilized in the context of the "mature" picture story. Recall that Mich and Eberman argued that a picture story should possess four characteristics: a sharply focused narrative, an emphasis on "people doing things," pictures "with impact," and themes of "universal interest." The 1939 picture story on *The Grapes of Wrath* reflects the generic constraints to which *Look*'s picture stories were expected to conform. The feature, which includes fifteen photographs made by FSA photographers and by *Look* staff photographer Earl Thiessen, is divided into two distinct but related sections. A two-page spread titled "Why John Steinbeck Wrote 'The Grapes of Wrath'" matches a series of photographs of farmers and migrants with captions taken directly from the text of Steinbeck's novel (Figure 4.5). The four pages that follow, "California's Answer To 'The Grapes of Wrath,'" feature additional migrant photographs and a response from California's governor, Culbert L. Olson (Figures 4.6–4.7). The two spreads are woven together textually by a brief introduction written by the editorial staff of *Look* and graphically by an image of migrant laborers that serves as a visual epigraph for the feature.

The feature opens with a two-page photograph of migrant workers standing in line, waiting for their day's harvest to be counted and their labor paid out (Figure 4.4). The headline reads, "A Jalopy Army of 300,000 Men, Women and Children Inspires a Great Novel, Perplexes a Great State":

> For a few dollars a day and a few days' work a week, more than 300,000 migrant
> laborers like these pea pickers travel up and down the highways of California

Figure 4.4. "America's Own Refugees: The Story Behind 'The Grapes of Wrath.'" *Look*, 29 August 1939. Courtesy Library of Congress.

harvesting cotton, fruit and vegetables as each crop ripens. Three or four workers vie for every job. . . . Most of these people were farmers before the Dust, industrious share-croppers before the tractor. Most of them are one step ahead of starvation. Some are starving.

John Steinbeck, the introduction goes on to explain, was "inspired" by the migrants' struggles to tell their story. *Look* will tell it too: "LOOK presents here the problem which moved Steinbeck to write one of the great novels of our time, and the answer of Gov. Olson of California to the challenge."[134] For *Look*, then, the feature is as much about Steinbeck's creative masterpiece as it is about the real-life situation of migrant agricultural laborers in California.

A two-page spread of captions and photographs titled "Why John Steinbeck Wrote 'The Grapes of Wrath'" follows the editorial introduction (Figure 4.5). The captions and the images trace the general narrative of the novel, telling the story of migration from the dust bowl, describing life on the road, and presenting the conditions migrants have found in California. The narrative layout of the images follows the path taken by the Joads in Steinbeck's novel. It begins

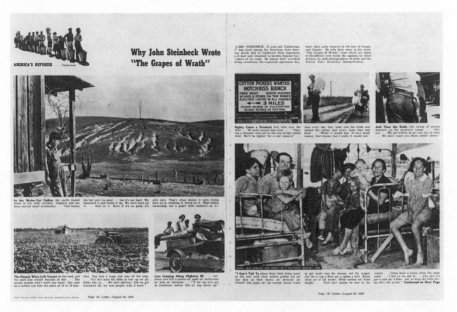

Figure 4.5. "Why John Steinbeck Wrote 'The Grapes of Wrath.'" *Look,* 29 August 1939. Courtesy Library of Congress.

with a large photograph of a young man standing on the porch of an old house, surveying the dusty, gullied land of the Great Plains. Smaller images follow, each developing a facet of the Joads' story: "tractored-out" land, migrants on the highway in their rickety truck, and images of what the Joads found in California: endless movement; cramped, dirty camps; and antagonistic law enforcement.

The captions, most several sentences long, are taken directly from the novel, in Steinbeck's own words, and matched with photographs. An image of a family riding along the highway in a truck, for example, is captioned, "Cars Limping Along Highway 66 . . . cut-down cars full a stoves an' pans an' mattresses an' kids an' chickens. . . . 'F we can on'y get to California before this ol' jug blows up.'"[135] The captions illustrate particular themes relevant to the book: connection to the land, the impact of agricultural mechanization on the system of farm tenancy, the blamelessness of the migrants in the face of oppressive social forces, and the migrants' desire for the basic necessities of food, water, and shelter. An Earl Thiessen (non-FSA) photograph of the "Bud Pearson Family"

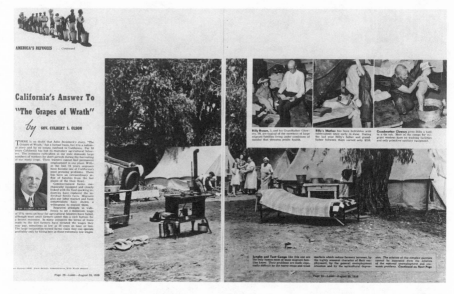

208

Figure 4.6. "California's Answer to 'The Grapes of Wrath.'" *Look,* 29 August 1939. Courtesy Library of Congress.

uses Steinbeck's words to illustrate the family's anxiety: "Gotta have a house when the rains come . . . I tell ya we got to . . . Jus' so's it's got a roof an' a floor. Jus' to keep the little fellas off'n the groun'."[136]

These captions give the feature something that the 1937 features did not offer: a sense that the subjects of the photographs are "actual" people facing real-life situations. Especially when paired with Steinbeck's own words, the photographs take on a vivid specificity, enabling the migrants in the images to "speak" (though the words themselves come from the mouths of fictional characters). As a result of the introduction of the voices of migrants into the feature, and of Steinbeck's attempts to give voice to the migrant experience as a whole, the *Look* feature reinforces the human dignity of its subjects. Just as Steinbeck's novel encourages the reader to identify with the migrants and feel, almost bodily, the reality of their situation, the feature attempts to construct a similar relationship by mobilizing Steinbeck's fictional words as a complement to the documentary images of the Historical Section.

But the *Grapes of Wrath* narrative is not the only story told here. The second part of the article includes a response from California governor Culbert L. Olson. This response, too, is accompanied by a set of photographs designed to

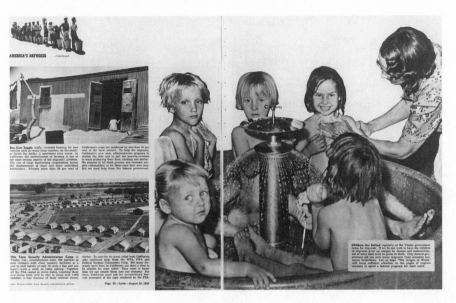

Figure 4.7. "California's Answer to 'The Grapes of Wrath.'" *Look,* 29 August 1939. Courtesy Library of Congress.

communicate a narrative about rural poverty (Figures 4.6–4.7). Thus the pages using the Steinbeck captions are meant to focus attention on the problems facing migrants, while the four pages of images and captions devoted to Olson's response are meant to suggest an "answer" to the novel, and by extension an answer to the migrant crisis in California.

Olson's response, the text of which surrounds a portrait of the governor himself, frames the second part of the feature. Seven photographs of migrants and migrant camps, including two large images that take up more than a page, are each accompanied by a caption. Whether Olson or his advisers penned some, or all, of the captions is unclear; in the feature there is no clear sense of where the governor's voice ends and the *Look* editorial voice begins. Despite the confusion, however, references throughout the four-page feature to "we" suggest that readers are meant to engage the captions as if it is Olson speaking. Furthermore, Olson speaks as the voice of the State of California: "*We* propose to let them [migrants] process and consume surplus commodities. . . . But *we* need help from the federal government."[137] *Look* presents Olson as the voice of state authority.

Olson begins with a brief introductory statement in which he argues that

the migrant problem is by no means unique to California but rather is national in scope. Each of the captions for the photographs develops aspects of the problem and the solution. While the photographs shown with the Steinbeck narrative focus on the transition from farmer to migrant, those accompanying the Olson comments emphasize camp life, both the "bad" and the "good." In contrast to the vivid specificity of the migrants' voices in the Steinbeck section, Olson's tone is informative, objective, and distanced: "For 50 years California has had its migratory agricultural laborers. The intensive cultivation in our state demands large numbers of workers for short periods during the harvesting of our many crops. These workers cannot find permanent employment in one place. Within the last 10 years migrants have become one of California's most pressing problems."

Contrary to Steinbeck's narrative, which emphasized the currency of the migrant problem as refugees from the dust bowl moved west, Olson points out (rightly) that migrants have existed in the state for many years. From there, he goes on to detail the forces that have created the conditions that migrants in California now face, including changes in commercial farming and mechanization, the large-scale size of farms, the inability of smaller farmers to pay good wages, the exploitation of workers, weak markets for crops, and the seasonal nature of agricultural labor.[138]

But the *real* problem for Olson is not the conditions for migrants; the *real* problem is that the federal government has not done enough to help the state deal with them. At the outset, Olson argues that the migrant problem is a *national* issue requiring *federal* attention: "There is no doubt that John Steinbeck's story, 'The Grapes of Wrath,' has a factual basis, but it is a national story and by no means confined to California."[139] Furthermore, Olson contends, *"the solution of this complex question cannot be separated from the solution of the national unemployment and economic problems."*[140]

With his arguments accompanied by photographs of migrants gathered in camps and taking care of children, Olson offers his solution to California's problems: intervention by the federal government. First, he hints that more FSA camps are needed, for "together all the FSA camps in seven states, counting those now being built, will be able to house only 7,900 families, a tiny fraction of those without decent shelter." Second, "to care for its great relief load,

California asks continued help from the WPA, PWA and Federal Surplus Commodity Corp. But many migrants have been in California too short a time to be eligible for state relief. They come in faster than we can absorb them into our economy. For them, California must ask for extraordinary federal assistance of the type rendered by the FSA."[141]

The photographs, a mix of images made by *Look* staff photographer Earl Thiessen and FSA photographers, participate in Olson's arguments via a dialectic of comparison and contrast. Photographs of "tent camps" and boxcars where migrants live in squalor are contrasted with orderly images of the large, clean FSA camp at Visalia, which features roads and sanitary facilities and even running water for bathing the children (Figures 4.6–4.7). The visual inference grounding Olson's arguments, then, is that the federal government, specifically the FSA, offers the only solution to the migrant problem. The two parts of the feature retell the epic narrative of Steinbeck's novel and suggest a federal solution to the problems facing the "real Joads."

Look editors argued that picture stories should always emphasize "people doing things." While in the 1937 features children were usually isolated, or shown with only passive adults nearby, the 1939 feature presents family units actively caring for children. Grandparents read to and bathe their grandchildren, and FSA workers care for migrant children in the federal camps. Rather than being isolated in small family units, groups of migrants and families gather together in extended units at work, on the road, or in the camps. In all, a greater sense of community and family may be found in these images when compared to the photographs used in the 1937 features. In addition, in the 1939 feature the adults are active and responsible, working and taking care of children—"people doing things."

None of the images is particularly compelling in a visual way, save perhaps for the Ben Shahn image of the backside of an armed police officer, which ominously suggests the threatening aspects of the law (Figure 4.5).[142] Similarly, unlike many of the disturbing images in the 1937 features, here we find little in the way of "sensational" imagery—no crying babies or children covered in flies. Instead, size is the strategy by which the photographs achieve their impact. The juxtaposition of very large with very small images in the feature enables the magazine to use large images to maximum effect and at the same time use

the smaller photographs to move along the narrative as a whole. Hence, a sequence of three photographs of "Billy Brown" and his "Grandmother and Grandfather Glowers," who are reading to him and bathing him, is a narrative unto itself—the story of Billy and his elders struggling together in a squalid migrant camp (Figure 4.6).

As for the large photographs, the image of the migrants waiting in line at the end of the harvest day, repeated three more times as a visual epigraph on succeeding pages, frames the overall narrative and helps the viewer see how the two parts of the feature are connected. Each two-page spread that follows features one large photograph that takes up a whole page, or even more. A photograph of a young boy looking out over dried-out land launches the Joads' story vividly (Figure 4.5).[143] The giant photograph of a squalid migrant camp (accompanying Olson's response) reveals the meager surroundings of the migrants, who, in the face of their suffering, still manage to smile for the photographer (Figure 4.6). And the final image of the feature, children being bathed in a giant tub by an FSA worker, suggests hope for the children (one of them, too, manages to smile) and reinforces Olson's argument that the FSA's help is vital to the future of California (Figure 4.7).

The feature conforms to *Look*'s insistence upon the rejection of "newsworthiness" in favor of "universal interest." Here, universal interest is achieved by the emphasis on the faces of the migrants, particularly the faces of children. In the portrait of Bud Pearson and his family in the migrant camp, the viewer engages the faces of the entire family; a few of them are even smiling for the photographer (Figure 4.6). Similarly, the final image of the children being bathed attracts universal interest in its presentation of a mundane activity to which anyone can relate—the need to keep clean. By showing the migrants engaged in activities in which *Look* readers would also be engaged—reading to children, bathing children, or sitting for a family portrait—*Look* emphasizes the universal elements of the family experience. And by appealing to the basic needs of shelter and cleanliness *Look* invites the reader into the lives of the migrants. Whereas in 1937 *Look* showed people who were not clean and children who were not taken care of, by 1939 the magazine was showing people who tried to do these things, allowing for greater identification on the part of readers. In addition, the feature's emphasis on "people doing things" points to the

irony of the situation of the migrants; they are "like" *Look* readers in that they are engaging in everyday activities, but they are decidedly *not* like *Look* readers in that they perform these activities under the worst conditions.

Another element of universal interest present in the feature is the use of Steinbeck's novel, itself rife with universal themes. The epic story of the Joads, with its emphasis on family unity, interdependence among all people, and the desire for radical social change, tapped into universal themes and at the same time challenged other "universal" beliefs about America, such as the myths of individualism and the unfettered frontier. By using Steinbeck's words, and applying them to photographs of "real" migrants, *Look* editors sought to link the Historical Section's visual documentation of migration to a fictional story with universal interest for readers. Governor Olson's remarks, too, invoke universal interest in that they frame the migrant problem not as simply a California problem but as a problem for the nation as a whole. Those tempted to dismiss even Steinbeck's novel are encouraged by Olson's comments to consider the ways in which all Americans are affected.

Look presents its version of the *Grapes of Wrath* story in ways that uphold the norms of the good picture story. It offers a coherent narrative, both of Steinbeck's migrants and of the problems and solutions facing California from a public policy perspective. It presents images that emphasize "people doing things," migrants attempting to live normal lives in spite of the hardships they face. The feature uses photographs with impact and offers the reader/viewer multiple ways to identify with a story cast with universal interest in mind. From the point of view of *Look*'s editorial vision, then, the 1939 feature is a "good picture story." Yet the very qualities that make it a good picture story also make it problematic from the point of view of *Look*'s professed interest in "educating" readers. Like the 1937 features, *Look*'s *Grapes of Wrath* picture story functions as a hermetically sealed narrative. It offers the reader little context through which to understand the forces that produced migration in the first place, and it does not explain the social forces that produced the current climate of agricultural labor in California.

The impetus for *Look*'s feature was not the ongoing problem of migrant agricultural labor but rather the fame of Steinbeck's novel. When *The Grapes of Wrath* was published it generated both praise and criticism, bringing re-

213

newed, and relatively sustained, attention to the migrant issue. Historian James Gregory writes: "Within weeks the novel was a national best seller, and less than a year later it was an even more popular film. Suddenly the Dust Bowl migration was no longer just California's problem. Now the nation, even the world, would watch and judge the way the Golden State treated its newest and poorest."[144] Furthermore, the instantly successful novel offered Americans a shorthand way to discuss the migrant problem. *Look* was not the only publication to use the fictional story in this way. Charles Shindo notes that *The Grapes of Wrath*'s migrant narrative was so quickly embraced by the public that it prompted the "radio program *America's Town Meeting of the Air* to pose the question 'What Should America Do for the Joads?'"[145] Thus, in one sense *Look* was doing nothing different from what other media did when presented with the spectacle of this incredibly popular novel. The Joads served a synecdochical function, becoming a universal, and useful, device for facilitating public discourse about the migrant issue.

But *Look* ignores the way Steinbeck wove politics through the novel and focuses instead on the migrants as dignified victims needing refuge from poverty through the protection of the federal government. *The Grapes of Wrath* emphasized interdependence and included discussions of radical politics, strikes, and unionization; the novel ends with Tom Joad's decision to become a vigilante for justice ("I'll be ever'where—wherever you look. Wherever they's a fight so hungry people can eat, I'll be there. Wherever they's a cop beatin' up a guy, I'll be there").[146] But the *Look* narrative suggests a more passive solution: the increased involvement of the federal government. In this way, the *Look* feature bears striking similarities to Paul Taylor's social science rhetoric of poverty in *Survey Graphic* (chapter 2), but without the more substantial analysis of the "system" that produced the migrants' conditions in the first place. In *Look*, too, migrants come from Oklahoma (like the Joads), struggle in California (like the Joads), and can be saved only by the intervention of the federal government. But in *Look* no mention is made of attempts to transform the feudal structure of industrial agriculture. Furthermore, even though Governor Olson appears in the pages of *Look* to discuss possible solutions, the magazine does not treat his remarks as "news." Bound by its own ahistorical perspective, *Look*

favors the construction of a universal narrative over the engagement of the politics of the day.

We must further consider the impact of *Look*'s use of the Historical Section's *documentary* images in the context of a feature about the popularity of a *fictional* story. Although the feature uses Steinbeck's words to frame the migrants as dignified subjects attempting to live "normally" under trying conditions, the narrative focus on Steinbeck's fiction also allows *Look* to distance itself, and thus its readers, from the situations faced by "real" migrants in California in 1939. Furthermore, by selecting *which* of the fictional voices would represent the real-life migrants in the photographs, *Look* constructs an incomplete narrative that excludes the more radical elements of Steinbeck's story. By encouraging the reader to think of the migrants pictured as "people like the Joads," a family that is fictional and already a part of American popular culture, *Look* encourages aesthetic distance on the part of the reader, who may become inclined to think of the migrants merely as characters in a fictional world. Thus a fascinating irony is at work here. In order to draw attention to the very real experiences of migrants, Steinbeck fictionalized them. In capitalizing on the novel's success, *Look* claimed to be "de-fictionalizing" the migrants of *The Grapes of Wrath*, depicting "the real Joads" in order to show the "reality" behind Steinbeck's fiction. Yet in doing so, *Look* imposed still another set of narrative conventions upon the migrants—those of the picture story—making the migrants ever more fictional and removing them even further from the concrete social and political contexts in which they lived and worked.[147] The Historical Section photographs, used in the feature as both representations of the "reality" and visualizations of the "fiction," get caught squarely in the middle.

If we consider the events that were taking place before and during 1939 in California, the extent of *Look*'s avoidance of these contexts is clear. Upon publication of *The Grapes of Wrath* there was an outcry from the large growers in California and others who disputed the "truth" of Steinbeck's narrative. Steinbeck, who had never been a friend to the growers, thanks to his previous writings and political activities, was roundly vilified. The Associated Farmers of California launched a public relations campaign against the novel, to do "everything possible to tell the public that . . . 'Grapes of Wrath' . . . cannot be

215

accepted as fact."[148] In a 1939 pamphlet called *The Truth About John Steinbeck and the Migrants,* George Thomas Miron built a case against Steinbeck and other like-minded critics. Within just the first few pages, Miron linked Steinbeck politically and philosophically to communists, Upton Sinclair, Sinclair Lewis, Émile Zola, John Dos Passos, and Erskine Caldwell.[149]

The Associated Farmers (AF) had been founded in 1934 as a collective of large growers who sought to "combat communism" in California agriculture.[150] Funded by "allied industrial interests" such as Pacific Gas and Electric, Santa Fe Railroad Company, Holly Sugar Corporation, and other manufacturers with an interest in large-scale agriculture, the Associated Farmers held considerable power to put pressure on state and local government and law enforcement.[151] In addition to funding anti-Steinbeck propaganda like Miron's pamphlet, the AF undertook the active suppression of union organizing in California, particularly between 1936 and 1939.[152] Using tactics ranging from "black-listing, espionage, the use of thugs and gunmen, [and] the technique of whipping a local community into a frenzy against strikes," the AF sought to quell unrest and "agitation" (and hence, attempts at unionization) among migrant agricultural laborers.[153]

Just a few months after *The Grapes of Wrath* was published, Carey McWilliams published *Factories in the Field,* an exposé of California's industrialized agriculture system. At the time of publication of this influential yet controversial book, McWilliams was the newly appointed head of California's Division of Immigration and Housing—an avowedly progressive political appointee of the state's recently elected liberal governor, Culbert L. Olson.[154] During Olson's first summer in office, two large strikes erupted. From May to July 1939, fruit pickers struck against the Earl Fruit Company in Marysville. From September through November, cotton pickers struck in the lower San Joaquin Valley. In both cases, it was widely reported that the Associated Farmers used "strong-arm" tactics to influence law enforcement and discourage the strikers. In Marysville, for example, where some workers of the Earl Fruit Company were striking for a ten-cent wage increase (to thirty-five cents an hour), law enforcement attempted to break the strike by arresting "ring leaders" and driving them out of the county, by invoking anti-picketing and vagrancy ordinances, and by doing nothing to protect the pickets from assault: "Mr. Newkom [assis-

216

tant superintendent of the fruit ranch], who had been observing the picket line from his car which was parked nearby, stepped out on the highway, loaded an automatic shotgun, and ran down the road toward the pickets." Newkom attacked two pickets with the muzzle of his shotgun; the police stood by and watched, then arrested the pickets.[155]

The election of a liberal governor in California, the publication of Steinbeck's and McWilliams's books, and the growing intensity of labor unrest in the state drew the attention of the federal government in 1939. The La Follette Committee, headed by Senator Robert M. La Follette Jr., had been formed in the U.S. Senate in 1936 to investigate "infringements of civil liberties that interfered with the right of workers to organize and to bargain collectively."[156] Olson, the first Democratic governor elected in California in the twentieth century, invited the inquiry of the committee on behalf of the state's labor movement, which had enthusiastically supported him during the campaign. In late 1939 and early 1940, the committee held hearings in San Francisco and Los Angeles, involving more than four hundred witnesses, including representatives of labor, representatives of the Associated Farmers and allied industries, local law enforcement officials, politicians, social scientists, and specialists in agricultural economics such as Paul Taylor and Carey McWilliams.[157]

Though Olson eventually testified before the committee and generally supported its findings, in *Look* he makes no mention of either the likely federal inquiry or the more general issue of labor unrest. Apart from a brief mention of the "farm industrialists [who] have shown a willingness to exploit" migrants, the Olson section of the *Look* feature gives the reader no sense that there are avenues for change besides the increased involvement of the FSA and the construction of additional labor camps.[158] As we have already seen, the Steinbeck portion of the feature focuses solely on the problems of migrant agricultural labor and does not posit collective bargaining as a potential solution, though *The Grapes of Wrath* does. And the feature as a whole ignores current events. Though the strike in Marysville was most certainly happening while *Look* editors assembled this feature, the "newsworthiness" of the strikes likely marked them as inappropriate for the *Look* picture story. Other publications, however, did not ignore the story. The strike and related federal inquiry were covered by major news outlets; they even garnered a long story in *Survey Graphic*, pub-

lished just a few weeks later, in September.[159] But from *Look*'s point of view, if there was "news" involved, it was Steinbeck's literary triumph, not the plight of the migrants whose lives and experiences he fictionalized.

Available Narratives in the Picture Story's Rhetoric of Poverty

218 Mobilizing a view that de-emphasized current events in favor of what was merely "current," Mike Cowles and his editors at *Look* envisioned a magazine whose stories would be in tune with popular sensibilities, yet function largely apart from political events of the day. *Look* in 1937 struggled to achieve respectability in the face of intense criticism that its picture stories were salacious and lacked substance. Indeed, *Look* presented sharecropper and migrant narratives much as it presented other features—as "curiosities and oddities" sealed off from real-world events. Similarly, though *Look* circa 1939 had matured in its telling of the picture story, the migrant narrative was still constrained—this time by the norms of the picture story itself. *Look*'s framing restricted the availability of narratives that might have encouraged social activism—or at least an awareness of the possibility of activism—in favor of a passive politics of spectacle.

Indeed, one might ask whether the Historical Section images could do anything but represent a politics of spectacle in this context. Mike Cowles argued that *Look* would be an "educational magazine," that it would tell "the news of the world" in "well edited pictures." Yet the norms of the genre that *Look* helped to create belie these goals. Cowles's "educational" mission was constrained by the emphasis on the spectacle of looking rather than the contextualization of that visual knowledge. In addition, *Look*'s professed aim of telling "the news of the world" was negated by its tendency to proscribe discussion of current events explicitly. Finally, by removing the Historical Section photographs from the contexts of their production and reproduction as representations of American citizens in poverty, *Look* employed these "well edited pictures" to further fictionalize the experiences of the photographs' subjects. Despite *Look*'s professed goal of education, and its occasional attempts to address controversial social issues, the magazine actually provided only limited possibilities for anything other than a "passive" response from viewers.

It bears asking, however, whether *Look*'s politics of spectacle is problematic from the point of view of Stryker and the FSA. Stryker, as we have seen, was often of two minds, appearing to be less interested in how the photographs would be used than in their collection for posterity. True, he did actively seek to circulate the photographs, but his aggressive pursuit of the picture magazines does not necessarily mean that he reflected deeply upon the ways in which the images were framed in print. Indeed, in the context of the picture magazines, he was more concerned about the painful fact of the images' noncirculation in *Life* than about the qualitative nature of their circulation in *Look*. The sensational presentation of the photographs in *Look* did not bother him, for the goal was simply for people to *see* the images and the accompanying credit lines. If using photographs of children covered in flies and "shooting the works" on vivid captions would accomplish this goal, then the publication of the photographs in a mass periodical was welcome. From this perspective, then, the magazine's command to "LOOK" fit with the institutional needs of the Historical Section. Furthermore, while the picture stories constrain the availability of other narratives about rural poverty (such as the issue of collective bargaining), each of the three picture stories concludes that the resources of the federal government, specifically the FSA, must be mobilized in order to improve conditions. In the end, although the features offered only partial solutions to the chronic rural poverty that they vividly (and often crudely) depicted, their conclusions contributed to a narrative that, while troublesome in many ways, did promote the FSA and its goals.

E P I L O G U E

Rhetorical Circulation and
the Picturing of Poverty

*Rather than ask, "What is the attitude of a work to the
relations of production of its time?" I should like to ask,
"What is its position in them?"*

—WALTER BENJAMIN, "THE
AUTHOR AS PRODUCER"

Throughout this book I have discussed the FSA photographs as they appeared
in print culture of the 1930s. Interestingly, however, 1930s print culture also ap-
pears in the FSA photographs. Consider an image of a newsstand made by
John Vachon in Omaha, Nebraska (Figure E.1). Picture magazines such as
Look, Life, and *Click* are featured prominently, as is the standard women's mag-
azine fare (*McCall's, Women's Home Companion*). Specialized periodicals such
as *Billboard* and *Poultry* (this is, after all, Nebraska) are nestled alongside pulp
magazines like *True Story* and *Weird Tales.* There are fan magazines and fashion
magazines and newsmagazines and comics—hundreds in all.

Vachon's image offers a number of points of departure by way of sketching
out some concluding remarks to this study. First, the sheer volume of material
is staggering, causing one to wonder that the Historical Section photographs
were able to garner any public attention at all in this increasingly visual mass
culture of print. That the images managed to rise above the din speaks volumes
about both their visual virtuosity and their significance as social documents of
their time. In addition, the photograph and the many others like it in the FSA
file illustrate vividly Benjamin's anxiety about the increasingly dominant role
that mass culture was coming to play in the production, reproduction, and cir-

Figure E.1. Newsstand. Omaha, Nebraska. Photograph by John Vachon (November 1938), FSA-OWI Collection, LC-USF34-008939-D.

culation of images. Such photographs suggest that people's *reading* was increasingly becoming also *looking*. Finally, and just as important, the existence of such images at all signals the government photographers' awareness of the ever-changing cultural practices of reading and looking. These cultural practices were in fact part of the social world that the photographers were charged with documenting.

If Vachon and other photographers recognized these facts, so, too, should we. It may appear that this book has been as much about the magazines themselves as it has been about the FSA project and its photographs. This is as it should be. In studying the photographs as they appeared in *Survey Graphic, U.S. Camera,* and *Look* (and as they *didn't* appear in *Life*), I have really engaged a broader question: What did it mean to picture poverty during the Depression? When Benjamin asks us to consider the *position* of a work in the relations of production, as opposed to its *attitude* toward those relations, he asks us to situate the work in its time, to study it in all of its specificity not only as a *response* to the relations of production, but as a *product* of them. Critical ques-

tions grounded in *position,* Benjamin observes, are "somewhat more modest," but are also ones that provide "more chance of receiving an answer."[1]

Here I have embraced Benjamin's "modest question" by grounding my interpretations of the FSA's representations of poverty in the immediacy and variety of the rhetorical situations in which the photographs found themselves embedded. That is why "circulation" is a key term of this study. I have asserted throughout this volume that a systematic account of circulation of the FSA photographs is necessary because the photographs participated so widely in the print culture of their time. Furthermore, I argued that a specifically *rhetorical* history of the Historical Section project must include an account of circulation if it is successfully to embrace both the specificity and the fluidity of the photographs' rhetorics of poverty in different contexts.

So, what has this account of circulation provided in terms of enabling an understanding of what it meant to picture poverty in the 1930s? Most obviously, it has affirmed that there was indeed no monolithic, overarching visual rhetoric of poverty during the Depression. To argue that the FSA photographs offer a single, easily definable and locatable narrative about poverty in the United States is not only impossible to verify historically, it is also disrespectful of the complexity, nuance, and rhetorical force of the images themselves. Perhaps less obviously, but equally important, this account has also reminded us of the multiplicity of ways in which the photographs visualized and interrogated the relation of poor citizens to the social world, and to representation itself.

As a child of the Progressive Era and a product of the new "science" of social engineering, *Survey Graphic* took up the relationship between the needs of citizens and the operation of their government. Editors at the magazine pictured poverty as a social condition that could be, if not eliminated, at least managed with the tools of social science and the heart of a progressive conscience. The lesson of the FSA photographs' participation in *Survey Graphic* is that there were limits to the extent to which the images could be made to illustrate a bureaucratic social science rhetoric of poverty that emphasized system-level solutions. Compelling photographic portraits such as Dorothea Lange's transcended the context of their presentation in *Survey Graphic* and visualized a persistent particularity not accounted for in the *Survey Graphic* ethos. Thus the very act of *picturing* the poor challenged the magazine's framing of poverty.

U.S. Camera's aesthetic rhetoric of poverty focused not explicitly on the relation of poor citizens to government but on the relationship between two forms of representation: documentary and art. Images of poor citizens in *U.S. Camera* functioned not as illustrations of a social condition but as embodiments of the problem of representation at its core: What does it mean to represent photographically "reality" or "truth"? To what extent is that representation "artful"? The FSA photographs in *U.S. Camera* foregrounded the issue of representation by questioning the political efficacy of photographic art in hard times. Thus while for *Survey Graphic* the act of picturing challenged its own framing of poverty, in *U.S. Camera* the result was something of the opposite: the fact of *poverty* challenged its picturing.

In *Look* the relation of poor citizens to the social world, and to representation itself, was not so much interrogated as merely illustrated. The command to LOOK suggested that the act of looking was an end in itself, rather than a prelude to social action or even deeper understanding. As a result, the popular rhetoric of poverty presented in *Look* was a passive one, leaving little room for the photographs to challenge the norms of their presentation in a context that ignored the urgent newsworthiness of poverty. While *Survey Graphic* sought to picture poverty to transform a social condition, and *U.S. Camera* pictured poverty to illustrate a series of relationships that affected our understanding of art, *Look* simply pictured poverty.

This account of circulation of the FSA photographs has also demonstrated something important about the nature of circulation itself. If we are to understand how images become inventional resources in the public sphere, then we need to abandon a sense of circulation as merely a medium of transfer, a passive conduit of meaning or representation. It may not be enough to note, as many FSA scholars have done, *where* the photographs circulated. It may also be vital, as I have attempted to show here, to explore *how* and *why* they circulated (or, in the case of *Life*, how and why they *didn't*). Here the tools of rhetorical history are useful, for they enable one to engage in what David Zarefsky has called "the study of historical events from a rhetorical perspective"; that is, cultivating a rhetorical sensibility allows one to understand people, events, situations (and, I would add, images) as rhetorical problems for which responses must continually be formulated, reformulated, and negotiated.[2]

What my study of the FSA photographs' circulation across American print

223

culture has shown is that circulation itself is a decidedly *rhetorical* process, meaning that it is always contingent, partial, and utterly context-bound. An account of Stryker's warm relationship with Florence Loeb Kellogg of *Survey Graphic*, for example, demonstrated clearly how interpersonal connections enabled the publication not only of large numbers of the Historical Section's photographs but also of articles influenced directly by Stryker's editorial vision. Kellogg's need for images, combined with Stryker's desire to cultivate their relationship, made the circulation of the photographs in that context fruitful for all involved. By contrast, Stryker's continual irritation with *Life's* rejection of the section's photographs revealed the ways in which institutional, interpersonal, and creative differences impeded the circulation of the photographs in arguably the single most important media outlet of the era. Overall, then, an account of rhetorical circulation enables not only an understanding of the complexity and multiplicity of ways in which the magazines pictured poverty, but also a deeper appreciation of how and why the photographs circulated at all.

There exists in some disciplines, including my own intellectual home of rhetorical studies, the assumption that visuality (often described in terms of "surveillance" or "spectacle") is inherently antithetical to the goals of "rational" discourse in the public sphere. My desire here has been to unsettle the assumptions behind such charges by turning to a specific instance in which visual images participated powerfully, though not univocally, in the public conversation about rural poverty. Thus one perhaps implicit goal of this study has been to make it more difficult to associate the FSA photography project solely with facile labels such as "art," "propaganda," "surveillance," or "spectacle." If this study has accomplished that goal, it has done so by enacting my belief that the study of images must remain grounded in the materiality of their rhetorical circulation. It is my hope that this approach not only enables us to understand more deeply the politics of American visual culture in the 1930s but also moves us beyond relatively outmoded ways of talking about images—emboldening us to engage the politics of all visual cultures both more critically and more charitably.

NOTES

Abbreviations Used in Notes

AAA Archives of American Art. New Deal and the Arts Oral History Project, interviewer Richard K. Doud. Smithsonian Institution, Washington, D.C. Microfilm reel 3697 unless otherwise noted.

ESA Edward Steichen Archive. Tom Maloney Correspondence Files. Museum of Modern Art, New York.

FSA-OWI FSA-OWI Collection. Prints and Photographs Division, Library of Congress, Washington, D.C.

PST Paul Schuster Taylor interview, 11 June 1970. *California Social Scientist,* interviewer Suzanne B. Riess. Regional Oral History Office, Bancroft Library, University of California, Berkeley, 1973.

RES Roy Emerson Stryker Papers. Photographic Archive. University of Louisville, Louisville, Kentucky.

SA Survey Associates Collection. Social Welfare History Archive. University of Minnesota, Minneapolis, Minnesota.

Preface: A Rhetorical History of Photographs

1. Franklin D. Roosevelt, "First Inaugural Address, 1933," in *American Voices: Significant Speeches in American History, 1649–1945,* ed. James Andrews and David Zarefsky (New York: Longman, 1989), 436.

2. Ibid., 436–38.

3. Ibid., 438.

4. See Martin Jay, *Downcast Eyes: The Denigration of Vision in Twentieth-Century French Thought* (Berkeley: University of California Press, 1993); David M. Levin, ed., *Modernity and the Hegemony of Vision* (Berkeley: University of California Press, 1993); Joel Snyder, "Picturing Vision," *Critical Inquiry* 6 (Spring 1980): 499–526; Chris Jenks, "The Centrality of the Eye in Western Culture: An Introduction," in *Visual Culture,* ed. Chris Jenks (New York: Routledge, 1995), 1–25; Jonathan Crary, *Techniques of the Observer: On Vision and Modernity in the Nineteenth Century* (Cambridge: MIT Press, 1990), and Crary, *Suspensions of Perception: Attention, Spectacle, and Modern Culture* (Cambridge: MIT Press, 1999), especially "Modernity and the Problem of Attention," 11–79.

5. Carl Fleischhauer and Beverly W. Brannan, eds., *Documenting America, 1935–1943* (Berkeley: University of California Press, 1988), 330.

6. Throughout the book I refer to the photographs alternately as the "Historical Section photographs" and the "FSA photographs." These designations are largely interchangeable, and I use both, pri-

marily to add variety to the writing. As I explain in chapter 1, the Historical Section was one of several departments in the Information Division of the Resettlement Administration (RA), which eventually became the Farm Security Administration (FSA). During World War II the Historical Section was absorbed into yet another agency, the Office of War Information (OWI). Although the designation "Historical Section" is the most accurate description of the project's location, most historians and scholars locate the project as a product of its sponsoring agency, the FSA. Hence, I use both designations.

7. Walter Benjamin, "The Work of Art in the Age of Mechanical Reproduction," in *Illuminations: Essays and Reflections,* ed. Hannah Arendt (New York: Schocken, 1968), 223.

8. Miles Orvell, *The Real Thing: Imitation and Authenticity in American Culture, 1880–1940* (Chapel Hill: University of North Carolina Press, 1989), xv–xvi.

9. Ibid., xvi.

10. Ibid., 199.

11. Ibid.

12. Given this claim, it is ironic that two of the best-selling books of the 1930s were fiction: Margaret Mitchell's *Gone with the Wind* and John Steinbeck's *The Grapes of Wrath.* But Steinbeck's book, at least, owed a strong debt to the realist and documentary traditions of the decade.

13. William Stott, *Documentary Expression and Thirties America* (Chicago: University of Chicago Press, 1973), 73.

14. Terry A. Cooney, *Balancing Acts: American Thought and Culture in the 1930's* (New York: Twayne Publishers, 1995), 158.

15. Benjamin, "Work of Art," 223.

16. Susan Sontag, *On Photography* (New York: Anchor Books, 1977), 8.

17. Alan Trachtenberg, *Reading American Photographs: Images as History from Mathew Brady to Walker Evans* (New York: Noonday Press, 1989).

18. Sontag, *On Photography,* 9.

19. On documentary as a mode of inquiry, see Erik Barnouw, *Documentary: A History of the Non-Fiction Film* (New York: Oxford University Press, 1974); A. William Bluem, *Documentary in American Television: Form, Function, Method* (New York: Communication Arts Books, 1965); Robert Coles, *Doing Documentary Work* (New York: Oxford University Press, 1997); Trinh T. Minh-ha, "Documentary Is/Not a Name," *October* 52 (Spring 1990): 76–98; Bill Nichols, *Representing Reality: Issues and Concepts in Documentary* (Bloomington: Indiana University Press, 1991); and Paula Rabinowitz, *They Must Be Represented: The Politics of Documentary* (London: Verso, 1994).

20. Paul Rotha, *Documentary Film* (London: Faber and Faber, 1966), 105.

21. Ibid., 116.

22. John Berger and Jean Mohr, *Another Way of Telling* (New York: Vintage, 1982), 85.

23. Ibid., 89.

24. Trachtenberg, *Reading American Photographs,* xv.

25. W. J. T. Mitchell, *Picture Theory: Essays on Verbal and Visual Representation* (Chicago: University of Chicago Press, 1994), 97. See also Mitchell, *Iconology: Image, Text, Ideology* (Chicago: University of Chicago Press, 1986), especially chapters 1 and 2.

26. Mitchell, *Picture Theory,* 95.

27. Martin Jay, "Scopic Regimes of Modernity," in *Vision and Visuality,* ed. Hal Foster (New York: New Press, 1988), 3–27; Jay, *Downcast Eyes;* Christian Metz, *The Imaginary Signifier: Psychoanalysis and the Cinema,* trans. Celia Britton, Annwyl Williams, Ben Brewster, and Alfred Buzzetti (Bloomington: Indiana University Press, 1982).

28. Jay, *Downcast Eyes*, 9.

29. "Straight photography" is a term used to describe a genre of photographs that privileges the capacity of photographs to represent the world with precision and clarity, without darkroom manipulations of any kind. The "straight" aesthetic came into being in the early twentieth century when pictorial photographers such as Alfred Stieglitz, Edward Steichen, and Paul Strand became disaffected with pictorialist images that sought to look like paintings. See Beaumont Newhall, *The History of Photography from 1939 to the Present*, 5th ed. (New York: Metropolitan Museum of Modern Art, 1994), 167–97.

30. See, for example, *Portrait of a Decade: Roy Stryker and the Development of Documentary Photography in the Thirties* (Baton Rouge: Louisiana University Press, 1972); William Stott, *Documentary Expression and Thirties America,* rev. ed. (Chicago: University of Chicago Press, 1986); Hank O'Neal, *A Vision Shared* (New York: St. Martin's, 1976); and Hurley's own *Russell Lee, Photographer* (Dobbs Ferry, N.Y.: Morgan and Morgan, 1978) and *Marion Post Wolcott: A Photographic Journey* (Albuquerque: University of New Mexico Press, 1989).

31. F. Jack Hurley, "The Farm Security Administration File: In and Out of Focus," *History of Photography* 17 (Autumn 1993): 244.

32. Pete Daniel, Merry A. Foresta, Maren Stange, and Sally Stein, *Official Images: New Deal Photography* (Washington, D.C.: Smithsonian Institution Press, 1987); Andrea Fisher, *Let Us Now Praise Famous Women: Women Photographers for the US Government, 1935 to 1944* (London: Pandora, 1987); Melissa A. McEuen, *Seeing America: Women Photographers between the Wars* (Lexington: University of Kentucky Press, 2000); Nicholas Natanson, *The Black Image in the New Deal: The Politics of FSA Photography* (Knoxville: University of Tennessee Press, 1992).

33. James Curtis, *Mind's Eye, Mind's Truth: FSA Photography Reconsidered* (Philadelphia: Temple University Press, 1989); John Tagg, *The Burden of Representation: Essays on Photographies and Histories* (Minneapolis: University of Minnesota Press, 1988); Maren Stange, *Symbols of Ideal Life: Social Documentary Photography in America, 1890–1950* (Oxford: Cambridge University Press, 1989).

34. This argument is developed in excellent detail by both Hurley, "The Farm Security Administration File," 244–52, and Natanson, *The Black Image in the New Deal,* 10–13.

35. Alan Trachtenberg, "From Image to Story: Reading the File," in *Documenting America,* ed. Fleischhauer and Brannan, 43–73.

36. Benjamin, "Work of Art"; see also Benjamin, "The Author as Producer," in *Reflections: Essays, Aphorisms, Autobiographical Writings,* ed. Peter Demetz (New York: Schocken, 1978), especially 220–23.

37. Stange, *Symbols of Ideal Life,* 111.

38. Penelope Dixon's bibliography of the FSA includes an incomplete but extensive list of newspapers and magazines that used FSA photographs during the years 1935–43. See Penelope Dixon, *Photographs of the Farm Security Administration: An Annotated Bibliography, 1930–1980* (New York: Garland Publishing, 1983), 201–10.

227

Introduction: Making Rural Poverty Visible: The Depression, the New Deal, and the Historical Section

1. This number is an estimate. In the FSA-OWI file the Elmer Thomas pictures are not kept together as a distinct, complete visual narrative; rather, they are distributed among several subject areas. Thus it is possible that a few prints escaped my notice.

2. Robert DeMott, introduction to John Steinbeck, *The Grapes of Wrath* (New York: Penguin, 1992), ix.

3. Charles Shindo, *Dust Bowl Migrants in the American Imagination* (Lawrence: University of Kansas Press, 1997).

4. Russell Lee to Roy Stryker, 11 May 1939, RES, series 1, reel 2.

5. Roy Stryker to Russell Lee, 17 May 1939, ibid. (emphasis in original).

6. Lee to Stryker, 7 July 1939, ibid.

7. Lee to Stryker, 21 June 1939, ibid.

8. Lee to Stryker, 22 June 1939, ibid.

9. James Gregory, *American Exodus: The Dust Bowl Migration and Okie Culture in California* (New York: Oxford University Press, 1989), 32.

10. Robert Asen, *Visions of Poverty: Welfare Policy and Political Imagination* (East Lansing: Michigan State University Press, 2002), 25.

11. William Ryan, *Blaming the Victim* (New York: Vintage, 1976).

12. Neil Betten, "American Attitudes toward the Poor: A Historical Overview," *Current History* 65 (July 1973): 1.

13. Ibid., 2.

14. Michael B. Katz, *In the Shadow of the Poorhouse: A Social History of Welfare in America,* rev. ed. (New York: Basic Books, 1996), 15.

15. Betten, "American Attitudes toward the Poor," 2.

16. Katz, *In the Shadow of the Poorhouse,* 17.

17. Robert H. Bremner, *From the Depths: The Discovery of Poverty in the United States* (New York: New York University Press, 1956), 18.

18. Katz, *In the Shadow of the Poorhouse,* 11.

19. Asen, *Visions of Poverty,* 30.

20. Betten, "American Attitudes toward the Poor," 3.

21. Ibid., 4.

22. Ibid.

23. Thanks to Stephen Hartnett for pointing me toward this text. Maren Stange also features a brief discussion of Brace in *Symbols of Ideal Life: Social Documentary Photography in America, 1890–1950* (Oxford: Cambridge University Press, 1989), 13, 21.

24. Charles Loring Brace, *The Dangerous Classes of New York and Twenty Years' Work among Them,* 3d ed. (New York: Wynkoop and Hallenbeck, 1880).

25. Ibid., ii.

26. "Social photography" is Hine's term; see Hine, "Social Photography," in *Classic Essays on Photography,* ed. Alan Trachtenberg (Stony Creek, Conn.: Leete's Island Press, 1980), 109–13. Substantial child labor reform laws were not passed at the federal level, however, until well into the New Deal era. On the history of the NCLC, see Walter I. Trattner, *Crusade for the Children: A History of the National Child Labor Committee and Child Labor Reform in America* (Chicago: Quadrangle Books, 1970). On Hine's work for the NCLC, see Verna P. Curtis and Stanley Mallach, *Photography and Reform: Lewis Hine and the National Child Labor Committee* (Milwaukee, Wis.: Milwaukee Art Museum, 1984).

27. See Hine, "Social Photography," especially 110–12.

28. Sidney Baldwin, *Poverty and Politics: The Rise and Decline of the Farm Security Administration* (Chapel Hill: University of North Carolina Press, 1968), 21–22.

29. James T. Patterson, *America's Struggle against Poverty in the Twentieth Century,* 4th ed. (Cambridge: Harvard University Press, 2000), 38.

30. Betten, "American Attitudes toward the Poor," 5.

31. Asen, *Visions of Poverty,* 33.

32. Franklin D. Roosevelt, "The Forgotten Man," *The Public Papers and Addresses of Franklin D. Roosevelt,* vol. 1, *1928–32,* compiled and collated by Samuel I. Rosenman (New York: Random House, 1938), 624.

33. Katz, *In the Shadow of the Poorhouse,* 218.

34. Ronald D. Cohen and Dave Samuelson, *Songs for Political Action* (Bamberger, Germany: Bear Family Records, 1996), 64.

35. Franklin Roosevelt, "Annual Message to Congress, 1935," *The Public Papers and Addresses of Franklin D. Roosevelt,* vol. 4, *1935* (New York City: Random House, 1938), 15.

36. Charles H. Trout, "Welfare in the New Deal Era," *Current History* 65 (July 1973): 12.

37. Patterson, *America's Struggle against Poverty,* 46.

38. "Farm Security Administration Picture Comments," 18–29 April 1938, RES, series 2, reel 6.

39. Socialism and fascism, interestingly, appear in both negative and positive ways in the comments. Some complained that the pictures were a "waste of tax payers hard earned money" and functioned as "purely propaganda for Communism" or "subversive propaganda." One viewer commented that the images were "pro-Nazi," but more than one respondent mentioned that the Germans seemed to be doing a better job of handling their depression than Americans were: "I think we need a Hitler"; "We sure need a Hitler. If he comes over I know a plenty who would vote for him." "Farm Security Administration Picture Comments," 18–29 April 1938, RES.

40. Quoted in Patterson, *America's Struggle against Poverty,* 46.

41. Ibid.

42. Baldwin, *Poverty and Politics,* 22.

43. Ibid.

44. Ibid., 30.

45. Shindo, *Dust Bowl Migrants in the American Imagination,* 13.

46. Baldwin, *Poverty and Politics,* 24.

47. Ibid.

48. Howard A. Turner, "Farm Tenancy Distribution and Trends in the United States," *Law and Contemporary Problems: Farm Tenancy* 4 (October 1937): 424.

49. Ibid.

50. William T. Ham, "The Status of Agricultural Labor," *Law and Contemporary Problems: Farm Tenancy* 4 (October 1937): 560.

51. Robert S. McElvaine, *The Great Depression: America, 1929–1941* (New York: Times Books, 1993), 21.

52. Ibid.

53. Quoted in Baldwin, *Poverty and Politics,* 25.

54. Richard Lowitt and Maurine Beasley, eds., *One Third of a Nation: Lorena Hickok Reports on the Great Depression* (Urbana: University of Illinois Press, 1981), 186.

55. William C. Holley, Ellen Winston, and T. J. Woofter Jr., *The Plantation South, 1934–1937,* WPA Research Monograph 22 (Washington, D.C.: Government Printing Office, 1940), 27.

56. Berta Asch and A. R. Magnus, "Farmers on Relief and Rehabilitation," in *The Great Depression,* ed. David A. Shannon (Englewood Cliffs, N.J.: Prentice-Hall, 1960), 31.

57. Ibid.

58. T. H. Watkins, *The Great Depression: America in the 1930s* (Boston: Back Bay Books, 1993), 190.

59. Ibid., 64.

60. Lowitt and Beasley, *One Third of a Nation,* ix.

61. Asch and Magnus, "Farmers on Relief and Rehabilitation," 30.

62. Holley, Winston, and Woofter, *The Plantation South,* 54.

63. John Webb, *The Transient Unemployed: A Description and Analysis of the Transient Relief Population,* WPA Research Monograph 3 (Washington, D.C.: WPA Division of Social Research, 1935), 2.

64. C. E. Lively and Conrad Taeuber, *Rural Migration in the United States,* WPA Research Monograph 19 (Washington, D.C.: Government Printing Office, 1939), 65.

65. Watkins, *The Great Depression,* 194.

66. Webb, *The Transient Unemployed,* 80.

67. Baldwin, *Poverty and Politics,* 221.

68. Gregory, *American Exodus,* 11.

69. Ibid., 15.

70. McElvaine, *The Great Depression,* 148.

71. Watkins, *The Great Depression,* 160.

72. McElvaine, *The Great Depression,* 150.

73. Baldwin, *Poverty and Politics,* 77.

74. Watkins, *The Great Depression,* 194.

75. Lowitt and Beasley, *One Third of a Nation,* 338.

76. Baldwin, *Poverty and Politics,* 4.

77. Rexford Guy Tugwell, Thomas Munro, and Roy E. Stryker, *American Economic Life and the Means of Its Improvement,* 3d ed. (New York: Harcourt Brace, 1930), 524.

78. Ibid., 525.

79. Ibid., 532.

80. Stange, *Symbols of Ideal Life,* 90.

81. Tugwell, Munro, and Stryker, *American Economic Life,* 534.

82. Ibid., 536.

83. Baldwin, *Poverty and Politics,* 93.

84. *The Resettlement Administration* (Washington, D.C.: Resettlement Administration, 1935), 1.

85. Ibid.

86. All pamphlet quotations that follow are from *Resettlement Administration,* 1–25.

87. On Greenbelt communities, see Joseph Arnold, *The New Deal in the Suburbs: A History of the Greenbelt Town Program, 1935–1954* (Columbus: Ohio State University Press, 1971), and Cathy D. Knepper, *Greenbelt, Maryland: A Living Legacy of the New Deal* (Baltimore: Johns Hopkins University Press, 2001).

88. Watkins, *The Great Depression,* 202.

89. Quoted in Studs Terkel, *Hard Times: An Oral History of the Great Depression* (New York: Pantheon, 1970), 280.

90. Baldwin, *Poverty and Politics,* 222.

91. Ibid.

92. Watkins, *The Great Depression,* 296.

93. Ibid.

94. Baldwin, *Poverty and Politics,* 117.

95. Frank Kluckhorn, "Tugwell Has Staff of 12,089 Create 5,012 Relief Jobs," *New York Times,* 17 November 1935, 1.

96. "Tugwell Protests Published Figures," *New York Times,* 20 November 1935, 5.

97. Baldwin, *Poverty and Politics,* 115.

98. McElvaine, *The Great Depression,* 205.

99. Norman Thomas, *After the New Deal—What?* (New York: Macmillan, 1936), 40.

100. Ibid., 47, 50.

101. McElvaine, *The Great Depression,* 205–6.

102. Baldwin, *Poverty and Politics,* 111.

103. Ibid., 112.

104. F. Jack Hurley, *Portrait of a Decade: Roy Stryker and the Development of Documentary Photography in the Thirties* (Baton Rouge: Louisiana State University Press, 1972), 162.

231

1. Imaging Poverty in the Historical Section

1. Of his settlement work, Stryker noted: "I was basically a radical. I was basically from a Socialist home. And there were a lot of things that I didn't think they [settlement workers] were doing as they should have. . . . But the settlement work was important." Roy Stryker, 13 June 1964, AAA.

2. Ibid.

3. F. Jack Hurley, *Portrait of a Decade: Roy Stryker and the Development of Documentary Photography in the Thirties* (Baton Rouge: Louisiana State University Press, 1972), 11.

4. Maren Stange argues that the ways in which Stryker captioned Hine's photographs constituted a serious distortion of their intent; see Stange, *Symbols of Ideal Life: Social Documentary Photography in America, 1890–1950* (Oxford: Cambridge University Press, 1989), 101–5.

5. Rexford Guy Tugwell, 21 January 1965, unmicrofilmed interview transcript, AAA.

6. U.S. Department of Agriculture to Roy Stryker, 31 May 1934, RES, series 1, reel 1.

7. As a result of these tendencies, Stryker is often made to take on the villain's role in some FSA scholarship; see, for instance, the characterizations of Stryker by Stange (chapters 3 and 4) and James Curtis, *Mind's Eye, Mind's Truth: FSA Photography Reconsidered* (Philadelphia: Temple University Press, 1989).

8. Actually, some photographs made by Stryker do appear in the file. In 1937 Stryker accompanied Russell Lee on a trip to the lumbering regions of northern Minnesota and Wisconsin. Stryker made a small number of images there, including a humorous set of Russell Lee in his car, titled "FSA (Farm Security Administration) photographer being pulled out of mud by tractor, near Littlefork, Minnesota." FSA-OWI, LC-USF33-015559-M4.

9. Roy Stryker, 23 January 1965, AAA.

10. Ibid., 17 October 1963.

11. Ibid., 13 June 1964.

12. Resettlement Administration to Walker Evans, 9 October 1935, RES, series 1, reel 1.

13. James Agee and Walker Evans, *Let Us Now Praise Famous Men: Three Tenant Families,* rev. ed. (Boston: Houghton Mifflin, 1960). Accounts of Evans's relationship with Stryker vary from warm to cordial to downright hostile. See, for example, Evans's account of their relationship in William Stott, *Documentary Expression and Thirties America* (Chicago: University of Chicago Press, 1973), 281–82. And, in an interview for the New Deal and the Arts Oral History Project, Stryker said of Evans, "I could have killed him a few times . . . but that's besides the point. I still respected him deeply as a photographer" (13 June 1964, AAA).

14. *America, 1935–1946: Index to the Microfiche* (Cambridge: Chadwyck-Healey, 1981), 1.

15. Stryker, "Suggestions recently made by Robert Lynd for things which should be photographed as American background," 1936, RES, series 2, reel 6.

16. Stryker to Russell Lee, 29 June 1939, RES, series 1, reel 2.

17. Roy Stryker and Nancy Wood, *In This Proud Land: America, 1935–1943, As Seen in the FSA Photographs* (London: Secker and Warburg, 1974), 188.

18. Carl Fleischhauer and Beverly W. Brannan, eds., *Documenting America, 1935–1943* (Berkeley: University of California Press, 1988), 252.

19. Stryker to Dorothea Lange, February 1936, RES, series 1, reel 1.

20. Stryker to Arthur Rothstein, 29 April 1936, RES, series 1, reel 1.

21. Stryker to Rothstein, 31 July 1936, ibid.

22. Stryker, "Shooting Script for Dorothea," ca. 1939–40, RES, series 2, reel 6.

23. Stryker to Lange, 21 December 1936, RES, series 1, reel 1.

24. Stryker to Lee, 12 December 1936, ibid.

25. Stryker to Lange, 18 June 1937, ibid.

26. Stryker to Lee, 7 April 1939, RES, series 1, reel 2.

27. Stryker to Marion Post, 1 April 1939, ibid.

28. Stryker to Lange, 17 January 1939, ibid.

29. See especially Curtis, *Mind's Eye, Mind's Truth.*

30. Hurley, *Portrait of a Decade,* 58.

31. Charlotte Aiken and Helen Wool, 17 April 1964, AAA. Aiken and Wool worked in the administrative offices of the Historical Section, Aiken in the early years and Wool starting in 1940.

32. Stryker, "General Notes for Pictures Needed for Files," 1939, RES, series 2, reel 6.

33. Stryker to Marion Post, 16 March 1939, RES, series 1, reel 2.

34. Stryker to Russell Lee, 30 January 1937, RES, series 1, reel 1.

35. Stryker to Walker Evans, 10 December 1935, ibid.

36. Stryker to Dorothea Lange, 25 August 1936, ibid.

37. Stryker to Lange, 21 December 1936, ibid.

38. Stryker to Lange, November 1939, RES, series 1, reel 2.

39. Stryker, 13 June 1964, AAA.

40. *America, 1935–1946,* 2. Stryker left the section in 1943; between 1943 and 1946, the Historical Section operated under the auspices of the Office of War Information (OWI).

41. Stryker to Dorothea Lange, 22 December 1938, RES, series 1, reel 1.

42. Post to Roy Stryker, 12 January 1939, RES, series 1, reel 2.

43. Post to Stryker, January 1939, ibid.

44. Post to Stryker, 24 February 1939, ibid.

45. Rothstein to Stryker, 16 February 1940, ibid.

46. Stryker to Arthur Rothstein, 20 February 1940, ibid.

47. Post to Stryker, 2 March 1940, ibid.

48. Lange to M. E. Gilfond, 19 October 1936, RES, series 1, reel 1.

49. Arthur Rothstein to Stryker, 27 January 1939, RES, series 1, reel 2.

50. Fleischhauer and Brannan, *Documenting America,* 338. One can view some of these "killed" prints in the Library of Congress FSA-OWI online database, where many are reproduced, holes and all.

51. Ibid., 339.

52. For an extended treatment of this controversy and an analysis of its implications for the study of controversy and visual argument, see Cara A. Finnegan, "The Naturalistic Enthymeme and Visual Argument: Photographic Representation in the 'Skull Controversy,'" *Argumentation and Advocacy* 37 (Winter 2001): 133–49.

53. "Some Iowa Farm Tenant Conditions as Pictured by the U.S. Resettlement Administration," *Des Moines Sunday Register*, 2 May 1937, 1.

54. A. A. Mercey to Russell Lee, 21 June 1937, RES, series 1, reel 1.

55. "Senator on Warpath," *Life*, 7 June 1948, RES, series 3, reel 9.

56. Ibid.

57. Stryker, 17 October 1963, AAA (emphasis in transcript).

58. Dorothea Lange, 22 May 1964, AAA.

59. Arthur Rothstein, 25 May 1964, AAA (emphasis in transcript).

60. John Vachon, 28 April 1964, AAA (emphasis in transcript).

61. Stange, *Symbols of Ideal Life*, 108.

62. Ibid., 111.

63. Ibid., 108.

64. Curtis, *Mind's Eye, Mind's Truth*, 23.

65. Margaret Bourke-White and Erskine Caldwell, *You Have Seen Their Faces* (New York: Viking, 1937).

66. Archibald MacLeish, *Land of the Free* (New York: Harcourt, Brace, 1938).

67. Dorothea Lange and Paul Taylor, *An American Exodus: A Record of Human Erosion* (New York: Reynal and Hitchcock, 1939).

68. Richard Wright and Edwin Rosskam, *Twelve Million Black Voices: A Folk History of the Negro in the United States* (New York: Viking, 1941).

2. Social Engineering and Photographic Resistance:
Social Science Rhetorics of Poverty in *Survey Graphic*

1. Clarke Chambers, *Paul U. Kellogg and "The Survey": Voices for Social Welfare and Social Justice* (Minneapolis: University of Minnesota Press, 1971), 128.

2. Michael B. Katz, *In the Shadow of the Poorhouse: A Social History of Welfare in America*, rev. ed. (New York: Basic Books, 1996), 69.

3. Ibid., 78.

4. Chambers, *Paul U. Kellogg and "The Survey,"* 8.

5. Ibid., 11.

6. Ibid., 29.

7. On the social gospel movement, see Donald K. Gorrell, *The Age of Social Responsibility: The Social Gospel in the Progressive Era, 1900–1920* (Macon, Ga.: Mercer University Press, 1988).

8. Sean Dennis Cashman, *America in the Age of the Titans: The Progressive Era and World War I* (New York: New York University Press, 1988), 46.

9. Ibid., 89.

10. Chambers, *Paul U. Kellogg and "The Survey,"* 212.

11. Ibid., 45.

12. Ibid., 51.

13. Ibid.

14. Ibid., 53.

15. After the war, formal educational programs in social work and professional associations popped up all over the country. Chambers notes that in 1915 there were five schools training social workers; by 1930 there were at least forty (ibid., 93).

16. Ibid., 84.

17. Ibid., 105.

18. Paul Kellogg, "Forward," *Survey Graphic* 47 (29 October 1921): 131.

19. *Survey Graphic* 47 (28 January 1922).

20. "Red Letter Issues," *Survey Graphic* 26 (December 1937).

21. Chambers, *Paul U. Kellogg and "The Survey,"* 239.

22. A. A. Berle, "Brandeis at 80," *Survey Graphic* 25 (November 1936): 596.

23. Ibid., 597.

24. Chambers, *Paul U. Kellogg and "The Survey,"* 109.

25. John Dewey, "Authority and Freedom," 605.

26. John Dewey, *The Public and Its Problems* (Athens, Ohio: Swallow Press, 1927), 169.

27. Ibid., 179.

28. John Dewey, *Liberalism and Social Action* (New York: G. P. Putnam's Sons, 1935), 72.

29. Dewey, *The Public and Its Problems,* 209 (emphasis in text).

30. Chambers, *Paul U. Kellogg and "The Survey,"* 95.

31. Ibid., 85.

32. Hine's "work portraits" featured intimate photographs of skilled craftsmen and laborers posing while performing their jobs. Hine's work had been used extensively years earlier, in Kellogg's Pittsburgh Survey.

33. This visual language, called the "Isotype," was a standardized system of symbols created by German mathematician Otto Neurath, who claimed that by using his icons experts would now be able to convert "profound research statistics . . . into ideas, ideas then designed into a picture narrative, a drama of social interpretation." See "Social Showman," *Survey Graphic* 25 (November 1936): 618; see also Neurath, "Visual Education: A New Language," *Survey Graphic* 26 (January 1937): 25–28.

34. Chambers, *Paul U. Kellogg and "The Survey,"* 128.

35. The numbers quoted here and below are based upon my classification of *Survey Graphic* articles from 1933 to 1940 into the following categories: urban/industrial issues, rural issues, general social trends, New Deal, and miscellaneous (including health, art, literature). Each article was assigned to only one category, though there may in actuality be some overlap. These numbers are intended only to demonstrate general trends in *Survey Graphic*'s coverage of particular kinds of issues.

36. Chambers, *Paul U. Kellogg and "The Survey,"* 135.

37. Ibid., 236.

38. Stryker, 13 June 1964, AAA.

39. Lewis Hine to Roy Stryker, 27 December 1935, RES, series 1, reel 1.

40. Florence Loeb Kellogg, telegram to Roy Stryker, 2 December 1935, SA, folder 1291, box 168.

41. Loeb Kellogg to Stryker, 15 December 1935, SA, folder 1291, box 168.

42. The numbers here represent images credited to the RA/FSA or to photographers associated with the agencies during the years in question. In one case I have identified an FSA photograph that was miscredited to another government agency, but that identification was only coincidental. For the sake of precision, I am focusing solely on photographs credited by the magazine to the RA/FSA's Historical Section.

43. Hartley Howe, "You Have Seen Their Pictures," *Survey Graphic* 29 (March 1940): 236–38.

44. Loeb Kellogg to Stryker, 3 March 1938, SA, box 168, folder 1291.

45. Beulah Amidon, "Sooners in Security," *Survey Graphic* 27 (April 1938): 203–7.

46. Loeb Kellogg to Stryker, 27 December 1939, SA, box 168, folder 1291 (emphasis Kellogg's).

47. Stryker to Dorothea Lange, 9 November 1936, RES, series 1, reel 1.

48. Howe, "You Have Seen Their Pictures," 236.

49. Ibid., 238.

50. Stryker to Victor Weybright, 1 September 1939, RES, series 1, reel 2.

51. Loeb Kellogg to Stryker, 20 March 1940, SA, box 168, folder 1291.

52. Roy Stryker, 23 January 1965, AAA.

53. Edwin R. Embree, "Southern Farm Tenancy: The Way Out of Its Evils," *Survey Graphic* 25 (March 1936): 149–52, 190.

54. Paul Taylor, "From the Ground Up," *Survey Graphic* 25 (September 1936): 526–29, 537–38.

55. Rosenwald Fund press release, 1928, SA, box 68, folder 507.

56. Charles S. Johnson, Edwin R. Embree, and W. W. Alexander, *The Collapse of Cotton Tenancy: Summary of Field Studies and Statistical Surveys, 1933–1935* (Chapel Hill: University of North Carolina Press, 1935).

57. Both photographers made extended trips to the South in late 1935.

58. When speaking of photographs, of course, the use of the term "original" is problematic. By "original" I mean the negative and the corresponding prints (with captions provided by photographers and FSA staff) cataloged in the FSA-OWI file of the Library of Congress's Prints and Photographs Division. These "originals" are what newspaper and magazine editors would have found when they went to Stryker's office to search the file.

59. Embree, "Southern Farm Tenancy," 150.

60. Ibid., 151.

61. Embree to Paul Kellogg, 14 January 1936, SA, box 68, folder 1291.

62. Kellogg to Edwin Embree, 17 January 1936, ibid.

63. Embree, "Southern Farm Tenancy," 152.

64. The notion of "tenancy as slavery" was a common topos at this time. Many writers of the day, as illustrated by Lorena Hickok in the introduction, likened the two systems.

65. Embree, "Southern Farm Tenancy," 149.

66. Ibid., 150.

67. Ibid., 151.

68. Ibid., 152.

69. Ibid.

70. Although tenancy did in many ways replicate the kinds of oppressions faced by slaves, it is of course suspect (even in 1936) to conclude that whites were not "harmed" by slavery or that tenancy constitutes a system of oppression equivalent to that of human bondage and servitude. Embree's blindness on this point suggests a fundamental moral dilemma inherent in a bureaucratic focus on "the system."

71. Stewart E. Tolnay and E. M. Beck, "Rethinking the Role of Racial Violence in the Great Migration," in *Black Exodus: The Great Migration from the American South*, ed. Alferdteen Harrison (Jackson: University Press of Mississippi, 1991), 27.

72. Arkansas migration statistics from Bureau of the Census, *Historical Statistics of the United States, Colonial Times to 1970, Part 1* (Washington, D.C.: Government Printing Office, 1975), 95; lynching statistics quoted in Tolnay and Beck, "Rethinking the Role of Racial Violence," 27.

73. Kimberley L. Phillips, *AlabamaNorth: African-American Migrants, Community, and Working-Class Activism in Cleveland, 1915–45* (Urbana: University of Illinois Press, 1999), 45.

74. Paul Kellogg to Edwin Embree, 20 March 1936, SA, box 68, folder 507.

75. Paul Taylor, PST.

76. Ibid.

77. Paul Taylor, "Mexicans North of the Rio Grande," *Survey Graphic* 66 (May 1931): 135–40, 197–202.

78. Paul S. Taylor and Clark Kerr, "Whither Self-Help?" *Survey Graphic* 23 (July 1934): 328–31, 348; and Paul S. Taylor and Norman Leon Gold, "San Francisco and the General Strike," *Survey Graphic* 23 (September 1934): 405–11.

79. Dorothea Lange, 22 May 1964, AAA.

80. Taylor, PST; see also Milton Meltzer, *Dorothea Lange: A Photographer's Life* (New York: Farrar, Straus, and Giroux, 1978), 83.

81. Taylor, PST (emphasis in transcript).

82. Meltzer, *Dorothea Lange,* 94. Taylor recalled: "I asked her if she had ever typed. She said that she had taken typing lessons for three days. That's the only typing I ever heard or saw her do in her life!" (Taylor, PST).

83. Taylor, PST.

84. Paul S. Taylor, "Again the Covered Wagon," *Survey Graphic* 24 (July 1935): 348–51+.

85. Paul Taylor to Paul Kellogg, 7 April 1935, SA, box 169, folder 1297.

86. Taylor Kellogg, 3 June 1935, SA, box 169, folder 1297.

87. Andrea Fisher, *Let Us Now Praise Famous Women: Women Photographers for the U.S. Government 1935 to 1944* (London: Pandora Press, 1987), 138.

88. Meltzer, *Dorothea Lange,* 135.

89. James Curtis analyzes the complete series of photographs in order to demonstrate how Lange "moved in" on Florence Thompson to get her final, iconic photograph. See Curtis, *Mind's Eye, Mind's Truth: FSA Photography Reconsidered* (Philadelphia: Temple University Press, 1989), 47–55.

90. Robert Coles, *Doing Documentary Work* (New York: Oxford University Press, 1997), 103.

91. Ibid., 104.

92. Paula Rabinowitz, *They Must Be Represented: The Politics of Documentary* (London: Verso, 1994), 87.

93. John Louis Lucaites and Robert Hariman, "Visual Rhetoric, Photojournalism, and Democratic Public Culture," *Rhetoric Review* 20 (Spring 2001): 37–42.

94. I am grateful to Dale Brashers for pointing out the regional nature of this expression.

95. *Survey Graphic* 25 (September 1936): 524. The caption, in fact, may be in error; Lange's notes on the image at the Prints and Photographs Division of the Library of Congress indicate that the family sold its *tires* for food, not its tent.

96. *Survey Graphic* 25 (September 1936): 525. While Margaret Bourke-White was known for inventing the words of her photographic subjects (particularly in her collaboration with Erskine Caldwell in *You Have Seen Their Faces*), Lange purportedly used the real words of her subjects. However, Maren Stange has noted that these were often taken out of context and might also be read as misrepresentations of what was actually said. See Stange, *Symbols of Ideal Life: Social Documentary Photography in America, 1890–1950* (Oxford: Cambridge University Press, 1989), 120.

97. See Graham Clarke, ed., *The Portrait in Photography* (London: Reaktion Books, 1992).

98. Graham Clarke, *The Photograph* (Oxford: Oxford University Press, 1997), 101.

99. John Tagg, *The Burden of Representation: Essays on Photographies and Histories* (Minneapolis: University of Minnesota Press, 1988), 37.

100. Susan Sontag, *On Photography* (New York: Anchor Books, 1977), 28.

101. Ibid., 37.

102. Clarke, *The Photograph,* 113 (emphasis in text). Lange was not the first to use the portrait in this way. Clarke notes that Lewis Hine, August Sander, Paul Strand, and others were expert in using the portrait style to photograph "common" or "unusual" subjects.

103. Taylor, "From the Ground Up," 526.

104. Ibid., 528.

105. Ibid., 537.

106. When Dorothea Lange was let go from the Historical Section in the fall of 1939, Jonathan Garst, a USDA official in California and friend of both Lange and Taylor, wrote to Stryker in her defense. He explained the controversial nature of Lange and Taylor's work and contended that Taylor's career had suffered because of it: "I know that the Taylors are hard up. . . . largely because Paul Taylor's energies have been devoted almost exclusively to the problem of agricultural labor, which is not popular with a Republican Board of Regents and their Head of the Economics Department of the University of California" (Jonathan Garst to Roy Stryker, November 21, 1939, RES, series 1, reel 2).

107. Florence Loeb Kellogg, memo to Victor Weybright, 27 May 1936, SA, box 169, folder 1297.

108. Beulah Amidon, memo to Victor Weybright, 23 June 1936, SA, box 169, folder 1297.

109. Victor Weybright, memo, undated (probably 23‒24 June 1936), SA, box 169, folder 1297. Interesting to note, Weybright's memo went on to suggest that "the plow that broke the plains (and the homesteaders) is a an [sic] old villain, in danger of becoming hackneyed." This statement is surprising, given that the great drought of 1936 had barely begun in June, and *The Grapes of Wrath,* the ultimate instantiation of the migrant narrative, was still three years away. This may suggest Weybright's, and *Survey Graphic'*s, level of social awareness of such issues compared to that of other media and/or the general population.

110. Loeb Kellogg, memo to Victor Weybright, 23 June 1936, SA, box 169, folder 1297.

111. Taylor to Beulah Amidon, 19 July 1936, SA, box 169, folder 1297.

112. Weybright, memo to Florence Loeb Kellogg, 21 July 1936, SA, box 169, folder 1297.

113. Roland Barthes, *Camera Lucida,* trans. Richard Howard (New York: Hill and Wang, 1981), 27.

114. Florence Loeb Kellogg, memo to Victor Weybright, 27 May 1936, SA, box 169, folder 1297; Victor Weybright, memo to staff, undated (probably 23‒24 June 1936), SA, box 169, folder 1297.

115. Quoted in Meltzer, *Dorothea Lange,* 162.

116. Quoted in ibid., 161.

117. Coles, *Doing Documentary Work,* 115.

118. Ibid., 114. See Dorothea Lange and Paul Taylor, *An American Exodus: A Record of Human Erosion* (New York: Reynal and Hitchcock, 1939); in an interview Taylor recalled that Paul Kellogg suggested the title to them when they brought him the dummy of the book in 1939 (Taylor, PST).

119. Dorothea Lange to Roy Stryker, January 19, 1940, RES, series 1, reel 2.

120. John Lucaites has studied this seminal text in terms of how its fragmented nature illustrates tensions inherent in conceptions of "the people" in liberal democracy. See Lucaites, "Visualizing 'The People': Individualism vs. Collectivism in *Let Us Now Praise Famous Men,*" *Quarterly Journal of Speech* 83 (1997): 269‒88. As Lucaites and many others note, the book received poor critical reviews, sold very few copies, and slipped out of circulation quickly (though it was later reintroduced to a more receptive audience during the social and political turmoil of the sixties).

121. James Agee and Walker Evans, *Let Us Now Praise Famous Men: Three Tenant Families,* rev. ed. (Boston: Houghton Mifflin, 1960), xlvii.

122. Ibid., xlvi.

123. On Agee and Evans, see also William Stott, *Documentary Expression and Thirties America* (Chicago: University of Chicago Press, 1986); Alan Trachtenberg, *Reading American Photographs: Images as History from Mathew Brady to Walker Evans* (New York: Noonday Press, 1989); Rabinowitz, *They Must Be Represented;* W. J. T . Mitchell, *Picture Theory: Essays on Verbal and Visual Representation* (Chicago: University of Chicago Press, 1994).

3. Intersections of Art and Documentary: Aesthetic Rhetorics of Poverty in *U.S. Camera*

1. Edwin Rosskam, "Not Intended for Framing: The FSA Archive," *Afterimage* 8 (March 1981): 11.

2. Beginning in 1938, Maloney also started publishing *U.S. Camera* as a quarterly, then as a bimonthly, and finally as a monthly magazine; this chapter is concerned only with the *U.S. Camera* annuals. Both the monthly magazine and the annuals were published well into the 1960s, until Maloney sold U.S. Camera Publishing to American Express. Eventually, what had been *U.S. Camera* became *Travel and Leisure*. For a history of *U.S. Camera* and a brief biography of Maloney, see Harvey Fondiller, "Tom Maloney and *U.S. Camera*," *Camera Arts* (July–August 1981): 16–23, 106–7.

3. Quoted in Martin Jay, *Downcast Eyes: The Denigration of Vision in Twentieth-Century French Thought* (Berkeley: University of California Press, 1993), 136.

4. Charles Baudelaire, "The Modern Public and Photography," in *Classic Essays on Photography*, ed. Alan Trachtenberg (Stony Creek, Conn.: Leete's Island Books, 1980), 88.

5. Lady Elizabeth Eastlake, "Photography," in *Classic Essays on Photography*, ed. Alan Trachtenberg (Stony Creek, Conn.: Leete's Island Press, 1980), 59.

6. Beaumont Newhall, *The History of Photography from 1939 to the Present*, 5th ed. (New York: Metropolitan Museum of Modern Art, 1994), 146.

7. Penelope Niven, *Steichen: A Biography* (New York: Clarkson Potter, 1997), 59.

8. Ibid., 128.

9. Quoted in ibid., 158.

10. Alfred Stieglitz, "Pictorial Photography," in *Classic Essays on Photography*, ed. Alan Trachtenberg (Stony Creek, Conn.: Leete's Island Press, 1980), 121.

11. Newhall, *History of Photography*, 164.

12. Edward Steichen, "A Life in Photography—An Excerpt," *Photography in Print*, ed. Vicki Goldberg (Albuquerque: University of New Mexico Press, 1981), 291.

13. Niven, *Steichen*, 518.

14. "The New York Times: March 6 1923," in *Photography in Print*, ed. Vicki Goldberg (Albuquerque: University of New Mexico Press, 1981), 293.

15. Steichen's encounters with the FSA project and other documentary approaches influenced his later career in several ways. During World War II, Steichen (with Maloney's help) finagled an appointment to the Navy, despite the fact that at sixty-one he was too old to serve. There, he was put in charge of a group of photographers who would document the war in the Pacific. He ran that photographic unit much as Roy Stryker ran the FSA's Historical Section, telling photographers to "tell the story of Naval Aviation" not only through propagandistic pictures that would satisfy the higher-ups, but also by "making those photographs which you feel should be made" (quoted in Niven, *Steichen*, 543). Throughout the fifties and early sixties Steichen remained devoted to documentary photography. He conceived and mounted the vast "Family of Man" exhibit, which took nearly seven years to complete and featured 503 photographs from sixty-eight countries. On "The Family of Man," see Eric Sandeen, *Picturing an*

Exhibition: The Family of Man and 1950s America (Albuquerque: University of New Mexico Press, 1995).

16. Quoted in William Stott, *Documentary Expression and Thirties America* (Chicago: University of Chicago Press, 1973), 119.

17. On Hollywood fiction film of the thirties, see Andrew Bergman, *We're in the Money: Depression America and Its Films* (New York: Ivan R. Dee, 1992); on documentary film, see Eric Barnouw, *Documentary: A History of the Non-Fiction Film* (New York: Oxford University Press, 1974), and Paul Rotha, *Documentary Film*, 3d ed. (London: Faber and Faber, 1966).

18. Milton Meltzer, *Dorothea Lange: A Photographer's Life* (New York: Farrar, Straus, and Giroux, 1978), 70.

19. That said, it must be noted that one of the best-selling novels of the thirties was Steinbeck's great *The Grapes of Wrath*. Yet, as many authors have noted, Steinbeck's novel owes much to documentary technique; see Stott, *Documentary Expression and Thirties America*, 121–22.

20. Jonathan Harris, *Federal Art and National Culture: The Politics of Identity in New Deal America* (Cambridge, Eng.: Cambridge University Press, 1995), 5. Of course, the documentary genre itself has never been politically "pure." Ever since Jacob Riis ventured into the urban ghettos of the immigrant poor to show elite New Yorkers "how the other half lives," the practice of documentary has been deeply implicated in the class politics of representation; see Susan Sontag, *On Photography* (New York: Anchor Books, 1977), 63–65.

21. Fondiller, "Tom Maloney and *U.S. Camera*," 19.

22. Ibid., 20.

23. Tom Maloney, "Edward Steichen and *U.S. Camera*," *U.S. Camera 1948* (New York: U.S. Camera, 1947), 10.

24. For a listing of each volume and the photographers' work appearing in each, see Penelope Dixon, *Photographs of the Farm Security Administration: An Annotated Bibliography, 1930–1980* (New York: Garland Publishing, 1983), 226–29.

25. Ansel Adams, "A Personal Credo," in *Photography in Print*, ed. Vicki Goldberg (Albuquerque: University of New Mexico Press, 1981), 380.

26. Fondiller, "Tom Maloney and *U.S. Camera*," 20.

27. M. F. Agha, "Is Photography Art?" *U.S. Camera 1936* (New York: U.S. Camera, 1936), 8.

28. Pare Lorentz, "Dorothea Lange: Camera with a Purpose," *U.S. Camera 1941* (New York: U.S. Camera, 1940), 93–100, 229.

29. Ralph Steiner, *U.S. Camera 1936* (New York: U.S. Camera, 1936), unpaginated index.

30. Tom Maloney to Arthur Rothstein, 25 January 1937, RES, series 1, reel 1.

31. Roy Stryker to Russell Lee, 22 June 1939, ibid.

32. Noel H. Deeks to Grace M. Mayer, 13 September 1972, ESA.

33. Evelyn Lamorey to Dorothea Lange, 12 August 1936, RES, series 1, reel 1.

34. Stryker to O. W. Reigel, 2 December 1938, ibid.

35. Stryker to Robert Lynd, 2 January 1939, RES, series 1, reel 2.

36. Stryker to Rosa Reilly, 22 June 1938, RES, series 1, reel 1.

37. Roy Stryker, 17 October 1963, AAA.

38. Roy Stryker, "The FSA Collection of Photographs," in *Photography in Print*, ed. Vicki Goldberg (Albuquerque: University of New Mexico Press, 1981), 352.

39. *U.S. Camera 1936* (New York: U.S. Camera, 1936), unpaginated index.

40. In her pioneering essay, "Visual Pleasure and the Narrative Cinema" (1975), Laura Mulvey uses Freud's idea of "scopophilia" to explain the pleasure a viewer receives from looking at an image. See

239

Mulvey, *Visual and Other Pleasures* (Bloomington: Indiana University Press, 1989). In the case of this image, we might describe such pleasure as tragic and cathartic, in Aristotle's sense of the terms. See Aristotle, *Poetics*, trans. Richard Janko (Indianapolis: Hackett, 1987), sections 49b20–50a35 and section 3 of "Poetics II."

41. Sontag, *On Photography*, 110.

42. There was a tense exchange between Stryker and Lange when Stryker discovered Lange had removed the thumb from the negative. See Meltzer, *Dorothea Lange*, 199–200; F. Jack Hurley, *Portrait of a Decade: Roy Stryker and the Development of Documentary Photography in the Thirties* (Baton Rouge: Louisiana State University Press, 1972), 142–43.

43. When I refer to *U.S. Camera*'s cropping of the scene, keep in mind that it is difficult to know who actually did the cropping for this photograph—Lange, *U.S. Camera*, or perhaps the technicians in Stryker's darkroom. Lange was not known for the quality of her darkroom work; her friend Ansel Adams often produced prints for her. It is possible that Adams printed the *U.S. Camera* version if Lange submitted it to Maloney directly from her home in Berkeley.

44. By "natural" I mean the outdoor light available to Lange at the moment she made the photograph.

45. These nude portraits appear on pages 24, 30, 44, 52, 78, and 79 of *U.S. Camera 1936*. Interesting to note, when I retrieved this volume from the University of Illinois library in order to have certain images photographed for duplication in this book, every single nude image had been excised from the volume (very precisely, I might add—with a razor blade).

46. Group f/64 was the name of a group of West Coast photographers that included Cunningham, Edward Weston, and Ansel Adams, among others. Named for its members' preferred aperture setting on the camera, the group advocated a straight photography aesthetic, arguing that "any photograph not sharply focused in every detail, not printed by contact on glossy black-and-white paper, not mounted on a white card, and betraying any handwork or avoidance of reality in choice of subject was 'impure'" (Newhall, *History of Photography*, 192). See also Therese Thau Heyman, ed., *Seeing Straight: The f.64 Revolution in Photography* (Oakland, Calif.: Oakland Museum, 1992).

47. Judith Fryer Davidov argues that Cunningham's images of women differ significantly from those of other Group f/64 photographers, particularly those of Edward Weston, precisely because she allows women an identity of their own and does not treat them solely in terms of form. See Davidov, *Women's Camera Work: Self/Body/Other in American Visual Culture* (Durham: Duke University Press, 1998), 340–43. This picture would seem to be an exception to that argument.

48. John Berger, *Ways of Seeing* (London: BBC), 53.

49. Ibid.

50. Ibid., 54.

51. Ibid., 47 (emphasis in text).

52. Laura Mulvey suggests that the notion of male spectatorship holds even when the spectator—or photographer, I might add—is female, because our conventions of seeing are so ingrained. Therefore, the notion of objectification of the female holds true even for Cunningham's photograph because the female photographer is adopting the viewing position of the "universal male" (Mulvey, *Visual and Other Pleasures*, 30–32).

53. Berger, *Ways of Seeing*, 54.

54. Niven, *Steichen*, 575.

55. Ibid., 227.

56. Many of those who contributed comments, though often sympathetic, referred to the people il-

lustrated in the images as "these people," "them," and even "the other half." Mention of the admission cost of forty cents is made in the comments. See "Farm Security Administration Picture Comments," RES, series 2, reel 6.

57. Steichen, "The FSA Photographers," 43–44.

58. Ibid.

59. Ibid., 45.

60. Ibid., 44.

61. Ibid., 45.

62. Alan Trachtenberg makes a similar point in his brief discussion of *U.S. Camera 1939*. See Trachtenberg, "From Image to Story: Reading the File," in *Documenting America, 1935–1943*, ed. Carl Fleischhauer and Beverly W. Brannan (Berkeley: University of California Press, 1988), 43–73.

63. Sontag, *On Photography*, 20–21.

64. The "B" of the negative number is a Library of Congress code indicating that the original negative for this print is 5 by 7 inches.

65. Roy Stryker tells the story of a woman who came to him requesting a copy of this photograph. He writes: "When I asked her what she wanted it for, she said, 'I want to give it to my brother who's a steel executive. I want to write on it, "*Your* cemeteries, *your* streets, *your* buildings, *your* steel mills. But *our* souls. God damn you"'" (Stryker, "The FSA Collection," 350).

66. James McCamy to Roy Stryker, 1 February 1938, RES, series 1, reel 1.

67. Harris, *Federal Art and National Culture*, 109.

68. Ibid., 10.

69. Ibid.

70. Quoted in Bruce I. Bustard, *A New Deal for the Arts* (Washington, D.C.: National Archives and Records Administration, 1997), 123.

71. "Department of Agriculture budget request, probably 1942–43," RES, series 2, reel 6.

72. Terry Cooney, *Balancing Acts: American Thought and Culture in the 1930's* (New York: Twayne Publishers, 1995), xiv.

4. Spectacle of the Downtrodden Other: Popular Rhetorics of Poverty in *Look* Magazine

1. "Picture Papers," *New Republic*, 24 March 1937, 197.

2. J. L. Brown, "Picture Magazines and Morons," *American Mercury*, December 1938, 407.

3. "Auto Kills Woman Before Your Eyes!" *Look*, February 1937, 14; "Will Former Dope Fiend Rule Germany?" *Look*, February 1937, 4.

4. Maren Stange implies that *Life* had a more significant relationship with the Historical Section when she notes that "newspapers and magazines that used FSA photographs included not only *Look, Life*, and the *New York Times*" but also more obscure publications. While this is technically correct, without further explanation Stange creates the impression that *Life* was a more frequent user of the photographs than it was (*Symbols of Ideal Life: Social Documentary Photography in America, 1890–1950* [Oxford: Cambridge University Press, 1989], 109; see also 113–14). Melissa McEuen creates an even stronger impression when she writes: "Stryker willingly shared the photographs with popular publications of the day, including *Life, Look, Camera*, and *Midweek Pictorial*" (126) and lists magazines in which FSA photographers "could boast numerous publications," including "*Life, Look*, and other magazines" (*Seeing America: Women Photographers between the Wars* [Lexington: University Press of Kentucky,

2000], 138). In each case McEuen lists *Life* first, implying perhaps stronger ties than what actually existed.

5. I am grateful to John Lucaites for suggesting this range of questions.

6. Robert Taft, *Photography and the American Scene* (New York: Dover, 1938), 446.

7. Ibid., 427–41, 446.

8. Frank Luther Mott, *A History of American Magazines, vol. 4, 1885–1905* (Cambridge: Harvard University Press, 1957), 2.

9. Otha Cleo Spencer, "Twenty Years of 'Life': A Study of Time, Inc.'s Picture Magazine and Its Contributions to Photojournalism," (Ph.D. diss., University of Missouri, 1958), 55.

10. See Keith R. Kenney and Brent W. Unger, "The *Mid-Week Pictorial:* Forerunner of American News-Picture Magazines," *American Journalism* 11 (Summer 1994): 242–56. In 1936 the *Times* sold the *Mid-Week Pictorial* to editor Monte Bourjaily, who promised to rejuvenate it. That effort failed, and the magazine ceased publication for good in 1937.

11. Jackson Edwards, "One Every Minute," *Scribner's,* May 1938, 22.

12. Ibid.; Theodore Peterson, *Magazines in the Twentieth Century* (Urbana: University of Illinois Press, 1964), 351.

13. Edwards, "One Every Minute," 22.

14. Loudon Wainwright, *The Great American Magazine: An Inside History of "Life"* (New York: Knopf, 1986), 5.

15. James L. Baughman, *Henry R. Luce and the Rise of the American News Media* (Boston: Twayne, 1987), 64–65.

16. *Fortune* did not ignore the Depression, but rather covered its impact on business extensively. James Agee and Walker Evans's *Let Us Now Praise Famous Men* was originally produced on assignment for *Fortune.* Editors rejected Agee's first article as too long and too experimental in form, and nothing from Agee and Evans's trip appeared in the pages of *Fortune.*

17. The first popularly used 35mm camera was the German-made Leica. In 1914 Oskar Barnack, a painter with an interest in cinematography, created the first 35mm miniature camera to serve as little more than an exposure meter. As Spencer notes, "Barnack designed this 'camera' for 35mm movie film so that he could shoot several frames of a scene, develop the film and determine the correct exposure for the movie camera" ("Twenty Years of 'Life,'" 49). World War I put his and others' experiments on hold. After the war, Barnack teamed up with lensmaker Leitz to produce the Leica camera in 1924. The Leica had the market generally to itself until another German product, the Contax, appeared in 1931. During the 1930s, the Leica and the Contax competed for the ever-growing market in 35mm photography. For an excellent contemporary history of miniature photography, see "The U.S. Minicam Boom," *Fortune,* October 1936, 125–29, 160.

18. Ibid., 160.

19. Wilson Hicks, *Words and Pictures: An Introduction to Photojournalism* (New York: Harper and Brothers, 1952), 31.

20. Spencer, "Twenty Years of 'Life,'" 38; "The U.S. Minicam Boom," 129.

21. Wainwright, *The Great American Magazine,* 8; James L. Baughman, *Luce and the Rise of the American News Media,* 69.

22. Hicks, *Words and Pictures,* 82.

23. Other technological developments transformed the possibilities for the new pictorial journalism as well. Beginning in the late nineteenth century, changes in printing presses made mass production possible. The development of high-speed, rotary presses, assembly lines, and timed production

scheduling enabled even small publications to aim for high circulation. Improvements in flash photography also contributed to the context in which *Life* and *Look* were born. For years photographers had used exploding flash powder to create enough light to make photographs in dark places. But flash powder was dangerous and had to be handled carefully. In 1930 the flashbulb was introduced in the United States. Although flashbulbs, like flash powder, could not initially be synchronized with the shutter of the camera, they took much of the danger out of photography. Soon after, the synchronization problem was solved so that photographers could open the shutter and activate the flashbulb simultaneously, taking much of the guesswork out of low-light and indoor photography. See Peterson, *Magazines in the Twentieth Century,* 5; Michael Carlebach, *American Photojournalism Comes of Age* (Washington, D.C.: Smithsonian Institution Press, 1997), 165; Spencer, "Twenty Years of 'Life,'" 50.

24. Spencer, "Twenty Years of 'Life,'" 42.

25. President's Research Committee on Social Trends, *Recent Social Trends in the United States* (New York: McGraw Hill, 1933), 1:207.

26. Peterson, *Magazines in the Twentieth Century,* 20.

27. Lee to Roy Stryker, 24 September 1940, series 1, reel 2.

28. Warren I. Susman, *Culture as History: The Transformation of American Society in the Twentieth Century* (New York: Pantheon, 1973), 160.

29. Baughman, *Luce and the Rise of the American News Media,* 86.

30. Wainwright, *The Great American Magazine,* 81.

31. Edwards, "One Every Minute," 21.

32. Ibid.

33. Ibid., 22.

34. James Alcott, *A History of Cowles Media Company* (Minneapolis: Cowles Media Company, 1998), 1.

35. Gardner Cowles, *Mike Looks Back: The Memoirs of Gardner Cowles, Founder of Look Magazine* (New York: Gardner Cowles, 1985), 24. On the history of Cowles Media Company after 1940, see Alcott, *A History of Cowles Media Company.*

36. Cowles, *Mike Looks Back,* 58.

37. Ibid.

38. Ibid.

39. Ibid., 59. Once it became clear that the two magazines were in fact competitors, the Cowles family went back to Luce and reacquired the Time, Inc. interest in *Look.*

40. Edwards, "One Every Minute," 22.

41. Cowles, *Mike Looks Back,* 61.

42. Ibid.

43. Quoted in Edwards, "One Every Minute," 23.

44. *Look,* February 1937, 2.

45. Cowles, *Mike Looks Back,* 60.

46. Ibid.

47. Ibid.

48. Daniel D. Mich and Edwin Eberman, *The Technique of the Picture Story: A Practical Guide to the Production of Visual Articles* (New York: McGraw-Hill, 1945), 11.

49. Ibid., 46.

50. Ibid., 106.

51. Ibid.

52. Ibid., 222.

53. Cowles, *Mike Looks Back,* 59.

54. Edwards, "One Every Minute," 23.

55. Ibid.

56. Wainwright notes that the criticism of "cookie-cutter" layouts came first from Clare Booth Luce, Luce's wife, who had derided early dummies of *Life* for the use of such layouts (*The Great American Magazine,* 45).

57. Baughman, *Luce and the Rise of the American News Media,* 97.

58. "Look Calls on Ann Sheridan," *Look,* 13 February 1940, 40–43.

59. "How Hollywood 'Discovered' Astaire," *Look,* 22 June 1937, 33.

60. "Ecstasy: The Movie That Caused a War," *Look,* March 1937, 28–32.

61. Cowles, *Mike Looks Back,* 113.

62. "Auto Kills Woman Right Before Your Eyes!" *Look,* February 1937, 14; "When Is a Woman Actually a Woman?" *Look,* February 1937, 38–39; "Interesting Facts about Japan," *Look,* February 1937, 12–13.

63. Edward W. Said, *Orientalism* (New York: Vintage, 1978). See also Homi K. Bhabha, "The Other Question: The Stereotype and Colonial Discourse," *Screen* 24, no. 4 (1983): 18–36.

64. "Hindu Rope Trick: How Does He Do It?" *Look,* March 1937, 11; "Romance in Zululand: A Savage Buys a Wife," *Look,* March 1937, 16–17.

65. Dave Botter, interoffice memo to George Benneyan, 30 March 1959, "Story of Look" file, Cowles Papers, Cowles Library, Drake University, Des Moines.

66. "As It's Done in the USA: They See a Hanging," *Look,* March 1937, 37; "The Story of the Ku Klux Klan: Is It Rising to Power Again?" *Look,* 21 December 1937, 6–9.

67. "Is America Really the Land of the Free?" *Look,* 12 October 1937, 6–9, and 26 October 1937, 14–17.

68. Brown, "Picture Magazines and Morons," 405–6.

69. Ibid., 407.

70. "More Picture Magazines," *Business Week,* December 4, 1937, 28–29.

71. Gardner Cowles Jr., to Roy Stryker, 23 November 1936, RES, series 1, reel 1.

72. Ibid.

73. Stryker to Cowles, 2 December 1936, ibid.

74. Ibid.

75. Ibid.

76. One of those featured the controversial "tenant madonna" story described in chapter 1.

77. Cowles to Stryker, 25 January 1937, RES, series 1, reel 1.

78. Stryker to Cowles, 6 February 1937, ibid.

79. Ibid.

80. Ibid.

81. Cowles to Stryker, 13 February 1937, ibid.

82. Stryker to Cowles, 13 January 1937, ibid.

83. Stryker to Russell Lee, 10 August 1937, ibid.

84. Stryker to Marion Post, 1 April 1939, RES, series 1, reel 2.

85. For example, see Stryker, "Weekly Gossip Sheet," 27 February 1940; Clara "Toots" Wakeham to Russell Lee, 10 August 1940; Russell Lee to Roy Stryker, 22 September 1940; Lee to Stryker, 24 September 1940; Stryker, memo to photographers, 22 May 1941; all RES, series 1, reel 2.

86. This number refers to images credited in the "*Life*'s Pictures" index to individual section photographers and/or the RA or FSA; I personally inspected each issue of *Life* for these three years. The first

section photograph to appear was a Dorothea Lange portrait of a rancher (actually credited underneath the photo to the Resettlement Administration), the second a 1937 cover image of "July corn" credited to Lange herself, and the third a nondescript aerial photograph of Greenbelt, Maryland, credited in "*Life*'s Pictures" to the FSA. See, respectively, "Dust Bowl Farmer Is New Pioneer," *Life,* 21 June 1937, 65; *Life,* 5 July 1937, cover; and *Life,* 23 May 1937, 58.

87. Dorothea Lange to Roy Stryker, 19 November 1936, RES, series 1, reel 1.

88. Stryker to Lange, 2 December 1936, ibid.

89. Ibid.

90. Lange to Stryker, 8 February 1937, ibid.

91. Lange to Stryker, 16 February 1937, ibid.

92. Stryker to Lange, 9 March 1937, ibid.

93. Lange to Stryker, 23 March 1937, ibid.

94. Stryker to Lange, 27 March 1937 and 21 April 1937, ibid.

95. Stryker to Lange, 10 May 1937, ibid.

96. Stryker to Grace Falke, 13 August 1937, ibid.

97. Stryker to Lange, 30 September 1937, ibid.

98. Lee to Stryker, n.d. June 1937, ibid.

99. Stryker to Lee, 24 June 1937, ibid.

100. Luce, quoted in Wainwright, *The Great American Magazine,* 99.

101. These and other *Life* staff photographers covered some of the same territory as Historical Section photographers. In 1937 Bourke-White published with Erskine Caldwell the very popular, but now oft-criticized, picture book on sharecropping, *You Have Seen Their Faces* (New York: Viking, 1937). *Life* featured images from the book in its November 22, 1937, issue. See "The South of Erskine Caldwell Is Photographed by Margaret Bourke-White," *Life,* 22 November 1937, 48–52.

102. Stryker to Edwin Locke, 25 April 1938, RES, series 1, reel 1.

103. "Myrna Loy: Dream Wife of a Million Men," *Look,* March 1937, 21.

104. "Is Spiritualism a Fake?" *Look,* 25 May 1937, 16–17; "How to Talk with Your Hands," *Look,* 25 May 1937, 20–21.

105. By "surveillance" here I mean less an all-encompassing, subject-less Foucauldian surveillance than something more akin to Laura Mulvey's description of the "controlling, curious gaze." See Mulvey, *Visual and Other Pleasures* (Bloomington: Indiana University Press, 1989), especially "Visual Pleasure and Narrative Cinema," 14–26.

106. This photograph appears in the file as Arthur Rothstein, "Child of North Carolina Sharecropper," FSA-OWI Collection, LC-USF33-002140-M4.

107. "Children of the *Forgotten Man! LOOK* Visits the Sharecropper," *Look,* March 1937, 18.

108. Stryker to Gardner Cowles Jr., 6 February 1937, RES, series 1, reel 1.

109. This photograph appears in the file as Ben Shahn, "Children of sharecropper, Little Rock, Arkansas," FSA-OWI Collection, LC-USF33-006026-M3.

110. This photograph appears in the file as Dorothea Lange, "'Cleanliness.' Southern California. Oklahoma refugees camping in Imperial Valley, California," FSA-OWI Collection, LC-USF34-001735-ZE.

111. Another bit of miscaptioning here, for the photograph is actually of a trapper in Louisiana, not a migrant in California. This photograph appears in the file as Ben Shahn, "Unemployed trapper, Plaquemines Parish, Louisiana," FSA-OWI Collection, LC-USF33-006156-M2.

112. This photograph appears in the file as Arthur Rothstein, "Wife and Children of Sharecropper, Washington County, Arkansas," FSA-OWI Collection, LC-USF33-002021-M1.

113. "Children of the *Forgotten Man!*" 19.

114. See Arthur Rothstein, "Wife and Children of Sharecropper, Washington County, Arkansas," FSA-OWI Collection, LC-USF33-002021-M3 and LC-USF33-002022-M1-M5.

115. "Children of the *Forgotten Man!*" 18.

116. This photograph appears in the file as Ben Shahn, "Colored Children of Sharecroppers, Little Rock, Arkansas," FSA-OWI Collection, LC-USF33-006026-M4.

117. This photograph appears in the file as Carl Mydans, "Children of Negro sharecropper at pump. Near West Memphis, Arkansas," FSA-OWI Collection, LC-USF34-006330-D.

118. "Children of the *Forgotten Man!*" 19.

119. Ibid., 18.

120. "Caravans of Hunger: Thousands of Landless Farmers Wander California's Highways," *Look,* 25 May 1937, 19.

121. Stryker to Gardner Cowles Jr., 6 February 1937, RES, series 1, reel 1.

122. "Children of the *Forgotten Man!*" 19.

123. "Caravans of Hunger," 19 (emphasis in text).

124. "Children of the *Forgotten Man!*" 19.

125. "Caravans of Hunger," 18–19 (emphasis mine).

126. "Children of the *Forgotten Man!*" 19.

127. On the STFU, see H. L. Mitchell, *Roll the Union On, As Told by Its Co-founder, H. L. Mitchell* (Chicago: C. H. Kerr Publishing, 1987); Donald H. Grubbs, *Cry from the Cotton: The Southern Tenant Farmers' Union and the New Deal,* rev. ed. (Fayetteville: University of Arkansas Press, 2000); Howard Kester, *Revolt among the Sharecroppers* (Knoxville: University of Tennessee Press, 1997).

128. "Children of the *Forgotten Man!*" 19.

129. Ibid.

130. "Caravans of Hunger," 19.

131. Stryker to Arthur Rothstein, 12 May 1939, RES, series 1, reel 2.

132. See "The Grapes of Wrath," *Life,* 5 June 1939, 66–67, and "Speaking of Pictures: These by *Life* Prove Facts in 'Grapes of Wrath,'" *Life,* 19 February 1940, 10–11. In 1938 Bristol had traveled with Steinbeck, hoping to work with the author on a picture book about the migrants in California. Steinbeck later abandoned the idea when he became absorbed in the writing of *Grapes.*

133. "America's Own Refugees: The Story Behind 'The Grapes of Wrath,'" *Look,* 29 August 1939, 16–23.

134. Ibid., 16.

135. Ibid., 18.

136. Ibid., 19.

137. Ibid., 22 (emphasis mine).

138. Ibid., 20.

139. Ibid.

140. Ibid., 21 (emphasis in text).

141. Ibid., 22.

142. This photograph was not made in the agricultural areas of California, however, but in West Virginia. This image appears in the file as Ben Shahn, "A Deputy with a gun on his hip during the September 1935 strike in Morgantown, West Virginia," FSA-OWI Collection, LC-USF33-006121-M3.

143. This image appears in the file as Arthur Rothstein, "Eroded land on tenant's farm. Walker County, Alabama," FSA-OWI Collection, LC-USF346-025121.

144. James N. Gregory, *American Exodus: The Dust Bowl Migration and Okie Culture in California* (New York: Oxford University Press, 1989), 97.

145. Charles Shindo, *Dust Bowl Migrants in the American Imagination* (Lawrence: University of Kansas Press, 1997), 3.

146. John Steinbeck, *The Grapes of Wrath* (1939; New York: Penguin, 1992), 572.

147. I am grateful to Tom Farrell for pointing out the irony of this reversal.

148. John Steinbeck, *Working Days: The Journals of "The Grapes of Wrath," 1938–1941* (New York: Viking, 1989), 98.

149. George Thomas Miron, *The Truth about John Steinbeck and the Migrants* (Los Angeles: Haynes Corporation, 1939).

150. U.S. Senate, Committee on Education and Labor, "The Associated Farmers of California, Inc.: Its Reorganization, Policies, and Significance, 1935–1939," *Employers' Associations and Collective Bargaining in California,* Report No. 1150, Pt. 8, 78th Cong. (Washington, D.C.: Government Printing Office, 1944), 1461.

151. Carey McWilliams, *Ill Fares the Land: Migrants and Migratory Labor in the United States* (Boston: Little, Brown, 1942), 27.

152. U.S. Senate, "The Associated Farmers of California, Inc.," 1474.

153. McWilliams, *Ill Fares the Land,* 16.

154. Mitchell, *Roll the Union On,* 191.

155. U.S. Senate, "The Associated Farmers of California, Inc.," 1479.

156. Jerold S. Auerbach, *Labor and Liberty: The La Follette Committee and the New Deal* (Indianapolis: Bobbs-Merrill, 1966), 6.

157. Ibid., 185.

158. "America's Own Refugees," 20.

159. Richard L. Neuberger, "Who Are the Associated Farmers?" *Survey Graphic* 28 (September 1939): 517–21+.

Epilogue: Rhetorical Circulation and the Picturing of Poverty

1. Walter Benjamin, "The Author as Producer," *Reflections: Essays, Aphorisms, Autobiographical Writings,* ed. Peter Demetz (New York: Schocken, 1978), 222.

2. David Zarefsky, "Four Senses of Rhetorical History," in *Doing Rhetorical History: Concepts and Cases,* ed. Kathleen J. Turner (Tuscaloosa: University of Alabama Press, 1998), 30.

SELECTED
BIBLIOGRAPHY

Books and Parts of Books

Agee, James, and Walker Evans. *Let Us Now Praise Famous Men: Three Tenant Families.* 1941. Rev. ed., Boston: Houghton Mifflin, 1960.

Alcott, James. *A History of Cowles Media Company.* Minneapolis: Cowles Media Company, 1998.

Anderson, Sherwood. *Home Town: The Faces of America.* New York: Alliance Book Company, 1940.

Asen, Robert. *Visions of Poverty: Welfare Policy and Political Imagination.* East Lansing: Michigan State University Press, 2002.

Baldwin, Sidney. *Poverty and Politics: The Rise and Decline of the Farm Security Administration.* Chapel Hill: University of North Carolina Press, 1968.

Barnouw, Eric. *Documentary: A History of the Non-Fiction Film.* New York: Oxford University Press, 1974.

Barthes, Roland. *Camera Lucida: Reflections on Photography.* Trans. Richard Howard. New York: Hill and Wang, 1981.

———. *Image—Music—Text.* Trans. Stephen Heath. New York: Hill and Wang, 1977.

Baughman, James L. *Henry R. Luce and the Rise of the American News Media.* Boston: Twayne, 1987.

Benjamin, Walter. "A Small History of Photography." In *One-Way Street and Other Writings,* 240–57. London: Verso, 1985.

———. "The Work of Art in the Age of Mechanical Reproduction." In *Illuminations: Essays and Reflections,* 217–51. New York: Schocken, 1968.

Berger, John. *Ways of Seeing.* London: BBC, 1972.

Berger, John, and Jean Mohr. *Another Way of Telling.* New York: Vintage, 1982.

Bourke-White, Margaret, and Erskine Caldwell. *You Have Seen Their Faces.* New York: Viking, 1937.

Brace, Charles Loring. *The Dangerous Classes of New York and Twenty Years' Work among Them.* 3d ed. New York: Wynkoop and Hallenbeck, 1880.

Bremner, Robert H. *From the Depths: The Discovery of Poverty in the United States.* New York: New York University Press, 1956.

Bustard, Bruce I. *A New Deal for the Arts.* Washington, D.C.: National Archives and Records Administration, 1997.

Carlebach, Michael L. *American Photojournalism Comes of Age.* Washington, D.C.: Smithsonian Institution Press, 1997.

Chambers, Clarke. *Paul U. Kellogg and "The Survey": Voices for Social Welfare and Social Justice.* Minneapolis: University of Minnesota Press, 1971.

Coles, Robert. *Doing Documentary Work.* New York: Oxford University Press, 1997.

Curtis, James. *Mind's Eye, Mind's Truth: FSA Photography Reconsidered.* Philadelphia: Temple University Press, 1989.

Daniel, Pete, Merry A. Foresta, Maren Stange, and Sally Stein. *Official Images: New Deal Photography.* Washington, D.C.: Smithsonian Institution Press, 1987.

Davidov, Judith Fryer. *Women's Camera Work: Self/Body/Other in American Visual Culture.* Durham: Duke University Press, 1998.

Dixon, Penelope. *Photographs of the Farm Security Administration: An Annotated Bibliography, 1930–1980.* New York: Garland Publishing, 1983.

Finnegan, Cara A. "Circulating Images: Visual Rhetorics of Poverty in Farm Security Administration Documentary Photography." Ph.D. diss., Northwestern University, 1999.

Fisher, Andrea. *Let Us Now Praise Famous Women: Women Photographers for the U.S. Government, 1935 to 1944.* London: Pandora Press, 1987.

Fleischhauer, Carl, and Beverly W. Brannan. *Documenting America, 1935–1943.* Berkeley: University of California Press, 1988.

Goldberg, Vicki, ed. *Photography in Print.* Albuquerque: University of New Mexico Press, 1981.

Gregory, James N. *American Exodus: The Dust Bowl Migration and Okie Culture in California.* New York: Oxford University Press, 1989.

Harris, Jonathan. *Federal Art and National Culture: The Politics of Identity in New Deal America.* Cambridge: Cambridge University Press, 1995.

Hurley, F. Jack. *Portrait of a Decade: Roy Stryker and the Development of Documentary Photography in the Thirties.* Baton Rouge: Louisiana State University Press, 1972.

Jay, Martin. *Downcast Eyes: The Denigration of Vision in Twentieth-Century French Thought.* Berkeley: University of California Press, 1993.

Katz, Michael B. *In the Shadow of the Poorhouse: A Social History of Welfare in America.* Rev. ed. New York: Basic Books, 1996.

Lange, Dorothea, and Paul Taylor. *An American Exodus: A Record of Human Erosion.* New York: Reynal and Hitchcock, 1939.

Lowitt, Richard, and Maurine Beasley, eds. *One Third of a Nation: Lorena Hickok Reports on the Great Depression.* Urbana: University of Illinois Press, 1981.

MacLeish, Archibald. *Land of the Free.* New York: Harcourt, Brace, 1938.

McElvaine, Robert S. *The Great Depression: America, 1929–1941.* New York: Times Books, 1993.

McEuen, Melissa A. *Seeing America: Women Photographers between the Wars.* Lexington: University Press of Kentucky, 2000.

McWilliams, Carey. *Factories in the Field: The Story of Migratory Farm Labor in California.* Boston: Little, Brown, 1939.

Meltzer, Milton. *Dorothea Lange: A Photographer's Life.* New York: Farrar, Straus, and Giroux, 1978.

Mich, Daniel D., and Edwin Eberman. *The Technique of the Picture Story: A Practical Guide to the Production of Visual Articles.* New York: McGraw-Hill, 1945.

Mitchell, W. J. T. *Picture Theory: Essays on Verbal and Visual Representation.* Chicago: University of Chicago Press, 1994.

Mulvey, Laura. *Visual and Other Pleasures.* Bloomington: Indiana University Press, 1989.

Natanson, Nicholas. *The Black Image in the New Deal: The Politics of FSA Photography.* Knoxville: University of Tennessee Press, 1992.

Newhall, Beaumont. *The History of Photography from 1839 to the Present.* 5th ed. New York: Metropolitan Museum of Modern Art, 1994.

Niven, Penelope. *Steichen: A Biography.* New York: Clarkson Potter, 1997.

O'Neal, Hank. *A Vision Shared.* New York: St. Martin's, 1976.

Olson, Lester. *Emblems of American Community in the Revolutionary Era: A Study in Rhetorical Iconology.* Washington, D.C.: Smithsonian Institution Press, 1991.

Orvell, Miles. *The Real Thing: Imitation and Authenticity in American Culture, 1880–1940.* Chapel Hill: University of North Carolina Press, 1989.

Patterson, James T. *America's Struggle against Poverty in the Twentieth Century.* 4th ed. Cambridge: Harvard University Press, 2000.

Ryan, William. *Blaming the Victim.* New York: Vintage, 1976.

Shindo, Charles. *Dust Bowl Migrants in the American Imagination.* Lawrence: University of Kansas Press, 1997.

Sontag, Susan. *On Photography.* New York: Anchor Books, 1977.

Stange, Maren. *Symbols of Ideal Life: Social Documentary Photography in America, 1890–1950.* Oxford: Cambridge University Press, 1989.

Steinbeck, John. *The Grapes of Wrath.* New York: Penguin, 1992.

Stott, William. *Documentary Expression and Thirties America.* Chicago: University of Chicago Press, 1986.

Stryker, Roy, and Nancy Wood. *In This Proud Land: America, 1935–1943, As Seen in the FSA Photographs.* London: Secker and Warburg, 1974.

Susman, Warren I. *Culture as History: The Transformation of American Society in the Twentieth Century.* New York: Pantheon, 1973.

Taft, Robert. *Photography and the American Scene.* New York: Dover, 1938.

Tagg, John. *The Burden of Representation: Essays on Photographies and Histories.* Minneapolis: University of Minnesota Press, 1988.

Terkel, Studs. *Hard Times: An Oral History of the Great Depression.* New York: Pantheon, 1970.

Trachtenberg, Alan. *Reading American Photographs: Images as History from Mathew Brady to Walker Evans.* New York: Noonday Press, 1989.

———, ed. *Classic Essays on Photography.* Stony Creek, Conn.: Leete's Island Books, 1980.

Tugwell, Rexford G., Thomas Munro, and Roy E. Stryker. *American Economic Life and the Means of Its Improvement.* 3d ed. New York: Harcourt Brace, 1930.

Wainwright, Loudon. *The Great American Magazine: An Inside History of "Life."* New York: Knopf, 1986.

Wright, Richard, and Edwin Rosskam. *Twelve Million Black Voices: A Folk History of the Negro in the United States.* New York: Viking, 1941.

Archival Resources

Archives of American Art. New Deal and the Arts Oral History Project, interviewer Richard K. Doud. Smithsonian Institution, Washington, D.C.

Edward Steichen Archive. Tom Maloney Correspondence Files. Museum of Modern Art, New York.

FSA-OWI Collection. Prints and Photographs Division, Library of Congress, Washington, D.C.

Paul Schuster Taylor. *California Social Scientist,* interviewer Suzanne B. Riess. Regional Oral History Office, Bancroft Library, University of California, Berkeley.

Roy Emerson Stryker Papers. Photographic Archive, University of Louisville, Louisville.

Survey Associates Collection. Social Welfare History Archive, University of Minnesota, Minneapolis.

INDEX

Addams, Jane, 60. *See also* Survey Associates

African Americans: discrimination, 62; in FSA file, xix; images of in New Deal, xx; infantilization of, 200–2; in *Look,* 199; lynching, 91; migration of, 60, 79, 83, 87–89, 91, 93–94; in *Survey Graphic,* 83. *See also* slavery

Agee, James, 41, 117. *See also Let Us Now Praise Famous Men*

agrarian myth, 7, 8, 20, 28. *See also* rural poverty: invisibility of

Agricultural Adjustment Administration (AAA): 26–27; failure of, 30; Stryker as employee, 37

American Economic Life and the Means of Its Improvement, 28, 36–38, 72. *See also* Hine, Lewis; Stryker, Roy Emerson; Tugwell, Rexford Guy

American Exodus, An, 56, 116. *See also* Lange, Dorothea; Taylor, Paul

Amidon, Beulah, 69, 113. *See also Survey Graphic*

art: conventions of, 120, 130, 145, 149; and documentary, xv, 119–21, 148–49, 162–67, 223; FSA photographs as, 135, 152, 158, 163, 224; modern(ism), xix, 127, 165; nudes in, 145–49; photographs as, xi, xvi, 122–23; realism, xiii

Associated Farmers of California (AF): criticism of *The Grapes of Wrath,* 215; federal investigation of, 217; goals of, 216; tactics of, 216

Bankhead-Jones Farm Tenant Act, 32, 45. *See also* Farm Security Administration

Benjamin, Walter, ix, xii, xiv, xx, 220, 222

Berliner Illustrierte Zeitung, 173. *See also* picture magazines

"Bitter Years, The," xviii. *See also* FSA photographs: exhibits; Steichen, Edward

Bourke-White, Margaret, 55, 128, 175, 196. *See also You Have Seen Their Faces*

Brace, Charles Loring, 11, 13, 14. *See also The Dangerous Classes of New York*

"Brains Trust," xi, 27. *See also* New Deal; Roosevelt, Franklin Delano; Tugwell, Rexford Guy

Brandeis, Louis, 61, 65–67, 94. *See also* social invention

Bubley, Esther, 41. *See also* FSA photographers, Historical Section

Caldwell, Erskine, 55. *See also You Have Seen Their Faces*

capitalism, 34

Charities and the Commons, 60–61. *See also* Kellogg, Paul; scientific charity; *Survey Graphic*

Charities/Charities Review, 57, 59–60. *See also* Kellogg, Paul; scientific charity; *Survey Graphic*

254

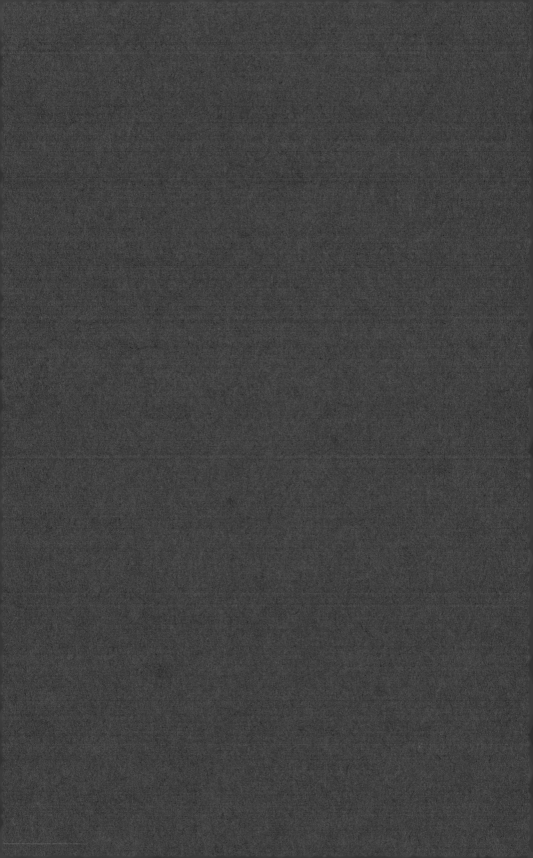